Sculptors and Sculpture of Caria and the Dodecanese

Sculptors and Sculpture of Caria and the Dodecanese

Edited by
Ian Jenkins and Geoffrey B. Waywell

with assistance from
Madeleine Gisler-Huwiler and Peter Higgs

Published for the
Trustees of the British Museum
by British Museum Press

© 1997 The Trustees of the British Museum
Published by British Museum Press
A division of The British Museum Company Ltd
46 Bloomsbury Street, London WC1B 3QQ

First published 1997

British Library Cataloguing in Publication Data

A catalogue record for this book is available
from the British Library
ISBN 0-7141-2212-2

Designed by James Shurmer

Typeset in Photina by Wyvern 21 Ltd

Printed in Great Britain by Cambridge
University Press

Contents

Preface

This volume arises out of a colloquium held at the British Museum and King's College London in December 1994. Generous support from the Caryatids (Friends of the Greek and Roman Department of the British Museum) and the Leverhulme Foundation provided the means for bringing together speakers from Turkey, Greece, Italy and Scandinavia, as well as a strong representation from Great Britain. The colloquium took as its theme marble sculpture produced in the workshops of the islands of the so-called Dodecanese and sites in mainland Caria. Papers were grouped according to island or mainland site, and this structure has been retained for these Proceedings.

The theme of the conference was determined partly by the research interests of the organisers and partly to provide a forum for celebrating the achievements of two honorands. In 1994 Sir Charles Newton (1816–1894) and Professor Bernard Ashmole (1894–1988) shared a centenary anniversary: the latter was born in 1894, the year of the former's death. Both had served as distinguished Keepers of the British Museum's Department of Greek and Roman Antiquities and both held the Yates Chair in Classical Archaeology in the University of London. More importantly for the archaeological theme of the conference, each had added greatly to knowledge and understanding of Classical sculpture.

Charles Newton's excavations in Asia Minor from 1856 to 1859, principally at Halicarnassus and Cnidus, unearthed vast quantities of the remains of the ancient marble-worker's craft. The eventual display of his finds in the galleries of the British Museum and his own published accounts of them opened a new chapter in the history of the regional development of ancient Greek sculpture. In his travels Newton collected every fragment of sculpture and every marble inscription he could find, not only at the sites he excavated, but also on the islands of Cos, Calymnus, Rhodes and elsewhere.

Newton's pioneering spirit, formidable even for the heroic age of nineteenth-century scholarship, made discoveries enough to keep generations of scholars occupied. One of his notable successors was Bernard Ashmole, whose life-long fascination with Classical sculpture caused him to return time and time again to Newton's excavation material. He is remembered not least for his work on the friezes of the Mausoleum of Halicarnassus and the Demeter of Cnidus. The first two essays in this volume, by Brian Cook and Geoffrey Waywell respectively, expand upon the achievements of Newton and Ashmole. Cook's includes an appendix listing for the first time Newton's published works in chronological order. This has already been done for Ashmole's publications in the autobiography published in 1944 (ed. Kurtz).

A number of the essays in this volume arise out of Newton's legacy, reviewing and adding to the body of accumulated knowledge, while others present the fruits of new excavations or other kinds of discovery. Whatever the subject, all these papers have in common a discipline of close observation and comparison of original material. The results are achieved by the application of skills that Newton and Ashmole themselves possessed and did so much to foster in others.

The editors wish to thank the Caryatids, the Leverhulme Foundation and the British Academy for funding the conference and the Caryatids for assistance with these Proceedings. Dyfri Williams, Keeper of Greek and Roman Antiquities, has supported the project throughout. Madeleine Gisler-Huwiler and Teresa Francis provided much help with the editing of this volume and Peter Higgs collated the illustrations.

Ian Jenkins
British Museum

Geoffrey Waywell
Institute of Classical Studies, University of London

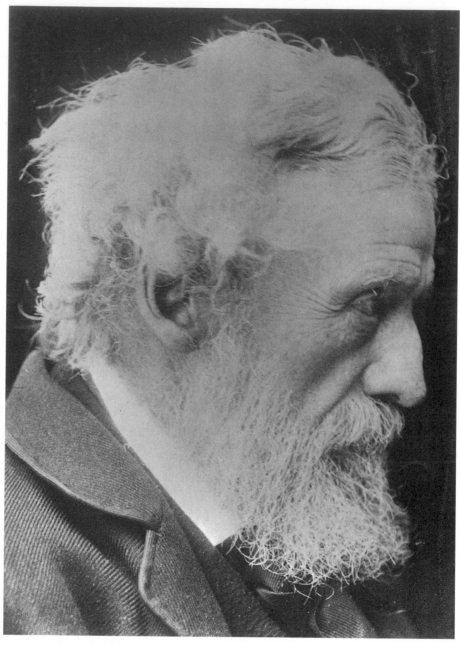

Photograph of Charles Newton. From P. T. Stevens, *The Society for the Promotion of Hellenic Studies. 1879–1979. A Historical Sketch* (n.d.) 12

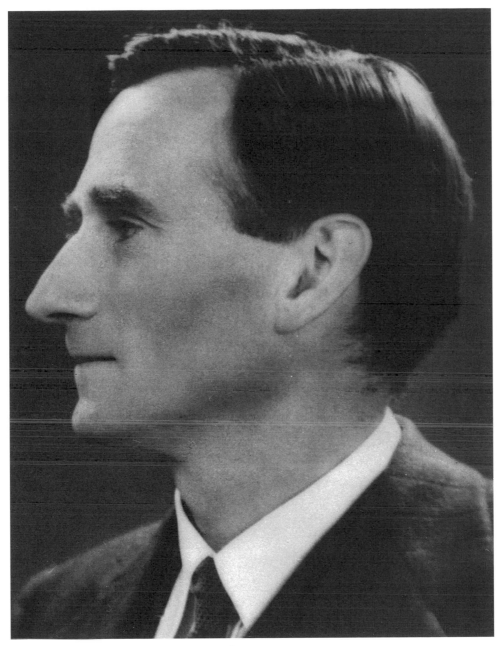

Bernard Ashmole, *c*.1938. Ashmole family

1

Sir Charles Newton, KCB (1816–1894)

Brian F. Cook

'No man in our time has done more to recover the monuments of Greek art and history, and to make them accessible to the study and appreciation of our own day.' Those are the words of Ernest Gardner, summing up the achievement of Sir Charles Newton at a meeting of the British School at Athens in January 1895.[1] They constitute a substantial claim, and it is one of the aims of this paper to make it good. Another aim is to fill in the background to remarks made by Stanley Lane-Poole in an obituary published in the *National Review*: 'To some of those immediately connected with him in archaeological researches he may at times have seemed open to the charge of scientific jealousy and a desire to claim exclusive credit for the results obtained.'[2] A third aim is to respond on Newton's behalf to some criticisms of his personality and conduct by more recent writers.

Newton was born in 1816 at Clungunford in Shropshire, where his father, the Revd Newton Dickinson Hand Newton, was then Vicar.[3] He went to Shrewsbury School and matriculated in 1833 at Christ Church, Oxford, where he was a contemporary of Ruskin.[4] In 1837 he obtained a second class in Literae humaniores. In 1840 he was able to proceed to the degree of Master of Arts, and in the same year was appointed as an Assistant in the Department of Antiquities at the British Museum. According to Eugénie Sellers, Newton's decision to join the British Museum was against the wishes of his family, who had intended him for a different career.[5] It does not seem difficult to decode that statement: his family's wishes must at that period have been those of his father. As a beneficed clergyman, himself the son and grandson of clergymen, Newton's father no doubt wanted Charles to follow him into the Church, as indeed his elder son William did.[6]

Newton's entry in the old *Dictionary of National Biography* suggests that a career in the British Museum 'as it then was, can have presented but few attractions to a young man.' This judgement, by Cecil Harcourt-Smith, who resigned the Keepership of Greek and Roman Antiquities in 1908 to become Director of the Victoria and Albert Museum, is no doubt correct

financially – and we have indeed Newton's own words to confirm that – but Percy Gardner presents a more positive view: 'There is no better career in England than in the British Museum for a man who is content with moderate pay, and is inspired by the love of research.'[7] Indeed, Harcourt-Smith admits that 'the department, as yet undivided, probably offered to Newton a wider range of comparative study in his subject than he could otherwise have acquired.' Newton, as we shall see, did find in the Museum the opportunity for research, and also for experience in the professional skills of curatorial work.

At the time of his appointment, the Department of Antiquities under its Keeper, Edward Hawkins, comprised almost all of today's departments, excluding only Prints and Drawings, and Newton's colleagues included Birch and Franks.[8] In his early years at the Museum Newton spent much time on the coin collection, writing the 'tickets' that accompanied each coin in its place in the drawers. He may well have been influenced by the numismatic practice of arranging coins in chronological sequences to approach sculptures and other antiquities in a similarly chronological manner.[9] Newton later described himself as a historian rather than an archaeologist.[10] He believed that one of the main functions of archaeology was to assemble evidence for the service of the historian, and from this point of view the most useful category of antiquities was inscriptions.[11] Newton was to make important contributions to epigraphy, both through his acquisitions for the Museum and by his own research and publication.

The acquisition in 1846 of the slabs from the Mausoleum that had been incorporated by the Hospitallers in their castle at Bodrum provided Newton with a new intellectual challenge and led to his first important publication.[12] It is a substantial article, discussing among other topics the attribution of the friezeblocks and the possible location of the Mausoleum. Newton's conjectures on the topography of Bodrum were based on a chart of the town produced by Lt Graves of the Royal Navy's Hydrographic Survey, and included the speculation that an area near the Aga's

palace observed by Thomas Donaldson to have been littered with the remains of a substantial marble building might mark the site of the Mausoleum.[13] This suggestion earned the scorn of Ludwig Ross, who excoriated Newton for presuming to express an opinion about a site that he had not personally visited, as Ross himself had.[14] Ross, it should be noted, had spent only a single day in Bodrum; his account makes it clear that he walked past the area described by Donaldson but did not notice it. The site Ross proposed for the Mausoleum eventually turned out to be the temple of Ares, as Captain Spratt of the Hydrographic Survey suggested. Spratt had his own candidate for the Mausoleum site.[15]

In 1848 Newton obtained leave of absence to travel in Europe to visit museums. As an indication of how conditions of service in the Museum have improved since those days, Newton did not receive his travel expenses or even his salary while away. The entire cost of his journey had to be met from his own resources. His travels took him to Florence, Naples, Rome, Siena, Pisa, Bologna, Verona and Munich, and led to another article.[16] Newton adopted a historical approach to different classes of antiquities, assessing the resources of the various museums for the study of each period and culture.

It was at this period that Newton gave two analytical lectures in Oxford: 'On the Method of the Study of Ancient Art' to the Oxford Art Society in November 1849,[17] and 'On the Study of Archaeology' to the Archaeological Institute in 1850.[18] The latter earned him much praise for having 'so well employed the advantages which his position at the British Museum had afforded him'.[19] Newton was much involved with the Archaeological Institute in its early years, before 'classical archaeology' grew into a discipline separate from British archaeology, a development for which Newton himself was chiefly responsible. He was one of the Secretaries at the York meeting of the Institute in 1846. His paper there on 'British and Roman Remains in Yorkshire' was not printed, although the Institute published the map Newton prepared to illustrate it.[20] His 'Notes on the Sculptures at Wilton House,' first printed by John Murray, were presented to the Salisbury meeting in 1849.[21]

In 1852, after twelve years at the Museum, Newton resigned to take up an appointment as Vice-Consul at Mytilene. In his letter of resignation he acknowledged the advantages of working in the Museum,[22] but privately he told his friend Layard, the excavator of Nineveh, that he was glad to be released from its 'intolerable routine'.[23] He also seems to have been weary of interruptions to his regular duties, which caused

delays and a backlog of work. Today's curators will sympathise.

In addition to his normal consular duties, Newton was 'instructed to use such opportunities as presented themselves for the acquisition of antiquities for the British Museum'.[24] This instruction has been misinterpreted, in particular by Robert Eisner, who recently claimed that Newton's appointment as Vice-Consul was merely diplomatic cover for his continuing employment by the British Museum.[25] Eisner was evidently ignorant of the documentary evidence that Newton really did resign his Museum post and later had to negotiate with Panizzi[26] and to apply to the Trustees for re-employment.[27] In making acquisitions, Newton soon found that permanent residence and his official position gave him a certain advantage over temporary visitors.[28]

He was always especially keen to acquire inscriptions, and when he heard that the people of Calymnus were planning to build a new church with stone reused from the temple of Apollo, he devised a scheme to assist them financially by purchasing any blocks with inscriptions.[29] He also conducted excavations himself from time to time. In 1855 he unearthed in the hippodrome at Constantinople the remains of the bronze serpent column originally set up in Delphi from the spoils of the battle of Plataea.[30] This was an important inscription, but publication of it had to be left to others.[31] It was probably this exploit that gave rise to another persistent modern misconception: that the British Museum possesses the head of one of the bronze serpents. It is, of course, actually in the Archaeological Museum in Istanbul.[32]

In 1855 Newton was offered the Regius Chair of Greek at Oxford to enable him to teach classical archaeology there. He was unable to accept the Chair since the salary attached to it was only nominal,[33] and it was left to Percy Gardner to make the subject a reputable one at Oxford.[34] As things turned out, nothing could have been more fortunate, for 1855 was also the year of Newton's first visit to Bodrum, which was to be the scene of his greatest archaeological triumph. This first visit was brief, but in the spring of the following year Newton was in Bodrum again, this time for long enough to conduct some minor excavations. From his field notebook[35] it is clear that at this stage he regarded as the probable site of the Mausoleum the 'platform' selected by Spratt. A more extensive excavation on this site was central to the scheme Newton proposed to Panizzi when he returned to England on leave that summer.[36] He thought it likely that excavation there would turn up inscriptions or sculpture from the Mausoleum, but he proposed to excavate

Ross's platform also, since he realised that, if not the Mausoleum, it must be the temple of Mars. There is no reference at this stage to the site noted by Donaldson.

Newton also proposed to investigate Cnidus, a site then remote from habitation. Thinking there was no labour available locally, Newton requested the services of a man-of-war. A reasonable amount would also be needed for expenses – not less than £2,000 (equivalent to about £120,000 in today's currency). The excavation staff should include an architect and (almost as an afterthought) a photographer. In the event Newton got his man-of-war (HM Steam-corvette *Gorgon* under Commander Towsey) and a contingent of Royal Engineers to provide the technical help. The Officer Commanding was Lt R.M. Smith (Fig. 6), who himself served as site architect, and his men included Cpl Benjamin Spackman, who was a photographer (Figs 6-10), and two brothers called Nelles, one a smith and the other a carpenter.[37]

If you take Newton's own accounts of the discovery of the Mausoleum[38] at face value, as most of his contemporaries did,[39] you will be left with the impression that Newton first investigated Spratt's and Ross's platforms, and then discovered the site described by Donaldson, where he began to excavate on 1 January 1857. This turned out to be the true site of the Mausoleum, as he had conjectured so many years before. The finds were quite spectacular, as any visitor to the British Museum may discover, and they have naturally underpinned Newton's archaeological reputation ever since. No one would wish to denigrate Newton's achievement in organising the expedition that led to such discoveries, but his posthumous reputation has inevitably been marred by the disclosure that he concealed, apparently quite deliberately, the fact that it was actually Lt Smith who first recognised Donaldson's site, overlain as it was by houses and gardens. Since Smith pointed it out, it was initially known as 'Smith's platform', to distinguish it from Spratt's platform and Ross's platform. This was evidently something of a joke, since the sites favoured by Spratt and Ross were marked by substantial foundations or 'platforms', while the true site had been so effectively quarried by the Hospitallers that only the marble fragments originally noticed by Donaldson gave a clue, by this time evidently rather faint, to its presence. Newton never refers to 'Smith's platform', but Towsey's diary provides independent evidence for the use of the term and for the commencement of excavation there on 27 December, rather earlier than Newton stated. By early January it was becoming evident that this was indeed the site of the Mausoleum, and on 7 January Towsey

wrote in his diary: 'Newton in raptures: thinks he has found the site of the Mausoleum and that his name will be immortalized among the number of antiquarians who delight in such things.' Smith noted wryly that no more was heard of 'Smith's platform', and the scattered references to the truth in his biography and in his entry in the *Dictionary of National Biography* never quite prevailed against the other version put about by Newton and widely accepted by archaeological colleagues.[40] This incident must be counted among those that lay behind Lane-Poole's remarks on Newton's unwillingness to give proper credit to his assistants.[41]

The location of the Mausoleum site having been established, Newton's next problem was to obtain possession of the ground in order to excavate it. The site was covered with houses and gardens, each belonging to a different owner, and Smith wrote in admiration of Newton's diplomacy and patience in dealing with the proprietors. Newton was not averse to less diplomatic and patient methods, such as experimenting to find how close to a house he could dig without actually undermining the foundations, or having the Sappers excavate by tunnelling under land he had yet to acquire. This could have unexpected results, as when Cpl Jenkins (Fig. 10), digging upwards from his mine, appeared inside one of the houses to the amazement of its occupant, or when a fig tree that Newton was negotiating to buy in order to dig below it suddenly fell down, having been undermined.[42]

The sides of the western staircase were also explored by mining, leading to the discovery of some bones of oxen. Fortunately Newton left most of the deposit undisturbed, to be excavated a century later in a more painstaking and scientific manner by the Danish Halicarnassus Expedition (Director, Professor Kristian Jeppesen).[43] In general Newton's field technique, with his failure to keep detailed records of the finds, leaves much to be desired. When excavating the field of Chiaoux, his practice was to backfill the trenches with the spoil produced by further digging in order to save time.[44] On the site of the Mausoleum itself, he wrote, 'There being no convenient manner of disposing of the earth and rubble as it was dug out, it had to be piled up in mounds.'[45] Newton of course did not have the advantages of a team of trained archaeologists to do the digging, but relied largely on the Sappers and the crew of *Gorgon*.

The sailors prepared a surprise for him at Christmas, as recorded by Towsey:

The party at the diggings ... hit upon a curious expedient – in effect – chairing Mr Newton or Columbus as they have named him. Accordingly at 12 oclock they caught

him hoisted him up to their shoulders seated in a *wheelbarrow* previously prepared in secret and paraded him round the town singing wild ditties and I fear some profane chants. Newton took it uncommonly well tho. he looked in his leafy perch very like the owl in the ivy bush, and it will be long before he forgets his ride round Boudroum. The Turks were lost in astonishment ... I believe they thought we were mad.[46]

A feature of the ship's concert on board *Gorgon* on Christmas Day was a song from a civilian member of Newton's party, the artist George Frederic Watts. Newton had expected him to draw for the expedition, but in the event Watts did very little by way of drawing at Bodrum, and he returned to England in May 1857. He later used Newton's head for Edward I in a mural, *Justice: a Hemicycle of Lawgivers*, in the Hall of Lincoln's Inn (Fig. 12).[47]

Newton excused himself for recording the find-spots of only a few major items by the state of the site, which had been much disturbed by the Hospitallers;[48] and there is something in this, for the records of the Danish excavation show that joining fragments could be found in widely separated squares of the grid. It should, moreover, be borne in mind that these were early days for field archaeology. Even fifteen years later Schliemann's excavation technique at Troy left much to be desired. Newton was also one of the first excavators to realise the value of a photographic record of the site and finds.[49]

Given the circumstances and the conditions of his work, it is amazing that Newton was able to accomplish as much as he did. He certainly found a remarkable quantity of sculpture, both free-standing and in relief, and he also found much tangible evidence to supplement Pliny's description of the Mausoleum. Attempts to restore the Mausoleum on paper now became serious archaeological ventures rather than mere exercises of creative imagination based on the text of Pliny.[50] Newton's finds at Bodrum and later at Cnidus, together with the sculptures recovered from Branchidae, constituted a very significant addition to the Museum's collections, and it would be hard to exaggerate their importance at the time for advancing contemporary knowledge of Greek sculpture in the fourth century BC.

Newton had begun his work in the Aegean area full of enthusiasm and hope. In June 1852 he wrote to Layard that he had been led there by a 'desire for change' and looked forward to the satisfaction of 'seeing new countries and people'; and in August he wrote that he was determined to stay in the Orient until he had accomplished something.[51] In April 1853, in a letter to Layard from Rhodes, he remarked that he would prefer to work full time as an archaeologist, but the need to earn his bread compelled him to sacrifice some time to his work as Consul. In this he was prepared to spend five years.[52] It was in fact to be a little over six years before, in May 1859, he was instructed by the Foreign Office to bring his excavations in Bodrum and Cnidus to a close,[53] but no one could deny that in that time he had certainly accomplished something. Indeed that period of six years encompassed the whole of his career as an excavator in the field.

Meanwhile he had written two letters to Panizzi on the possibility of a return to work in the Museum. In a letter dated 9 November 1856,[54] he wrote at some length of the duties of the Keeper of Antiquities, which were basically those that would be accepted by any curator today: custody, acquisition, display, interpretation and publication. His previous experience at the Museum from May 1841 to February 1852 had clearly given him a detailed grounding in his profession. Newton's proposal was that he should not perform general departmental administration, which he regarded as uncongenial and time-consuming, but should instead undertake what he called the 'literary labour' of writing and editing catalogues. In other words, Newton wanted to have the satisfaction of research and publication without the burden of administration. But there was more: he wanted two months' leave each year, since his health was not good enough to spend the winter in England; he wanted an increase in his salary, which in fifteen years of public service had been inadequate; and he also wanted an allowance for foreign travel, which he had previously financed from his private means. On 14 October 1858 Newton wrote again to Panizzi along the same lines, since he realised that decisions on the administration of the Department after the departure of Hawkins might have to be made while he was out of England.[55]

Newton's appointment as Consul in Rome in June 1859 was accompanied by a substantial increase in salary over what he had been paid as Vice-Consul in Mytilene, and placed him in a very different intellectual and social milieu. He wrote to Layard in May 1860 that he had been lecturing on the Mausoleum with great success. He much preferred lecturing to other work, but remained in doubt as to whether he would be permitted to indulge in this predilection in his native country or would be 'condemned to the Consular service forever'.[56] Within a month the picture had changed. Newton had evidently heard unofficially from Panizzi about the plan to divide the Department of Antiquities into three: 'Nothing would be more satisfactory', he wrote on 12 June; such an opportunity for employment in England might not

recur.[57] He would prefer sculptures to coins, but would accept what was offered.[58] When Hawkins eventually resigned in October, Newton lost no time in making a formal application for his post. He had still not been informed officially of the proposed division of the Department,[59] but applied through the Foreign Office to the Archbishop of Canterbury and the Lord Chancellor, two of the three Principal Trustees of the Museum as it was then constituted.[60] By the following January he had been appointed Keeper of Greek and Roman Antiquities and had taken up his duties. Ian Jenkins has observed that Newton was influenced to change his mind and to undertake the full duties of a Keeper after all by the decision to split the old Department of Antiquities into three parts;[61] but there is more to it than that, and in order to understand events fully we must look at Newton's personal life and see how private factors influenced his public actions.

When Newton was in London in 1858, he wanted someone to make drawings of his finds from the Mausoleum.[62] William Vaux, a colleague who had been appointed to the Department of Antiquities not long after Newton himself, was a friend of Joseph Severn and his family. Severn was an artist who was not particularly successful commercially – in fact he once had to flee to Jersey to escape his creditors while the bailiffs seized his furniture. His children were artists too, the most talented being his daughter Mary. She made a respectable income from drawing, and was the mainstay of the family's finances. With some hesitation, because Newton had a reputation for being difficult in some ways and inclined to sarcasm, Vaux introduced him to Mary, who began to make drawings of the Mausoleum sculptures. Newton liked her work, came to inspect it daily, and stayed to talk. Mary enjoyed these conversations and was impressed by Newton's learning. In her book on the Severns, Sheila Birkenhead used Mary's letters and diaries, and these must be the source of her description of Newton as a man whose stern face and air of distinction gave an initial impression of austerity, later modified by lines of humour around his mouth. Newton called on the Severns and was invited to dine. Before returning to Cnidus he proposed marriage, and while away sent Mary letters and poems. His second letter to Panizzi suggesting the terms on which he would like to return to the Museum was written at this time.[63] Newton now specified a salary – not less than £300 – and remarked: 'It is time for me to make up my mind what is to be my future course in life, and, if the post I wish to have at the Museum be not attainable, I must find myself a niche elsewhere.' He was evidently wanting to settle down in married life. This may have influenced him to leave Mytilene for the Consulship in Rome, where his salary was higher. He was later to write that he was not unmindful of what the Foreign Office had done for him.[64]

In June of the following year (1859), Newton was again in London for a brief period before taking up his new appointment as Consul in Rome. He gave a lecture on the Mausoleum, which was attended by the Severn family. Mary remained unwilling to marry, since her income from drawing was still essential for the family. In June 1860 she was invited to Bredwardine to stay with Newton's widowed mother, and Mrs Severn thought that an engagement was possible. Now Newton unfolded his plan: to obtain for himself the new Keepership at the Museum, and then to get Mary's father appointed as Consul in Rome in his place. On the strength of this, Newton and Mary became engaged. Newton, as we know, did become Keeper in January 1861, and at the end of that month Joseph Severn was appointed Consul in Rome. With the family's financial problems solved, Charles Newton and Mary Severn were married in April 1861. William Vaux was the best man.

Their marriage was to last only five years. In 1866 Mary caught measles and rapidly succumbed. Lady Birkenhead's account is unsympathetic to Newton, and reads almost as though she thought him responsible in some way for Mary's death, making her work too hard, adding to her own work all the drawings for his lectures, and insisting on having them redrawn if they were not perfect. He was also strict on household accounts, which drove Mary to despair.[65] His fondness for company, whether entertaining or dining out, which could be presented as a sign of an agreeably convivial nature, is somehow made to contribute to the picture of Newton as a hard taskmaster. A particular incident is cited as evidence of his caustic tongue: as well as drawing sculptures, Mary experimented with copying the Parthenon frieze in modelling clay. Asked to comment, Newton remarked: 'A very tolerable mud pie is produced, that's all.' In cold print it sounds merely sarcastic (Birkenhead calls it 'damping'); but Mary herself recorded the incident as a cartoon (Fig. 11b), surely showing that the remark was intended – and received – as an affectionate joke, especially since Mary addresses Newton as 'Charles', not more formally as 'Mr Newton', as in Birkenhead's inaccurate transcription.[66] Since another of Mary's cartoons showed her 'driven to despair' by the accounts, that incident too may be viewed in a less harsh light.[67] That Mary was devoted to her husband is evident in every line of her drawing (Fig. 11a) entitled 'Last touches before going out to dinner' (Mary trimming

her husband's beard with scissors).[68] Newton himself
was devastated by her death. In his memorial address
to the Hellenic Society, Professor Jebb, who knew
Newton personally, spoke of Mary's death as 'a crush-
ing sorrow ... the shadow of that loss never passed
away'.[69] Today two of Mary's large drawings grace the
ante-room of the Department's offices. They were used
to illustrate *Travels and Discoveries*,[70] and are reprinted
here (Figs 5a-b) to pay tribute to her memory also by
using them again for their original purpose: to illustrate
a paper, this time about rather than by her husband.

To return now to Newton's career in the Museum.
His main opportunities for acquisition came in the
earlier years of his Keepership, and the sources were
the traditional ones: old collections, new excavations,
and the market.[71] On 20 April 1864 Newton reported
to the Trustees the opportunity to acquire eleven sculp-
tures from the Farnese collection for about £4,000.
The purchase, he thought, was desirable at this price,
'as statues of merit seldom come into the market'.
Three days later he set off for Rome to negotiate the
purchase, reporting its completion on 7 July. The total
cost was £3,873 13s 6d, including packing, freight,
legal services, bank charges and a payment of £10 to
the custodian of the Palazzo Farnese. Such presenta-
tions, he explained, were necessary to expedite mat-
ters in Italy at that time.

In February 1865 the Pourtalès collection was sold
at auction in Paris. Newton had examined the collec-
tion and reported to the Trustees in January that it
contained many desirable objects, including a relief
commemorating a physician called Iason[72] and a splen-
did krater from Sant'Agata dei Goti,[73] 'distinguished',
as Newton wrote, 'not only for the interest of the sub-
ject but for the richness and variety of the composi-
tion on both sides'.[74] Newton expected high prices at
the sale, but thought it would be regrettable if short-
age of funds were to prevent the Museum from taking
the opportunity to buy. In the event he was able to
acquire several sculptures, including the relief of Iason,
as well as the krater and more than twenty other
vases. He bought few of the desired bronzes because
the prices were so high, with competition from Berlin
and St Petersburg. The total cost, including commis-
sion to Rollin and Feuardent, was £5,821 7s 11d,[75]
equivalent to about £350,000 today: Newton had both
much greater funds at his disposal and a much greater
discretion in allocating them than any Keeper would
nowadays be allowed.

Even that amount pales into insignificance beside
the sum spent on the Blacas collection, which was
offered to the Museum under the terms of the will of
the Duc de Blacas for £80,000. Newton reported in

October 1866 that it was 'one of the finest private col-
lections in Europe', and worthy of addition to the
National Collection. After negotiations on the price, it
was acquired in November 1866 for £48,000, a sum
approaching £3,000,000 in today's terms. It was
actually very good value. The Greek and Roman
Department received over 1,400 objects. There were
almost 750 engraved gems, including the celebrated
cameo-portrait of Augustus that is still known as the
'Blacas Cameo'.[76] There were over 500 vases, as well
as terracottas, glass, wall-paintings, inscriptions, bronzes
and gold. The sculptures included the head of Asclepius
from Melos.[77] There were objects for other departments
too: some 400 Egyptian items and a group of Early
Christian silver objects including the Projecta Casket,
now known collectively as the Esquiline Treasure. For
Newton to acquire this collection was a great coup.
His report to Parliament in 1867 contained a long
and quite detailed account of the collection. This was
subsequently printed as a guidebook[78] to satisfy the
public demand for information on the collection when
it was first exhibited, since Newton found that this was
taking up a disproportionate amount of the time of
members of his department.

The second great source of acquisitions was exca-
vation.[79] Only John Turtle Wood was to rival Newton
by excavating one of the Seven Wonders of the World,
the temple of Artemis at Ephesus,[80] but many others
made important discoveries. Wood's excavations at
Ephesus lasted from 1863 to 1875 and had Newton's
support from the beginning.[81]

Newton's former assistant at Bodrum, Lt Smith, had
there acquired a taste for excavating, and undertook
an expedition to Cyrene with Commander E. A. Porcher,
RN, in 1860.[82] They began work at their own expense,
but their finds were so spectacular that within months
of his appointment as Keeper Newton was writing
enthusiastic reports to the Trustees, initially support-
ing a request for a supply of timber for packing, and
later urging an approach to the Admiralty for help
with the removal of the finds.[83] Indeed without the use
of naval vessels for transport and the exertions of their
crews ashore, Smith and Porcher's finds would never
have found their way to London.

Newton also supported other excavators whose finds
enriched the Museum's collections, including Crowe[84]
and Dennis at Benghazi,[85] Salzmann and Biliotti at var-
ious sites on Rhodes as well as in Bodrum,[86] and
another of his former assistants in Bodrum, Richard
Pullan, who excavated the temple of Athena Polias at
Priene with financial support from the Society of
Dilettanti.[87] Newton was not content merely to observe
excavations from afar. He visited Wood at Ephesus in

1865, 1871, 1873 and 1874[88] and Pullan at Priene in 1869,[89] in both places making important contributions on the practical matters of packing and transport. He also visited Biliotti at Bodrum in 1865.[90]

The third source of acquisitions was the market, and no dealer provided Newton with more splendid material than Alessandro Castellani. Newton had acquired antiquities from him as early as 1865, but it was in 1872 and 1873 that the two most important purchases were made. The 1872 purchase comprised sealstones and gold jewellery, and among the latter was an important group from a tomb at Taranto consisting of a necklace, a sceptre and a ring. Having valued the objects in the collection individually, coming to a total of £19,719, Newton rounded this figure up to £20,000 as a fair price. A suggestion by the Treasury that the Castellani material might include unnecessary duplicates was firmly refuted.[91]

In addition to the sealstones and jewellery, Castellani had for sale another large group of objects in many materials. Some had actually been in the British Museum since 1871, but the rest were still in Rome, and Newton reported from there in February 1873. The asking price was £30,000, but Newton thought that £25,000 would not be an extravagant valuation, and urged that Government approval be sought for negotiation at that figure. The question was urgent because there was competition from Berlin.[92]

Perhaps the most important individual object was the bronze head of a goddess that had previously belonged to a Turkish diplomat. Newton was particularly enthusiastic about this piece, and strove in public and private on three separate fronts to obtain it. He described it to the Trustees as 'the finest bronze which he ever saw'. A week later he wrote to the Chancellor of the Exchequer along similar lines, estimating this piece alone at about £8,000.[93] A note on the back of the letter postponing action until the views of the Trustees should be known is initialled 'W.G.': the Prime Minister, William Gladstone, had also taken a hand. Newton wrote directly to him on 9 April, having just arrived in London with Castellani and the bronze head. Newton hoped that Gladstone would visit the Museum to see the head, especially as this was the most favourable time to deal with the proposed purchase.[94] On the following day a report by Newton on the head and the importance of acquiring it appeared in *The Times*,[95] and a week later Newton was in Downing Street, still urging Gladstone to come to see the head, and giving his opinion that Castellani would not accept less than £27,000 for the whole group of objects.[96] Newton's three-pronged campaign was successful: the bargain was indeed struck at £27,000, and

on 16 May he wrote again to Gladstone, enclosing photographs of the bronze head by Charles Harrison, and expressing his gratitude to the Government for its liberality.[97] His assurance that the expenditure would prove very worthwhile in the long run has certainly been borne out.

Even before returning to the Museum Newton had played an important part in opposition to proposals to remove the great series of classical sculptures from the Museum and to exhibit them with the paintings in the National Gallery.[98] As Keeper one of his most pressing tasks was to obtain space to exhibit the collection properly.[99] The sculptures of the Mausoleum posed a particularly difficult problem. For years many of them were stored in sheds on the colonnade, but eventually the Elgin Collection was rearranged, releasing for the Mausoleum sculptures the former First Elgin Room, which was renamed the Mausoleum Room in 1869.[100] It was not until 1884 that the Mausoleum sculptures were exhibited in a gallery especially designed for them.[101]

Space for the collection was a perpetual problem, and Newton was far from the last Keeper of Greek and Roman Antiquities who had to defend departmental territory against predators from the central administration. In 1864 he resisted attempts to take over a storeroom in the basement to be turned into a laboratory for Professor Maskelyne. He argued that he could not afford to surrender the space, and urged that in any case it was unsuitable, the risk of fire or explosion there being potentially dangerous both to the health of the staff and to the safety of the collection: far better to provide a separate building where gas could be used with greater safety.[102]

Not that Newton was in any way opposed to scientific research as such. In fact in 1874 he and Franks collaborated with Professor Maskelyne and with Dr Flight of the Department of Minerals in the analysis of some bronze spear-heads from sites in Cyprus.[103] A letter to Gladstone on the subject contains a reference to the 'British Museum laboratory', which antedates by some seventy years the foundation of the present Research Laboratory.[104] A further proposal that the Museum should form a collection of slags from ancient sites was not acted upon at the time, and was only fulfilled through an independent initiative more than a century later.[105] Newton was also involved in the early application of science to conservation. In 1862 he reported to the Trustees that some of the vases were exhibiting an efflorescence. This was successfully treated by Professor Hofmann and Dr Frankland by soaking in distilled water – still the accepted treatment for an efflorescence of salts.[106]

Newton's success in making classical archaeology 'accessible to the study and appreciation of [his] own day', as Ernest Gardner put it,[107] can still be judged from his many publications, ranging from his excavation report and catalogues of vases and inscriptions to relatively popular works like his *Guides* to various galleries of the Museum and the account of his travels in Turkey and the Greek islands during his vice-consulship.

In the 1870s he produced a series of articles on new developments in archaeology, mainly in the form of extended reviews (up to 10,000 words long) of publications on numismatics and excavations at Troy, Mycenae, Olympia and in Cyprus and the Crimea. He also wrote two articles on Greek inscriptions that were considered so important as to merit translation into both French and German.[108] His lectures and reviews on Schliemann's excavations at Troy and Mycenae are particularly significant, since Newton was one of the first to recognise the importance of these discoveries for the study of what was then called the pre-Hellenic period.[109] He defended Schliemann's finds in the shaft graves at Mycenae against the charge of forgery levelled against them by some European scholars. Of his own contribution to this international debate Newton modestly remarked to Gladstone that he was relieved to find his views confirmed by Conze, who had paid more attention to the prehistoric period than he had himself.[110]

Newton's influence on the development of classical archaeology in England was also felt in other ways. He played a prominent part in the foundation of the Society for the Promotion of Hellenic Studies in 1879 and although he declined the presidency, he regularly chaired meetings in the absence of the President, the Bishop of Durham.[111] His inaugural address to the Society displays the breadth of his vision, embracing all aspects of the study of Greek and Greece, stressing the importance of archaeology as a new discipline with much to offer, and including the study of the Byzantine and more recent periods alongside that of ancient Greece.[112] He was also involved in the founding of the Egypt Exploration Society in 1882 and the British School at Athens in 1883. He was later to help the School financially by suggesting that it should receive the surplus of funds publicly subscribed for his marble portrait (Fig. 2). These funds supported two temporary studentships and made a more lasting contribution by paying for periodicals for the library.[113]

Meanwhile in 1880 Newton had been appointed as the first holder of the Yates Chair of Classical Archaeology at University College London, which he held jointly with the Keepership. Newton had at last achieved his old ambition of giving lectures on a regular basis, although reports suggest that his uncompromising standards did not contribute to the popularity of his lectures with students.[114] Newton was already 64 years old, well past the age at which today's Trustees expect Keepers to retire, but he remained at the Museum until 1885 and kept the chair at University College London until 1888. His powers were now failing. Indeed Ernest Gardner described his address at the opening of the Museum of Casts in Cambridge as 'one of the last which he ever attended in the full vigour of his mental and physical powers'.[115]

Newton was noted for his courtesy and conversational skills.[116] His manner was dignified and rather severe, at least in later years, after the death of his wife. Percy Gardner, however, records that when travelling in Greece he abandoned the austere bearing for which he was known in London.[117] Although highly respected by fellow scholars, he was not really popular with his subordinates, who found him a hard and demanding taskmaster, expecting them to match his own uncompromising and high standards. His first assistant, Grenfell, lasted only five years.[118] Grenfell's successor, Alexander Murray, appointed in 1867, was more to Newton's liking. Newton reported enthusiastically on his work when recommending him for promotion in 1872[119] and also wrote of him in glowing terms to Gladstone.[120] Newton's approval, when given, was highly valued,[121] and he enjoyed the friendship of the Revd E.L. Hicks, who prepared two volumes of *Greek Inscriptions in the British Museum* under his general editorship. Hicks dedicated his handbook on *Greek Historical Inscriptions* to Newton, describing him as both teacher and friend.[122]

Newton's *Guides* to the various galleries maintained his habitual standards of scholarship. Jebb noted that they made no concession to a popular desire for relatively elementary knowledge; Lane-Poole described them more bluntly as dry and technical.[123] The *Synopsis of the Contents of the British Museum*, which was first published in 1808 and underwent many revisions over the years, had no author's name on the title page, and the same practice was followed in Newton's *Guides*, which were treated as parts of the *Synopsis*. His name usually appeared only at the end of the introduction. His recommendation for Murray's promotion lists several *Guides* and other publications on which Murray had given him valuable assistance,[124] but no public acknowledgement was made. This is perhaps another example of that tendency on Newton's part to claim exclusive credit that so irked his associates.

Newton's achievements were fully recognised in his

lifetime by academic and other honours. He was elected Fellow of the Society of Antiquaries in 1879 and Honorary Member of the Royal Academy in 1881. Abroad he was a Corresponding Member of the Institut de France and honorary member of the central directorate of the German Archaeological Institute. He was made Honorary Fellow of Worcester College, Oxford, in 1874, and received honorary doctorates from Oxford in 1875 and from Cambridge and Strasbourg in 1879. He was elected to the Society of Dilettanti in 1863.[125] Appointed Companion of the Most Honourable Order of the Bath in 1875, he was raised to Knight Commander of the same order in 1877. He died on 29 November 1894. On that day one hundred years later, I was working on a draft of this paper, my personal tribute to a great man whose office in this Museum I was myself privileged to hold.

One of the review articles he wrote in the 1870s was entitled 'Greek Art in the Kimmerian Bosporus', and in it he discussed the then recent archaeological discoveries in the Crimea for the benefit of those without access to Stephani's publication.[126] He had much to say about jewellery and gems, including remarks about the use of filigree and coloured stones. Among the objects he discussed was a celebrated earring showing a Nereid with the arms of Achilles.[127] Characteristically he set these wonderful finds from an outpost of the Greek world into their historical place in the development of Greek art, mentioning among

material in other museums the sceptre, necklace and ring from Taranto that he had acquired for the British Museum from Castellani.[128] I wonder what Newton's thoughts would have been during the last months of his life if he had realised that exactly one hundred years later these wonderful examples of the Greek goldsmith's work from the Crimea and from Taranto would be on exhibition in the same room at the British Museum.[129] Who can doubt that this would have met with his enthusiastic approval? Given his experience of the unremitting efforts that have to be undertaken if anything worthwhile is to be accomplished in the Museum, who would have been better placed than Newton to appreciate the achievement of his latest successor? 'In regard to enterprises not his own, no signs of jealousy were ever apparent.'[130]

After Newton's death, some of his books were presented to the library of the Ashmolean Museum, where they are distinguished by a commemorative bookplate.[131]

Ex libris
Caroli Thomae Newton I. C. D.
Ord. Balnei Eq. Com.
Academiae Oxoniensi
in usum archaeologiae studentium
D D D
amici quidam
in piam memoriam
viri illustris
MDCCCXCV

NOTES

1. Gardner 67.

2. Lane-Poole 624.

3. Newton's birthplace is incorrectly given as Bredwardine near Hereford by some obituarists: Lane-Poole 616 and Sellers 273. The error seems to have arisen because Newton's father was Vicar there from 1830. The correct birthplace may be confirmed from Newton's own statement to the 1871 Census (Public Record Office RG 10/352).

4. Sellers 274, n. 1; Jebb xlix.

5. Sellers 274.

6. William Newton succeeded his father as Rector of Bredwardine, 1854–62. I am indebted to the present incumbent, the Revd Paul Barnes, for this information.

7. P. Gardner, *Autobiographica* (Oxford 1933) 32.

8. Samuel Birch (1818–85), Newton's collaborator in *A Catalogue of the Greek and Etruscan Vases in the British Museum* I-II (London 1851, 1870), Keeper of British, Medieval and Oriental Antiquities, 1861–6, Keeper of Oriental (i.e. Egyptian and Assyrian) Antiquities, 1866–85. Sir Augustus Wollaston Franks (1826–97), Keeper of British and Medieval Antiquities and Ethnography, 1866–96. See Edward Miller, *That Noble Cabinet* (London 1973) 193, n. 2 (Hawkins's assistants) and 313–16 (Franks).

9. Jenkins (1992) 59.

10. Jebb lii.

11. Infra n. 18.

12. 'On the Sculptures of the Mausoleum at Halicarnassus', *Classical Museum* 5 (1848) 170–201.

13. Thomas Leverton Donaldson, 'The Temple of Apollo Epicurius at Bassae, near Phigalia, and other Antiquities ...' in C. R. Cockerell *et al.*, *Supplement to the Antiquities of Athens by James Stuart, FRS, FSA and Nicholas Revett* IV (2nd edn, London 1830).

14. Ludwig Ross, *Reisen nach Kos, Halikarnassos, Rhodos und der Insel Cypern* (Halle 1852) 30–41. Ross was himself criticised for sneering at Newton by W. S. W. Vaux, *Ancient History from the Monuments. Greek Cities and Islands of Asia Minor* (London 1877) 64, n. 1. I am indebted to T. C. Mitchell for this reference.

15. T. Spratt (Commander, RN), 'On Halicarnassus', *TransRSocLit* 5 (1856) 1–23.

16. 'Remarks on the Collections of Ancient Art in the Museums of Italy, the Glyptothek at Munich and the British Museum', *The Museum of Classical Antiquities* I (1851) 205–27.

17. Published in Oxford in 1850.

18. 'On the Study of Archaeology', *ArchJ* 8 (1851) 1–26, also printed in *Memoirs Chiefly Illustrative of the History and Antiquities of the City and County of Oxford, Annual Meeting of the Archaeological Institute of Great Britain and Ireland Held at Oxford, June 1850* (London 1854) 1–26; republished in *Essays* 1–38.

19. Mr Hallam, seconding the vote of thanks, *ArchJ* 7 (1850) 308.

20. *ProcSocAnt* 2nd series 15 (1893–5) 382.

21. Reprinted in *Memoirs Illustrative of the History and Antiquities of Wiltshire and the City of Salisbury. Communicated to the Annual Meeting of the Archaeological Institute of Great Britain and Ireland Held at Salisbury, July 1849* (London 1851) 248–78.

22. British Museum Archives, *Original Papers* XLVII, 31 January 1852; cf. Jenkins (1992) 173.

23. Letter to Layard, 6 June 1852, Add. Ms. 38981, fol. 54.

24. *TD* I, 1. Newton's Vice-Consular reports are preserved in the Public Record Office; I have not consulted them myself and am grateful for this information to Lucia Patrizio Gunning of University College London, who is studying them.

25. Robert Eisner, *Travelers to an Antique Land* (Ann Arbor 1991) 168. Eisner's criticisms of Newton's character and behaviour ('a mean-spirited personality engaged in admiring itself and exploiting or disdaining others') are anachronistic. It seems unfair to castigate Newton for failing to meet the standards of American political correctness current a century after his death.

26. Supra n. 22, and infra n. 54–5.

27. Infra n. 57.

28. Letter to Layard, 6 August 1852, Add. Ms. 38981, fol. 107–8.

29. Letter to Layard, 21 June 1853, Add. Ms. 38981, fol. 375. His purchase later formed a substantial part of *Greek Inscriptions in the British Museum* II (London 1883), which he edited personally.

30. *TD* II, 29.

31. Originally by Frick, *Jahrbücher für klassische Philologie* Supp. vol. III, no. 4 (Leipzig 1859) 487–555. For a text and partial bibliography, see Russell Meiggs and David Lewis (eds), *A Selection of Greek Historical Inscriptions to the End of the Fifth Century* B.C. (Oxford 1988) 57–60, no. 27.

32. P. Devambez, *Grands bronzes du Musée de Stamboul* (Paris 1937) 9–12, pl. II.

33. Harcourt-Smith in *DNB*, s.v. Newton.

34. George Hill, 'Percy Gardner 1846–1937', *ProcBritAc* 23 (1937) 464.

35. Preserved in the British Museum, Department of Greek and Roman Antiquities.

36. British Museum Archives, *Original Papers* LIV, 8 August 1856; cf. Jenkins (1992) 174–5.

37. On Smith see Dickson and *DNB*. Smith recorded Newton's joking suggestion that some of the Sappers should speak Greek: the Nelles brothers were fluent in that language, having been born in Corfu, Dickson 20–21.

38. *Dispatches* (1858), 12 January 1857; *HCB* 86; *TD* II, 84–6.

39. E.g. W. S. W. Vaux, 'On Recent Discoveries at Budrum (the Ancient Halicarnassus), Branchidae and Cnidus by C. T. Newton, Esq., British Vice-Consul at Mytilene' (the substance of papers read on 25 November 1857 and 2 February 1859), *ProcSocLit* 2nd series 6 (1859) 448–502 especially 461; Sellers 275–6; Jebb lii; Adolf Michaelis, *Ein Jahrhundert kunst-archäologischer Entdeckungen*[2] (Leipzig 1908) 96.

40. See Jenkins (1992) 178–80 and, in greater detail, B. F. Cook et al., *Relief Sculptures of the Mausoleum* (forthcoming).

41. Supra n. 2.

42. *TD* II, 89–91.

43. *The Maussolleion at Halikarnassos, Research Reports of the Danish Archaeological Expedition to Bodrum*, I, *The Sacrificial Deposit* (Copenhagen 1981).

44. Dickson 27.

45. *HCB* 91, and pl. XII.

46. Towsey's journal is preserved in the British Museum, Department of Greek and Roman Antiquities.

47. Wilfrid Blunt, 'England's Michaelangelo': *A Biography of George Frederic Watts, O.M., R.A.* (London 1975) 92–7. I am grateful to W. H. Cole for bringing this work to my attention and for kindly lending it to me.

48. *HCB* 99.

49. On Newton's place in the history of archaeological photography, see Gabrielle Feyler, 'Contribution à l'histoire des origines de la photographie archéologique: 1839–1880', *MEFRA* 99, 2 (1987) 1023.

50. *BMCS* II, 73–8.

51. Letters to Layard, 6 June and 6 August 1852, Add. Ms. 38981, fol. 54 and 106–8.

52. Letter to Layard, 7 April 1853, Add. Ms. 38981, fol. 279–80.

53. By cable via Smyrna, 10 May 1859, Dickson 140.

54. Letter to Panizzi, Add. Ms. 36717, fol. 612–21; cf. Jenkins (1992) 194, n. 184.

55. Letter to Panizzi, Add. Ms. 36718, fol. 501.

56. Letter to Layard, 15 May 1860, Add. Ms. 38986, fol. 364–5.

57. Letter to Panizzi, Add. Ms. 36720, fol. 485.

58. Letter to Panizzi, 18 June 1860, Add. Ms. 36720, fol. 493.

59. Letter to Panizzi, 6 November 1860, Add. Ms. 36721, fol. 79.

60. Letter to Panizzi, 12 November 1860, Add. Ms. 36721, fol. 134.

61. Jenkins (1992) 194.

62. This account of Newton's courtship and marriage is heavily dependent on Birkenhead 129–31. For a different account of their meeting (in the house of Wharton Marriott at Eton), see Lane-Poole 621.

63. 14 December 1858, Add. Ms. 36718, fol. 501; Jenkins (1992) 194, n. 185.

64. Letter to Panizzi, 12 June 1860, Add. Ms. 36720, fol. 485–8.

65. Birkenhead 157.

66. Birkenhead 128; the cartoon is illustrated facing p. 121.

67. Oxford Arts Club, *Catalogue of Drawings by Max Beerbohm and Mrs. Newton* (Oxford 1922) 4, no. 19: 'M. N. can't make the balance come right'.

68. Birkenhead, facing p. 141.

69. Jebb li; Lane-Poole 621.

70. Pls 8–9 and 10.

71. The main collections are listed by Sellers 277. For sculptures see also Jenkins (1992) 212.

72. *BMCS* I, 629.

73. H. B. Walters, *Catalogue of the Greek and Etruscan Vases in the British Museum*, IV, *Vases of the Latest Period* (London 1896) no. F 68; *ARV*2 1446, Pourtalès Painter, no. 1.

74. Report, January 1865.

75. Report, 25 February 1865.

76. H. B. Walters, *Catalogue of the Engraved Gems and Cameos Greek Etruscan and Roman in the British Museum* (London 1926) no. 3577.

77. *BMCS* I, 550.

78. *A Guide to the Blacas Collection of Antiquities* (London 1867).

79. Sellers 277–8.

80. Wood, *Ephesus*.

81. Report, 18 February 1863.

82. Captain R. Murdoch Smith, RE, and Commander E. A. Porcher, RN, *History of the Recent Discoveries at Cyrene, made during an Expedition to the Cyrenaica in 1860–61, under the Auspices of Her Majesty's Government* (London 1864).

83. Reports, 22 May and 25 July 1861.

84. See D. M. Bailey, 'Crowe's Tomb at Benghazi', *BSA* 67 (1972) 1–11; 'Crowe's Tomb at Benghazi – a Postscript', *JLibS* 19 (1988) 87–94.

85. See Dennis E. Rhodes, *Dennis of Etruria* (London 1973).

86. Biliotti. For Biliotti at Bodrum, cf. Waywell (1978) *passim*.

87. Society of Dilettanti, *Antiquities of Ionia* IV (1881); see also Carter, *Priene* 4–23.

88. Report, 8 June 1865; Wood, *Ephesus* 195–7 (January to February 1871), 225 (March 1873) and 255 (January 1874).

89. Carter, *Priene* 23.

90. Report, 8 June 1865.

91. Report, 4 August 1871.

92. Report, 17 February 1873.

93. Add. Ms. 44437, fol. 163.

94. Add. Ms. 44438, fol. 170–73.

95. *The Times* 10 April 1873, republished in *Essays* 400–3.

96. Add. Ms. 44438, fol. 209.

97. Add. Ms. 44438, fol. 237–8.

98. His letter on this subject to the Chairman of the Select Committee on the National Gallery was printed in *Report of the Select Committee on the National Gallery* (1853), Appendix XII, 772 and *Report of the National Gallery Site Commission* (1857), Appendix II, 159 (republished in *Essays* 39–72). For a discussion, see Jenkins (1992) 198–205.

99. See Jenkins (1992) 212–21.

100. Report, 9 February 1869.

101. Newton's *Guide to the Mausoleum Room* was published in 1886, not long after his retirement.

102. Report, 7 December 1864.

103. Franks reported the results to the archaeological congress held in Stockholm in 1874: 'Den anthropolojisk–arkeologiska Kongressens Sammantrade i Stockholm', *Kungliga Vitterhets, Historie och Antikvitets Akademien, Manadsblad* 3 (1874) 127.

104. Letter to Gladstone, 7 May 1874, Add. Ms. 44443, fol. 224. Newton reported the results to Gladstone on 12 August (Add. Ms. 44444, fol. 196–7) and a week later sent him a copy of Flight's report (Add. Ms. 44444, fol. 217–18).

105. Metallurgical samples from the University of Madrid's excavations at Rio Tinto were presented in 1982 by Professor Antonio Blanco Freijeiro through Dr Paul Craddock of the Department of Scientific Research, and slag samples from Italian sites were presented in 1984 by Dr Craddock. Newton's recommendation was in a letter to Gladstone, 12 August 1874, Add. Ms. 44444 fol. 196–7.

106. Reports, 25 April 1861 and 6 February 1862.

107. Gardner 67.

108. The articles were reprinted in *Essays*. Details will be found in the Bibliography published in this volume, pp. 22–3.

109. See also Gardner 77, Lane-Poole 624 and Fitton. For Newton's extensive correspondence with Schliemann, see Lesley Fitton, *Heinrich Schliemann and the British Museum* (*BM Occasional Paper* 83, London 1991); some of Schliemann's letters were copied to and discussed with Gladstone: see Add. Ms. 44439, fol. 257–66 (5 August 1873), 44440, fol. 179 (9 October 1873) and 44441, fol. 238–40 (28 December 1873).

110. Letter to Gladstone, 17 October 1874, Add. Ms. 44444, fol. 309 10.

111. P. T. Stevens, *The Society for the Promotion of Hellenic Studies 1879–1979: A Historical Sketch* (London 1979) 11.

112. 'Hellenic Studies. An Introductory Address', *JHS* 1 (1880) 1–6.

113. Gardner 76; Helen Waterhouse, *The British School at Athens: The First Hundred Years* (*BSA*, Suppl. 19, London 1986) 11, 69.

114. Lane-Poole 625.

115. Gardner 76.

116. Gardner 74; Sellers 280; Lane-Poole 626.

117. P. Gardner, *Autobiographica* 33.

118. From June 1861 to October 1866, Reports, June 1862 (confirming that Grenfell had satisfactorily completed his year of probation) and 8 October 1866.

119. Report, 4 March 1872.

120. Murray was among the guests at a breakfast given by Gladstone at 10 Downing Street in Schliemann's honour on 25 June 1875, Add. Ms 44785, fol. 48.

121. Gardner 75; cf. Lane-Poole 625.

122. *The Collection of Ancient Greek Inscriptions in the British Museum* I (1874) and III (1890). E. L. Hicks, *A Manual of Greek Historical Inscriptions* (Oxford 1882), a work that has been revised several times by later scholars. For the most recent version, see above, n. 31. The dedication of the first edition reads:

CAROLO . THOMAE . NEWTON
MAGISTRO . DISCIPULUS
AMICUS . AMICO
D . D

123. Jebb liii; Lane-Poole 625.

124. The second volume of the *Catalogue of Vases* (1870), and the *Guides* to the Blacas Collection (1867), the First and Second Vase Rooms (1868 and 1869) and the Bronze Room (1871), Report, 4 March 1872.

125. Lionel Cust (ed. Sir Sidney Colvin), *History of the Society of Dilettanti* (London 1914) 301.

126. *CRPetersb 1865* (1866) 41–54, pl. II.

127. From the tomb of the 'Priestess of Demeter', Great Bliznitsa, *Essays* 383–4, Williams and Ogden 186–7, no. 120.

128. Williams and Ogden 202–5, nos 134–6.

129. The exhibition *Greek Gold* held at the British Museum in 1994 (Williams and Ogden).

130. Lane-Poole 624.

131. 'From the books of Charles Thomas Newton, K.C.B., LL.D., to the University of Oxford for the use of students of archaeology, some of his friends gave and dedicated a gift in affectionate memory of a great man, 1895.'

Appendix *A Bibliography of C. T. Newton*

'A Description of Four Bronzes Found at Colchester: From the Collection of Henry Vint, Esq.', *Archaeologia* 31 (1846) 443–7

Map of British and Roman Yorkshire prepared under the direction of the Central Committee of the Archaeological Institute for the Annual Meeting at York in 1846 by Charles Newton. Drawn and engraved by W. Hughes (London 1847). The map was intended to illustrate Newton's paper on the same subject, which was not printed

'On the Sculptures of the Mausoleum at Halicarnassus', *Classical Museum* 5 (1848) 170–201

Translation into Greek iambic trimeters of four lines spoken by Juliet in *Romeo and Juliet*, Act 3, Scene 5, in *Sabrinae corolla in hortulis Regiae Scholae Salopiensis* (London 1850) 186–7

On the Method of the Study of Ancient Art, lecture to the Oxford Art Society, 14 November 1849 (Oxford 1850)

Notes on the Sculptures at Wilton House (privately printed 1849), reprinted in *Memoirs Illustrative of the History and Antiquities of Wiltshire and the City of Salisbury. Communicated to the Annual Meeting of the Archaeological Institute of Great Britain and Ireland Held at Salisbury, July 1849* (London 1851) 248–78

'On the Study of Archaeology', *ArchJ* 8 (1851) 1–26, reprinted in *Memoirs Chiefly illustrative of the History and Antiquities of the City and County of Oxford. Communicated to the Annual Meeting of the Archaeological Institute of Great Britain and Ireland Held at Oxford, June 1850* (London 1854) 1–26, republished in *Essays* 1–38

'Remarks on the Collections of Ancient Art in the Museums of Italy, the Glyptothek at Munich and the British Museum', *The Museum of Classical Antiquities* 1 (1851) 205–27

A Catalogue of the Greek and Etruscan Vases in the British Museum 1 (London 1851) (with S. Birch)

'On the Arrangement of the Collections of Art and Antiquities at the British Museum' (Letter to the Chairman of the Select Committee on the National Gallery), *Report of the Select Committee on the National Gallery* (1853), Appendix XII, 772. *Report of the National Gallery Site Commission* (1857), Appendix II, 159, republished in *Essays* 39–72

'Antiquities at Athens and in its Neighbourhood' (Extracts from a letter to W. R. Hamilton, dated 18 April 1852, read 2 July 1852, introduced by W. S. W. Vaux), *TransRSocLit* 2nd series 5 (1856) 60–84

'Letter from Charles T. Newton, Esq., to W. Martin Leake, Vice-President, on some inscriptions at Mavrodhilissi, the site of the Amphiaraion' (dated 1 August 1853, read 9 November 1853), *TransRSocLit* 2nd series 5 (1856) 107–52

'Letter from Charles T. Newton, Esq., to W. Martin Leake, Vice-President, on some inscriptions at Mavrodhilissi' (dated 5 April 1855, read 9 May 1855), *TransRSocLit* 2nd series 5 (1856) 275–83

'Excavations and Discoveries at Calymnos, made, in November, 1854, by direction of Lord Stratford de Redcliffe, H. B. M. Ambassador at Constantinople', *ArchJ* 13 (1856) 14–37. (The paper had been read to the Archaeological Institute of Great Britain and Ireland, Section of Antiquities, at the Shrewsbury meeting in August 1855, and was also published separately, paginated 1–24)

Report on the Campana Collection (London 1856) (with S. Birch)

Papers Respecting the Excavations at Budrum. Presented to both Houses of Parliament by Command of Her Majesty (London 1858)

Further Papers Respecting the Excavations at Budrum and Cnidus (In continuation of Papers presented to Parliament, March 26, 1858) Presented to the House of Commons by Command of Her Majesty (London 1859)

Report on the Arrangement of the Parthenon Sculptures (London 1861)

A History of Discoveries at Halicarnassus, Cnidus, and Branchidae (London 1862–3)

'Recent Acquisitions in the Department of Greek and Roman Antiquities at the British Museum', *Fine Arts Quarterly Review* 1 (May–October 1863) 191–2

'The Camirus Vase', *Fine Arts Quarterly Review* 2 (January–May 1864) 1–8

Travels and Discoveries in the Levant (London 1865)

A Guide to the First Vase Room (London 1866, 2nd edn 1868, 3rd edn 1869, 4th edn 1871, 5th edn 1875, 6th edn 1876, 7th edn 1879. New edition 1883)

Report by Mr Newton on his Proceedings at Corfu Relative to Objects Missing from the Woodhouse Collection of Antiquities (London 1866)

'The Department of Greek and Roman Antiquities' in *Guide to the Exhibition Rooms of the British Museum* (London 1866)

'On a Greek Inscription at Mytilene, Relating to the Coinage of That City and of Phocaea' (read 21 November 1866), *TransRSocLit* 2nd series 8 (1866) 548–58

'Note on Mr. Strutt's Vase' (read 21 November 1866), *TransRSocLit* 2nd series 8 (1866) 597–9 (plate at 596–7)

* *A Guide to the Blacas Collection of Antiquities* (London 1867)

* *A Guide to the Second Vase Room* (London 1869, 2nd edn in two parts 1878)

'An Inscription from Halicarnassus Relating to Lygdamis' (read 18 December 1867), *TransRSocLit* 2nd series 9 (1870) 183–96

'The Dioscuri on a Rhodian vase' (read 23 June 1869), *TransRSocLit* 2nd series 9 (1870) 434–7

'On a Hill Fortress on the Road from Halicarnassus to Mylasa, in Caria' (read 23 June 1869), *TransRSocLit* 2nd series 9 (1870) 438–9

A Catalogue of the Greek and Etruscan Vases in the British Museum II (London 1870) (with S. Birch, revised for the press by a certain Grenfell and A. S. Murray)

* *A Guide to the Bronze Room* (London 1871)

'On an Unedited Tetradrachm of Orophernes II, King of Cappadocia', *Numismatic Chronicle* n.s. 11 (1871) 18–27

'Notes on Inscribed Strigils', *Archaeologia* 43 (1871) 258

'The Castellani Collection', *The Saturday Review* 31, no. 813 (27 May 1871) 665–6

'Recent Discoveries in Cyprus', *The Saturday Review* 34, no. 893 (7 December 1872) 729–30

'The Cesnola Collection of Cyprian Antiquities', *The Academy* 3, no. 62, 15 December 1872, 466–7

'The Bronze Head in the Castellani Collection', *The Times* 10 April 1873, republished in *Essays* 400–3

'Greek Numismatics' I, review of *BMC Italy* (London 1873), *The Saturday Review* 36, no. 929 (16 August 1873) 222–3, republished in *Essays* 404–12

'Dr. Schliemann's Discoveries at Ilium Novum', *The Academy* 5, no. 93 (14 February 1874) 173

'Dr. Schliemann's Discoveries in the Troad,' *The Saturday Review* 37, no. 963 (11 April 1874) 461–2.

'Remarks on Dr. Schliemann's Discoveries on the Plains of Troy' (to the Society of Antiquaries, 30 April 1874) *ProcSocAnt* 2nd series 6 (1873–76) 215–25 (discussion 225–32); abstract in *The Academy* 5, no. 104 (2 May 1874) 496–7

'Greek Sculptures from the West Coast of Asia Minor in the British Museum', *The Portfolio* 5 (1874), no. 55 (June) 82–5, and no. 56 (July) 102–6, revised in *Essays* 73–94

'Greek Art in the Kimmerian Bosporos', *The Portfolio* 5 (1874), no. 58 (October) 146–50 and no. 60 (December) 181–7, revised in *Essays* 373–99

* *A Guide to the Graeco-Roman Sculptures in the Department of Greek and Roman Antiquities*, Part I (London 1874, 2nd edn 1879)

(edited) *The Collection of Ancient Greek Inscriptions in the British Museum* I–III (1874–90, I and III by E. L. Hicks)

* *A Guide to the Graeco-Roman Sculptures in the Department of Greek and Roman Antiquities*, Part II (London 1876, 2nd edn 1879)

'Greek Numismatics' II, review of *BMC Sicily* (London 1876), *The Times* 11 July 1876, republished in *Essays* 413–26

'On Greek Inscriptions', *Contemporary Review* 29 (December 1876–May 1877) 70–94, revised with notes added in *Essays* 95–135

'Address on Dr. Schliemann's Discoveries at Mycenae' (to the Society of Antiquaries, 31 May 1877), *ProcSocAnt* 2nd series 7 (1877) 236–42 (discussion 242–9)

'Researches in Cyprus', review of L.P. di Cesnola, *Cyprus: A Narrative of Researches* (1877), *Essays* 303–20, there said to be from *The Academy* 1877

'Discoveries at Ephesus', review of J. T. Wood, *Discoveries at Ephesus* (London 1877), *Essays* 210–45, there said to be from *Edinburgh Review* January 1876

'The Religion of the Greeks as Illustrated by Greek Inscriptions', *The Nineteenth Century* 3 (January-June 1878) 1033–51 and 4 (July-December 1878) 303–26, revised with notes added in *Essays* 136–209

'On Two Greek Inscriptions, from Kamiros and Ialysos, in Rhodes, Respectively' (read 19 June 1878), *TransRSocLit* 2nd series 11 (1878) 435–47

'Dr. Schliemann's Discoveries at Mycenae', review of H. Schliemann, *Narrative of Researches, etc., at Mycenae* (London 1878), in *The Edinburgh Review* 147 (January-April 1878) 220–56, republished with additional notes in *Essays* 246–302

'Discoveries at Olympia', review of E. Curtius *et al.*, *Die Ausgrabungen zu Olympia* I–III (Berlin 1876–9), in *The Edinburgh Review* 149 (January-April 1879) 211–43, republished with additional notes in *Essays* 321–72

Essays on Art and Archaeology (London 1880). Republished papers, with an appendix on 'Greek Inscription from Halicarnassus'

'Hellenic Studies. An Introductory Address', *JHS* 1 (1880) 1–6. Newton's inaugural address to the Hellenic Society

**Guide to the Sculptures of the Parthenon. Elgin Room*, Part I (London 1880, 2nd edn 1882)

**Guide to the Sculptures in the Elgin Room*, Part II (London 1881)

Die griechischen Inschriften, authorised translation from *Essays* by Dr I. Imelmann (Hanover 1881)

The Collection of Ancient Greek Inscriptions in the British Museum II (London 1883)

'Greek Inscriptions' translated into French (with additions and extra footnotes, including illustrations, in brackets) as Part I of S. Reinach, *Traité de l'Epigraphie grecque* (Paris 1885) 1–174

**A Guide to the Mausoleum Room* (London 1886)

The Catalogue of Printed Books of the British Library also lists the following:

Photographs by Cav^e. Leonida Caldesi of Ancient Marbles, Bronzes, Terracottas, &c., in the British Museum. Published by Permission of the Most Honourable the Trustees, and under the Direction of C. T. Newton, Esq. (London n.d.). There is no text by Newton.

T. Panofka, *Manners and Customs of the Greeks*, translated from German (London 1849). According to the Catalogue, the work was edited by Newton, but there is no indication of this in the book itself.

*The *Guides* to the various rooms and collections in the Department of Greek and Roman Antiquities have no author's name on the cover or title-page since they were treated as updated parts of the *Synopsis of the Contents of the British Museum*, which was issued anonymously in numerous editions from 1808. The Keeper of the day signed the introduction to the *Guides*, often little more than a list of abbreviations, but this is not necessarily a claim to authorship of editions after the first. Those compiled while Newton was Keeper have been treated as his work, although A. S. Murray is known to have assisted with some of them. On the paper covers, which do not always survive, the titles begin *A Guide* to ... but on the title-pages these words are replaced by the heading *Synopsis of the Contents* ... The old binders' custom of discarding paper covers probably accounts for the cataloguing (e.g. by the British Library) of several *Guides* as parts of the *Synopsis*.

2

Bernard Ashmole (1894–1988): his contribution to the study of ancient Greek sculpture

G. B. Waywell

Bernard Ashmole (Fig. 13) is the second of the great figures of British classical archaeology to whom this colloquium is dedicated, having been born 100 years ago in 1894, as chance would have it the same year in which Sir Charles Newton died. Between them the lives of Newton and Ashmole cover almost two centuries of ancient sculptural studies in quite remarkable fashion. The year in which Charles Newton was born, 1816, was the year after the end of the Napoleonic Wars at the Battle of Waterloo, the year in which the British Museum acquired the Elgin Marbles. It was a time when the eighteenth-century tradition of the private connoisseur's sculpture collection founded on Roman sculpture from Italy was very much alive, as demonstrated by the displays of Thomas Hope and Sir John Soane; although the former is now long since dispersed, the other – Soane's – is miraculously still in existence at Lincoln's Inn Fields in London. The great contribution of Newton, as acknowledged by Adolf Michaelis in the introduction to his *Ancient Marbles in Great Britain* (1882), and as recently demonstrated by Ian Jenkins in his *Archaeologists and Aesthetes* (1992), was his active promotion of the change from aesthetic dilettantism to archaeological professionalism that one sees occurring in the nineteenth century. There was now careful attention paid to questions of interpretation, display and presentation in public museums, and notably the British Museum, rather than private galleries; the promotion of grand, scientific archaeological expeditions, particularly to East Greece and Turkey, to expand the national collection; and above all the introduction of classical archaeology to the universities as a serious academic discipline through the establishment of professorships at Oxford, Cambridge and London. Newton, appropriately, was the first incumbent of the Yates Chair at University College London.

Seen in this light, Newton is almost a Winckelmann-like figure, the father of modern classical archaeology in Great Britain – not that British scholars on the whole have much time for such hero-worship – but there is no doubt that it was the change to a more scientific and professional approach to classical archaeology, promoted largely by Newton, which allowed so many great British students of the subject to come to the fore in the late nineteenth and early twentieth centuries. Among these was Bernard Ashmole, arguably the finest British interpreter of ancient Greek (and Roman) sculpture since the time of Charles Newton, and a scholar to whose love for the subject, and contribution to its study, it is an honour and privilege to pay tribute, in this the centenary year of his birth.

In the course of his long, varied and active life, Bernard Ashmole provided inspiration to generations of scholars, colleagues and friends by his sensitivity to sculpture, by his imaginative insight, by his articulacy in interpretation, by his practicality and common sense approach, founded on personal observation of detail and technique, and not least by his urbanity, wit, generosity and modesty. It is, I suppose, mainly as a result of these last two qualities, or possibly even the last three, that this colloquium on the ancient sculptures from one of the areas of the world that inspired him is being held here at King's College London, as well as at the British Museum.

My own first personal encounter with Bernard occurred nearly thirty years ago, in 1965, at the Greek and Roman Department of the British Museum, where he continued to be a frequent visitor after his retirement from the Lincoln Professorship at Oxford in 1961. Although at first sight he seemed an awe-inspiring figure of Olympian eminence, I soon found him to be of remarkably open and approachable attitude, only too willing to share his views with a serious fellow-researcher in the field, however junior. He was a prolific letter-writer, and much enjoyed arguing out sculptural complexities point by point over a prolonged period of time, often taking on the role of 'advocatus diaboli', and this is a characteristic of his approach which comes out very much in his published writings, particularly those of his later years. One thinks in this respect of the lively exchange of articles with Denys Haynes in the *Journal of Hellenic Studies* over the interpretation of the scenes on the Portland Vase.[1]

It is not my intention to go through the detail of Bernard Ashmole's personal and private life: this aspect has been amply covered by his autobiography, edited

by Donna Kurtz and published in 1994.[2] There is also another sensitive and perceptive appreciation of him by Martin Robertson in the *Proceedings of the British Academy*.[3] What I propose to do is to highlight and illustrate different aspects of his professional career as an interpreter of Greek and Roman sculpture, in the hope of conveying an impression of the range and quality of his scholarship.

To acknowledge the academic distinction of Bernard Ashmole, we may, to begin with, rehearse his impressive list of achievements and offices held. After his undergraduate career at Oxford, interrupted by military service in World War I in which he was seriously wounded, he held studentships and spent much time at the British Schools of Archaeology at Athens and Rome, travelling widely in Greece and Italy, before being appointed Director of the Rome School from 1925 to 1929. In 1929 he took up the Yates Chair of Classical Archaeology at University College London, so beginning his long period of service in London, both to the University and to the British Museum, which was to last until 1956 when he succeeded Sir John Beazley at Oxford as Lincoln Professor. His appointment to the Keepership of Greek and Roman Antiquities at the British Museum came at a time of crisis in the Department in 1939, and for a number of years either side of World War II until 1947 Ashmole held both this post and the Professorship at University College, a remarkable and these days quite unthinkable combination of two senior positions. In fact he spent most of these years in military service again, this time with the RAF in which he held the rank of Wing-Commander, and later took charge of the Air Defences of London. Ashmole as the military man-of-action is one of the more interesting facets that emerges from his autobiography, and however harrowing some of his experiences undoubtedly were, there was clearly much that appealed to him in the military way of life, developing innate qualities that turned him into a first-class administrator and organiser, able to sum up people and situations, formulate clear (and usually correct) judgements, and carry out firm and decisive action. An illuminating remark in his autobiography reveals the after-effects of his military training: 'After taking up the full-time Keepership of the Greek and Roman Department', he says, 'I tried to make a tour daily of the whole Department: as anyone who has served in the Forces knows, this is the only way of ensuring that everything is as it should be.'[4]

Ashmole's research into ancient sculpture was, not surprisingly, shaped and guided by his major career appointments. His first article, on 'The So-called

Sardanapalus', published in the *Annual of the British School at Athens*,[5] was the result of a period of travel and study in Greece for two years after World War I. As befits all the best interpreters of Greek sculpture, he began his career by making an impressive link between disparate fragments, discovering in 1920 that a bearded head in the Acropolis Museum joined on to a torso in the National Museum, Athens of the draped Dionysus type known as the Sardanapalus. Thus provided with an excuse for re-examining the other Roman replicas of this famous statue type, including the Hadrianic version in the British Museum seen here (Fig. 14), he argued from careful analysis of the facial features and drapery treatment that the Greek original came from the workshop of Praxiteles rather than his father Cephisodotus, as had been previously supposed. This was a neat example of *Kopienkritik* – comparison of Roman copies to establish a lost Greek original work – that arose out of a real discovery made by a combination of acute observation and luck, both indispensable elements for progress in the academic life as in any other. It was while he was travelling in Greece and later in Italy in the 1920s that he developed his interest in photography, carrying around with him his plate camera and tripod. Ashmole held strong views on photographing sculpture. He liked dark backgrounds and natural light, which combine to give a slightly sombre, but often dramatic view of his subjects. He had a deep suspicion of artificially lit sculptures, which he maintained to the end of his days, and would in no way countenance painting around outlines to eliminate backgrounds, a practice which was much favoured by certain publishers at one time, and indeed still is, although these days it tends to be done by computer-aided techniques: I am sure Ashmole still would not have approved.

Throughout the 1920s, practising around the museums of Europe, he developed a pioneering expertise in the photography of ancient sculpture. Apart from the benefits that they gave to his own publications, his beautiful photographs also illustrate the works of others, notably *The Sculptures of the Nike Temple Parapet* (1929) by Rhys Carpenter, the then Director of the American School in Athens, with whom he established a lifelong affectionate, if combative, friendship, and the *Catalogue of Greek and Roman Antiquities* in the Melchett Collection (1928) by Mrs Eugénie Strong, the indomitable eminence of the British School at Rome in the 1920s, where her ghost is still said to haunt the galleries of the library.

It was during his highly successful stay as Director of the School in Rome in 1925–9 that Ashmole completed the long-delayed work of H. Stuart Jones on the

Catalogue of Sculptures in the Palazzo dei Conservatori (1926), for which he wrote many of the entries anew and edited the whole text. The approaches of both Stuart Jones and Eugénie Strong to cataloguing sculpture were initially very influential on Ashmole, rooted as they were in the sound methodology employed in the catalogues of the Vatican Museums published in 1903 and 1908 by Dr Walther Amelung, a venerable figure who was also still prominent in the Rome of the 1920s as Director of the German Archaeological Institute. Ashmole has acknowledged the heritage, which is manifest in his first book, *A Catalogue of the Ancient Marbles at Ince Blundell Hall* (Oxford 1929). This handsome volume is a major contribution to the recording of English country-house collections, forming an all too rare link in the twentieth century with Adolf Michaelis's pioneering catalogue of *Ancient Marbles in Great Britain* of 1882. The style of cataloguing, however, and the addition of multiple, small-scale illustrations owe far more to the later catalogues of the Roman collections than they do to Michaelis. Modern and up-to-date as the Ince catalogue must have seemed at the time, its untrimmed pages betokening influence from the Arts and Crafts movement, it now seems redolent of a bygone age. Even so, a recent project to republish the Ince Blundell sculptures, removed since 1959 to Liverpool Museum, has confirmed the quality and lasting value of Ashmole's early scholarship.[6]

Apart from photographs, Bernard Ashmole also emphasised the value of cast collections in the study of ancient sculpture, and he was instrumental in 1929 in setting up the cast museum which still survives at University College London, taking over the casts made redundant by changes in display practices at the British Museum, so creating a lesser but important display in the style of the more extensive collections at Oxford and Cambridge. This indeed was the theme of his inaugural lecture on 'Aim and Method in the Study of Ancient Art', delivered in October 1929 but unpublished apart from an account in *The Times* for 24 October.[7] This reported that Professor Bernard Ashmole's 'insistence on the need of casts was based not only on their value to the student who cannot travel to examine all the originals, but also on the more complete examination which they permit.' And: 'he spoke of the advances in the knowledge of works of art which had been made possible lately by the intensive study of originals, casts and photographs'.

These varied approaches are combined and illustrated in one of the best short articles Ashmole wrote, on 'Hygieia on Acropolis and Palatine', in the *Papers of the British School at Rome*,[8] in which he compared a fragment of a head in the Acropolis Museum, Athens (shown in original and cast forms), and a beautiful Roman replica of a head from the Palatine in Rome, with the statue type known as the Hope Hygieia, the best example of which was then in the Melchett Collection in Hampshire, which Ashmole had recently photographed (it is now in the Los Angeles County Museum of Art).[9] He argued that the Acropolis fragment was part of an original Greek work, sensibly leaving the door of doubt ajar, and that the statue to which it belonged once stood on the Athenian acropolis near the Propylaea; further, that it was probably by the sculptor Cephisodotus, the father of Praxiteles. Leaving aside whether these claims are correct, or even sustainable, his paper was a model of academic ingenuity, and an interesting alliance between up-to-the-minute modern methodology and traditional *Kopienkritik* which attempted to reconstruct the output of master sculptors named in the ancient sources.

For Ashmole 1932 was something of a 'golden year'. Not only did he publish then, with J. D. Beazley, the beautifully succinct account of Greek art in the joint book entitled *Greek Sculpture and Painting* (Cambridge, reprinted 1966), but he also delivered a series of nine weekly broadcasts on BBC radio on the subject of 'Art in Ancient Life', which were published verbatim in *The Listener* magazine between 19 October and 14 December 1932.[10] One of the more curious offerings was week 6, entitled 'Is There Any Greek Sculpture?', which took the form of a discussion, or rather an argument, between R. H. Wilenski and Professor Bernard Ashmole. As printed in *The Listener* it reads like an extract from a particularly polemical Platonic dialogue. Let me quote a short passage:

R. H. Wilenski: I decline to accept your copies as good copies or as copies at all. How can you call a copy 'good' when you have not seen the original? And in any case, to return to the Greeks, what you call copies are always marbles, and I believe I am right in saying that all the famous Greek sculptors were workers in bronze and not in marble?

B. Ashmole: That is so. But all you are saying is that we cannot put names on the Graeco-Roman statues. Names do not really matter very much. There exists a mass of real Greek art, from which you can get a tremendous amount of aesthetic pleasure.

R.H.W.: It is not your business as an archaeologist to talk about aesthetic pleasure. Your business is to tell us *facts* ... to tell us what the objects *are*, not what you regard as their aesthetic merit.

B.A.: I do not admit that. The aesthetic qualities of a work of art are the best evidences of what it is. The archaeologist must be a judge of aesthetic quality as well as a collector of facts.

How the words ring out over the years, how must the modern archaeological student squirm at the confident assertion that an archaeologist might legitimately discuss aesthetics as well as collect facts.

During his post-war years as Keeper at the British Museum, Ashmole focused his research on two of its greatest ancient monuments: the sculptures of the Parthenon, and the sculptures and architectural remains of the Mausoleum at Halicarnassus. Together with his sensitive studies of the Olympia temple sculptures, these formed the subject of his excellent book *Architect and Sculptor in Classical Greece* (1972), published from the Wrightsman lectures which he gave on this subject for the Institute of Fine Arts in New York. Although Ashmole's profounder writing was devoted to the Olympia and Parthenon sculptures, to whose superbly idealistic figures his admiration was naturally inclined, it is his work on the Mausoleum at which I propose to look in detail, bearing in mind the theme of our colloquium.

Ashmole did not travel widely in the Dodecanese and Caria, but in 1964, as he recounts in his autobiography,[11] he made a trip to Bodrum and Cnidus in the company of Donald Strong and Kristian Jeppesen. While at Bodrum he participated in the discovery by Jeppesen in the walls of the castle of a portion of the Amazon frieze which completes the fine slab (BM 1015) brought back to the British Museum by Newton. Although Ashmole did not complete his long-projected *catalogue raisonné* of the relief friezes of the Mausoleum – this is now being brought to publication by Brian Cook – he wrote over the years a number of articles, in addition to the chapter in *Architect and Sculptor*, which take in the monument and its sculptors.

These include his justly renowned article on the Demeter of Cnidus in the *Journal of Hellenic Studies*,[12] in which he argues for its authorship by Leochares, one of the Mausoleum sculptors, comparing the facial features of the Demeter with the head of Alexander the Great in the Acropolis Museum, Athens, which he believed also to be an original work by Leochares. And he returned to the same theme in the last article he ever wrote, in 1977, entitled 'Solvitur Disputando', published in the *Festschrift für Frank Brommer*, in which he sought to settle the controversies once and for all over the origin and date not only of the Demeter of Cnidus but also of the Mausolus and Artemisia statues from the Mausoleum.[13] Already in 1941, Rhys Carpenter, Ashmole's long-time American collaborator and friend, had attempted to down-date the Demeter statue to a classicising work of the first century BC, and he was to repeat the assertion later in his *Greek Sculpture* of 1960, extending a lower date also (now,

in fact, the second century BC) to the principal Mausoleum sculptures.[14]

Ashmole was amusingly critical of the eccentric theories of Carpenter, whom he described in 1951 as 'quietly loosing one of his ample stock of hares', but much more bitingly so in 1977 of Christine Mitchell Havelock, one of the chasers from Bryn Mawr of Carpenter's hares, when she repeated the lower second-century BC date in her book on *Hellenistic Art* (1971) – the stimulus for Ashmole's tart 'Solvitur Disputando'.[15] After paying tribute to Carpenter's 'wonderfully acute observation and masterly analysis', which he suggests 'has perhaps done more than any living scholar to illuminate the history of Greek sculpture, and more to obfuscate it by impish heterodoxy and esoteric prose', he justifies the polemical diatribe to come on the grounds that: 'the real danger arises when his pronouncements, harmless enough in themselves, are treated by disciples as gospel, and thus may come to be generally accepted merely by reiteration'. He then proceeds forcefully and successfully to demolish the arguments one by one, disproving the claims of Carpenter (repeated by his unfortunate disciple Havelock) that the Demeter of Cnidus and the colossal statues from the Mausoleum belong to the later Hellenistic period, and returning them firmly and rightly to the mid-fourth century BC. It is a remarkable example of almost Ciceronian advocacy from an elderly scholar, eighty-three years old at the time, who was still as razor-sharp in his wits as the time forty years before when he had crossed swords more than once with the Italian scholar G. E. Rizzo.[16] There is no doubt, as suggested earlier, that Ashmole loved a good argument in print, and the Latin title of his last publication, 'Solvitur Disputando' (a solution is reached through argument), is certainly intended as a memorial to his adversarial approach to scholarship. Nonetheless, there is discernible beneath his stylish and effective rhetoric the serious basis of his own intellectual approach to Greek sculpture: his preference for empirical rather than theoretical argument, his dependence on long, close, thoughtful scrutiny of the original object, and the interpretation of it by carefully composed rational argument, in which style was allowed its place, but over-reliance on it was treated with deep suspicion. For him Rhys Carpenter's famous trumpeted conclusion, 'inevitable on the unappealable verdict of style' was simply unacceptable.

It was his careful attention to the original object which led to his famous joining of two slabs of the Amazon Frieze of the Mausoleum, published in barely more than a single page of the *Journal of Hellenic Studies*,[17] accompanied by carefully arranged illustra-

tions, including as often a comparative appeal to vase-painting, a legacy inherited from his collaboration forty years before with Sir John Beazley. By this apparently simple means he recreated the longest slab among those surviving from the Amazon Frieze, showing Herakles fighting with an Amazon, in all probability Queen Penthesilea, which he diffidently suggested 'formed the centre of the principal side of the Mausoleum frieze, presumably the east.'

One of the achievements of his later life, with which, to judge from his autobiography, Bernard Ashmole was particularly pleased, was the role he played as adviser to J. Paul Getty in broadening and establishing the oil magnate's antiquities collection at Malibu, California, in the famous reconstruction of the Villa of the Papyri at Herculaneum.[18] Apart from feeling flattered, understandably, by the spontaneous approach from 'the richest man in the world', one suspects that for Ashmole one of the attractions was the chance it gave him to spot fakes and forgeries among the objects on offer, a favourite pastime for sculpture specialists, for which Ashmole's keen powers of observation and expression particularly commended him. Although, on his own admission, the occasional forgery may have escaped even his eagle eyes and intuitive mind, they were not many, and the Getty Museum owed much to Bernard Ashmole for the part he played in its formative years, as was demonstrated when the first two volumes of the *J. Paul Getty Museum Journal* were dedicated to him. One of Ashmole's most pleasing discoveries was the inscription 'Menandros' on the small bronze bust now in Malibu, so at last identifying the well-known type as the comic poet Menander, perhaps based on the portrait of him made at Athens in 307/6 BC by the sons of Praxiteles.[19] As he triumphantly wrote, this comprehensively disproved Carpenter's views, and 'in an instant killed the four-thousand-word attempt to prove that the portrait was not Menander but Virgil'.

In the final assessment, one has to acknowledge that it was the sculptural achievements of the fifth century BC which proved the enduring enticement for Ashmole, in particular the original architectural sculptures of the temple of Zeus at Olympia and the Parthenon. Apart from his book of 1967 on Olympia, these formed the subject of an outstanding lecture which he gave at the British Academy in 1962 entitled 'Some Nameless Sculptors of the Fifth Century BC' – the title is significant for its emphasis on sculptor rather than sculpture.[20] In the course of this masterly interpretation of the sculptural quality of both buildings, he made a particular contribution to the interpretation of the characterisation of Herakles on the twelve metopes from Olympia, pointing out that Herakles is here depicted as: 'a real person, not a changeless, invulnerable hero. A real person, but completely unlike either the roistering boon-companion or the muscle-bound athlete of later literature and art. He is young at first, then mature, finally ageing: and we are shown his feelings as he passes through these trials and triumphs – weariness, elation, intense effort, steady endurance, even, on one occasion – you can doubtless guess which – disgust.' For Ashmole Herakles carried with him a message of ultimate hope, representing the 'type of struggling and suffering humanity, destined, in spite of every kind of obstacle throughout a life of toil, to be received by Zeus into Olympus'.[21]

The impression Ashmole's lecture made on his audience may be judged by a letter from the great Latinist Eduard Fraenkel taped into the back of Ashmole's own offprint kept in the Ashmole Archive, which will serve as a fitting tribute to his life's work. 'Dear Ashmole', he begins, 'You know that I am not given to flattering. But you must allow me to say that this is a masterpiece of observation, of feeling, of phrasing. Not only as a perfect interpretation of great works of art, but also as γενναίως μυθολογεῖν. Never before have the ἆθλα [of Herakles] moved me so deeply.'

NOTES

1. D. E. L. Haynes, *The Portland Vase* (London 1964); B. Ashmole, 'A New Interpertation of the Portland Vase', *JHS* 87 (1967) 1–17; D. E. L. Haynes, 'The Portland Vase Again', *JHS* 88 (1968) 58–72.

2. Ashmole (1994), with a full list of his published writings at 191–4.

3. *ProcBritAc* 75 (1989) 313–28; cf. also the same author's appreciation in Ashmole (1994) 199–201.

4. Ashmole (1994) 129.

5. *BSA* 24 (1919–21) 78–87.

6. J. Fejfer and E. Southworth, *The Ince Blundell Collection of Classical Sculpture* I: *The Portraits; Part 1* (London 1991).

7. Ashmole (1994) 195–6.

8. *PBSR* 10 (1927) 1–11.

9. G. B. Waywell, *The Lever and Hope Sculptures* (Berlin 1986) 68–9.

10. Ashmole (1994) 191–2 for detailed references. Copies are kept in the Ashmole Archive.

11. Ashmole (1994) 148–9.

12. *JHS* 71 (1951) 13–28.

13. *Festschrift für Frank Brommer* (Mainz 1977) 13–20.

14. R. Carpenter, *Greek Sculpture* (Chicago 1960) 214–16.

15. C. M. Havelock, *Hellenistic Art* (London 1971) 35–6; cf. also Havelock, 'Round Sculptures From the Mausoleum at Halikarnassos', in *Studies Presented to G. M. A. Hanfmann* (Mainz 1971) 56–64.

16. B. Ashmole, 'Manners and Methods in Archaeology', *JHS* 58 (1938) 240–46; and 'The Same Methods', *JHS* 59 (1939) 286.

17. *JHS* 89 (1969) 22–3.

18. Ashmole (1994) 155–61.

19. B. Ashmole, 'Menander: An Inscribed Bust', *AJA* 77 (1973) 61.

20. *ProcBritAc* 48 (1963) 213–33.

21. Ibid. 221.

3

A newly found fragment of free-standing sculpture from the Mausoleum at Halicarnassus

Peter Higgs

The excavations by Sir Alfred Biliotti at the site of the Mausoleum at Halicarnassus produced numerous sculptural and architectural finds. Assisted by Auguste Salzmann, Biliotti conducted excavations at the site between March and September in 1865, in properties that Sir Charles Newton had failed to purchase in his earlier excavations. Biliotti was unable to acquire and demolish all of the remaining later buildings covering the site, but managed to investigate several more areas, particularly on the southern side of the Mausoleum. These excavations did not, however, reveal substantial deposits of sculpture, such as that found by Newton in the Imam's field on the north side, which included fragments of the chariot group and the so-called Mausolus and Artemisia. He did, however, remove many fragmentary pieces from the later houses and walls which were scattered over the site. Most of these fragments of sculpture were brought back to the British Museum, but only a few were registered in 1865, with a few more in 1868. The majority were finally registered in 1972. Those that were registered on their arrival in the Museum were mostly frieze fragments, architectural elements and small sculptures that are unconnected with Mausolus's tomb building.[1]

Biliotti's travels to the islands of Rhodes and Cos, and around the Carian peninsula provided the British Museum with numerous sculptures, ranging in scale from statuettes to the colossal Scylla group from Bargylia.[2] This material includes a hitherto unrecognised fragment of the colossal-scale sculpture from the Mausoleum. This was found by studying three sources of archival material, namely Biliotti's diary concerning his excavations of the Mausoleum site, the Annual Reports of the Greek and Roman Department, and the departmental registers.

Biliotti's account of his investigations at the Mausoleum are recorded in his diary, which has been published recently by Poul Pedersen.[3] Although interesting and informative, the diary is really only a synopsis of his work. Luckily, he mentions the find-spots of some of the sculptures, but often, as he himself states, they are too fragmentary to merit a detailed description. Many of the sculptures that he describes

in detail are not in fact from the tomb, but are stray finds of probable Hellenistic or Roman date. Other sculptures that Biliotti found were considered by him to be worthy of more lengthy description, and one entry in his diary which stands out is for 29 March 1865. On this day, after purchasing Hagi Nalban's property situated at the south-west corner of the Mausoleum, Biliotti began to dismantle the garden wall and, in addition to numerous fragments of the friezes, he discovered there 'a head – larger than life-size, but so defaced it can hardly be recognised as such'.[4] This head has recently been located in the Museum and an account of its 'rediscovery' is given below.

It had previously been thought that all the heads from the Mausoleum had been unearthed, not by Biliotti but during the earlier excavations conducted by Newton. Close reading of Biliotti's diary, however, suggests that there is another head which has so far not been identified. Working from Biliotti's account alone, Professor Geoffrey Waywell tentatively associated the damaged head reported in the diary with a neck fragment.[5] This, however, does not agree with other documentary evidence.[6] There is, for example, an entry in the departmental registers for a 'Colossal female head, hair stiffly arranged in small round curls, nose, mouth, chin and back of head wanting; very little original surface left'.[7] This suggests one of the colossal female portraits from the Mausoleum, of which the so-called Artemisia is the only full-length example (*BMCS* II, 1001).[8] A search through the Museum's sculpture reserves revealed a colossal, though somewhat disfigured, female head, more of a mask than a proper head. This was the one found reused as building material in Hagi Nalban's property (Fig. 15).

The fragment itself is extremely disfigured, but it does warrant a detailed description before any comparisons can be drawn with similar heads from the Mausoleum. It measures 35 cm from crown to chin; its greatest depth is at the forehead, measuring some 12 cm, which is best seen in the right profile (Fig. 16). Given the damage to the face, only a few features are distinguishable. The original marble surface is pre-

served in a few patchy areas, the best being around the inner corners of each eye, particularly the right one. The brow retains its original shape, but the surface is extremely weathered. There is also an area of original surface on the lower right cheek, and on the underside of the chin. Much of the damage probably occurred when the statue to which this head belonged fell from the building. Further damage no doubt followed as a result of it being left on the ground, and certainly when it was broken up to make a suitable building block for the wall in which it was eventually found. Fortunately, the outlines of each eye are just visible, the trace of the right eye being apparent for almost its full length and height, although the eyelids are rather worn, as shown in the detail in Figure 17. The tear ducts of both eyes are the best-preserved features, with a small amount of red pigment surviving on that of the right eye. Also apparent are a few remaining scars of the so-called snail-shell curls that are a feature of the other female heads from the building. These are clearest on the proper right side where a block of hair projects from the face almost to its original width (Fig. 18). Traces of two rows of these curls can be made out here, but of the third almost nothing remains. On the left side these curls have been almost entirely obliterated, although some of their inner edges are just about visible. The only other surviving feature is part of the right ear, which is hidden behind the projecting layers of curls, and most of what remains comes from the upper and inner section of the ear. Finally, on the underside of the chin there is a slight ridge which indicates the beginning of the line of the neck.

What further information this find can provide lies in its relationship with other sculptures found by both Newton and Biliotti during their excavations at the Mausoleum site. To begin with, this face fragment is known to have been discovered on the south side of the Mausoleum site, but more specifically in a property located to the south-west of the tomb itself. Few of the sculptures found during any of the excavations were recovered from the southern side of the site, but one large fragment of a colossal statue was found on this side (*BMCS* II, 1053).[9] What remains is the back part of a severely weathered female head wearing a sakkos (Fig. 19).[10] It was found, not by Biliotti but by Newton in 1857, in Hagi Nalban's property lying among rubbish on the surface of the field.[11] This fragment preserves the back of the left and upper side of a female head, and part of the neck. The left ear also survives, the upper part of which protrudes over the tightly bound material of the head-dress.[12] The right side and the back have been deliberately hacked away, but some of the damage may have occurred when the figure fell from the building.

Given the similar find-spots of the face fragment found by Biliotti and Newton's segment preserving the rear part, it seemed worth investigating the possibility that the two pieces belonged together. When brought together, the two fragments joined with several points of contact, as seen in Figure 20. Marble analysis provided further evidence that the two pieces belonged together, and the results indicated that both fragments were carved out of Parian marble.[13] A project involving the analysis of many of the sculptures from the Mausoleum indicated that Parian marble was utilised for many of the heads, including two other colossal female heads (*BMCS* II, 1051 and 1052). The excep-

Sculpture No.	Width	Depth	Chin to crown	Width at eye level	Chin to hairline	Ear length/ width	Hair height	Eye width/ height	Between tear ducts	Between tear ducts/ hairline	Diam. of curls
1001	33 cm	42 cm	36 cm*	?	?	7 cm/ 5 cm	5 cm	4.5 cm/?	5 cm	9.5 cm	?
1051	31 cm	43 cm	35 cm	21.5 cm	28 cm	9 cm/ 4.5 cm	6.2 cm	4.5 cm/ 3 cm	6 cm	11 cm	2.2 cm
1052	30 cm	32 cm*	34 cm	20 cm	24 cm	?	?	4.5 cm/ 3 cm	5 cm	9.5 cm*	?
1053/ GR 1865. 12–11.6	32 cm	31 cm*	35 cm	22.5 cm	28 cm	10.5 cm/ 5 cm	6 cm	5.5 cm/ 2.5 cm	5.4 cm	11 cm	2.2 cm

Key cm = centimetres ? = not possible to see feature * = fragmentary feature

Table showing the measurements of the four colossal female heads from the Mausoleum.

tion is the so-called Artemisia, a figure carved entirely out of one block of Pentelic marble.

The joining of the two fragments has created a fine parallel for the other colossal female heads from the Mausoleum, which in terms of survival are second only to the series of lions as the best represented group among the numerous sculptural fragments carved in the round from the building. There are now four relatively complete heads of this type and a further fragment, identified by Waywell as part of the left side of a sakkos, gives us a total of five.[14] There are numerous additional fragments of sculpture which have also been assigned to the series of colossal female figures, including hands, feet, parts of limbs and large draped portions, which may belong with the known heads or come from other similar figures. There is, however, a general lack of neck fragments of this scale, and none could be found to belong to the two joining fragments (hereafter referred to as the new head).

Despite the rather fragmentary and worn condition of the new head, it can be compared and contrasted with the other female heads in terms of scale, style and technique. The table on page 31 illustrates the measurements of certain features of each head and shows the minor discrepancies in scale.

As the table indicates, most of the differences in the scale of certain features are minimal, and the fragmentary or worn condition of some of the facial features renders an exact measurement almost impossible. The joining fragments of the new head, however, are comparable in size with all of the other three colossal female heads (Figs 21–4). The width of the face at eye level is about a centimetre wider than *BMCS* II, 1051, the best-preserved of the female heads, and the right eye is slightly longer than that of 1051. One noticeable difference between the new head and the others is the larger size of its preserved left ear, as noted by Waywell in his analysis of the back portion.[15] The ears of the so-called Artemisia are a good three centimetres shorter than those on the new head, yet her head is approximately the same size. These discrepancies in scale are too small to indicate that we are dealing with sculptures intended to be of different scales, but rather that they are perhaps the work of different sculptors. Yet the similarities in composition and style of all of the four surviving female heads, particularly their massive structure and rounded fleshy forms, show that they were clearly designed by the same individual and carved under a carefully observed blueprint. The arrangement of the curls in all cases is certainly a stylistic linking point. The motive behind such a hair-style may have had as much to do with a Carian fashion for women of the court as with an indication of an age gone by: the Hecatomnid dynasty possibly demanded such an archaising motif in the portraiture of its female members to show that their family line went back a long way. Other examples of this type of hair-style are well known, as, for instance, in the similar head found at Priene, the so-called Ada, and the same queen on the relief from Tegea.[16] One obvious division among the female heads from the Mausoleum, however, is that two of them wear both a sakkos and a veil, whereas three wore a sakkos only, if we are to include the fragment of a sakkos identified by Waywell (Waywell (1978) cat. no. 62).

In stylistic terms, the new head has much in common with *BMCS* II, 1051, particularly in the treatment of the eyes, which are clearly defined and precisely carved, especially around the tear ducts. Similar also is the shape of the eyes, with their flat lower eyelids and arching upper lids. The shape and form of the eyes of the so-called Artemisia also compare well with that of the new head, although the eyes here do not appear to be as deeply set; the brow of the so-called Artemisia is perhaps less pronounced than that of the new head (compare all four heads in Figures 25–8). In fact the head with the most deeply set eyes is *BMCS* II, 1052, although the angle at which the heads are viewed, and the nature of the damage to their brow and the bridge of the nose can mislead us as to the extent of the setting of the eyes. An interesting observation is that, of all four surviving female heads of this scale, the so-called Artemisia has the least contoured forehead, and the flattest brow. When the right profile of each of the heads is compared, however, the differences in form and structure seem minimal, and the new head shows little, if any, obvious difference in style and construction, despite its rather angular appearance in its battered state. Fortunately, the surface of the brow has survived, and shows the same slightly swollen contours as that on *BMCS* II, 1051.

Technically the four heads do differ. *BMCS* II, 1051 has a rectangular lewis-hole at the top of the sakkos. Such a lifting device would probably not have been required if the head was carved as a separate piece from the body, and therefore this may suggest that the figure was cut from one block of marble.[17] If this were the case, verification should exist in the so-called Artemisia, where the head and body were carved as one piece. Unfortunately, the top of her head is so badly damaged that it is impossible to find any traces of a similar lewis-hole. Moreover, there is no such feature in the top of the new head, which may demonstrate that this was carved with the lower part of the neck in the form of a tenon, which was then inserted into a draped body, as in the case, for example, of

BMCS II, 1052, and the head of the so-called Mausolus, *BMCS* II, 1000.

Leaving aside this technical difference, in view of the obvious parallels between *BMCS* II, 1051 and the new head, it is reasonable to suppose that they were the work of the same sculptor, or at least workshop, who had proficiency both in the piecing of statues and in the carving of figures from one block of marble. This is of some interest as *BMCS* II, 1051 was discovered at a spot close to the north-west corner of the Mausoleum, in Mahomet's field, while both fragments of the new head were discovered in Hagi Nalban's property to the south-west of the tomb building.[18] While it is possible that the figure from which *BMCS* II, 1051 survives stood at the west end of the north side, and that the figure belonging with the new head may have been positioned at the west end of the south side, it is tempting to think that both figures actually stood on the west side of the Mausoleum.[19] If indeed the statue from which the new head is a remnant did stand on the south-west corner of the monument, it may explain the extremely weathered nature of the marble, as this would have been the side most exposed to the south-westerly winds. Furthermore, other fragments of sculpture found on the southern side of the site also exhibit severe indications of weathering, particularly the life-sized head of a young man, *BMCS* II, 1056.[20]

The slight twisting of the head of *BMCS* II, 1051 may perhaps be explained if the figure was positioned at or near to the end of a row of figures, the head turned slightly towards the centre.[21] Positioned at the north end of the west side, such a posture would be reasonable and visually striking. An obvious parallel for this arrangement is found on another fourth-century monument, the so-called Sarcophagus of the Mourning Women, found with several others in a series of tomb chambers at Sidon.[22] This four-sided monument with carved figures in high relief shows a series of women in attitudes of mourning. They face in different directions, and stand or lean in a variety of postures, but more importantly, on one of the long sides, the two outermost women both face inwards.[23] It could be pos-

sible that this sarcophagus was loosely based on the Mausoleum, or a similar monument. Judging from the extant fragments that have been attributed to the series of colossal female figures from the Mausoleum, their postures were not quite so extreme as those carved in relief on the sarcophagus from Sidon, but an additional analogy is that the women on the sarcophagus are portrayed standing between Ionic columns, a similar setting to that of the Mausoleum women.

An accurate reconstruction of the original pose of the female statue to which the new head belonged is rendered impossible by the loss of the neck; without this, the intended angle of the head on the body cannot be ascertained. Of the other two female heads, the so-called Artemisia is more or less frontal in posture (a possible candidate for a central figure in a group), although her head is slightly lowered. *BMCS* II, 1052 has the neck preserved and in its present restored state is lowered and turned slightly to the right, although as Waywell correctly points out, this position may not be accurate because the join between head and neck is rather jagged.[24]

To conclude, therefore, a new face fragment joins another fragment, known since the time of Newton, making sense now as a complete, though damaged, head. The new head does not provide a type previously unknown among the fragments of sculptural decoration from the Mausoleum, but it does give us further confirmation that the distinctive snail-shell hair-style, and the wearing of a sakkos, was typical of Hecatomnid women. It is to be hoped that in the future other fragments may be found of the colossal female portraits, perhaps some without the distinctive sakkos or veil. Such a further affinity with the women portrayed on the sarcophagus from Sidon, some of whom wear a veil, while others are bare-headed, would then help us to determine whether all of the women from the Mausoleum carved on this scale were intended to be members, past and present, of the ruling Hecatomnid family (with the distinctive hair-style) or generic representations of grieving women.

Peter Higgs

NOTES

1. It is possible that not all of the finds from Biliotti's excavations reached the British Museum. This is suggested by Biliotti's comments in his diary on 2 March 1865, when he stated that he would keep all of the fragments of cornice that he discovered until Mr Newton had arrived to decide what to do with them. It appears, however, that sculptural finds were given a higher priority and were returned to the Museum, in case they joined with those fragments brought back by Newton.

2. For the Bargylia group see Waywell (1990) 386–8. The entire monument will be the subject of a lengthy investigation in a forthcoming publication by Waywell, *AntPl* 25. The smaller statuettes have only really been examined in broader studies of sculpture from the Dodecanese and Caria, for example Kabus-Preisshofen (1989) catalogue entries 47, 70, 71, 73, 74, 75. Unfortunately few of the small-scale sculptures presented to the British Museum by Biliotti were discovered in an archaeological context. Most were chance finds and therefore have no secure provenance, but are useful as comparisons with those sculptures found on Cos, Rhodes or at Bodrum, where most of Biliotti's pieces were acquired.

3. The original diaries are preserved in a bound volume in the Department of Greek and Roman Antiquities in the British Museum. For the transliteration see Pedersen (1991) 117–56.

4. See Pedersen (1991) 122.

5. See Waywell (1978) 122 cat no. 56; Department of Greek and Roman Antiquities, GR 1972.4–2.6.

6. Annual Report of Greek and Roman Department, 6 June 1865. See the Officer's Reports to the Trustees, 1865, kept in the Department of Greek and Roman Antiquities, British Museum.

7. GR 1865.12–11.6.

8. GR 1857.12–20.233 (body), 1857.12–20.260 (head); Waywell (1978) cat. no. 27.

9. For a list of those sculptures known to have been found on the south side of the Mausoleum site see Waywell (1978) 10–11.

10. GR 1972.3–30.17; Waywell (1978) cat. no. 32.

11. See *Dispatches* (1858), 47.

12. For references to this type of head-dress see I. Jenkins and D. Williams, 'Sprang Hair Nets: Their Manufacture and Use in Ancient Greece', *AJA* 89 (1985) 411–18. Also I. Jenkins and D. Williams, 'A Bronze Portrait Head and its Hair-net', *Record of the Art Museum Princeton University* 46 no.2 (1987) 8–15; J. Prag, in Isager (1994) 106, fig. 14.

13. I am indebted to Keith Matthews of the Department of Scientific Research at the British Museum for this information, and to Susan Walker for providing me with useful advice and information.

14. See Waywell (1978) cat. no. 62; GR 1972.4– 2.11.

15. See Waywell (1978) 35.

16. For the so-called Ada from Priene see Carter, *Priene* 217–6, cat. no. 85 (*BMCS* II, 1151). For the relief from Tegea see Waywell (1993) 79–86.

17. For this view see Waywell (1978) 107.

18. See *HCB* 104, for a description of the find-spot of the colossal head (*BMCS* II, 1051).

19. It is of course possible that these two heads belonged to figures that stood anywhere on the monument, and that the heads were later removed, and either reused as building material or discarded. Furthermore, if we are to accept a reconstruction whereby the colossal portraits were arranged in an alternate male–female composition (which Waywell logically connects with the Hecatomnid practice of brother and sister marriage), it is not possible for two female statues to stand either end of the row on a shorter side of the building.

20. Waywell (1978) cat. no. 46 (*BMCS* II, 1056). Other heavily weathered sculptures found on the southern part of the site include the lower part of a standing draped man (Waywell (1978) cat. no. 44; *BMCS* II, 1049).

21. The proposal by Jeppesen (1992) 81–2, that *BMCS* II, 1051 is actually a remnant of an acroterion, positioned at the foot of the stepped pyramid, was prompted by the slight twist of the neck. He claims that, along with the so-called Apollo (*BMCS* II, 1058 (Waywell (1978) cat. no. 48)), the movement of the necks suggests that the figures to which these heads were attached were in rapid motion, rather than quietly standing. Furthermore, he suggests that the rather 'pathetic' appearance of their faces would suit the theme of the slaughter of the children of Niobe by Apollo and Artemis. This suggestion does not seem likely on several counts.

First, this head follows the same general principles of design and the same scale as the so-called Artemisia, and the other colossal female heads from the building. As the posture of the so-called Artemisia's body and fragments of similar figures would suggest, these colossal female statues were probably standing still. Second, the facial features of the colossal female head, *BMCS* II, 1051, do not appear any more animated or 'pathetic' than the other female heads, nor indeed do they on the so-called Apollo. Third, their peculiar hair-styles would suit a particular court hair-style, rather than that used for a mythological figure. And fourth, the colossal head, with its protruding and cumbersome sakkos, would have made such a figure unstable if the body was in motion, as is usual on acroteria.

22. For a recent and thorough publication concerning this monument see Fleischer (1983).

23. For an illustration see Fleischer (1983) pl 4.

24. For this information see Waywell (1978) 108. *BMCS* II, 1052 is at present rather poorly restored, and with all of the missing area of the middle part of the neck restored in plaster, it is impossible to determine the actual extent of the join. In its restored state, there are no points of contact between the upper and lower parts of the neck. Perhaps, the plaster can be removed in the future to see if the marble surfaces join further into the neck.

4

The polychromy of the Mausoleum

Ian Jenkins, Corrado Gratziu and Andrew Middleton

Charles Newton was a pioneer of the modern approach to archaeology.[1] His quest for knowledge of classical antiquity led him into fields of study that, in his day, were often in their infancy.[2] One such was the colouring of ancient marble, to which he was introduced in a direct and dramatic way by the recovery of the remains of the Mausoleum of Halicarnassus.[3] In publishing his discoveries, Newton regretted the fact that much of the colour he saw on the freshly excavated marbles had subsequently 'scaled off from exposure', especially on the larger pieces. He went on, however, to say that traces still survived, and it was from these that the architect Richard Pullan was able to create his reconstruction (Col. Pl. 1) of the colouring of various mouldings.[4] Today enough survives of what Newton once saw to confirm the broad principles of his account, and Pullan's reconstruction can be matched to existing colour traces on similar mouldings (Col. Pl. 2). These and other examples of polychromy, both on the architecture and on the sculpture, have recently been re-examined in an archaeological and scientific collaboration between the British Museum's Departments of Greek and Roman Antiquities and Scientific Research, and the Dipartimento de Scienze della Terra of the University of Pisa.[5] These are some of the results of a joint enquiry, which both confirm and enlarge upon Newton's own findings. This chapter will begin by briefly reviewing what those were, before going on to look in detail at some of the surviving archaeological evidence.

C. T. Newton, KCB

During the winter and spring of 1857 Newton's men uncovered a mass of marble fragments from the Mausoleum, many of which bore copious traces of ancient colour. Newton wrote both in official dispatches and in his private letters of the remarkable extent and preservation of these colours. Unfortunately, once exposed some colour traces proved fugitive, and what seemed obvious at the time cargoes were being packed, did not live up to the expectations of those who opened the packing cases upon arrival. Fearing he would be disbelieved, therefore, Newton paid par-

ticular attention to recording evidence of colour, as it was found. The most detailed accounts, however, are not to be found in the published versions of his discoveries, but in the hitherto unpublished letters he wrote to Antonio Panizzi, Principal Librarian of the British Museum.

Newton had himself witnessed the transience of some painted surfaces. The instance most often cited is that of the colossal seated figure.[6] 'When we first turned the statue over', Newton wrote in a letter to Antonio Panizzi, 'colour was distinctly visible all over the drapery. The paint, however, is rapidly scaling off.' We learn elsewhere that this colour was purple (Fig. 29).[7]

In July 1857, shortly after the first consignment of Mausoleum marbles had been dispatched for England, Newton wrote to Antonio Panizzi of the need to record colour traces immediately upon arrival. 'It is quite certain from the observations which I have made already', he wrote, 'that the columns, their bases and capitals, were all coloured, so were the cornice, frieze and subordinate architectural mouldings. Traces of colour appear on the principal sculptures in the round. In short it will be the business of those who examine this question to show what part of the whole design was *not* coloured, so universally do traces of colour appear.'[8]

We can guess at the result when we read a further letter from Newton to Panizzi written the following November, expressing surprise that the colours were not more evident. Newton, it must be remembered, was writing at a time when it was still possible to doubt, at least for the classical period, that sculpture and architecture were polychromatic in antiquity.[9] His letter ends with a general reflection: 'Freshly cut Parian marble is offensive to the eye under a bright sun, from its glare. We admit white marble statues because time has toned them down, but I am convinced ancient art was polychromatic.' He went on to give a full list of instances where colour had been observed:

I am surprised that the traces of colour on the sculptures are not more apparent. I may as well mention some sculptures on which it was most distinct:

1. The anterior half of the colossal horse had red colour near the collar on his chest.

2. One of the lions found in the Iman's field north side may be easily distinguished as the only lion unbroken from head to hindquarters, had his tongue painted bright red.

3. The hindquarters of a lion marked 'Delta' on the [?] and found in the Iman's field north side had red colour about the thighs.

4. Red colour was visible on the inside of the shield in one of the long pieces of frieze.

5. You will, I think, find red colour in channellings of the tail of the colossal horse.

6. Among the fragments of frieze is one that had a patch of bright blue colour in the ground.

7. The colossal seated figure was when first dug out covered with paint, which faded and peeled off as it dried. But this figure must still have much of the coating of pigment on the surface of the marble.

8. In the corners of the head supposed to be Mausolus was white pigment forming the *leucoma* or ground. If I remember right, colour was traceable inside the nostril of this figure.

9. Among the fragments of frieze was one with red colour on the drapery. I cannot specify which fragment, but the drapery was flying in the wind.[10]

In February 1858, he again had occasion to comment upon the remarkable survival of colour, this time upon the fragmentary sculpted coffers of the Mausoleum. Again, in a letter to Panizzi we read, 'The ground of these panels was painted blue, like that of the frieze, the flesh red, on a white ground, leucoma. Nothing can be more distinct than these traces of colour. It is at this moment an actual coat, which I could scrape off with a knife.'[11]

In the eventual publication of his discoveries, Newton insisted upon the colouring of the Mausoleum, both of its architecture and its sculpture. Its architectural polychromy was limited to two colours, red and blue. In the earlier of his two books Newton had suggested that the blue pigment was ultramarine, which in the second publication he more correctly described as copper silicate, and alluded to a cake of similar material (Col. Pl. 3), which had recently emerged from one of the tombs excavated by Auguste Salzmann and Alfred Biliotti on Rhodes.[12] The third colour in Newton's architectural scheme was the white of the marble itself, but even this he thought was not left raw white, but varnished so as to tone it in with the rest. 'The system adopted', he wrote, 'seems to have been to tone down the whole of the marble with a coat of varnish and wax, to paint all grounds of sculpture and ornament blue and to pick out the ornament in red.'[13] In arguing for such a varnish, Newton was in step with other nineteenth-century observers of clas-

sical polychromy, who had also come to the conclusion that protective and colour-enhancing washes were applied to the surface of architectural marble in antiquity.[14]

Archaeological evidence

Newton's colour samples

Today two sorts of evidence survive. First, there are actual samples of colour taken by Newton from the Mausoleum. A small bottle neatly labelled 'Mausoleum 1857' (Col. Pl. 4) contains Egyptian blue taken from one of the mouldings.[15] A shell (Col. Pl. 5) containing blue colour was said to have come from the site of the Mausoleum, but there is no indication of what it was used for.[16] More problematic are some scrapings of 'colour' said to have been taken from the fluting of a column.[17] These now appear as colourless and, although copious blue pigment survives in the leaf ornament of the best preserved of the Ionic capitals (Col. Pls 6–7), it would be surprising if the actual fluting were painted. Newton claimed not only that the capitals, but the columns and their bases were coloured. We shall come back to this problem.

Free-standing sculpture

The second category of evidence is the colour surviving on the marble itself. The blue and red of the mouldings has already been mentioned. Geoffrey Waywell, in his catalogue of the free-standing sculptures, noted instances of colour including the blue of the saddle cloth of the Persian rider.[18] A recent re-examination of this surface further revealed a fragment of gilding, which hints at the potential complexity of the polychromy of the free-standing sculpture (Col. Pls 8–10).

One problematic survival on the free-standing sculpture, which has previously gone unnoticed, needs fuller discussion. The Mausoleum was topped by a quadriga of which several fragments survive, principally the front and rear parts of one or, possibly, two different horses (Figs 30–1).[19] On the front part, fragment A, are the remains of a thick coating of a dark brown appearance. These are to be found on the right leg and on the broad, vertical band of the harness (Col. Pl. 11). If the rough, outer crust is scraped, the inner part is soft and has a silver metallic appearance. Analysis in the electron microscope confirms that the principal component of these coatings is lead. On the rear portion of the horse the same lead coating, here grey in colour, appears over the inside of the legs and scrotum (Col. Pl. 12).

The question arises as to the origin of these coatings and whether they are accidental or due to a deliberate surface treatment. There is, for example, the possibility that the coatings are secondary and relate to the period of the spoliation of the Mausoleum when metal, as well as stone, was reused from the building. As the cuttings on fragment B show, the horse fragments were pieced and joined with metal clamps. It may be considered whether the lead is the result of heating the joints of the stone to release the clamps from their lead seating. This argument would depend upon the horse fragments being accessible after their fall from the building, but on this point Newton's account of their discovery is quite explicit. The sculptures were found with other important pieces of free-standing sculpture in an area just to the north of the *temenos* wall bounding the site (Fig. 6). There, in Newton's own words, 'was a mass of large marble slabs, lying piled one over the other in the earth and intermixed with statues'. These slabs were some of the steps of the pyramid surmounting the building and, according to Newton, lay where they fell. This, for Newton, was proved, 'not only by the freshness of the fractured edges, most remarkable in the case of marbles of such weight, but also by the quantity of wrought copper found with them ... It is impossible that the bronze bridle and the cramps of the steps could have escaped the cupidity of the middle ages, had these marbles been exposed to view for any length of time after their fall.'[20]

Newton's reasoning seems convincing, and the possiblity of an accidental cause at the time the Mausoleum stood as a ruin must be ruled out. Could the coatings, therefore, be the result of a spillage of lead in the construction process itself? A possible source for the coating on fragment B is the fixing for the tail (Fig. 32). A mortice and pour channel (Fig. 33) were cut at the rear of horse fragment B for attaching the tail.[21] The latter survives, and formerly the two were displayed together in the Museum. A modern mortice was cut below the ancient one, in order to receive a new tenon fitted to the tail. On the body of the horse the ancient metal pin, by which the tail was attached in antiquity, is still in place, held firm by the ancient lead sealing. The question is whether or not, in the process of pouring the lead into this joint, the molten metal could have run down the cleavage of the horse's rump and covered the inside of the rear legs and scrotum. The extent and location of it would seem to make this unlikely since, in order to reach the surfaces it covers, the lead would have had to run uphill and across impenetrable obstacles. Nor does the lead have the property under the microscope of something that has run down the marble. Rather, it seems to be a lamina, and as such would represent a surface treatment, artificially applied. With this possibility in mind it is interesting to remark upon the relative roughness of the finish on the colossal horse fragments, in comparison with other free-standing sculpture from the same building. The final finish using the claw chisel and rasp seems to have been given only sparingly to the horses, whose broad flanks retain copious traces of the point chisel. Newton himself noticed this and suggested it had to do with the greater distance at which the sculpture was seen from the ground.[22] The real reason is perhaps that the surface was not meant to be seen at all, but was rough-worked to receive a lead laminate coating. In Greek art it was the convention when showing a quadriga to represent the horses as being of different colour. The back of the throne from the so-called Tomb of Eurydice at Vergina makes the point. Here we see two white and two chestnut horses.[23]

The Chariot Frieze from the Mausoleum suggests another parallel for the differentiation of the colours of horses pulling chariots. This frieze, like the other relief sculptures of the Mausoleum, employed a combination of red and blue for its polychromatic effect. Blue survives from the background and red on details such as the harness straps.[24] The most extensive coatings on the Chariot Frieze have the appearance of paint but no pigment survives in them. A yellowish patina covers the drapery of a charioteer,[25] for example, and a similar treatment has been applied to the body of one of the horses of a group of four (Col. Pl. 13).[26] Here, significantly, the patina covers only the one horse, and a clear boundary exists between this and a neighbouring animal. Although the original colouring of the first horse has faded, the remaining patina must surely represent the residue of a paint.

An indication that the harness straps of the colossal horses were also red is to be found in the traces of iron oxide pigment which can be seen on the strap of fragment A, where it passes under the belly of the beast. Here, perhaps, the lead was discontinued and the detailing finished in red.[27] If this surmise is correct, it is interesting to remark upon the use of the claw chisel at this point. An alternative explanation is that the iron oxide is part of a preparation process, and was itself intended to be covered by the lead. We shall encounter again the possible use of red as a primer coat, when we come to the colouring of the Amazon Frieze.[28]

In conclusion, the probable explanation for the lead coatings on the Mausoleum horse fragments is a special polychromatic technique using a lamina to

37

create a durable colouring effect at this, the most exposed point on the building. The freshly laid sheet of lead was perhaps itself coloured or even gilded. Such a gilding of lead is to be found on the volute of an archaic column capital from Ephesus in the British Museum (Col. Pl. 14 and Fig. 34). A channel between two astragal mouldings is stopped with lead, and over this can be seen some tiny specks of gold-leaf.[29] This is remarkable evidence of the potential complexity of ancient polychromatic technology.

The Amazon Frieze

The majority of the free-standing sculptures were excavated by Newton and had lain in the ground for centuries since their displacement from the building. The case of the Amazon Frieze is rather different, since the greater part of what survives was retrieved from the crusader castle at Bodrum. Around AD 1505–7 the Hospitaller Knights of St John seized upon a number of slabs of the Amazon Frieze and mounted them on the walls of their castle.[30] Three Amazon Frieze slabs,[31] together with the Centaur Frieze slab[32] were displayed on the external sea wall, but most were deployed within the fortress, until their removal in 1846. In all, eleven slabs of the Amazon Frieze and one of the Centaur Frieze were recovered from the castle,[33] and a further four slabs, together with various fragments, came from Newton's excavations.[34]

The history of the frieze blocks taken from the castle may be divided into three phases: first, there is the original installation into the Mausoleum; second, the dismantlement and removal to the castle; third, the Museum life of the sculptures. Those pieces excavated by Newton have a three-phase history also: Mausoleum, burial, Museum. This chronological framework needs to be borne in mind in any attempt at understanding the various coatings on the sculptures. The term 'coating' is used here to signify both relict polychromy and the yellow-brown patinas, which are much in evidence on the frieze. What follows is based upon a joint archaeological and scientific investigation into the nature of the coatings and their relationship one to another.

Observation confirms Newton's statement that the background of the frieze was blue and the figures were detailed in red.[35] The blue is preserved, for example, on the ground of slab 1019, and above the hand of a warrior on slab 1018 (Col. Pl. 15 and Fig. 35). The latter is an interesting instance, since the colour here seems to trace the outline of a dagger or sword rising from the hand. It is unlikely that the sword was the same colour as the background, and this blue is probably therefore the background colour, which has sur-

vived because it was once protected by the colouring of the sword. This was probably done by gilding, an instance of which we have already seen on the Persian rider. Analysis shows the blue to be a crushed Egyptian blue frit set in a calcareous matrix.

The red colour, which is an iron oxide, appears in more places than the blue (Col. Pls 16 and 17): on the drapery, accoutrements and flesh of the figures, as well as on the background. Such extensive use of red begs closer definition of its function and its relationship to the other surface coatings. In particular, the question may be asked whether the red colour is all original to the date of construction.

Finally, there are the patinas to be found over large areas of the marble. Some of these surfaces appear naturally patinated. The coatings of slabs that were exposed on the seaward wall, as we saw earlier, have the appearance of a general staining affecting ancient worked and broken surfaces alike. The coating of other surfaces can be explained historically, as, for example, in the case of the traces of a limewash, which is reported to have coated the sculptures at the time of their removal from the castle.[36] Other coatings, however, appear to have been applied in antiquity, and the question arises as to their relationship to the traces of actual colour.

Microscopic observation of the remaining colour and of the patinas, both *in situ* and in polished thin section samples suggest the following tentative sequence of application, beginning with the earliest (Col. Pl. 18):

1. Brown patina on the figures and the ground.

2. Red paint, probably based on an iron oxide pigment, applied mainly to the figures but also found on the ground.

3. Egyptian blue pigment applied exclusively to the ground.

4. Brown patina on both the figures and the grounds, overlying the early red and blue pigments.

5. Red paint, thought to be based on an iron oxide pigment, found on both the figures and the grounds.

The first patina in the sequence is found both on the frieze slabs removed from the castle and on those pieces excavated by Newton. The distinctive feature of this layer is the fact that it underlies the applied polychromy and it would appear to be a base coat, applied deliberately. Analysis shows it to be high in phosphorus. Although the origin of this phosphatic material is unknown, we suggest it was some animal-derived product, such as casein or bone ash. A similar base coat appears on other elements of the Mausoleum. On the corner column capital in the British Museum, for example, it forms the foundation for an Egyptian blue. In thin section there is evidence for some reaction

between the phosphatic patina and the marble, and this probably accounts for the white bloom that sometimes appears between the marble and the patina. It is probably this white reaction layer that Newton had in mind when he wrote of a 'leucoma' covering much of the surface of the Mausoleum marble, and he scraped it from the flutes of the columns in the belief that it was evidence of their having been painted chromatically. What now seems probable is that the column shafts of the Mausoleum were not coloured, exactly, but that a varnish was applied which, like the base coat of the polychromy itself, produced a white reaction layer.

Next in the sequence come the red and blue pigments. These appear to have been applied over the phosphatic patina, which was prepared especially for them. The blue pigment is set in a calcareous matrix, which probably represents the medium by which it was applied (Col. Pl. 19). Sometimes, on the ground of the frieze the blue colour has been applied over a layer of red, which itself overlies the phosphatic patina. In this situation the red is thought to be accidental, having found its way on to the ground at the time of the painting of the figures. An alternative would be to see it as a deliberate undercoat for the blue, perhaps serving to intensify the colour rather in the manner of a bole in gilding.

The stratigraphy continues with a second brown patina, which is sometimes seen to overlie the earlier red and blue traces, or may occur directly on the marble surface. This patina is most extensive on the slabs formerly displayed within the walls of the crusader castle. It has been found to contain calcium oxalate, a substance commonly present in ancient architectural patinas suspected of being degraded paint treatments, such as, for example, those found on the Parthenon.[37] This layer should be seen as representing the alteration products of an organically based coating applied to the surface of the sculptures as a protective varnish. Whether this was done in antiquity or at the time of their incorporation into the castle, it is impossible to say.

The final stage in this stratigraphic sequence is the application of a later red paint both to the figures and the grounds (Col. Pl. 20). This overlies some areas of the blue pigment and must represent a second phase of red painting. This may well belong to the period when the sculptures were incorporated into the castle.

This stratigraphic analysis, given the nature of the evidence, must be regarded as a tentative reconstruction of the sequence by which the various surface coatings were applied to the frieze. A salient feature of it is the identification of layers which, although now perceived as brown patinas, must in fact be the residues of artificial paint treatments.

Conclusion

In conclusion, much of what Newton said regarding the polychromy of the Mausoleum nearly one hundred and fifty years ago can be confirmed today. The architectural polychromy appears to have been a simple scheme of red, blue and the white of the marble itself with some gilded details, the glare being taken off by a varnish applied to the whole of the building. In his most recent reconstruction, Professor Jeppesen has emphasised the importance of the colour contrast between the blue limestone and the white marble of the outer ashlar facing of the Mausoleum.[38] This contrast would have been intensified by a varnish serving to bring out the natural colour of the stone.

The colouring of the friezes matched that of the architecture, the grounds being blue and the figures picked out in red and gold. The horses of the Chariot Frieze were perhaps differentiated by the use of other pigments which have not survived. Only the patina formed by the residual medium is left. The colouring of the free-standing sculptures is more problematic. Red and blue were certainly used, but there is also pink in the dress of the lower part of a draped standing male figure[39] and we have Newton's testimony to the fact of the colossal seated figure having been painted purple. The yellow which he and others have seen in the manes of the lions cannot, in fact, be distinguished from the tawny patina that may be seen all over the sculptures. Finally, there is the exceptional case of the lead which may have been a lamina applied to the horses of the colossal quadriga.

This analysis is not enough to provide a full visual reconstruction of the polychromy of the Mausoleum and, given the gaps in our knowledge – especially of the free-standing sculpture – we shall never be able to achieve that. It is hoped, nevertheless, that this study combining archival, archaeological and scientific evidence gives some reminder of the integral role played by the painter's craft in the architectural and sculptural conception of Mausolus' celebrated funerary monument.

NOTES

1. For a recent account of his life and work, with further bibliography, see Jenkins (1992) 171–95, and the contribution to this volume by Brian Cook (pp. 10–23).

2. On Newton as a pioneer of the study of prehistory, see Fitton *passim*.

3. Jenkins (1992) 174–85.

4. The principal reference by Newton to the colouring of the Mausoleum is *HCB* 185 and pl. 29.

5. Preliminary reports of this work have been given in Jenkins and Middleton (1988) 194–7; Jenkins, Gratziu and Middleton (1989) 317–26 and (1990) 220–23.

6. *BMCS* II, 1047; Waywell (1978) 108–10, cat. no. 33.

7. Newton to Antonio Panizzi, Add. Ms. 36718 fols 60–1, 6 April 1857; *Dispatches* (1858) 5, 3 April 1857, 13; *HCB* 222–3; *TD* (Testimonies) 272–3.

8. Add. Ms. 36718, fol. 173; cf. British Museum Archives, *Original Papers* LVII, Bodrum 25 July 1857.

9. Jenkins and Middleton (1988); Jenkins (1992) 51.

10. Newton to Panizzi, Add. Ms. 36718, fols 220–1, 27 November 1857.

11. Add. Ms. 36718, fol. 261, 9 February 1858; *Dispatches* (1859) 2, 10 February 1858. For a definition of *leucoma* see M.-C. Hellmann, *Recherches sur le vocabulaire de l'architecture grecque d'après les inscriptions de Délos* (Paris 1992) 38: 'to whiten with limewash or very fine stucco'.

12. *TD* 123. GR 1860.2–1.106.

13. *HCB* 185; cf. *TD* 131–3, 137, 139.

14. Jenkins and Middleton (1988).

15. *Dispatches* (1859) 9, 25 September 1858, enclosure headed: 'Invoice of Antiquities shipped on board HMS Supply, from June 24 1857 to September 26 1858, item 296.15'.

16. GR 1857.12–20.199.

17. GR 1857.12–20.198.

18. *BMCS* II, 1045; Waywell (1978) 66 and 111, cat. no. 34.

19. *BMCS* II, 1002–3; Waywell (1978) 85–7, cat. nos 1–2; Newton in *HCB* seems to have accepted that they are parts of two separate animals.

20. Newton to Panizzi, Add. Ms. 36718, fols 76–80, 26 April 1857; *HCB* 107–9; Waywell (1978) 6; cf. Jeppesen (1958) 21.

21. GR 1972.3–30.1; Waywell (1978) 87–8, cat. no. 2.

22. *HCB* 218; Waywell (1978) 86–7.

23. *Ergon* 1987 (1988) pls 45–9; R. Ginouvès (ed.), *Macedonia from Philip II to the Roman Conquest* (Princeton 1994) pls 136–7.

24. On the friezes of the Mausoleum, see B. Cook *et al.*, *Relief Sculptures of the Mausoleum* (forthcoming).

25. GR 1972.7–14.5.

26. GR 1972.7–14.3.

27. Waywell (1978) 86.

28. Red pigment appears on the joining surfaces of the colossal pieced head from Melos, *BMCS* I, 550 and appears to have been a preparation applied to the marble in order to seal it. This prevented the stucco between the joints from drying out too quickly.

29. J. T. Wood, *Discoveries at Ephesus* (London 1877) 245; F. N. Pryce, *Catalogue of Sculpture in the Department of Greek and Roman Antiquities of the British Museum*, I, *Prehellenic and Early Greek* (London 1928) 43, no. 50.

30. For the later history of the Mausoleum frieze see Luttrell in Jeppesen and Luttrell (1986) 204–8. The problem of the location of the frieze slabs on the castle is further discussed by Jenkins and Middleton (1988) 194–7.

31. *BMCS* II, 1006, 1007 and 1019.

32. *BMCS* II, 1032; Jenkins and Middleton (1988) n. 35.

33. *BMCS* II, 1006–12 and 1018–21 and 1032.

34. *BMCS* II, 1013–16.

35. *TD* 131.

36. Luttrell in Jeppesen and Luttrell (1986) 207.

37. Jenkins and Middleton (1988).

38. Jeppesen (1992) pls 27–8.

39. *BMCS* II, 1048; Waywell (1978) 113, cat. no. 42.

Colour captions on page 41

1

2

5

3

6

7

4

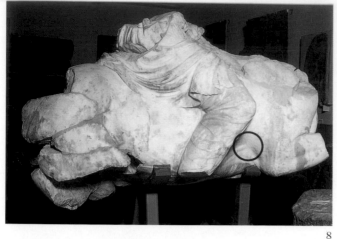

8

10

9

11

12

13

14

15

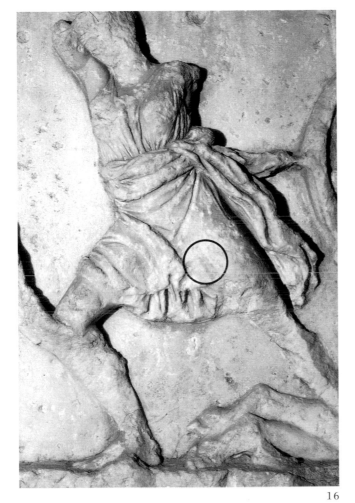

16

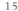

17

19

DIAGRAM SHOWING SEQUENCE AND
SPATIAL DISTRIBUTION OF COATINGS ON
THE SLABS OF THE AMAZON FRIEZE

SEQUENCE		SPATIAL DISTRIBUTION	
		Background	Figures
	Later red paint	√	√
	Grey-brown patina	√	√
	Blue paint	√	
	Red paint	(√)	√
	Yellow-brown patina	√	√
	Marble		

18

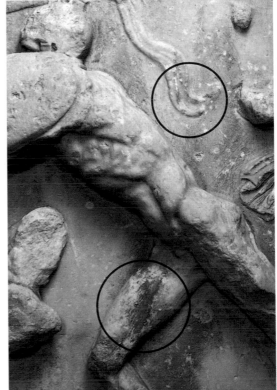

20

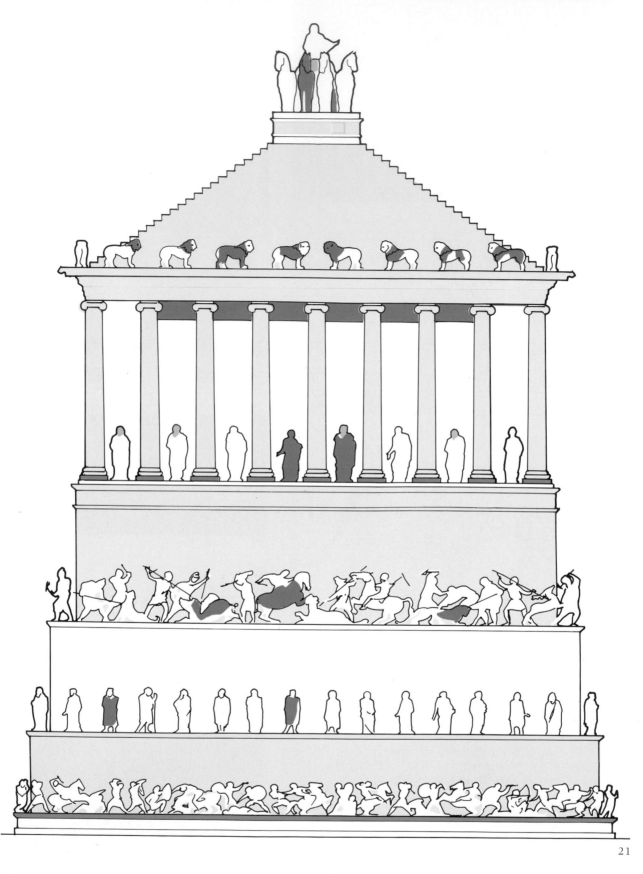

Blue limestone

Greek island

Parian lychnites

Proconnesian and local

Pentelic

Colour Plates

PLATE 1
Engraved plate from Newton, *HCB*, showing the colouring of some architectural mouldings of the Mausoleum at Halicarnassus.

PLATE 2
Bead and reel from a coffer moulding of the Mausoleum with traces of surviving red and blue pigment.

PLATE 3
A cake of 'Egyptian blue' pigment excavated by A. Salzmann and A. Biliotti in a tomb at Camirus, Rhodes (GR 1860.2–1.106).

PLATE 4
A miniature bottle containing a sample of blue pigment taken by C. T. Newton from one of the mouldings of the Mausoleum.

PLATE 5
A shell containing blue pigment found by C. T. Newton on the site of the Mausoleum (GR 1857.12–20.199).

PLATE 6
Corner capital from the Ionic peristyle of the Mausoleum: general view.

PLATE 7
Detail of Pl. 6 showing blue pigment overlying a yellowish-brown layer and, below that, a white 'reaction layer'.

PLATE 8
The so-called 'Persian rider', a free-standing sculpture from the podium base of the Mausoleum (*BMCS* II, 1045).

PLATE 9
Detail from the right flank of the 'Persian rider' showing the blue of the painted saddle-cloth. The pigment appears to overlie a yellowish-brown stratum, which in turn rests upon a white 'reaction layer'.

PLATE 10
Detail from the left flank of the 'Persian rider' showing a few fragments of gilding resting upon a dark brown substance, probably the adhesive by which the gold was attached.

PLATE 11
Fragments of the lead lamina adhering to the right leg of the colossal horse, *BMCS* II, 1002. The metal is silver-grey beneath the brown, oxidised outer crust.

PLATE 12
The scrotum of a colossal horse, partially coated with a lead lamina (*BMCS* II, 1003).

PLATE 13
Oblique view of a fragment of the Chariot Frieze of the Mausoleum showing one horse overlapping another. The surface of the uppermost horse only is coated in an orange-brown patina (GR 1972.7–14.3).

PLATE 14
Detail of the Archaic column capital from Ephesus showing the lead stopping in the astragal moulding upon which fragments of ancient gilding survive.

PLATE 15
Blue pigment above the hand of a warrior on slab 1018 of the Amazon Frieze of the Mausoleum. The blue is part of the original colouring of the background of the frieze. It is thought to have been preserved by an overlay of gilding (now lost) that was applied to represent a weapon, which the warrior held in his hand (*BMCS* II, 1018).

PLATE 16
Amazon from a slab of the Amazon Frieze (*BMCS* II, 1018).

PLATE 17
Detail showing the red stripe on the dress of the Amazon in Pl. 16.

PLATE 18
Diagram showing the stratification and distribution of the coatings on the Amazon Frieze.

PLATE 19
A thin-section analysis of a sample of blue pigment from slab 1019 of the Amazon Frieze showing fragments of the colour 'suspended' in a buff-coloured matrix. The latter is probably the adhesive by which the pigment, first ground in a mortar, was applied.

PLATE 20
A figure of a Greek warrior from the Amazon Frieze showing the 'later' red colour on his right thigh and helmet crest (*BMCS* II, 1020).

PLATE 21
Reconstruction drawing of the Mausoleum, showing the positions of the more commonly used stones. Drawing by Sue Bird after Waywell 1987.

5

The Mausoleum at Halicarnassus
Sculptural decoration and architectural background

Kristian Jeppesen

The sculptural decoration of the Mausoleum was an integral part of its architecture. It was applied to and put up on the outside of the building, so that before we can suggest precisely where and in which context we think the friezes and the free-standing sculptures are likely to have been placed, we must try to reconstruct the architectural framework they were intended to adorn. This will also permit us to form an idea of the original extent of individual sections of the sculptural *mise-en-scène*. Newton managed to identify evidence for the restoration of the stepped roof and of the colonnade on which it rested. But instead of examining properly the rest of the architectural fragments, he left the bulk on the site; and apart from obvious showpieces only a random collection of samples was taken to the British Museum. Since Newton's reconstruction of the lower part of the building, its podium, amounted to little more than mere conjecture (Fig. 36), he was also at a loss where to place the sculptures on the monument. Until recently, this was a problem nobody had seriously attempted to solve.

Newton suggested that some of the figures might have stood in rooms inside the building (Fig. 37). But as Geoffrey Waywell has pointed out, traces of surface corrosion indicate that most if not all the free-standing sculptures were exposed to weathering and must have been placed on the outside of the building.[1] A methodical study of all the fragments of sculptures in the round collected by Newton and Biliotti from the site had never been attempted until Waywell published his capital *catalogue raisonné* in 1978.[2] A provisional classification of the most impressive pieces of statuary according to scale and subject-matter had been outlined in my 'Paradeigmata' from 1958.[3] To the various groups I had defined, Waywell attributed a considerable number of smaller fragments, which proved that some of the compositions they had belonged to must have consisted of many figures requiring extensive bases to support them. Since such compositions were unlikely to have stood in the colonnade, where the columns would have interfered with the perception of their entirety, they could only have been placed on bases built around the podium.

The excavations of 1966–77 produced substantial remains of a base of bluish limestone, in particular fragments of its moulded cornice, on top of which are shallow cuttings for the plinths of sculptures in the round (Figs 38a–b). The moulding is an ovolo, on which the traces of a painted egg-and-tongue ornament can be discerned. Two corner fragments prove that the base extended along adjacent sides of the building and make it probable that it encompassed the whole circumference.

While the column plinths (Fig. 51) were made of an homogeneous type of bluish limestone, the stone used for the cornice is penetrated by irregular veins of a rusty-red colour. Ashlars and fragments of a foot moulding of the same material can be attributed to the lower part of the base (Fig. 39). The ashlars are tooled on the back in the same way as the slabs of the Amazon Frieze and the wall ashlars of white marble, i.e. either flattened in horizontal bands corresponding to the courses of greenish tufa that abutted on their back, or merely hammer-faced, which features make it certain that they come from the Mausoleum.[4] The masonry was composed of courses of varying heights, headers alternating with stretchers. The surviving material comes from at least seven different courses corresponding to a joint height of at least four metres (Figs 39–40).

Judging from one cornice fragment (SLa3), the depth of the platform on which the sculptures were placed was *c.* 83 cm inclusive of the projecting moulding underneath, and the cuttings in which they rested show that they were very close to the wall behind them and were kept at a distance of about 20 cm from the front edge of the cornice. Some of the cuttings are ellipsoid in outline, obliquely placed on the base, and intersect each other so as to suggest that the sculptures they contained were groups of figures involved in vigorous action. Waywell has plausibly conjectured that they were intended for life-size groups representing battles between Greek and Persian warriors on foot or on horseback, of which he has identified seventy fragments.[5]

Of the cornice itself eighty-five fragments have been

found, including two in the British Museum, which by Mausoleum standards is an impressive figure, particularly in view of the fact that not a single fragment has turned up of any other cornice provided with cuttings for free-standing sculptures. It is not impossible, though, that the surviving fragments come from different bases which were similar in design but were used for different purposes. In some parts of the base the cuttings must have been rather widely spaced and may well have been intended for single statues rather than for closely grouped figures represented in motion.[6]

In the preface to his catalogue of 1978 Waywell explained his approach to the problems connected with the restoration of the Mausoleum in the following terms: 'The restoration which is offered is one which is based on what seems to me to be the evidence of the sculptures in the round, and it is one which at the time of writing appeared not to be invalidated by the architectural evidence available.'[7] His restoration is in my view, however, certainly invalidated by the architectural evidence now available and also needs considerable revision in other respects.

Until 1987 my own approach was experimental and tentative. During the 1970s most of my time had been spent on measuring and classifying hundreds of architectural fragments from the site of the Mausoleum, in the castle at Bodrum, and in the British Museum. Next came the problem of how to combine all these *disjecta membra* to form a reliable picture of the entirety into which they had once been incorporated. I also realised that I would have to face the difficulties connected with an archaeological interpretation of the literary sources, in particular the elder Pliny's description of the Mausoleum. All these topics were dealt with in a series of preliminary reports.[8] What I now consider the final outcome of all my investigations and experiments was published in an article in the *Jahrbuch des deutschen archäologischen Instituts* for 1992 which summarises the results of the Danish expedition since the excavations on the site of the Mausoleum were begun in 1966.[9] A description of the distinctive features of Waywell's reconstruction (Figs 41–3) as compared to those of my own (Figs 44–8) will also permit me to explain and to discuss the many problems both of us have had to face.

The new excavations confirmed the dimensions of the foundation cutting recorded by Newton, and judging from the foundation slabs of greenish tufa that were found remaining in position at the bottom of the cutting, the foundations must have measured *c.* 32.5 m in width and 38.15 m in length.[10] This rectangle indicates the limits within which the lower superstructure was contained.

The fragments that Newton brought to the British Museum had not permitted him to calculate the distance between the columns. But in 1972 I discovered in the castle at Bodrum a complete specimen of the half-beams that had once been inserted between the crossbeams supporting the coffers of the colonnade,[11] and since the thickness of the crossbeams was known, the interaxial column spacing could now be calculated at almost exactly 3 m (Fig. 49). Once again in the castle I had the luck to discover in 1987 yet another complete specimen of exactly the same dimensions. Of these stones there must have been altogether twenty-eight, six on each of the shorter sides, and eight on each of the longer sides of the building. So far, therefore, only one-fourteenth (= 7 per cent) of the original number has been identified, which is not statistically sufficient to prove that the column spacing was the same on all the sides of the building. I do not believe that it was and shall explain my reasons for thinking so below.

I also managed to identify remains of the cornice that crowned the podium immediately under the colonnade (Fig. 50).[12] This could be proved to fit the top of the Amazon Frieze, and a groove delimiting the corroded surface on top of the cornice indicates the line from which the stylobate arose. Traces on fragments of the column plinth of bluish limestone and of the disc of white marble that rested on it prove that while the disc was fastened to the plinth by means of one centrally placed biconical dowel, two diagonally placed dowels of the same type were used to fix the plinth to the stylobate underneath (Fig. 51). This observation permitted me to identify with certainty the only fragment of the stylobate that survives (Sjf1). It is 30 cm high, but broken on all sides. On top of it is a conical hole in which was inserted one of the dowels for a column plinth, the outline of the plinth being marked by a corroded groove outside which the surface is weathered.

Presumably, as on the Nereid Monument from Xanthos and the Heroon at Limyra (Figs 52–3), the stylobate consisted of one step only.[13] If this is accepted, and it is assumed that the column spacing was the same all around the building, its podium must have measured 26 × 32 m at the top. Between this rectangle and the rectangle indicating the outline of the foundations, 32.5 × 38.15 m, the intermediate space would have amounted to 3.25 m along the longer sides, and a little less, about 3.08 m, along the shorter sides of the building.

According to Waywell's restoration (Figs 41–3) this margin was utilised to accommodate three bases for sculptures in the round, while below there was only a narrow bottom step to mark the foot of the build-

ing. The arrangement I have proposed (Figs 44–8) follows classical traditions in having the form of a three-stepped crepidoma on top of the bottom step. This leaves room for only two bases for sculptures, for which reason the third one is assumed to have been placed along the wall behind the colonnade.

Waywell's solution agrees in some respects with an earlier proposal of my own, which was conceived before further architectural evidence came to light. Corroded setting lines on top of two 30-cm-high blocks of white marble in the British Museum indicate that they were used as steps measuring 11 and 45 cm in width respectively (Fig. 55). There must have been many more stones of both types. Of the type with the larger step, nine pieces can still be seen in the walls of the castle, and three smaller fragments have been identified on the Mausoleum site, while of the type with the smaller step there are three pieces in the castle and one fragment from the site. That the last mentioned stones are from a bottom course, like the one shown in my preliminary draft (Fig. 54), is also proved by the strips of *apergon*, or lack of finish, along their vertical joints. This feature is typical of the so-called *euthynteria* course which used to indicate in Greek architecture the top of the foundations and the bottom of the superstructure, situated at a level where it was partly covered by earth.[14]

If the steps had belonged to the stylobate of the colonnade, they would undoubtedly have been given dimensions equal to the interaxial column spacing, or to a half or third of it, as was the usual way of composing the stylobate in classical architecture.[15] However, just like the wall ashlars of the Mausoleum, the complete steps are of varying lengths: 154.5, 156, 180.7, 189.5, 202, 207.7, 212.3, 230.2 and 261 cm, and none of these figures conform to the column spacing calculated on the basis of the above-mentioned coffer stones, *c.* 3 m, or to fractions of it. Besides, at a level some 25 m above the ground, a *euthynteria* course would have been entirely irrelevant; and in such a position the lack of finish on the extant pieces would be hard to explain, given the fact that the steps of the larger width are tooled to perfection. Unquestionably, therefore, there was a *euthynteria* course at the foot of the Mausoleum, and on top of this there must have been at least one step 45 cm wide. This detracts so much from the available space, that there could not have been room for three, but only for two bases for sculptures around the podium. By cancelling the middle base and transferring the statues of 'heroic' size (h. *c.* 2.4 m) to positions on the upper building, this modification will permit the inclusion of a three-stepped crepidoma at the foot of the

building in full accordance with the canonical system applied in classical architecture. Such a feature was by no means reserved for temples, but is also found in early Hellenistic tomb buildings imitating the prototype at Halicarnassus, for example the Mausoleum at Belevi and the so-called Ptolemaion recently excavated at Limyra (Figs 56–7).[16] However, where the three-stepped structure was designed to carry a wall – as in the Erechtheum on the Acropolis, to mention a classical example[17] – there was a moulded course near the front edge on top of the third step to embellish the wall base.

Newton brought to the British Museum two fragments of an exquisitely carved cavetto of white marble decorated with a tiny cyma reversa at the top (Fig. 58).[18] Nine fragments of the same moulding were found at the recent excavations. Two angle pieces prove that the course in which it was carved extended on all the sides of the building. On top of them is a rebate for a supplementary moulding, and traces of corrosion indicate that this was a 9-cm-high leaf-and-dart ornament with leaves spaced 13 cm apart. Nine pieces fitting that description are in the British Museum,[19] while thirty-six more were found at the recent excavations; and even during a visit to Cos in 1985 I identified five pieces in the Hospitallers' castle there, where they had been discharged as ballast among other fragments from the Mausoleum.[20]

If it is assumed that the moulded course reconstructed from the above-mentioned fragments was placed on top of the uppermost step of the crepidoma, the wall above it was probably also of white marble, for, as we have seen, the foot moulding attributable to the sculpture base of bluish limestone was made of the same material, and not of white marble.

At the bottom of the wall course just above the moulding there must have been a carved bead-and-reel to supplement the leaf-and-dart underneath, but so far no fragment belonging to such a course has been identified.

Not including the bead-and-reel, the moulding measures *c.* 20.7 cm in height and does look rather low as compared with the steps underneath; however, equally thin and delicate is the *c.* 20-cm-high cornice crowning the sculpture base of bluish limestone (Fig. 40), and just a little larger (24 cm) the cornice on top of the Amazon Frieze (Fig. 50).

If it is assumed that carved ornament was reserved for mouldings placed at crucial levels of the building, while mouldings of subordinate architectural members were only painted, the following distribution of the extant mouldings will make sense:

Foot moulding of lower sculpture base on top of crepidoma	carved
Cornice of sculpture base of bluish limestone around the podium	painted
Foot moulding of Amazon Frieze	painted
Principal cornice of podium on top of Amazon Frieze	carved
Foot moulding of sculpture base of bluish limestone in the colonnade	painted
Foot moulding of Chariot Frieze	painted
Ornaments on coffers and epistyle	carved
Foot moulding of Centaur Frieze (quadriga base)	painted

Judging from the surviving evidence (Figs 38a–b), there was no foot moulding at the base of the wall above the sculpture base of bluish limestone around the podium, and the surviving fragments of a foot moulding of bluish limestone should probably be attributed to the sculpture base in the colonnade (on which see further below). Foot mouldings behind the sculptures would have been largely hidden by them and would inevitably have interfered with the cuttings made for their plinths.

Granted that my conclusions hold true, the lower sculpture base was designed to hold the colossal compositions in the round, whereas the base of bluish limestone for the life-size groups was placed at a higher level. In my drawing the top of the lower base is situated about 6 m above the ground, i.e. at least some 3 m above the top of the wall that surrounded the Mausoleum enclosure and in a position where the sculptures it carried would have been fully visible to people approaching on the 15-m-wide avenue that passed along the northern side of the enclosure (Fig. 59).

A drawing published by Waywell in 1980[21] gives the erroneous impression that there was ample space for visitors to inspect the building from all sides. However, to fit the facts the wall and the avenue shown on the drawing must have been placed much closer to the monument, the true distance between the building and the wall being only c. 3.3 m.[22] Placed within such a narrow passage, the life-size groups would have been concealed behind the wall for observers standing outside; and would have been visible at close quarters only, and not at a distance, from inside the enclosure.

Waywell maintains that his solution is supported by the scarcity of finds of fragments of life-size sculptures in the great deposit which Newton discovered in the Imam's field immediately outside the northern enclosure wall opposite to the Mausoleum.[23] If the life-size groups

were placed at the bottom of the building, Waywell argues, fragments from them could not have fallen outside the enclosure wall, but would have accumulated in the area between the wall and the Mausoleum, whence they would eventually have been removed by the Knights, if not before, and used for making lime.

It seems logical, indeed, that sculptures placed at the foot of the building could not have fallen outside the enclosure wall. But the statistical basis for Waywell's deduction does not inspire confidence. Altogether seventy fragments are attributed to the life-size groups, but there are only ten whose find-spots are recorded.[24] Two came from the south side, two from the west side, and one from the east side, while one or two were found on the north side of the Mausoleum and three were extracted from modern walls.[25] If anything, what can be inferred with some probability from this pattern of distribution is only that the life-size groups extended along all the sides of the monument. Also according to Waywell, the builders of the Mausoleum deliberately put the smallest groups level with the spectator standing on the ground, while the groups above were gradually enlarged to make it easier to appreciate their details at a distance.[26] I am not aware of any other ancient building testifying to the application of such a principle, and I fail to see its aesthetic merits.

While, as we have seen, the colossal and life-size groups must have been placed on extensive bases around the podium, the statues of 'heroic' size would not necessarily have required a common base, but might well have stood detached from one another between the columns or have been combined with the lion groups on the roof, in which case there might have been as many as sixty-four.[27] Waywell attributes eighty fragments to figures of that size[28] and estimates that seventy-two statues would have been needed to fill the middle base in his restoration.[29] It is hard to imagine any principle of setting up so many figures in a systematic way other than by placing them at equal intervals all around the building, but equally hard to believe that such a monotonous arrangement was actually put into shape. Lined up like that, the statues must have represented a distinguished class of individuals enjoying the same status, and Waywell suggests that they should be seen as Mausolus' ancestors.[30] Greek potentates used to claim descent from gods or prominent heroes; so did Alexander the Great, and so probably also did Mausolus.[31] But the pedigree proper would only comprise a few generations, and apart from mythical namesakes of historical members of the dynasty, ancestors living before would have been largely fictitious and nameless. It does not, however, seem likely that the builders would have honoured a

multitude of anonymous characters by giving them such a prominent place on the monument, nor would one expect any category of subordinate personnel collectively attached to the Satrapal court, such as bodyguards or household officials, to have been placed in a separate context detached from that of the dynastic portraits in the colonnade.[32]

Judging from the finds of roof steps and pieces of architraves, the deposit found in the Imam's field resulted from the collapse of upper parts of the building. This assumption is corroborated by the finds made in the same context of substantial fragments from the Chariot Group, and of twenty-two fragments of the standing lions that were set up on the roof.[33] Mixed up with this debris were also several fragments of statues, at least nine of the colossal and nine of the 'heroic' size, which therefore in all probability belonged to figures that were placed in the colonnade or on the roof.

Waywell calculated that the base on which the colossal compositions around the podium were placed would not have had to be deeper than 1.25 m.[34] However, this would not have sufficed to hold the colossal seated figure that Newton found lying in the north-east quarter of the foundation cutting.[35] This was undoubtedly intended to be seen in frontal view, and when complete it must have measured at least *c.* 1.4 m in depth. To accommodate a figure of such dimensions, the base on which it stood must have been some 25 cm deeper, inclusive of the projecting cornice, and have measured *c.* 1.65 m, i.e. some 40 cm more than the base required for the standing figures of colossal size (Fig. 60).

Waywell offers an excellent analysis of the torso and concludes that it has all the appearance of being dynastic and may well be taken to represent Mausolus himself.[36] Oddly enough, however, he does not suggest a convenient place where such an important figure may be assumed to have stood. A position at the middle of the east front would be consistent with the find-spot, but would also imply that the base for the colossal compositions on the fronts was considerably deeper than that required for the standing figures.

The recent excavations brought to light the remains of rows of pillars along the north and south sides of the foundation cutting placed exactly opposite one another (Fig. 61). Being built of roughly tooled ashlars quarried from the living rock, which is rather soft and brittle, they were hardly expected to carry much more than their own weight. In all probability they were not intended to be permanently visible, but were planned to serve some temporary purpose connected with the erection of the Mausoleum. It may be assumed

that they were raised to a uniform level and that crosses indicating crucial lines in the ground-plan of the Mausoleum were incised on their top. They are uniformly spaced, their axial spacings averaging 5.76 m. Possibly this distance should be understood to equal two axial column spacings of 2.88 m, in which case the intercolumniations on the longer sides of the Mausoleum were 12 cm shorter than those on the fronts. If so, the colonnades on the longer sides were 1.2 m shorter than previously assumed, thus permitting 60 cm to be added to the depth of the base for the colossal compositions at both ends of the building and providing sufficient space to allow for the colossal seated figure.[37] Even so, some kind of shallow recess, for instance in the form of a sham door, would have been required to throw the figure into relief against its architectural background.[38] It is usually taken for granted that in all buildings designed in the Ionic style and erected in classical and later times the columns were uniformly spaced. Admittedly this was the case in the temple of Athena at Priene, which is considered to be a little later than the Mausoleum and to have been built by one of the two architects who designed the Mausoleum. On the other hand, in the Nereid Monument from Xanthos, the intercolumniations on the fronts certainly differed from those on the longer sides, though it is not known precisely how much.[39]

So little survives of the colossal compositions that any attempt to reconstruct them must be largely conjectural. The extant fragments suggest that what was represented were episodes typical of Mausolus' life, such as hunting, sacrifice and audience. As Waywell suggested, the seated statue may well have formed part of a scene of audience,[40] while judging from Newton's find of a colossal rider on his horse near the tomb chamber at the west side,[41] the theme on this side was probably hunting.

In Waywell's reconstruction the intercolumniations are supposed to have contained the colossal portraits. In my opinion, however, the available space seems too narrow to offer sufficient elbow-room for statues of such dimensions, in particular on the longer sides of the building, where, if I am right, the columns were more closely spaced than on the fronts. Instead I suggest that the colossal portraits were mounted on a separate base along the wall behind the colonnade, one opposite each intercolumniation, while statues of the 'heroic' size were used to fill the intercolumniations. Sculptures between the columns were to be seen on the Nereid Monument, but the Mausoleum may well have been the first building to exemplify the display of sculptures on a base behind the columns. The latter

feature was imitated in monuments of the early Hellenistic era such as the Sarcophagus of the Mourning Women from Sidon, the Tomb of the Leucadians in Macedonia, and the altar in the sanctuary of Athena at Priene (Figs 62–4).[42]

Given the position of the Amazon Frieze at the top of the podium and the probability that the Centaur Frieze was used to face the base of the quadriga,[43] hardly any more suitable place could be suggested for the Chariot Frieze than the wall above the colossal statues in the colonnade. Situated just below the coffers, the frieze would have lent additional lustre to the colonnade and made it clear that this part of the building was meant to offer a splendid view not only on the outside, but also, and perhaps even more, inside the columns. It was not to be seen as merely a feature of architectural formality, but intended to serve a practical purpose of the greatest importance: that of accommodating in stately surroundings the portrait statues of Mausolus and his family.

Not until recently was it possible to establish the existence of corner acroteria. The combination of two fragments has permitted the identification of a marble slab from one of the bases on which the acroteria were mounted. On this is a cutting suggesting that they were composed of figures in motion, presumably of 'heroic' or colossal size.[44] There is evidence that standing lions were placed on the second roof step, i.e. between the acroteria,[45] and it seems to me most likely that they were grouped in pairs; but how many more there may have been and where else on the roof they may have been placed is still a matter of conjecture.[46]

The graphic juxtaposition of Waywell's restoration and mine given in Figure 59 will facilitate a comparative assessment of their basic characteristics, among these their respective heights. While Waywell takes the total of 140 ft given in Pliny's ambiguous text to include the quadriga (the traditional view), it seems to me equally possible that the figure should be understood to indicate the height at which the quadriga was effectively added to form a crowning group on top of the architectural structure.[47]

The difference in height involved, about 15 ft or 4.8 m, detracts so much from the podium in Waywell's restoration that the building becomes squat and clumsy (Figs 41–3). Viewed from the north-west it must have looked considerably lower and much more compact than suggested in the distorted perspective view where its longer sides are foreshortened to the extent of equalling its fronts. Their proportions are practically the same as those of the longer sides in the restoration proposed by me, and if the drawing represents the Mausoleum as Waywell would like to believe that it looked, his version of the restored building should conform to the extended height deducible from the alternative interpretation of Pliny's text rather than to the lower figure traditionally held to be valid.[48]

NOTES

1. Waywell (1978) 14–15.

2. Waywell (1978).

3. Jeppesen (1958) 46–53.

4. Ibid. 21f., 24f., figs 10, 11 D.

5. Waywell (1978) 37, 50, 77.

6. Ibid. 57, pl. 46.4.

7. Waywell (1978) xiv.

8. Cf. the bibliography in Jeppesen (1992) 101–2.

9. Jeppesen (1992), cf. summary in Jeppesen (1994).

10. The measurements recorded by Newton, 108×127 ft, refer to the dimensions of the foundation cutting itself, cf. Jeppesen and Zahle (1975) 75, n. 31.

11. Jeppesen (1975) 77–8, ill. 6.

12. Ibid. 76, ill. 5.

13. P. Coupel and P. Demargne, *Fouilles de Xanthos* III (Paris 1969) pl. C; J. Borchhardt, *Die Bauskulpturen des Heroon von Limyra*, IstForsch 32 (1976).

14. R. Martin, *Manuel d'architecture grecque* I (Paris 1965) 322f.

15. Ibid.

16. C. Praschniker, M. Theuer *et al.*, *Forschungen in Ephesos* VI (Vienna 1979); *Das Mausoleum von Belevi*, 13–15, figs 4–6, 8–11a; J. Borchhardt, 'Zur Grabung am Naos des Ptolemaions', *XI. Kazi Sonuçlari Toplantisi* II (1989) 198–9, figs 3b-4.

17. J. M. Paton and G. P. Stevens, *The Erechtheum* (Cambridge, Mass., 1927) pl. xxii.

18. GR 1972.8-22.9-10. A most inaccurate cross-section is reproduced in *HCB* pl. xxviii, fig. 6.

19. GR 1972.5-9.195-8 and 215-19. Possibly identical with the moulding reproduced in *HCB* pl. xxviii, fig. 3.

20. As yet unpublished. In the museum building inside the castle I recognised a fragment of the lowermost course of the coffers, and in the open air is the torso of a lion of white marble which strongly resembles the lion statues from the Mausoleum.

21. Reproduced in his paper on 'Mausolea in South-West Asia Minor', *YAYLA* 3 (1980) 4-11. According to Waywell, the drawing was commissioned by the journalist Felix Barker from a commercial artist, Peter Jackson, and was intended and used to illustrate a popular newspaper article on the Seven Wonders of the World, published by the *London Evening News* in 1979.

22. Correctly indicated by Newton, *HCB* pl. iii (*c.* 11 ft) and in Waywell's plan of the site, Waywell (1978) 4-5.

23. *HCB* 102f.; Waywell (1978) 5-7.

24. Waywell (1978) 50-53.

25. Ibid. nos 46, 49, 56, 165, 199, 200, 201, 203, 221, 358; cf. Jeppesen (1992) 83f.

26. Waywell (1978) 51, 61; (1988) 112.

27. That is, thirty-six between the columns and twenty-eight on the roof.

28. Waywell (1978) 47.

29. Ibid. 60.

30. Ibid. 49.

31. Jeppesen (1977) 211.

32. Jeppesen (1992) 96.

33. Waywell (1978) 5–6.

34. Ibid. 57.

35. Ibid. no. 33.

36. Ibid. 44, 109–10.

37. Jeppesen (1992) 88f.

38. Ibid. 80.

39. The design of the Mausoleum should probably be dated in the late sixties or early fifties of the fourth century BC, i.e. at least about ten or perhaps even some twenty years before the erection of the temple at Priene was begun. Of the two architects of the Mausoleum, Satyros and Pytheos, the former was presumably the elder and the one primarily responsible for the planning of the monument, while, after having assisted in supervising the building operations, his younger associate, qualified to work on his own, was entrusted with the building of the temple at Priene (Jeppesen (1992) 100). As a matter of fact, the two buildings differ not only in their basic layout but also in several details, and the temple may well have been the first to be built on the basis of a grid plan with axial column spacings equivalent to twice the width of the column plinth ('Plinthenraster'). At any rate, this system was not applied to the Ionic temple of Zeus at Labraynda, which was erected by Idrieus between 351 and 344 BC, i.e. after the Mausoleum had been built (Hellström and Thieme (1982) 47f.). Epoch-making classical buildings like the Mausoleum and the temple at Priene should be seen as original creations of art and architecture each in their own right rather than as works resulting by and large from the application of fixed rules. Hoepfner and Schwandner (1986) 192–3 insist that the grid plan of the temple must have been modelled on that of the Mausoleum without, however, referring to any tangible evidence in support of their view.

40. Waywell (1978) 44, n. 1.

41. Ibid. no. 34.

42. Jeppesen (1992) 92–3.

43. Jeppesen and Zahle 76; endorsed by B. F. Cook, 'The Sculptors of the Mausoleum Friezes', in Linders and Hellström (1989) 33.

44. Jeppesen (1992) 81–2, pls 22.3.

45. Ibid. 86.

46. Ibid. 83, 93.

47. Ibid. 74.

48. Ibid. 93.

6

The marbles of the Mausoleum

Susan Walker and K. J. Matthews

Introduction

The British Museum collections include a remarkable range of architectural elements and sculptured decoration from the Mausoleum at Halicarnassus, offering an almost unique opportunity to study the selection of stone for a large building project, and, more generally, the movement of marble from various sources at the time of the Mausoleum's construction in the mid-fourth century BC. Although no contemporary documentary record survives of the programme of construction of the Mausoleum at Halicarnassus, it is clear from the surviving remains that a range of stones was selected for various functions within the building. In this respect the Mausoleum may be compared with the near-contemporary development of the sanctuary of Asclepius at Epidaurus in the Greek Peloponnese, for which written accounts survive describing the letting of contracts and the pattern of usage of stone and other building materials.[1]

Though different types of white marble may be observed among the surviving elements of the Mausoleum, individual marbles are difficult to identify by eye. While freshly quarried blocks may have readily visible characteristics such as coloured veins, large or small crystals, colour differences (there is an almost infinite range of shades of 'white' from cream through to pale grey), once the stone has been carved and polished and then subjected to the processes of weathering, erosion, vandalism and reuse over the course of two thousand years or so, such distinguishing characteristics tend to become obscured. The problem was recognised by archaeologists and historians long ago: Richard Lepsius, for example, assembled a reference collection of marble types in the nineteenth century.[2] Among many recent initiatives, the late John Ward-Perkins's efforts to develop and encourage the archaeological study of the ancient trade in white marbles have been especially influential.[3]

There are several scientific techniques available to distinguish white marbles, many developed over the past twenty years or so.[4] The consensus of opinion at recent specialist conferences has been that no one single technique can uniquely identify every type of white marble known to have been used in the ancient world.

Nonetheless a great deal of information may be obtained where only one method of analysis is available. The main technique used in the Department of Scientific Research at the British Museum is stable isotope ratio mass spectrometry, which, from its earliest application to marble analysis in 1972 by Craig and Craig,[5] has proved to be the most successful of the minimally invasive analytical techniques currently available. Grain-size has been shown to be a helpful discriminator,[6] and, although in the present programme of research it was not possible to quantify this parameter using petrographic techniques, examination of the stone by eye to assess its grain-size was also of value.

An extended programme of analyses to try to characterise the range of various types of white marble used for the Mausoleum was undertaken in the early 1980s. As a preliminary exercise, a representative group of marble elements was selected to characterise the various features of the building. The early progress of the work has already been reported,[7] but recent improvements in the data obtained from reference material have necessitated reassessment of the early results and their interpretation. A second series of measurements was carried out at the request of Brian Cook, then Keeper of Greek and Roman Antiquities, to try to distinguish fragments of the Centaur Frieze from iconographically similar fragments of the Amazon Frieze.

Apart from the main aim of characterising the stone, it was hoped that a pattern of marble usage could be established for the building. Subsequently, comparisons of particular aspects of usage with those in the temple of Athena Polias at Priene and the theatre at Halicarnassus proved of interest.

The experimental procedure is based upon the work of McCrea,[8] although it was not applied to the provenancing of classical white marble until the 1970s.[9] Samples were only removed from already damaged areas of the sculptures; thus no worked surfaces were affected, and the site from which the sample was

removed was chosen to be visually unobtrusive. The samples were collected from the sculptures by using a 4 mm masonry bit in a slow speed drill. The initial drillings were discarded to avoid inadvertent measurement of weathered material.[10] From the powder thus obtained, 10 mg were reacted with 100 per cent orthophosphoric acid *in vacuo*. The carbon dioxide evolved was isotopically analysed using a VG Micromass 602D mass-spectrometer.

The isotopic ratio (δ) obtained is given in parts per mil (‰, i.e. per thousand) relative to the PDB standard,[11] where

$$\delta = \frac{R_{sample} - R_{standard} \times 1000}{R_{standard}}$$

where

$$R = {}^{13}C/{}^{12}C$$

or

$$R = {}^{18}O/{}^{16}O$$

The standard error on these measurements is typically ±0.05 ‰.

The analytical results are presented in Tables 1–3 and in diagrams a-c, which have been arranged by sculpture type. The two isotopic ratios have been plotted as $\delta^{13}C$ versus $\delta^{18}O$: also on the plot are the 90 per cent ellipses[12] of isotopic signatures obtained from quarry data very kindly made available by Professor Norman Herz of the University of Georgia, USA,[13] supplemented by data from quarry samples measured in the Department of Scientific Research, the British Museum.[14] The selected ellipses include those for some of the more important marble quarries exploited in antiquity, and for which data are available, albeit limited. Since the date of construction of the Mausoleum is well known, only those quarries known to have been in use at the time of its construction are represented: for example it is known that the Carrara quarries were not exploited for export until almost three hundred years after the Mausoleum had been built,[15] and the isotopic signature of Carrara marble is therefore excluded from the database. Thus judgements based upon historical and archaeological knowledge have been used to weight the database; the interpretation, therefore, is not based on scientific measurements alone.

Using the ellipse data, it was possible to assign each tested marble piece to its most probable quarry on the basis of its stable isotope ratios for carbon and oxygen.[16]

Discussion

The range of stones used in the construction of the Mausoleum

It has been suggested that marble from quarries on the nearby island of Cos was used in the construction of the Mausoleum, and, from petrographic study and limited chemical analysis, it has been noted that stone from Cos closely resembles the marble used for the Amazon Frieze.[17] However, only a very small number of samples (only one from the frieze itself) were available for these studies, and comparative material from Proconnesus in the Sea of Marmara, where, as we shall see, the marble is likely to have come from, was not considered.

In response to this suggestion, samples were collected from potential sources on Cos by Brian Cook and Kristian Jeppesen for stable isotope analysis. The results showed that the oxygen isotope ratios were very negative in comparison with every other marble type in the current database, exhibiting a range from −11.95 to −9.64 ‰ in oxygen ratios, and 3.43 to 5.23 ‰ in carbon ratios. These results cannot be accommodated on conventional graphs such as those below. Thus, if all the analyses of elements from the Mausoleum reported here are taken into consideration, none of the marble that has been studied is likely to come from Cos.

Comparison of the plots of the results confirms that several different sources of marble were exploited to provide stone for the Mausoleum. As the selection of individual stones appears to be related to their function on the monument (see Col. Pl. 21), the various categories of sculpture and architectural elements are considered individually below.

Free-standing sculpture

This group (Table 1) includes such sculptures as the two larger than life-size figures set between the columns and conventionally identified as Mausolus and Artemisia (Fig. 65), lions from the roof of the building (Fig. 66), other animals from hunting and sacrificial scenes on the podium, and some portrait heads. With the exception of four of the portrait heads (2, 17–20) and the chariot shaft (22), the samples taken from sculptures coincide with the isotopic signature of Pentelic marble, long believed by art historians to be the material used for the free-standing figures.[18]

When these sculptures were analysed in the early 1980s, the comparative data obtained from various marble quarries were extremely limited. This meant that the isotopic 'fields' that appeared in earlier pub-

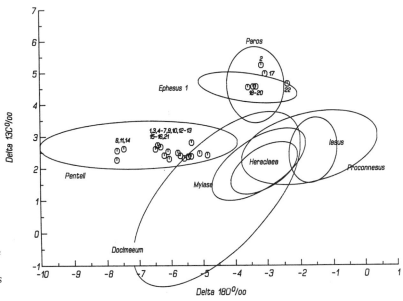

a. Plot of stable isotope ratio results for the free-standing sculptures from the Mausoleum.

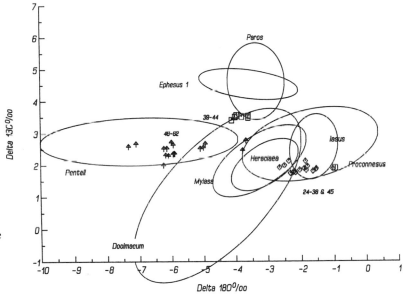

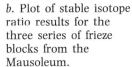

b. Plot of stable isotope ratio results for the three series of frieze blocks from the Mausoleum.

c. Plot of stable isotope ratio results for the architectural components from the Mausoleum.

Table 1 Free-standing sculptures

Number in diagram	Description	Reg. No.	BMCS	BMRL No.	δ ^{13}C ‰	δ ^{18}O ‰
1	Mausolus	1857.12–20.232	1000	23310T	2.30	−6.04
2	Head of Mausolus	1857.12–20.232	1000	51858U	5.24	−3.14
3	Artemisia	1857.12–20.233	1001	23311R	2.53	−6.08
4	Head of Artemisia	1857.12–20.233	1001	51859S	2.68	−6.31
5	Seated figure	1857.12–20.235	1047	23290X	2.42	−4.84
6	Persian man	1857.12–20.263	1057	23287Y	2.81	−5.34
7	Figure in Persian dress	1857.12–20.279	1049	23289U	2.40	−5.69
8	Persian rider	1857.12–20.234	1045	23347V	2.27	−7.68
9	Servant	1857.12–20.237	1048	23288W	2.37	−5.44
10	Ram	1857.12–20.258	1097	23299Q	2.41	−6.20
11	Panther	1857.12–20.256	1095	23302T	2.62	−7.46
12	Bull	1972.4–8.4		23304P	2.32	−5.56
13	Boar	1857.12–20.287		23303R	2.73	−6.40
14	Lion	1857.12–20.240	1075	23301V	2.56	−7.67
15	Lion	1857.12–20.243	1083	23300X	2.38	−5.35
16	Head of a bearded man	1857.12–20.267	1054	23308S	2.61	−6.47
17	Head of a bearded man	1857.12–20.266	1055	23309Q	4.97	−3.03
18	Female head	1857.12–20.259	1051	23286P	4.56	−3.32
19	Female head (fragment)	1865.12–11.6		51623P	4.56	−3.40
20	Female head (fragment)	S. 1053		51624Y	4.54	−3.57
21	Horse from chariot	1857.12–20.238	1002	23285R	2.47	−5.09
22	Chariot shaft	1972.4–17.7		23305Y	4.65	−2.37
23	Chariot wheel	1857.12–20.239	1004	23306W	2.49	−5.77

Notes to Tables 1–3
Standard errors are typically ± 0.05‰
Frieze samples registered (Ashmole) are those collected by Professor Bernard Ashmole.

lications did not accurately represent the possible range of composition of the marble from some of the quarries.[19] The analyses seemed to indicate that some of the large free-standing sculptures were not Pentelic but of Docimaean (Phrygian) origin.[20]

More recently, a team of Belgian archaeologists, geologists and chemists from the universities of Ghent and Leuven has completed a thorough survey of all of the known quarries on Mount Pentelicum, and has been able to collect more reference samples. A reassessment of the stable isotope data for the Pentelic marble quarries was jointly undertaken by the University of Ghent and the British Museum to determine the extent of isotopic compositions of this marble. At the same time, samples were collected for comparison from the Parthenon sculptures, which are known to be of Pentelic marble, to investigate whether the marble quarried in ancient times was different from that collected from extant quarry faces.[21] The data thus obtained demonstrated that Pentelic marble can exhibit a more positive range of oxygen isotope ratios than was previously recognised and therefore that the Mausoleum sculptures could have been of Pentelic origin. It should be noted that the samples of Pentelic marble sculpture exhibiting the hitherto unrecognised isotopic characteristics, i.e. a more positive oxygen isotope ratio, correlated with quarry samples from the Spilia area of Mount Pentelicum.

In the course of these analyses, an interesting parallel was discovered: the large pedimental figures from the Parthenon were found to have similar isotopic ratios to the large figures from the Mausoleum (Fig. 65). Apparently it was known at the time of the building of the Parthenon that large, fault-free blocks of Pentelic marble could be obtained from Spilia,[22] and, nearly a century later, when the Mausoleum was built, this source was still being exploited.

Portrait heads[23]

With the exception of the so-called Artemisia, in which the head is cut in one block with the Pentelic marble body (Fig. 67), the female heads thus far sampled from the Mausoleum fall within the isotopic signature of Parian lychnites marble (Table 1, diagram a),[24] as do the head of the so-called Mausolus (Figs 21–3, 68) (2) and that of a bearded man (17). This stone is notoriously difficult to extract from subterranean mines located on the island of Paros; the quarries may extend for some 200 m, often at steep gradients. Parian lychnites marble was therefore sparingly used in classical antiquity, and was often quarried in small blocks of irregular shape.[25] It was especially favoured for making the heads, hands and feet of acrolithic figures and

sculptures composed of joined blocks of different types of stone, as Parian marble could be highly polished to give the appearance of refined white flesh.

The Chariot Group[26]

The chariot shaft (22), like the architrave (64), coffer (70) and roof block (84), appears to be of marble from Ephesus, although the wheel (23) and the horse (21) from the Chariot Group (Fig. 69) are both Pentelic.

The Friezes

The three friezes are carved of different marbles (Col. Pl. 21; Table 2).

The Amazon Frieze

Before blocks from this frieze were permanently mounted in the post-war arrangement in the Museum's galleries, the then Keeper of Greek and Roman Antiquities, Bernard Ashmole, had collected samples in the form of small lumps taken from the rear of the blocks. Given Ashmole's interest in the materials of sculpture, it is likely that the samples were intended for analysis, although, at the time of their collection, only visual comparative techniques, much favoured by Ashmole, were available.[27]

Diagram b shows that the results lie in an area of isotopic overlap for several different types of marble, but only the Proconnesus ellipse encompasses all of the results. Visual examination of the stone reveals that it is coarse-grained and some of the panels also exhibit the blue-grey banding often seen in this marble (Fig. 70). It seems possible, therefore, that Proconnesus may be the source of this marble frieze, as it may have been for many of the architectural elements of the Mausoleum (see below).

The Centaur Frieze

The isotopic results cluster near the junction of the ellipses representing the Paros and Docimaeum quarries. However, Docimaeum may be eliminated as a source on grounds of the coarse grain-size of the marble.

Marble exhibiting isotopic ratios found for the Centaur Frieze occurs in the quarries at Cape Vathy on the island of Thasos. Thasos is attractive as a potential source of marble for the Mausoleum, given its relative proximity to the Proconnesian quarries and similar ease of access by sea. Significantly, however, the marble from Cape Vathy is dolomitic.[28] X-ray diffraction analysis has shown the Centaur Frieze to be calcitic, so Cape Vathy cannot be the source of this marble.

Table 2 The Friezes

A: The Amazon Frieze

Number in diagram	Reg. No.	*BMCS*	BMRL No.	δ ^{13}C ‰	δ ^{18}O ‰
24	1847.4–24.5	1006 (Ashmole)	23326Z	1.87	−1.03
25	1847.4–24.13	1008 (Ashmole)	23327X	1.74	−2.33
26	1847.4–24.9–10	1009 (Ashmole)	23328V	1.99	−2.51
27	1847.4–24.3	1010 (Ashmole)	23329T	1.84	−2.05
28	1847.4–24.1	1011 (Ashmole)	23296W	1.83	−1.85
29	1847.4–24.1	1011	23296W	1.89	−1.91
30	1847.4–24.2	1012 (Ashmole)	23330W	1.80	−1.64
31	1857.12–20.270	1013 (Ashmole)	23331U	1.76	−2.25
32	1857.12–20.268	1015 (Ashmole)	23295Y	1.86	−1.55
33	1857.12–20.268	1015	23295Y	1.88	−1.53
34	1857.12–20.271	1016 (Ashmole)	23323U	1.96	−1.81
35	1857.12–20.271	1016 (Ashmole)	23323U	1.76	−2.18
36	1847.4–24.4	1018 (Ashmole)	23324S	1.92	−2.65
37	1847.4–24.4	1018	23324S	2.12	−1.87
38	1847.4–24.7	1020 (Ashmole)	23332S	2.12	−2.38

B: The Centaur Frieze

Number in diagram	Reg. No.	*BMCS*	BMRL No.	δ ^{13}C ‰	δ ^{18}O ‰
39	1857.12–20.276	1033	35089P	3.55	−3.96
40	1857.12–20.277	1034	35090S	3.53	−3.60
41	1857.12–20.278a	1035a	35091Q	3.48	−3.61
42	1857.12–20.278b	1035b	35092Z	3.51	−4.01
43	1857.12–20.278c	1035c	35093X	3.50	−4.01
44	1972.7–20.8	1031 (Ashmole)	23333Q	3.40	−4.11
45	1847.4–24.6	1032	23325Q	1.90	−0.97

Number in diagram	Reg. No.	BMRL No.	δ ^{13}C ‰	δ ^{18}O ‰
46	1857.12–20.272	39507X	2.29	−6.09
47	1857.12–20.272	39508V	2.52	−6.23
48	1857.12–20.272	39509T	2.64	−5.94
49	1857.12–20.273	39510W	2.77	−3.68
50	1857.12–20.273	39511U	2.46	−3.78
51	1972.7–14.1	23294P	2.55	−4.99
52	1972.7–14.3	39512S	2.71	−6.00
53	1972.7–14.3	39513Q	2.52	−6.14
54	1972.7–14.3	39514Z	1.99	−6.25
55	1972.7–14.13	39515X	2.36	−5.89
56	1972.7–14.13	39516V	2.31	−6.18
57	1972.7–14.13	39517T	2.35	−5.94
58	1972.7–14.14	39518R	2.52	−5.10
59	1972.7–14.14	39519P	2.67	−4.93
60	1972.7–14.17	39520S	2.58	−7.33
61	1972.7–14.17	39521Q	2.67	−7.10
62	1972.7–14.18	23293R	2.36	−5.91

One panel of this frieze (Fig. 71) is of the same marble as that used for the Amazon Frieze. Given that there can be no doubt over the assignation of this complete block to the Centaur Frieze on grounds of its size, design and iconography, this non-conforming result is of some interest. In general, the pattern of usage of marble seems less consistent in the upper parts of the building (see the remarks on the chariot shaft above), and it seems possible that insufficient marble from the alternative, as yet unidentified, source was available to complete the Centaur Frieze (Fig. 72).

The Chariot Frieze

It has long been recognised that the Chariot Frieze is of higher artistic quality than the other friezes and was carved of finer stone.[29] Diagram b shows that the samples taken from this series of panels correspond with the isotopic signature of Pentelic marble, as do those taken from the large free-standing figures discussed above.

An attempt was also made to reassociate fragments that may have come from any one of several blocks of stone all quarried from the same source at one time. Multiple samples were taken from six large blocks of the Chariot Frieze to determine the inter- and intra-block homogeneity of the marble. The results show that, for the six different panels (46–8, 49–50, 52–4, 55–7, 58–9, 60–61), the intra-block variation in the isotopic ratios was of a similar magnitude to the inter-block variation. Such isotopic similarities unfortunately do not permit the association of any of the unidentified fragments to any individual panel.[30]

Architectural elements

As Table 3 shows, it was possible to analyse samples from a wide range of architectural features ranging from ornately moulded elements of the order to plain building blocks.

Diagram c shows that most of the results fall in an area where several of the quarry ellipses overlap with each other. Unfortunately, stable isotope analysis cannot be used to differentiate between sources where the results for the artefacts fall into such areas of the plot. However, it was noted during sample collection that the marble was coarse-grained and often exhibited the blue-grey banding characteristic of Proconnesian marble. Indeed, the Roman architect Vitruvius observed that Proconnesian marble was used to decorate Mausolus' brick-walled palace at Halicarnassus (*De Architectura*, II, 8, 10), and it is known that the extensive quarries on the island of Proconnesus were already exploited for export long before the Mausoleum was built.[31] On the basis of stable isotope data alone, however, the quarries of Iasus, Mylasa and Heraclaea cannot be ignored.[32] It is especially likely that either Mylasa or Heraclaea provided the marble used in the construction of the upper courses of the peribolus wall; from the wall blocks a cluster of samples falls distinctly separate from the mass of other results, both within the Proconnesian field and within the signature of the more local quarries.[33]

Other samples which fall outside the isotopic range of Proconnesus are worthy of comment. There are three items (67: a dentil; 71: a coffer; 76: the Ionic angle capital) that appear to be of the same marble as the Centaur Frieze (see above). Others (64: architrave; 70: a coffer; 84: a roof block) appear to be of Ephesian marble, like the chariot shaft (22).

Among the architectural members there are elements for which it has been possible to analyse several examples in the Museum's collections and compare results. For example, three coffers (70, 71, 72) were examined and they apparently originate from as many different sources.

Analysis of the marble used for the peribolus wall (85–9) has provided useful information for the building history of the theatre in Halicarnassus. It was suggested by Poul Pedersen that the entablature of the stage-building of the Roman theatre was built of reused blocks from the Mausoleum with similar drafting lines to those found at the site of the peribolus wall; stable isotope analysis of the theatre blocks confirmed that they were indeed of the same isotopic composition as the Mausoleum wall blocks.[34]

Synopsis

Stable isotopic analysis has demonstrated that there are clear patterns of marble usage for the construction of the Mausoleum. The use of Pentelic marble from Spilia for the very large free-standing sculptures suggests the continued exploitation of this particular quarry for sculptures of exceptional scale.

Parian marble was used for some of the portrait heads: two of the female examples are closely comparable to results obtained from stable isotope analysis of a contemporary head, perhaps representing Mausolus' sister Ada, from the temple of Athena Polias at Priene, and also in the British Museum collections (Fig. 73).[35]

Stones of coarser grain were used for most of the architectural elements and for two of the friezes. The results appear as distinct clusters within the quarry ellipses (diagrams b and c). While Proconnesian marble seems to be the most likely source for many of the architectural components of the Mausoleum as well as for the Amazon Frieze, it is possible that the nearby quarries at Iasus, Mylasa and Heraclaea also provided stone for some architectural features. The Chariot Frieze, like the large sculptures, is of Pentelic marble while, with one exception, the Centaur Frieze appears to be of coarse-grained marble from a source as yet unidentified. There is also evidence to suggest that, in Roman times, some of the blocks from the peribolus wall of the Mausoleum were reused to build the stage-building of the theatre at Halicarnassus.

In general, the use of stone appears to be less consistent in the upper parts of the Mausoleum, perhaps reflecting some difficulty in controlling the supply of blocks in sufficient quantities in the later stages of the commission.

The presence of another stone should also be noted. This is a red-veined blue limestone identified by Professors Waywell and Jeppesen as forming the highest course of steps at the base of the podium, into which life-sized free-standing statues were inserted (Col. Pl. 21).[36] Professor Jeppesen also associates this stone with the revetment of the central zone of the podium wall, suggesting an intended contrast between the blue limestone base for the lowest course of statues and the blocks that formed the backdrop for that arrangement, with the implication that the latter were of white marble. The limestone was also used for the plinths supporting the column bases on the top of the podium, and for the toichobate of the peribolus wall.[37] This stone was evidently critical to the overall appearance of the Mausoleum. Isotopic analysis, unfortunately, cannot be used for the provenancing of

Table 3 Architectural components

Number in diagram	Description	Reg. No.	BMCS	BMRL No.	δ ^{13}C ‰	δ ^{18}O ‰
63	Architrave	1972.5–4.8	984	23298S	1.86	−1.44
64	Architrave	1857.12–20.314		23320P	4.49	−2.25
65	Upper part of architrave	1857.12–20.310	985	23297U	1.93	−2.00
66	Angle block of sima	1972.6–8.24		23319X	1.91	−2.30
67	Dentil	1857.12–20.319		23317Q	3.41	−3.87
68	Dentil moulding	Newton 67		23322W	5.45	−3.34
69	Cornice	1972.5–4.3		23318Z	1.82	−2.00
70	Coffer	1857.12–20.323		23321Y	4.36	−1.82
71	Coffer	1972.7–21.28		23291V	3.48	−3.51
72	Coffer	1972.7–21.29		23292T	1.86	−2.58
73	Lower drum of column base	1972.6 28.1 2	980(a)	23315U	2.01	−2.58
74	Lower part of column	1857.12–20.298–9	980(b)	23314W	1.39	−3.33
75	Upper part of column	1857.12–20.292–3	980(c)	23313Y	1.09	−3.32
76	Ionic angle capital	1857.12–20.294	981	23312P	3.42	−3.35
77	Architectural block	1		23275V	1.93	−0.79
78	Pyramidal roof block	2		23276T	1.98	−1.71
79	Corner roof block	3		23282X	2.00	−1.62
80	Roof block	4		23280Q	1.55	−2.33
81	Podium facing	5		23274X	1.86	−0.88
82	Podium facing (?)	6		23277R	1.78	−0.94
83	Corner of podium	7		23273Z	1.86	−1.37
84	Pyramidal roof block	8		23284T	4.31	−2.16
85	Peribolus wall stretcher	9		23281Z	0.73	−2.40
86	Upper peribolus wall	10		23283U	1.81	−2.84
87	Peribolus wall	11		23279Y	1.65	−3.22
88	Peribolus wall	12		23278P	1.74	−3.11
89	Peribolus wall	13		23272Q	1.08	−3.36

limestone because, unlike marble, it has not been homogenised by recrystallisation during geological processes.

ACKNOWLEDGEMENTS

An undertaking of the magnitude of this work, which has been allowed to proceed over the course of several years, cannot but involve several people without whose support the whole project would have foundered. Brian Cook, Keeper of the Department of Greek and Roman Antiquities, and his successor Dyfri Williams both very kindly allowed the removal of samples from all the sculptures and architectural elements treated here. Michael Tite and Sheridan Bowman, successively Keepers of the Department of Scientific Research, have made available resources within the department so that the analyses could be undertaken. Richard Burleigh and Michael Hughes, Department of Scientific Research, have given one of us (KJM) much help and encouragement. Sylvia Humphrey, also of the Department of Scientific Research, very kindly did the XRD analyses. Norman Herz made his database of marble quarry analyses available to us. In the Department of Greek and Roman Antiquities, Susan Walker is grateful for academic advice from Brian Cook, Ian Jenkins and Peter Higgs, and from Geoffrey Waywell of King's College London. Bill Cole and his successor Ken Evans (Greek and Roman Antiquities) very kindly assisted with the collection of samples from the objects themselves. The authors thank Susan Bird for the reconstructed drawing of the marbles of the Mausoleum (Col. Pl. 21) and Nic Nicholls for the photographs, reproduced by courtesy of the Trustees of the British Museum.

NOTES

1. A. Burford, *The Greek Temple Builders at Epidauros* (Liverpool 1969).

2. M. Moltesen, *The Lepsius Marble Samples* (Copenhagen 1994).

3. H. Dodge and B. Ward-Perkins (eds), *Marble in Antiquity: Collected Papers of J. B. Ward-Perkins* (London 1992).

4. Reported e.g. in N. Herz and M. Waelkens (eds), *Classical Marble: Geochemistry, Technology, Trade* (Dordrecht and Boston 1988), and M. Waelkens, N. Herz and L. Moens (eds), *Ancient Stones: Quarrying, Trade and Provenance* (Leuven 1992).

5. H. Craig and V. Craig, 'Greek Marbles: Determination of Provenance by Isotopic Analysis', *Science* 176 (1972) 401–3.

6. L. Moens *et al.*, 'A Multi-variate Approach to the Identification of White Marbles used in Antique Artifacts', in Herz and Waelkens (supra n. 4) 243–52.

7. S. Walker and K. Matthews, 'Recent Work in Stable Isotope Analysis of White Marble at the British Museum', in J. Clayton Fant (ed.), *Ancient Marble Quarrying and Trade* (Oxford 1988) 117–26.

8. J. M. McCrea, 'The Isotopic Chemistry of Carbonates and a Palaeotemperature Scale', *Journal of Chemical Physics* 18 (1950) 849–57.

9. See e.g. Craig and Craig (supra n. 5); M. Coleman and S. Walker, 'Stable Isotope Identification of Greek and Turkish Marbles', *Archaeometry* 21.1 (1979) 107–12; Walker and Matthews (supra n. 7).

10. K. J. Matthews, 'Variability in Stable Isotope Analysis: Implications for Joining Fragments', in Herz and Waelkens (supra n. 4) 339–46.

11. H. Craig, 'Isotopic Standards for Carbon and Oxygen and Correction Factors for Mass-Spectrometric Analysis of Carbon Dioxide', *Geochimica et Cosmochimica Acta* 12 (1957) 133–49.

12. M. N. Leese, 'Statistical Treatment of Stable Isotope Data', in Herz and Waelkens (supra n. 4) 347–54.

13. N. Herz, 'Carbon and Oxygen Isotope Ratios: A Data Base for Classical Greek and Roman Marble', *Archaeometry* 29 (1987) 35–43.

14. K. J. Matthews *et al.*, 'The Re-evaluation of Stable Isotope Data for Pentelic Marble', in Waelkens, Herz and Moens (supra n. 4) 203–12.

15. E. Dolci, 'Marmora Lunensia: Quarrying Technology and Archaeological Use', in Herz and Waelkens (supra n. 4) 77–84.

16. Statistical techniques for assigning the measurements are discussed by Leese (supra n. 12).

17. N. Stampolidis, 'On the Provenance of the Marble of the Mausoleum Amazonomachia Frieze', in Linders and Hellström (1989) 45–9.

18. The free-standing sculptures are catalogued by Waywell (1978). On the marble, see p. 14.

19. E.g. Craig and Craig (supra n. 5); Coleman and Walker (supra n. 9); S. Kane, 'Sculpture from the Cyrene Demeter Sanctuary in its Mediterranean Context', in G. Barker, J. Lloyd and J. Reynolds (eds), *Cyrenaica in Antiquity* (Oxford 1985) 235–47.

20. Walker and Matthews (supra n. 7).

21. Matthews *et al.*, (supra n. 14).

22. M. Korres, *Vom Pendeli zum Parthenon* (Munich 1992) 63–5, figs 4–10.

23. Portraits sampled for isotopic analysis include Waywell (1978) 97–105, nos 26–7; 106–7, no. 30; 108–12, nos. 32–4; 113–14, no. 42; 115–16, nos 44–5; 117–18, no. 47; 119–20, no. 49 (for BM catalogue numbers see Table 1). For the female portrait heads, see now P. Higgs, pp. 30–34 in this volume.

24. K. Germann *et al.*, 'Provenance Characteristics of Cycladic (Paros and Naxos) Marbles: A Multivariate Geological Approach', in Herz and Waelkens (supra n. 4) 251–62.

25. J. Clayton Fant, *Cavum Antrium Phrygiae: The Organisation and Operations of the Roman Imperial Marble Quarries in Phrygia* (Oxford 1989) 12, with n. 58. On joined figures of more than one marble, see A. Claridge, 'Roman Statuary and the Supply of Statuary Marble', in Fant (supra n. 7) 139–52, esp. 144 and nn. 16–18.

26. Waywell (1978) 85–96, nos 1–25.

27. B. Ashmole, 'Aegean Marble: Science and Common Sense', *BSA* 65 (1970) 1–2.

28. J. J. Herrmann Jr, 'Exploitation of Dolomitic Marble from Thasos: Evidence from European and North American Collections', in Waelkens, Herz and Moens (supra n. 4) 93–9.

29. See most recently Jeppesen (1992) 59–102, esp. 86.

30. Compare the findings of Coleman and Walker (supra n. 9) 109 11 with reference to (then unidentified) marble from Docimacum.

31. On the Proconnesian quarries, see most recently N. Asgari, 'Observations on Two Types of Quarry-items from Proconnesus: Column Shafts and Column Bases', in Waelkens, Herz and Moens (supra n. 4) 73–80, with earlier bibl. p. 76. On the isotopic signature of Proconnesian marble, see N. Asgari and K. J. Matthews, 'The Stable Isotope Analysis of Marble from Proconnesus', in Y. Maniatis, N. Herz, Y. Basiakos (eds), *The Study of Marble and Other Stones Used in Antiquity* (London 1995) 123–30. On pre-classical exploitation of the quarries, see S. Walker, 'The Marble Quarries of Proconnesus: Isotopic Evidence for the Age of the Quarries and for Lenos-sarcophagi carved at Rome' in P. Pensabene (ed.), *Marmi Antichi* (Rome 1985) 57–68.

32. A. Peschlow-Bindokat, 'Die Steinbrüche von Milet und Herakleia am Latmos', *JdI* 96 (1981) 157–235.

33. K. J. Matthews in Pedersen (1991) Appendix III, 189–92. The blocks now in the British Museum are described and illustrated by Pedersen, pp. 24–30, figs 23–38.

34. K. J. Matthews in Pedersen (1991). The blocks from the stage-building are illustrated and described in Pedersen (1991) pp. 34–5, figs 47–9.

35. *BMCS* II, 1151: Carter, *Priene* 271–6, no. 85. For the marble, see p. 72 and F. Waddell, in Appendix 2: investigation of marble fragments from the temple of Athena, Priene, pp. 339–43. See also A. N. J. W. Prag and R. A. H. Neave, 'Who is the Carian Princess?', in Isager (1994) 97–109, esp. pp. 101–3, with figs 6–9.

36. Waywell (1978) 49, 57, n. 158, 245 with pl. 46, 1–4; Jeppesen (1992) 85.

37. Pedersen (1991) 18–22. For the toichobate blocks in the British Museum, see pp. 19–22, figs 9–18.

7

The sculptors of the Mausoleum at Halicarnassus

G. B. Waywell

The four sculptors immortalised by the elder Pliny as responsible for the sculptural decoration of the Mausoleum – Scopas, Bryaxis, Timotheos and Leochares – have been a perpetual source of discussion and controversy.[1] Were they responsible for the overall decoration, as Pliny suggests? Did they take one side each in competition with one another? If not, how was the work divided up? For many years the attention of scholars was particularly devoted to the division of the slabs of the Amazon Frieze among the four masters, attributions which have been effectively criticised by Brian Cook, who concludes that, as far as the Amazon Frieze is concerned, the famous artists are unlikely to have participated in either the design or the execution.[2] The frieze, he suggests, was 'decorative sculpture' which would have come within the preserve of the architect, Pytheos, or perhaps both Satyros and Pytheos. These are the two architect–artists named as joint authors of the book on the Mausoleum by Vitruvius,[3] and on the generally accepted supposition that Satyros is the same man as the Satyros, son of Isotimos of Paros, who signed the Delphi statue base which carried the bronze portrait statues of Ada and Idrieus, younger sister and brother of Mausolus and Artemisia (c. 347/6 BC), this has led to an alternative or supplementary interpretation according to which Satyros is credited with overall responsibility for the sculptural decoration, as a sort of 'court sculptor' known to have made images of the ruling Hecatomnid house.[4] Further to this is the question of Pliny's 'fifth artist' – quintus artifex – Pytis, according to the MSS.[5] Is he the same man as the architect Pytheos, and was he therefore a sculptor as well as an architect, in line with the supremacist view attributed to him elsewhere by Vitruvius, according to which an architect should be better at all other art-forms even than individual specialists in one art-form, including presumably sculpture?[6] A seventh artist's name associated with the Mausoleum is that of Praxiteles, mentioned by Vitruvius who relegates Timotheos to a parenthesis, a suggestion which, leaving aside Jeppesen's bold textual emendation of Praxitelis to prae ceteris to expunge him from the record, has found some support in recent views expressed by Corso and Stewart, who both accept the possibility of his participation.[7]

It is now nearly twenty years since I reviewed the question of the sculptors of the Mausoleum in the discussion section of my catalogue of free-standing sculptures.[8] My tentative conclusions then, from which I do not wish particularly to depart now, were that it was reasonable to conclude from Vitruvius that Satyros and Pytheos were responsible for the overall form of the building (perhaps also including the sculpture), an interpretation supported recently by Jeppesen;[9] and that Vitruvius and Pliny were broadly correct in their attribution of the sculptural decoration to four leading Greek sculptors of the day (or five if you include Praxiteles), each of whom would presumably have had numerous assistants. My suggested apportionment of work was (Fig. 43): chariot group on summit by Pytheos, his name garbled as Pytis by Pliny; lions on roof also by Pytheos, from similarity of design to horses; since then Jeppesen has confused, or amended, the roof sculptures by adding human standing figures to some of the pyramid steps, and corner acroteria (Figs 44–6).[10] The colossal series of male and female portraits, Mausolus–Artemisia, Ada–Idrieus, and their ancestors, I suggested may have been by Satyros. Again Jeppesen has complicated the picture now by assigning a double series of figures to the spaces behind rather than between the columns.[11] The once-numerous but exceedingly fragmentary free-standing sculptures on the stepped bases of the podium had, I suggested, the best chance of being the work of the four sculptors mentioned by Pliny, and their assistants, on the grounds that these artists would have had most experience with 'pedimental-type' group sculptures that had to be fitted expertly into a shallow depth along the sides of the building – a kind of legacy from Doric architectural sculpture which was now applied to an Ionic construction. I did not discuss the authorship of the three friezes, amazonomachy, chariot race and centauromachy, or of the coffer reliefs, but I felt then, and still do, that these masterly designs and executions are in no way inferior to the three-dimensional sculpture, and should therefore also have

been the work in some way of the main participating artists.

With regard to the association of individual artists with sides, a more complex division of work was proposed, according to which different levels of sculpture on different sides of the building might have been shared out more equally.[12] This arose from a general observation about the sculptures whose position is reasonably well known, which still seems to me to apply: namely that the subject-matter and design of the sculptures of the Mausoleum tends to change according to level rather than side, especially on the upper half of the building. Subjects which are the same on all four sides of the building, such as the Chariot Group, the lions, the portrait statues and the three friezes, are likely therefore to have had only one basic designer, although details could have been left to executant masons. Lower down on the podium it was conceded that there may have been a different designer for each of the four sides.

This overall interpretation has not been seriously challenged, or even much discussed, since it was first expounded. It has found general favour with, for example, Robertson, Stewart and, apart from minor reservations, Jeppesen, who concludes that both Satyros and Pytheos are likely to have had equal responsibility for both the architecture and the sculptural decoration of the building, a partnership in which he gives precedence to Satyros as leading project-designer, considering Pytheos to be his younger assistant and eventual successor.[13]

Can we now go any further than this, and try to be more specific about the practical requirements of building design and sculptural decoration for such a large-scale project as the Mausoleum in the mid-fourth century BC? In order to attempt this I should like to look at aspects of the building inscriptions from the sanctuary of Asclepius at Epidaurus, the most complete series of accounts that we possess of the letting of contracts for building construction and decoration, dating to just before or contemporary with the Mausoleum, and from a site which has a definite artist link with the Mausoleum in the person of Timotheos, if not others.[14]

Of particular interest are two inscriptions, *IG* IV[2], I, 102, the well-known account for the construction of the temple of Asclepius, and *IG* IV[2], I, 118, which is more fragmentary and difficult to interpret.[15] I shall deal with the latter first (Appendix, no. 4). This inscription (no. 118) used to be thought to be the accounts for the chryselephantine cult statue of Asclepius, perhaps reflected in the contemporary votive relief Athens NM 173, because it contains the name, among others, of Thrasymedes (lines 56A, 68, 73), recorded by Pausanias (II. 27.2) as the sculptor of the temple image, as well as materials such as ivory (lines 40, 42, 45, 46, 50) and gold (lines 20, 56A).[16] However, since the addition by Mitsos of a joining fragment, it has been reinterpreted as the specification for the construction (side A) and fitting out (side B) of the enkoimaterion or incubation building at Epidaurus, where suppliants would stay overnight. Mitsos even cast doubt as to whether the Thrasymedes mentioned is the same person as the Thrasymedes of Paros responsible for the cult image and interior of the temple cella, but this is perhaps going too far, because there are other recognisable names among the suppliers of equipment for the building. One of these is Astias (lines 57, 62), who is paid as an assistant architect in the main temple accounts (line 111). Another, more interestingly from our point of view, is Satyros, whose name appears four times in lines 61–2 as supplier of '*zygastria*' and '*sidaria*'. The latter word is ironware, or iron goods, possibly tools; the former, *zygastria*, although sometimes translated as 'cupboards', strictly speaking means fastenings or fixtures, and perhaps has a generic meaning of this kind here, as the word appears several times in the inscription, not only with Satyros' name, but also with other suppliers, including Damokrates (line 63), Philon (line 64) and Damoteles (lines 68–9). Now, we cannot of course be sure that this Satyros is the one who later worked on the Mausoleum and on the statues of Ada and Idrieus at Delphi, but given the proximity to the fellow Parian artist Thrasymedes, there must be a fair chance that it is he. If so, it would make a much stronger link between the Mausoleum and Epidaurus than that which exists already through the name of Timotheos, and it would tend to confirm an Ionian group of artists from Paros, who had already worked together at Epidaurus, as the originators of the design and construction of the Mausoleum (it was traditionally from Paros that the marble building stone came).

Timotheos' name occurs at Epidaurus, of course, in the main temple accounts, *IG* IV[2], I, 102, and it is to aspects of these that I now wish to turn (Appendix, no. 5). The numerous clauses of these accounts run for a period of four years and eight months, the time it apparently took to build and decorate with sculpture the temple of Asclepius, and the absolute dates for the project are now reckoned by most commentators to be *c*. 375–370 BC, at any rate before the commencement of work on the Mausoleum. They make it plain that even for a relatively small building like the temple of Asclepius, less than one quarter the size of the Parthenon, the actual work of construction and

decoration was divided up and sub-contracted to numerous artists, masons and suppliers, all of whom had their financial guarantors. There was an overall architect, Theodotos, who seems to have had an assistant, Astias, in the last phase, and it is the payment of Theodotos' salary at a modest 350 drachmas per year (or a drachma a day) which provides the chronological sequence of the accounts. The architects' control over the sculptural decoration is uncertain, for this was contracted for separately, and was taken up (as is well known) by a variety of sculptors, the first-named of whom is Timotheos. As soon as the workshop was built in the second year, Timotheos took up the contract to produce *typoi* for 900 drachmas (lines 36–7), whatever is meant by *typoi* (a topic much discussed). One theory is that these were six metopes sculptured in relief intended for the pronaos, which were made first so that they could be slotted into place before the temple roof was finally completed.[17] But there is no evidence that the temple had sculptured metopes, and the more favoured interpretation is that the *typoi* were the scale-models for the whole of the sculptured decoration, which would make Timotheos the designer of the extant pediments, which were then contracted out to other artists for execution.[18] A recent new interpretation by Posch, that Timotheos worked with Thrasymedes in the cella, and that the *typoi* are reliefs from the throne of Asclepius, seems unwarranted.[19] Timotheos' name subsequently appears among the sculptor–contractors, as he undertakes one of the groups of figured acroteria (lines 90–91), placed at the opposite end of the building from the pediment made by Hektoridas, the work for which was itself divided into two separate contracts more than a year apart for some unknown reason (lines 89, 112). Most people guess that Hektoridas' pediment is at the west, so that Timotheos' acroteria are at the east. The other set of acroteria (i.e. at the west) are made by Theo [...] (line 97), usually restored as Theodotos, the architect of the temple, but not with certainty, as among the other names working at Epidaurus are Theodoros, Theotimos and Theophilos.[20] The sculptor who then takes up the contract for the whole of the other pediment, presumably the main east one, is famously unknown, as the stone is broken at this point (lines 98–9). Some have inevitably suggested Timotheos, but the favourite restoration is Theo[dotos], because the guarantor, Theoxenidas, is the same as appears for this artist on the acroteria, which need not of course be conclusive.

Whatever the truth behind all this, one point which is clear is that at Epidaurus sculptures on different parts and levels of different sides of the building are contracted separately to different sculptors. The result of this, and very likely the intention, would have been to blend together the work of different artists into a unified whole. It seems highly probable that a similar approach would have been adopted for the Mausoleum, with different parts of the decoration being separately contracted at the appropriate time and paid pro rata. It may also be inferred from the Epidaurus accounts that the name of a sculptor implies a number of assistants to help him complete the work. The full contract for the complete (east) pedimental sculptures to the nameless sculptor (Theodotos) is not let out until just before the fourth year, and must have been completed in twelve to eighteen months at the most. Given the number of sculptures involved, twenty-one according to Posch and Yalouris, and the contract price of 3,010 drachmas, giving an average cost of about 140 drachmas per figure, it may be calculated that a further seven or eight men would have been required, working at a drachma a day, to complete the sculpting in a year (or five or six men for eighteen months).[21]

The other indispensable requirement for a building project of this kind was an ergasterion or workshop building, of capacious dimensions suited to the part or parts of the structure to be decorated. This was usual practice, as we know from Olympia, Delphi and elsewhere.[22] The ergasterion provided a safe place for the sculptures to be carved in all weathers, and stored with security until their time for installation. At Epidaurus there are clear costs and instructions for the workshop (lines 32–39). Assuming the accounts follow a chronological sequence, the workshop was not commenced until year two (after the main construction of temple colonnade and cella walls), when the rubble stone for the foundations and socle was delivered. It was built with plastered mud-brick walls, stout doors, and a wooden-beamed and tiled roof. It was therefore a substantial, if utilitarian, structure, which was first used, it would seem, for the *typoi* of Timotheos, and later we may suppose for the acroteria and pedimental sculptures.

Turning to the Mausoleum, we must envisage a similar arrangement for a workshop on site. Just as at Epidaurus one ergasterion could apparently serve for the combined operations of several sculptors on a single project, so we should anticipate the same situation on the Mausoleum site, but given the greatly increased scale of the undertaking one would expect it to be correspondingly larger. Are there any traces remaining of such a structure? The best candidate among the ancillary buildings excavated on the Mausoleum terrace is the so-called Building A, a long, rectangular structure located in the north-west area of the peri-

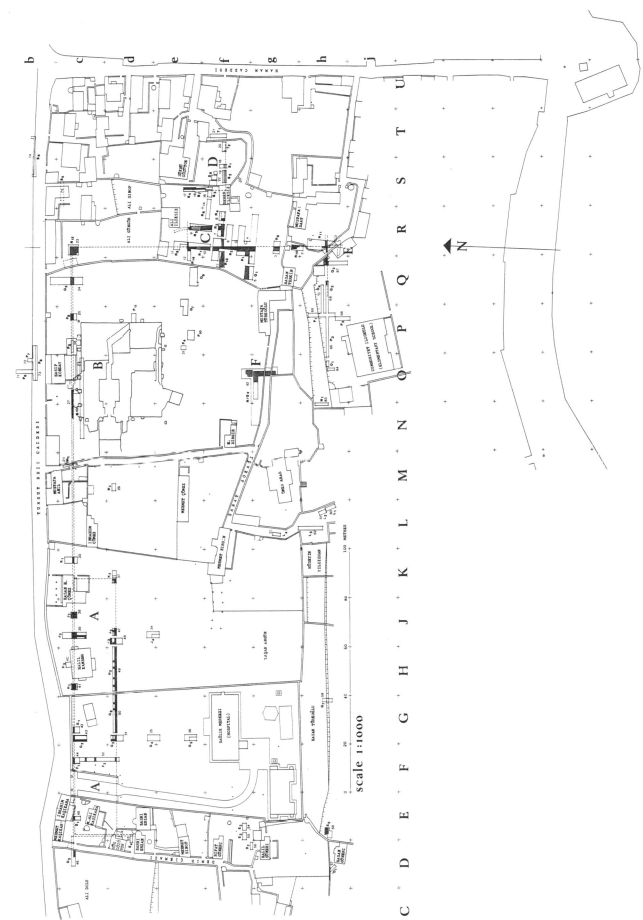

The Mausoleum excavations 1966–77, showing building A at the top left-hand corner. 1:1000. (After Jeppesen.)

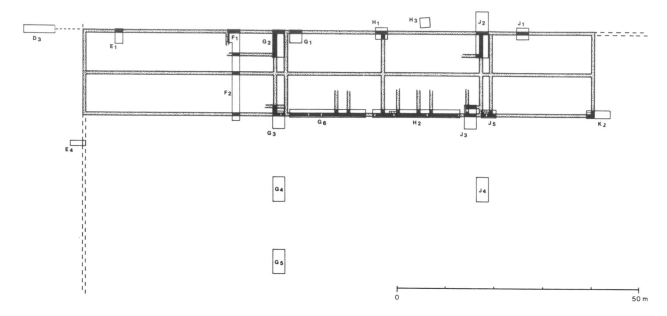

Building A with some hypothetical walls based on remains found in the excavated trenches. 1:800. (After Pedersen.)

bolus, abutting on the inside of the peribolus wall (see plans). From what has been ascertained of its structure and arrangement from trial trenches carefully published by Pedersen, it would seem quite suitable for such a purpose.[23] With its substantial stone foundations and socle, and its tiled roof, it seems to have been the counterpart of the type of workshop prescribed by the Epidaurus inscription. Its scale too might even be sufficient for the vast quantity of sculpture from the Mausoleum, being some 105 m in length, with an enclosed area of more than 2,000 sq. m. The excavators note that it has all the characteristics of a building intended for industrial output, but have not made any link with a possible workshop. The date suggested from the finds is put in the first centuries BC and AD, but this does not appear to be founded on any conclusive stratigraphy, and possibly this represents a later reuse of an earlier structure. The level of the foundations, Pedersen notes, seems more suitable for a temporary building that may have antedated any paving of the Mausoleum terrace area.[24] The building has a number of unusual features, including water-basins along the southern side wall, which might well have been convenient for the processes involved in large-scale sculptural production.

Whether or not this interpretation is correct, it does not necessarily bring us any closer to solving the question of participation of particular sculptors on the Mausoleum. It does, however, make the participation of several artists and their assistants on a single project operated by a pair of architect–sculptors (i.e. Satyros/Pytheos) more plausible, and by reference to the presumed practice at Epidaurus, we may perhaps suppose that the overall decoration would have been first carried out in the form of models, or *typoi*, which would then have been executed in separate contracts by the participant sculptors in such a way that their work would have blended together into a homogeneous unified plan of embellishment. Would this also have applied to the friezes and other reliefs? I refer back for a last time to the Epidaurus accounts. Hektoridas, the executant sculptor of one of the sets of pedimental figures, is also recorded as providing the example (*paradeigma*) for the painting of the lion-heads from the sima (line 303). It seems from this that such a humble, but necessary, task in building design and construction was not beneath the dignity of one of the prominent sculptors of the pediments, emphasising again the versatility of ancient artists at turning their hands to a wide variety of skills. One should therefore not exclude the frieze sculptures of the Mausoleum, or even the lion-head waterspouts, from being designed by one or other of the participant sculptors. Such versatility may well have been the special recommendation of the architect–sculptors, many of them from Paros, who carried out the design and construction of the Mausoleum at Halicarnassus.

NOTES

1. Pliny, *Natural History* 36. 30–31. For the relevant part of the text, see the Appendix of sources, no. 1, at the end of this article.

2. Cook (1989) 31–42.

3. Vitruvius, *De Architectura* vii. *Praef.* 12–13; see below, Appendix of sources, no. 2.

4. Delphi statue base: see below, Appendix of sources, no. 3. For a recent discussion of the base in relation to the Ada, Zeus and Idrieus relief in the British Museum see G. B. Waywell in O. Palagia and W. Coulson (eds), *Sculpture from Arcadia and Laconia: Proceedings of an International Conference Held at the American School of Classical Studies at Athens (April 10–14, 1992)* (Oxford 1993) 79–86. For the role of Satyros, see Waywell (1978) 80, n. 297, Cook (1989) 40–41, and Jeppesen (1992) 100–101.

5. Jeppesen and Luttrell 63.

6. Vitruvius, *De Architectura* i. 1. 12 and 15.

7. Jeppesen and Luttrell 65; Corso, *Prassitele* I (1988) 63, n. 181; A. F. Stewart, *Greek Sculpture* (New Haven and London 1990) 181.

8. Waywell (1978) 79–84.

9. Jeppesen (1986) 63–5.

10. Jeppesen (1992) 81–3, 90–96, pls 22, 27–31. I find his suggested placing of the roof sculptures hard to accept. The base assigned to the corner acroteria more probably supported a horse forepart from the chariot group, and a doubling of the rows of figures on the pyramid roof steps would require a second wider step to accommodate them, which would destroy the continuity of outline of the pyramid shape drawn through the apexes of the steps.

11. Ibid. 92–3.

12. Waywell (1978) 83–4.

13. M. Robertson, *A Shorter History of Greek Art* (Cambridge 1982) 158–64; Stewart (supra n. 7) 180–1; Jeppesen (1992) 99–101.

14. *IG* IV², 1,102ff.; *SEG* xxv. 208; A. Burford, 'Notes on the Epidaurian Building Inscriptions', *BSA* 61 (1966) 254–334; eadem (1969); I. Papadimitriou, *ArchEph* (1948–9) 135ff.; S. Charitonides, *Ellenika* 14 (1955) 23ff.; M. Mitsos, 'Epigraphika ex Asklepieiou Epidaurou', *ArchEph* (1967) 1–28; R. A. Tomlinson, *Epidauros* (London 1983); L. Gounaropoulou, *Die Bauurkunde des Asklepiostempels von Epidauros* (unpublished dissertation, Vienna 1983); Yalouris (1992) 67–74.

15. The relevant sections of text are given below in the Appendix of sources, respectively nos 5 and 4.

16. So Charitonides (1955) and Burford (supra n. 14). For the seated cult statue of Asclepius by Thrasymedes, see B. Krause, *AA* (1972) 240–57.

17. Supporters of this interpretation include G. Roux, *BCH* 80 (1956) 519–21; Burford (1969); A. Donohue, *Xoana and the Origins of Greek Sculpture* (1988) 22, n. 52, where full literature is given.

18. So B. Schlörb, *Timotheos* (Berlin 1965) 1ff.; M. Robertson, *A History of Greek Art* (Cambridge 1975) 397ff.; Stewart (supra n. 7) and Yalouris (1992) 170, 273–4. For a critical review of rival interpretations, see J. J. Pollitt, *The Ancient View of Greek Art* (Cambridge 1974) 284–93.

19. W. Posch, *AA* (1991) 69–73.

20. Burford (supra n. 14) 258 (Theotimos), 263 (Theodoros, Theophilos); cf. index on p. 325.

21. Posch (supra n. 19) 70 with n. 14; Yalouris (1992) 64.

22. A. Mallwitz and W. Schiering, *Die Werkstatt des Pheidias in Olympia*, Olympische Forschungen 5 (1964); W. Schiering, *Die Werkstatt des Pheidias in Olympia II: Werkstattfunde*, Olympische Forschungen 18 (1991); Burford (1969) 58, n. 5; 59, n. 2.

23. Pedersen (1991) 88–92, fig. 90; cf. Jeppesen (1992) 62, pl. 21.1, no. 4.

24. Pedersen (1991) 89.

Appendix *Sources*

1. Pliny, *Natural History* 36. 30–31 (c. AD 75)

Scopas habuit aemulos eadem aetate Bryaxim et Timotheum et Leocharen, de quibus simul dicendum est, quoniam pariter caelavere Mausoleum. . . . accessit et quintus artifex . . . in summo est quadriga marmorea, quam fecit Pythis. (Mayhoff, Teubner edn)

Scopas had as rivals and contemporaries Bryaxis, Timotheus and Leochares, about whom we must speak at the same time, because together they carved the sculptures of the Mausoleum . . . A fifth artist took part . . . On the summit is a marble four-horse chariot, which Pythi(us) made.

2. Vitruvius, *De Architectura* vii *Praef.* 12–13 (c. 25 BC)

de Mausoleo Satyrus et Pytheos [volumen ediderunt]. quibus vero felicitas maximum summumque contulit munus; quorum enim artes aevo perpetuo nobilissimas laudes et sempiterno florentes habere iudicantur, et cogitatis egregias operas praestiterunt. namque singulis frontibus singuli artifices sumpserunt certatim partes ad ornandum et probandum Leochares, Bryaxis, Scopas, Praxiteles, nonnulli etiam putant Timotheum, quorum eminens excellentia coegit ad septem spectaculorum eius operis pervenire famam. (Krohn, Teubner edn)

Satyrus and Pytheos wrote a treatise about the Mausoleum. On them good fortune certainly conferred the greatest and highest tribute; for their artistic skills are adjudged to have a merit which is renowned throughout the ages and of eternal freshness, and they have produced works remarkable for their ingenuity. For individual artists undertook the decoration of the separtate façades competing with one another for approval, Leochares, Bryaxis, Scopas, Praxiteles, some also think Timotheus, and their outstanding excellence caused the building to be included among the Seven Wonders of the World.

3. Delphi Museum 631, statue base (J. Marcadé, *Signatures* I, 93)

Μιλήσιοι ἀνέθεν ʼΑπόλλωνι Πυθίωι
ʼΙδριεὺς ʽΕκατόμνω. ῎Αδα ʽΕκατόμνω
[Σ]άτυρος ʼΙσοτίμου ἐποίησε Πάριος

The Milesians dedicated [this] to Pythian Apollo
Idrieus son of Hekatomnos Ada daughter of Hekatomnos
Satyros son of Isotimos of Paros made it

4. Epidaurus building inscription: *IG* IV², 1, 118: B 56A–73

56A [- - - - - - - κυά]νου Θεαρί[ων]ⵥⵥ Ε.ΚΗΡΟΥ Θρασυμήδης ⦂⦂⦂ [χρ]υ[σ]ίου Ἀντιφά[νης]
56B - - - - - - - - νωρ.... Μνασαρ[εῦ]ς .ΡΙΟΧΟΝΑ ⦂·ⵋ ..ΑΛ.ΛΩΝ [ʼΕ]ρετρια[κῶν - -]
 - - - - - - - ΠΩ...ΦΟΙΜΟΣ..ΩΝⵥ πριόνων Ἀστίας ⦂⦂⦂⦂< πριό[νω]ν Ἀντ-
 ˌιφάνης - - - ʽΕλ]λάνικο[ς] ⦂⦂⦂⦂ ϙόγχων [Δ]ιοκλείδα[ς] ΑΝΤΟ..ΕΩΝ ῎Ολυμ[πος]
 - - - - - μερίδων ʽΗρακλείδας [. σ]τυππείου Πάμφιλος ΙΙΙΙΙ
60 ˌ - -Μνάσ]ιλλος Ιⵋ [ψ]ιμιθίου Θέων ΙΙ< ὀστρείου Κλείμαχος Γ ἐρ⟨υθ⟩ρό - - -
 ˌ - - - ϡυγάστρο]υ Σάτυρος Ιⵋⵥ ϡυγαστρίων Σάτυρος . ϡυγαστρίων Δαμο - - -
 ˌ - - - ϡυγασ]τρίων Σάτυρος ·ΙⵋΑΖ Ἀστίας ·ΙΙΙΙ σιδαρίων Σάτ[υρος]
 - - - - - - - - Ι ⟨ΑΙ⟩σάνωρ Ι· ϡυγαστρίου· Δαμοκράτης Γ φαρμακίων υυυ
 [- - - - - ϡυγα]στρίου Φίλων Ιⵋ ἀγγροφέων Φίλων Ι ἀγγροφέων Δαμο[τέλης]
65 [- - - - - - Εὐ]μάρης Δερματίδι ἀγρῶν ἀρόσιος ·Ι ὅρμου Δαμοκρά[της]
 - - - - - - Νυραίων Πυθέας καλωιδίων ΙΙⵋ καλλωιδίου Αἰσάνω[ρ ..]
 - - - - - - Νικόστρατος ΙΙⵦ σινδονίων Σωγένης τ[ε]σσάρων Δαμ[.....
 [- - - - - Θ]ρασυμήδης Ι Μαλίας Φίλων· ϡυγάστρου Δαμοτέλης
 - - - - - ης ⦂⦂⦂ΙΙ φοίνικος Φίλων ⦂⦂⦂ ϡυγάστρου Δαμοτέλης ⦂⦂⦂·ΙΙΙ - - -
70 [- - - - ἐν]κα[ύ]σιος σινδόνος Ν[ου]μηνίς ⦂⦂⦂ σινδόνος Νικόσ[τρατ-]
 [ος - - - σινδον]οστολῆς ⦂⦂·Ι σινδόνος Λυκία ⦂⦂ΙΙ< σινδόνος Κῆδο[ς ...]
 - - - - - - - - ⦂⦂<ʼ σινδονοστολῆς ⦂ΙΙΙ σινδόνος Σαν[νίων9....]
 [- - - - φοίν]ικος Φίλων ⦂ ἄ[κ]μονος Θρασυμήδης ⦂·Ι< πρι[στίων ..]

5. Epidaurus building inscription: *IG* IV², 1, 102: A 31–40, 89–112, 303–5

ἌΛΛΟΥ ἘΝΙΑΥΤΟΫ· ΘΕΟΔΌΤ- *annus* II

32 ωι ΒΒΒ══–⫶ ΔΑΜ[Ό]ΝΟΟC ἝΛΕΤΟ ΔΟΚῸC ἐC ΤῸ ἘΡΓΑCΤΉΡΙΟΝ ΒΒ══

══–⫶⫶⫶⫶·ΙΙΙΙΙ, Ἔ[Ν]ΓΥΟC ΤΙΜΌΔΑΜΟC ΛΥCΙΚΡΆΤΗC ἝΛΕΤΟ CΤΟΙΒᾺΝ

ΤΑΜῈΝ ΚΑὶ ἈΓΑ̣[Γὲ]Ν ΚΑὶ CΥΝΘΈΜΕΝ ΤῶΙ CΤΡῶΜΑΤΙ ΒΒΒΒΒΒΒΒ══⫶·ΙΙ,

35 ἜΝΓΥΟC ΕΫ̣[ΑΜ]ΐΔΑC, ΛΑΚΡΊΝΗC ΦΆΫΛΛΟC ἝΛΕΤΟ ΤῸ ἘΡΓΑCΤΉΡΙΟ ΤᾺΝ

ἘΡΓΑCΊΑΝ Β[ΒΒ.]══⫶⫶⫶⫶, ἜΝΓΥΟC ΔΩΡΙΕΫC ΤΙΜΌΘΕΟC ἝΛΕΤΟ ΤΎΠ-

ΟC ἘΡΓΆCΑ[C]ΘΑΙ ΚΑὶ ΠΑΡΈΧΕΝ ΒΒΒΒΒΒΒΒΒ, ἜΝΓΥΟC ΠΥΘΟΚΛῆC· ἈΡΧΈCΤ-

ΡΑΤΟC ἝΛΕΤΟ ΘΎΡΩCΙΝ ΤΟΫ ἘΡΓΑCΤΗΡΊΟΥ ΒΒ–⫶⫶⫶·, ἜΝΓΥΟC ἈΡΊCΤΑΡΧΟ-

C CΑΜΊΩΝ ἝΛΕΤΟ ΞΛΙΝCΙΝ ΤΟΫ ἘΡΓΑCΤΗΡΊΟΥ ΚΑὶ ΚΟΝΊΑCΙΝ ═══⫶⫶⫶, ἜΝΓΥΟC

40 ἘΠΊCΤΡΑΤΟC ΜΝΆCΙΛΛΟC ἝΛΕΤΟ ΛΑΤΟΜΊΑΝ ΤῶΙ CΤΡῶΜΑΤΙ ΚΑὶ ΤᾺΙ

ἙΚΤΟΡΊΔΑC ἝΛΕΤΟ ΚΕΡΚΊΔΑ ΤῸ ΑἸΕΤῸ ἘΡΓΆCΑCΘΑΙ Χ ΒΒΒΒΒΒ–,

90 ἜΝΓΥΟC ΦΙΛΟΚΛΊΔΑC, ΤΙΜΟΚΛΕΊΔΑC ΤΙΜΌΘΕΟC ἜΛΕ[ΤΟ ἈΚΡΩ]-

ΤΉΡΙΑ ἐΠὶ ΤῸΝ ΆͅΤΕΡΟΝ ΑἸΕΤῸΝ ΧΧ ΒΒ══, ἜΝΓΥΟC ΠΥΘ[ΟΚΛῆC, ἈΓΈΜ]-

[Ω]Ν ΘΙΌ[Δ]ΟΤΟC ἝΛΕΤΟ ΧΡΥCΟΧΌΙΟΝ ἘΡΓΆCΑCΘΑΙ Χ Β[..., ἜΝΓΥ]-

ΟC ἜΝΤΙΜΟC, ΔΑΜΟCΘΈΝΗC ΔΑΜΟΦΆΝΗC ἝΛΕΤΟ ΤῶΙ ΜΕ[ΓΆΛΩΙ ΘΥ]-

[Ρ]ῶ[ΜΑΤΙ ἭΛ]ΟC ΚΑὶ ΠΊCCΑC ΚΑὶ [.]Δ..⫶..ΙΟΝ ΒΒ══– ΠΑCΊΘ[ΕΜΙC ἝΛΕΤΟ]

95 [....⫶⫶⫶.... ἘΡΓΆ]CΑCΘΑΙ [..⫶.., ἘΝ]ΓΥΟC ΛΑ[ΚΡΊΝΗC – – – – – –]

– – – – – ω...ο..\ΙΙ...Ι.. ΒΒΒΒ – – – –

ΩΝ [...Γ]ΑΝΏΜΑΤΟC ἸΜΆ[ΝΤΩ]Ν ᾮΛΩΝ ΒΒ ΘΕΟ[ΔΌΤΩΙ ἈΚΡΩΤΗΡΊΩΝ ἐΠὶ]

ΤῸΝ ΆͅΤΕΡΟΝ ΑἸΕΤῸΝ ΧΧ ΒΒΒ[═]══, ἜΝΓΥΟC ΘΕΟΞΕΝΊΔΑ[C (Τῷ ΔΕῖΝΙ) ἘΝΑΙ]-

ΕΤΊΩΝ ἐC ΤῸΝ ΆͅΤΕΡΟΝ ΑἸΕΤῸΝ ΧΧΧ –, ἜΝΓΥΟC ΘΕΟΞΕΝΊ[ΔΑC (ὁ ΔΕῖΝΑ) ἜΛΕ]-

100 ΤΟ ΠΑΡΑΙΕΤΊΔΑC ΚΑὶ ἈΓΕΜΌΝΑC ΚΑὶ ΒΆΘΡΑ ΤΟῖC ἈΚ[ΡΩΤΗΡΊΟΙC – – – – –]

ΒΒΒ══, ἜΝΓΥΟC ἈΤΛΑΤΊΔΑC, ΑἸΝΈΑC, ΠΥΡΡᾶC, ΕΫΚΛῆ[C (Τῷ ΔΕῖΝΙ) – –]

110 ΠΥΘΟΚΛῆC ΚΛΑΙΚῸC ἐC ΤῸ ΜΈΓΑ ΘΎΡΩΜΑ ΔΑΜ[Ο]ΦΆΝΕΙ ΒΒ══ ΆͅΛΛΩΝ *annus* V

ἘΞ ΜΗΝῶΝ ΘΕΟΔΌΤΩΙ Β═══–⫶⫶· ἈCΤΊΑC ἜΧΕΙ ΜΙC[ΘῸΝ] ΒΒ════–·⫶⫶ ἙΚΤΟΡΊΔΑ[Ι]

ἘΝΑΙΕΤΊΩΝ ΤᾶC ἈΤΈΡΑC ΚΕΡΚΊΔΟC Χ ΒΒΒΒ ΘΕΟ[ΔΌΤ]ΩΙ ═══–

303 ἙΚΤΟΡΊΔΑΙ ΠΑΡΑΔΕΊΓΜΑΤΟC ΛΕΟΝΤΟ[Κ]ΕΦΑΛᾶΝ ἘΝΚΑΎCΙΟC –⫶⫶⫶Ｃ ΞΫΛΩΝ

ἐCΦΟΡᾶC ἈΡΙCΤΑΊΩΙ ·ΙΙΙΙΙ ἈΓΓΈΛΩΙ ΙΙ ἈΡ[Ι]CΤΑΊΩΙ CΤΕΓΆCΙΟC ⫶ ΚΛΕΙΝΊΑΙ ΘΥΡΌΤΟΙΝ(!)

ΛΕΥΚΏCΙΟC · ΘΥΡΏΤΟΙΝ ΦΟΡᾶC Ἁ[Ρ]ΙCΤΑΊΩΙ ΙΙΙΙ *vac.*

31 Year II [payment of salary] for another year to Theodotos
353 dr. Damonoos took up the contract for beams for the workshop, 299 dr. 5 ob., guarantor
Timodamos. Lysikrates took up the contract to quarry and transport and lay [stone for] the
foundation-core for the pavement, 843 dr. 2 ob., guarantors Eudamidas and Lakrines.

35 Phaullos took up the contract to construct the workshop, 368 [?] dr., guarantor Dorieus.
Timotheos took up the contract to make models [*typous*] and supplied them, 900 dr.,
guarantor Pythokles. Archestratos took up the contract to make doors for the workshop,
219 dr., guarantor Aristarchos. Samion took up the contract to scrape down and plaster the

39 workshop, 68 dr., guarantor Epistratos.

89 Hektoridas took up the contract to make one half of the pediment, 1,610 dr., guarantors
90 Philoklidas, Timokleidas. Timotheos took up the contract for the akroteria over the
other pediment, 2,240 dr., guarantors Pythokles, Agemon. Thiodotos [*sic*] took up the
contract to make the golden pitcher, 1,100+ dr., guarantors Entimos, Damosthenes.
Damophanes took up the contract [to supply] the great door nails, pitch, and door-ring,
95 230 dr. Pasithemis took up the contract to make . . . dr., guarantors Lakrines and
. . . took up the contract to . . . 400+ dr. . . . [took up the contract for]
97 polishing the studs of the framework [?], 200 dr. To Theo[dotos?] for the akroteria over
the other pediment, 2,340 dr., guarantor Theoxenidas. To . . . for the sculptures in the
other pediment, 3,010 dr., guarantor Theoxenidas.

100 . . . took up the contract for roof-tiles and antefixes and bases for the akroteria, +320 dr.,
guarantors Atlatidas, Aineas, Pyrras, Eukles.

110 Year V To Theodotos, payment for
another six months, 175 dr. Astias has a wage of 276 dr. To Hektoridas for the sculptures
of the other half-pediment, 1,400 dr. To Theodotos, 70 dr.

303 To Hektoridas for a model for the painting of the lion-heads, 16 dr. ½ ob.

8

Initiates in the underworld

Olga Palagia

ὦ μάκαρ, ὅστις εὐδαίμων
τελετὰς θεῶν εἰδὼς
βιοτὰν ἁγιστεύει
καὶ θιασεύεται ψυχὰν

<div align="right">Euripides, Bacchae 72–5</div>

The cylindrical monument (Figs 75–85) was presented to the British Museum by Sir Stratford Canning, British Ambassador to the Ottoman Porte at Constantinople in 1847.[1] It had been removed from Halicarnassus the year before by the captain and crew of HM Sloop *Siren*, as recorded in the ship's log for January and February 1846.[2] 'In a wall about one and a half miles from the town,' writes Captain H. Edgell,

we discovered the capital of a most beautiful column; it was octangular with figures in mezzo rilievo, of superior workmanship on each side, and from being discovered on such a site was in a fair state of preservation. It took us a day and a half with thirty men to get it safe on board, and a most difficult task it was as it had to be conveyed over corn fields and walls, across roads and streams, but with zeal and care it reached Siren safely.

Some evidence about the find-spot of the relief can be gleaned from a drawing by Richard Dalton, dating from 1749 (Fig. 86).[3] The monument, which appears to be complete, is located very close to the site of the Mausoleum, and therefore in the ancient cemetery of Halicarnassus. According to the account of Lord Charlemont, Dalton's employer, also written in 1749, 'in a field below [the theatre] we found an altar, large in its dimensions, and enriched with figures in basso relievo in the finest taste, of exquisite workmanship, and apparently of the best age for sculpture'.[4] Dalton's drawing shows it complete, but the details he drew on separate sheets are so inaccurate that it seems likely that he restored what he saw.[5] It is interesting that Charlemont, who saw the monument in a field by itself, called it an altar, while a hundred years later, Captain Edgell saw it embedded in a wall, doing duty for a column. Smith's catalogue of the sculptures in the British Museum, published in 1900, classifies it as a votive altar, carrying ten deities.[6] The monument has since passed into oblivion, except for a brief mention in

Peter Fraser's *Rhodian Funerary Monuments*, repeating Smith's assessment.[7]

While the monument appears to be an altar, the iconography of the figures points to a funerary use, and this may in fact be supported by the find-spot, assuming that Dalton drew the monument *in situ*. Cylindrical funerary altars are very common in South Caria, the Dodecanese and the islands of the Aegean in the late Hellenistic period.[8] Most are decorated with swags and bucrania, sometimes with a sunken panel inserted.[9] In a small class of circular altars the field is divided between figural friezes and garlands. The finest surviving example, of unknown provenance, is in the British Museum (Figs 87–8).[10] Cylindrical altars decorated with figural friezes without swags can be either funerary or votive,[11] hence Smith's and Fraser's initial classification of our altar as carrying deities.

It is carved of white, coarse-grained marble with grey streaks, of poor quality. The grain of the marble is horizontal. The top is razed off. The diameter is 91 cm, the maximum height 78.5 cm. Ten figures, all missing their heads and facing the spectator, stand on a ledge 4 cm high. There are no mouldings at the bottom. The surface is heavily weathered, due not only to long exposure to the sea air but also to the poor quality of the marble. Whereas there is no cutting at the bottom, the top has a square dowel hole, situated off-centre, and probably not original (Fig. 75). This is too deep for an empolium, its present depth being 16 cm. Its sides measure 8.5 × 8.5 cm. Because of its large size, the piece may well have been reused as a column drum, as Captain Edgell's journal seems to suggest. The lack of empolium at the bottom, however, excludes the possibility that it was originally a *columna caelata*.

The funerary character of the scene is established by a group of three figures flanking a pillar which may serve as our point of departure for a brief description (Figs 76–9). The pillar is topped by a shaft, probably the remains of a herm. Against it leans a man in chiton and himation, cross-legged, left hand on hip. His right hand, which is now lost, held an open scroll, suggesting that he was in the midst of reading it.[12] His

companion on the other side of the pillar is also dressed in chiton and himation. He embraces a woman, presumably his wife. He too holds a scroll, its last page open to display its title.[13] The wife wears a chiton girt high under the breasts and a himation covering her thighs in front. In her right hand she holds a stick reaching from her belly to the ground, slightly curved at the bottom (Fig. 77). This was taken by Dalton for a downturned torch, and he may well be right. The chiton and himation of the two men is standard dress for the Hellenistic period, while the closest parallel for the woman's drapery is provided by the Muse leaning on a kithara on the late Hellenistic votive Altar of the Muses from Halicarnassus in the British Museum.[14] The only difference lies in the Muse wearing a peplos with overfall instead of a chiton.

Men leaning on herms are a common feature of East Greek grave reliefs of the Hellenistic period.[15] The herm may on occasion signpost a gymnasium, indicating an interest in sports; it may also represent an underworld deity of particular importance to the deceased. More significantly, it can mark the boundary of Hades.[16] The significance of the scroll in grave reliefs should be reconsidered. It probably relates to a specific text, sacred or otherwise, rather than denoting an interest in literature and the arts.[17] A grave relief of the late second century BC in Vienna, possibly from Rheneia, combines both motifs of herm and scroll: a man with a sacred text standing at the gates of Hades.[18] The downturned torch, albeit of funerary significance, is not part of East Greek grave iconography. In this period we expect to see it in free-standing figures.[19] Torches on East Greek stelai, held upright, are the attributes of priestesses of Demeter.[20] Family groups of two men and a woman, sometimes with a herm (Fig. 89),[21] can depict a couple with their son or two brothers with their mother.

Behind the young man by the herm another male figure, in short chiton and billowing chlamys, runs to the left, his right hand extended behind his neighbour's back with a fawning goat in front of his left leg (Figs 78–9). The runner is somewhat incongruous among his stately neighbours. The goat points to Hermes, appropriate in a funerary context as psychopompos. His pose may be borrowed from funerary representations of Hermes leading Pluto's chariot to the underworld.[22] The goat clinging to Hermes' leg also occurs in the Roman Hermes of Troezen in the National Museum in Athens, after a fourth-century BC prototype of the Polycleitan circle.[23] Hermes in short chiton is also known from an underworld sarcophagus from Ephesos in Istanbul.[24] But the short chiton is unusual in a funerary context, where he normally wears a chlamys and winged hat and holds a kerykeion.

Next stands a woman in high-girt chiton and himation with triangular overfall (Fig. 80). She draws the edge of her himation off her left shoulder, holding what appears to be a bunch of grapes. Young girls with grapes frequently appear on East Greek grave reliefs.[25] Like the girl with the grapes on our altar, they are not shown as children – they are rather like young adults. The drapery and extremely elongated proportions of our girl are late Hellenistic. A close stylistic parallel can be found in a limestone relief with a sacrificial scene from Rhodes cemetery, now in the Rhodes Museum (Fig. 90).[26]

At the right we see two figures and an animal (Fig. 81). A half-naked figure in a himation sits on a rock, supported on her left hand, with her right hand extended over a rearing animal, now fragmentary. Its anatomy suggests a fawn or a kid. A little girl in peplos stands in the background. Because of its poor state, it is not clear whether the seated figure is a young man or a girl. The female attendant rather suggests that the seated figure is also female. If a girl, the iconography of the half-naked female sitting on a rock is borrowed from Hellenistic nymphs, of which a well-known example is in the Rhodes Museum.[27] The pastoral character of the scene is related to Hellenistic painting, particularly to the Dionysiac entourage of the great fresco in the Villa of the Mysteries at Pompeii: compare the satyress sitting on a rock, giving her breast to a kid (Fig. 91).[28]

Further to the right a frontal peplos figure with a himation down her back stands before a figure sitting rather stiffly on a tall throne, sceptre in right hand (Figs 82–4). Peplos figures are rare in the Hellenistic period when the peplos went out of fashion. One expects to see it mainly on goddesses, removed from the human sphere. Very like our peplos figure in style is a statuette of the first century BC from Cos in Istanbul.[29] A himation covers the enthroned figure's back and legs; its left edge can be seen hanging over the left armrest of the throne (Fig. 84). A transparent, sleeveless chiton has slipped off the figure's right shoulder revealing part of the chest. The upper part of the figure, along with the left arm and hand are broken off. Is it male or female? The exposed part of the chest bears no trace of breasts and the chiton does not preclude a male. A man in a himation with the chiton slipping off the right shoulder can be found on a grave relief from Pergamon in Berlin.[30] But the closest parallel to the enthroned figure is Pluto on the frieze from the late Hellenistic funerary naiskos of Hieronymus of Tlos (Fig. 92).[31] This was acquired in Alexandria

69

around 1900 for Hiller von Gaertringen but was allegedly found on Rhodes and is now lost. Pluto on the Hieronymus relief sits on a tall throne holding a sceptre in precisely the same manner, legs covered by a himation, chest bare. He raises his left hand to his head which is covered by the himation, a gesture which we could also restore on our figure. The enthroned god clad in transparent chiton and himation also recalls Sarapis, another underworld deity.[32] The standing woman before Pluto on the Hieronymus frieze is very likely Persephone: a similar identification may be proposed for our peplos figure (Fig. 83).

The man standing behind Pluto's throne on the Hieronymus frieze has been interpreted as the tomb's owner because of his proximity to the god and his prominent position on the axis of the scene. Behind our Pluto stands a stately woman in bridal dress, reminiscent of a Muse or goddess (Fig. 85). She is frontal, relaxed, swathed in a clinging himation, also covering her arms and hands, with a chiton underneath. Her right hand is placed on the hip, the left is brought over the chest; if she held an attribute there, it is now lost. The lack of parallels in standard funerary iconography compels us to regard this figure as exceptional, perhaps the owner of the tomb. The clinging himation wrapped obliquely across the body is usual in the late Hellenistic period: compare the Muse with the double flute on the Halicarnassus Altar of the Muses,[33] the Muse with the kithara underneath Zeus on the relief of the Apotheosis of Homer by Archelaos of Priene (Fig. 94),[34] and the portrait statue of Cleopatra on Delos,[35] all dated to the 130s BC. The elongated proportions, small breasts placed high and the high girding of the female figures on our monument are generally comparable to the relief of Archelaos of Priene and to certain slabs of the Lagina frieze.[36] Whereas the relief by Archelaos is usually dated around 130 BC, the dates proposed for the Lagina frieze range from 130 to 80 BC.[37] Our monument easily fits within this chronological framework.

What of its iconography? Comparison with a number of East Greek grave reliefs reveals that the frieze combines motifs used individually on stelai with others borrowed from repertories other than funerary. Our artist has been particularly creative. If we look at the cylindrical altar in the British Museum (Fig. 87),[38] we will see that its frieze consists of groups lifted entirely from standard funerary iconography. The centre is dominated by the customary handshake between a standing man and a seated woman attended by a slave girl, known from several East Greek stelai.[39] Behind the seated woman stands Hermes, facing, holding his kerykeion, next to a pillar with a sundial (Fig. 87). A

similar representation of Hermes next to a pillar or altar, this time carrying an eagle, is known from a funerary altar of the first century, once in the Basle market.[40] Behind the husband stands another man, then a slave boy and a column topped by a cone round which is a snake (Fig. 88). The funerary significance of the cone is enhanced by its appearance on a Hellenistic grave relief in the Museo Biscari.[41] The pine-cone is a symbol of rebirth and immortality, as demonstrated by its use in the cult of Adonis.[42]

The closest parallel to our frieze is provided by the relief of Hieronymus of Tlos (Fig. 92). Only one block is known, but we can conjecture further scenes unfolding right and left. In addition to the divine couple of Pluto and Persephone which reappears on the altar from Halicarnassus (Fig. 83), the scene at the extreme right is repeated on other grave reliefs. A seated woman to the right, presumably deceased, is flanked by another woman with butterfly wings, probably Psyche, and a larger one emerging from the ground, possibly Ge. The scene may be intended as an allegory of the soul ascending to heaven while the earth receives the body.[43] A very similar episode, with the addition of a female attendant, appears on a late Hellenistic East Greek grave relief in Basle.[44]

The scene at the extreme left of the Hieronymus frieze, far from being funerary, illustrates a reading of sacred texts comparable to an episode in the fresco of the Villa of the Mysteries at Pompeii (Fig. 93).[45] The reading session in the Hieronymus frieze, in combination with the appearance of the deceased before the gods of the underworld, illustrates the privileged position of the initiated. Sadly, the identity of the Mysteries implied in the Hieronymus relief remains unknown since the rest of the frieze is not preserved.[46] The burial of initiates can sometimes be advertised, as on a late Hellenistic altar from Rhodes inscribed with the last verses of the chorus of initiates of the Eleusinian Mysteries from Aristophanes' Frogs, which describes their blissful existence in Hades: 'μόνοις γὰρ ἡμῖν / ἥλιος καὶ φέγγος / ἱερόν ἐστι ὅσοι / μεμυήμεθ' εὐσεβῆ τε / διήγομεν τρόπο[ν] / περὶ τοὺς ξένους / καὶ τοὺς ἰδιώτας'.[47] The initiate's afterlife in the realm of Pluto and Persephone is also graphically described in a late Hellenistic epigram commemorating the death of a school teacher from Rhodes: Πλούτων γὰρ αὐτὸν καὶ Κόρη κα[τ]ῴκισ[αν], / ['Ε]ρμῆς τε καὶ δαδοῦχος Ἑκάτ[η] προσφ[ιλῆ] / [ἅ]πασιν εἶναι μυστικῶν τε [ἐ]πιστ[άτην] / ἔταξαν αὐτὸν πίστεως πά[σ]ης χ[άριν].[48] Initiation ensured that the deceased was armed with the necessary knowledge that would enable him to answer Persephone's questions, thus avoiding punishment for his misdeeds.[49]

The underworld scene of the Hieronymus frieze has been compared to a handful of sarcophagi of the second century AD from Asia Minor, where the deceased couple, led by Hermes as psychopompos, are received by Pluto and Persephone.[50] On the sarcophagus from Ephesus in Istanbul already mentioned[51] the front face portrays the dead couple between the gods of the underworld and four women, usually interpreted as the Fates with an initiate. A sarcophagus in Aphrodisias shows the dead couple between Pluto and Hermes at the right and Demeter with Persephone at the left, thus connecting the Mysteries with Demeter.[52] At the extreme left Eros leans on a downturned torch, which brings us back to the torch held by the wife on our altar. In addition to serving as a symbol of death, the downturned torch is also used in mystery rites, for example on a Dionysiac sarcophagus in the Villa Medici.[53] Torches were sometimes taken home as souvenirs after the ceremony.[54] The torch therefore indicates that the wife on our altar is an initiate. The men's scrolls may contain either the sacred text of the Mysteries in which they were initiated or instructions for answering Persephone's questions.[55] Apart from the reading scene in the Villa of the Mysteries (Fig. 93), a further instance of an initiate holding a scroll is provided by another Dionysiac sarcophagus in the Villa Medici.[56]

If we look again at our frieze, we begin to realise that certain motifs and attributes borrowed from grave reliefs have a particular significance. The family group by the herm (Fig. 76), along with the standing woman in bridal attire (Fig. 85)[57] are encompassed by Hermes (Fig. 79) on one side and Pluto and Persephone on the other (Fig. 75). The entire scene could thus be read as an introduction of the family (two men and two women) to the lords of the underworld, while the group's torch and scrolls may well relate to their participation in the Mysteries. The family by the herm stands at the boundary of Hades. The women with the fawn/kid and the grapes form a separate scene (Figs 80–81), set in an idyllic landscape. Even though the young woman with the grapes is lifted from funerary iconography, the girl on the rock is not, and could in fact be a nymph or a maenad. This pair is directly related to the deity of the Mysteries in which the deceased were initiated: the girl's grapes show that he must be Dionysus.

A crucial question remains to be asked: were the owner or owners of the tomb heroised? As Peter Fraser has shown in his study of Rhodian funerary altars, the mere placement of an altar on a tomb did not entail heroic cult.[58] The sheer numbers of funerary altars extant are enough to cast doubt on the notion of heroisation unless it was universal practice. Would heroisation be implied by the prominent position of the deceased placed between Pluto and Hermes and by the mingling of human and divine figures? The absence of inscriptions forbids speculation. But the name of the tomb's occupant inscribed without the epithet 'hero' on the similar relief of Hieronymus of Tlos (Fig. 92)[59] shows that we cannot draw conclusions on the basis of iconography alone.

ACKNOWLEDGEMENTS

I am grateful to the Trustees of the British Museum for permission to publish the altar BM 1107, and to the Department of Greek and Roman Antiquities for providing every possible assistance for its study. I much profited from discussions with Ian Jenkins and Susan Walker, who examined the monument with me. Kevin Clinton pointed me in the direction of initiates in the underworld. For additional advice I am indebted to John Boardman, Jacque Clinton, Brian Cook, Evelyn Harrison and Iphigeneia Leventi. The photos Figs 75–85, 87–8, and 94 are reproduced courtesy of the Trustees of the British Museum.

NOTES

1. *BMCS* II, 1107.

2. *Journal of H. M. Sloop Siren by H. Edgell*, typescript copy, available to me through courtesy of B. F. Cook.

3. Engraved in R. Dalton, *Antiquities and Views in Greece and Egypt* (London 1791); W. B. Stanford and E. J. Finopoulos (eds), *The Travels of Lord Charlemont in Greece and Turkey 1749* (London 1984) 91.

4. Stanford and Finopoulos (supra n. 3) 92.

5. Dalton (supra n. 3).

6. Supra n. 1.

7. Fraser 118, n. 157.

8. Fraser 25–33; Pfuhl-Möbius I, 57–9; D. Berges, *Hellenistische Rundaltare* (Diss. Freiburg 1986) 14–19.

9. Berges (supra n. 8) *passim*. Swags with sunken panel: Fraser 32; cf. altar in Iasos, Berges cat. 95, fig. 131b; in Rhodes Museum, Fraser pl. 86a.

10. Diameter: 82 cm, white, coarse-grained marble, *BMCS* I, 710; Pfuhl-Möbius no. 1105, pl. 166.

11. Fraser 31.

12. For the depiction of open scrolls see T. Birt, *Die Buchrolle in der Kunst* (Leipzig 1907) 186–96. I am indebted to David Jordan for this reference.

13. Birt (supra n. 12) 128–30.

14. *BMCS* II, 1106. D. Pinkwart, 'Die Musenbasis von Halikarnass, London, B. M. 1106', *AntP* 6 (1967) 89–94, pl. 55B.

15. E.g. an example of the first century BC from Erythrae: Munich Glyptothek 509; Pfuhl-Möbius no. 137, pl. 31. Herms on grave reliefs: H. Wrede, *Die antike Herme* (Mainz 1986) 44–8.

16. Pfuhl-Möbius 46 and no. 2106; B. Schmalz, *Griechische Grabreliefs* (Darmstadt 1983) 227. The herm as boundary to Hades appears on an Apulian calyx-krater in the British Museum (F 270); M. Schmidt, A. D. Trendall and A. Cambitoglou, *Eine Gruppe Apulischer Grabvasen in Basel* (Mainz 1976) 38; M. L. West, *The Orphic Poems* (Oxford 1983) 25, pl. 3.

17. So S. Schmidt, *Hellenistische Grabreliefs* (Cologne and Vienna 1991) 138; P. Zanker, 'The Hellenistic Grave Stelai from Smyrna: Identity and Self-Image in the Polis', in A. Bulloch, E. S. Gruen, A. A. Long and A. Stewart (eds), *Images and Ideologies* (Berkeley 1983) 218.

18. Vienna, Kunsthistorisches Museum I 753, from Rheneia (?); M.-T. Couilloud, 'Les Monuments funéraires de Rhénée', *Délos* 30 (1974), no. 297, pl. 58; *LIMC* V (1990) s.v. 'Hermes' no. 95 (G. Siebert).

19. E.g. a clay figurine of Eros from Myrina: Louvre, Myrina 683; S. Mollard-Besques, *Catalogue raisonné des figurines et reliefs en terre cuite grecs, étrusques et romains, Musée du Louvre* II (Paris 1963) 61, pl. 77a; *LIMC* III (1986) s.v. 'Eros' no. 989 (H. Cassimatis).

20. E.g. stele of the second century BC, formerly in Lowther Castle: Pfuhl-Möbius no. 529, pl. 82. For the identification of Demeter priestesses see R. Känel, 'Drei hellenistische Grabreliefs aus Smyrna in Basel', *AntK* 32 (1989) 54, n. 29.

21. E.g. stele of the second century BC in Izmir: Pfuhl-Möbius no. 646, pl. 98.

22. E.g. sarcophagus in the Velletri Museum: B. Andreae, *Studien zur römischen Grabkunst*, RM-EH 9 (1963) 46, pl. 25,1; *LIMC* IV (1988) s.v. 'Hades/Pluto' no. 40 (R. Lindner).

23. Athens, National Museum 243; G. Despinis, 'Zum Hermes von Troizen', *AM* 96 (1981) 237–44, pls 77–8; *LIMC* V (1990) s.v. 'Hermes' no. 298 (G. Siebert).

24. Istanbul Museum 2768; Curtius pl. 9; H. Wiegartz, *Kleinasiatische Säulensarkophage* (Berlin 1965) 40–41, 61–2, 179, no. 36, pl. 14b; *LIMC* IV (1988) s.v. 'Hades' no. 162 (R. Lindner).

25. E.g. stele from Halicarnassus in the Louvre: Pfuhl-Möbius no. 748, pl. 111. Stele from Izmir in Leiden, Rijksmuseum 1901/7.3: Pfuhl-Möbius no. 749, pl. 111.

26. G. Konstantinopoulos, Αρχαία Ρόδος (Athens 1986) fig. 262.

27. Rhodes Museum 13614; G. S. Merker, *The Hellenistic Sculpture of Rhodes* (Göteborg 1973) 26, cat. 8, pl. 3.

28. Nilsson fig. 10c; G. Cerulli Irelli, M. Aoyagi, S. De Caro and U. Pappalardo (eds), *Pompeianische Wandmalerei* (Stuttgart and Zurich 1990) pl. 111. For another satyress of the first century BC see the bust from the Mahdia shipwreck, Bardo Museum C. 1189, H.-H. von Prittwitz und Gaffron, 'Die Marmortondi', in *Das Wrack: Der antike Schiffsfund von Mahdia* I (Bonn 1994) 303, 316, figs 5–9.

29. Istanbul Museum 1556; Kabus-Preisshofen (1989) 272–3, cat. no. 72, pl. 69.

30. Pfuhl-Möbius no. 817, pl. 118.

31. Once in the possession of Hiller von Gaertringen in Berlin. There is a cast in Bonn, Akademisches Kunstmuseum 1912 (cf. infra n. 45). Signed by the sculptor Damatrios. Second century BC. H. von Gaertringen and C. Robert, 'Relief von dem Grabmal eines rhodischen Schulmeister', *Hermes* 37 (1902) 121–46; Curtius 20–32; M. P. Nilsson, *Geschichte der griechischer Religion*[3] II (Munich 1974) 234–5, pl. 4,1; Fraser 34–6, fig. 97; Pfuhl-Möbius no. 2085, pl. 300; *LIMC* IV (1988) s.v. 'Hades' no. 161 (R. Lindner).

32. E.g. marble statuette, Ostia Museum 1125: E. J. Milleker, 'Three Heads of Sarapis from Corinth', *Hesperia* 54 (1985) 134, pl. 29e.

33. Pinkwart (supra n. 14) pl. 55a.

34. *BMCS* II, 2191; D. Pinkwart, 'Das Relief des Archelaos von Priene', *AntP* 4 (1965) 55–65, pl. 32.

35. A. Linfert, *Kunstzentren hellenistischer Zeit* (Wiesbaden 1976) 114–15, fig. 273.

36. A. Schober, 'Der Fries des Hekateions von Lagina', *IstForsch* 2 (1933) North frieze slab I, cat. 213A, pl. 5.

37. Schober (supra n. 36) 26 (c. 130); A. Yaylali, *Der Fries des Artemisions von Magnesia am Mäander*, IstMitt-BH 15 (1976) 160 (c. 100); Stampolidis (1987) 222 (c. 80); U. Junghörter, *Zur Komposition der Lagina-Friese und zur Deutung des Nordfrieses* (Frankfurt 1989) 9 (early first century BC).

38. Supra n. 10.

39. E.g. Chios Museum 271; Pfuhl-Möbius, no. 1077, pl. 162.

40. *MuM* 40 (1969) no. 172, pl. 66; *LIMC* v (1990) *s.v.* 'Hermes' no. 621 (G. Siebert).

41. G. Libertini, *Il Museo Biscari* (Milan and Rome 1930) no. 70, pl. 23.

42. F. Cumont, *Recherches sur le symbolisme funéraire des Romains* (Paris 1942) 219. Funerary altars topped with pine-cones, from Phrygia: Izmir Museum 338 and 339, second century AD, L. Robert, *Hellenica* x (1955) 249–52, pls 33–4. Attis with pine-cone: marble table support, Athenian Agora S344, M. J. Vermaseren, *Corpus Cultus Cybelae Attidisque* 2 (Leiden 1982) no. 135, pl. 22.

43. For this concept see Cumont (supra n. 42) chapter II.

44. Antikenmuseum BS 246, unknown provenance. E. Berger (ed.), *Antike Kunstwerke aus der Sammlung Ludwig*, III: *Skulpturen* (Mainz 1990) 289–93, pl. 31, fig. 1 (R. Känel), dated 150–120.

45. I am grateful to Kevin Clinton for pointing out the significance of the reading session. This scene has been mostly interpreted as a philosophical school: Fraser 35; see also A. Scholl, 'Πολυτάλαντα μνημεῖα', *Jdl* 109 (1994) 247–9, fig. 7 (cast in Bonn). Villa of the Mysteries scene: Nilsson 116, fig. 10a; R. Ling, *Roman Painting* (Cambridge 1991) pl. IXA.

46. The underworld scene is an introduction of initiates, not a judgement as postulated by R. R. R. Smith, 'The Monument of C. Julius Zoilos', *Aphrodisias* I (Mainz 1993) 52, pl. 30c.

47. G. Pugliese Carratelli, 'Versi du un coro delle "Rane" in un epigrafe rodia', *Dioniso* 8 (1940/41) 119 23.

48. *IG* XII, 1, 141, lines 3–6. See also Fraser 36 and nn. 202–3.

49. F. Graf, 'Dionysian and Orphic Eschatology: New Texts and Old Questions', in T. H. Carpenter and C. A. Faraone (eds), *Masks of Dionysus* (London and Ithaca 1993) 239–58; S. G. Cole, 'Voices from Beyond the Grave: Dionysus and the Dead', ibid., 276–95.

50. Curtius 20–32; *LIMC* IV (1988) *s.v.* 'Hades' no. 161 (R. Lindner).

51. Supra n. 24.

52. K. T. Erim, *Aphrodisias, City of Venus Aphrodite* (London 1986) 150; *LIMC* IV (1988) *s.v.* 'Hades' no. 163 (R. Lindner); Smith (supra n. 46) 52, pl. 30d.

53. M. Cagiano de Azevedo, *Le antichità di Villa Medici* (Rome 1951) no. 65, pl. 30, 48; Nilsson figs 20a–b. Torches are frequently mentioned in the Dionysiac ceremonies in Euripides, *Bacchae*.

54. Libanius, *Declamatio* 12.28 and frg. 50.3. See K. Clinton, *Myth and Cult* (Stockholm 1992) 132.

55. Graf (supra n. 49).

56. Cagiano de Azevedo (supra n. 53) no. 58, pl. 30, 47; Nilsson fig. 19.

57. Note also that two brides are represented in the frieze of the Villa of the Mysteries: Ling (supra n. 45) 102–3.

58. Fraser 76–81. On the question of heroisation see also Berges (supra n. 8) 17–26.

59. Ἱερωνύμου τοῦ Σιμυλίνου Τλωίου.

9

The sculpture from the late Roman villa in Halicarnassus

Birte Poulsen

Towards the end of 1856 C.T. Newton found and investigated part of a late Roman villa with mosaic floors in Halicarnassus. The finding of the lower part of a draped female torso was the immediate reason for his interest in this area. During the excavation and lifting of some of the mosaic floors Newton found a further three pieces of sculpture, a Nike, a male portrait and a small fragment of a relief; all four are now in the British Museum. During the recent Danish excavation another part of this 'Roman villa' has been discovered, but only a few and very fragmentary sculptures have been found. Neither the sculptures in the British Museum nor the recently excavated ones can be ascertained to have formed part of the sculptural setting of the late Roman villa in Halicarnassus.

In his search for the Mausoleum Newton started to excavate on the field of Hadji Captan in the western part of the city of Bodrum towards the end of 1856.[1] The immediate reason for his investigations in this area was the discovery some years earlier of a torso of a draped female statue (Figs 95–6). As we know, Newton did not succeed in finding the Mausoleum in this part of the town; instead he found and investigated several rooms with mosaic floors belonging to a large late Roman villa (see plan on p. 76).[2] The building excavated by Newton included five rooms connected by two long corridors: an almost square room (A) originally with a shallow basin in the middle; an oblong room (B) with mythological hunting scenes; an apsidal room (C) with a representation of a goddess carried by Tritons in the apse; a partly excavated room (E) with personifications of Halicarnassus, Alexandria and Berytos; and two corridors (a and b) surrounding an irregular room (D) with a well and containing mosaics representing Europa and the Bull, and several Dionysiac scenes. Newton was not able to determine the original limitations of the building; only to the north had he discovered a strong ashlar wall. He could neither extend his excavation further east, due to the location of a cemetery, nor to the west and south, since this was the property of Hadji Captan.

During the recent Danish–Turkish excavations in ancient Halicarnassus another part of this 'Roman villa' has been discovered.[3] This includes nine rooms, some of which have only been partially excavated, grouped around two small yards and containing mosaics stylistically similar to the ones excavated by Newton: a large apsidal room (F) with representations of hunting scenes and a dedicatory inscription (the inscription informs us that a certain Charidemos paid for the embellishment, and we may assume that he was the owner of the building); a room (B) only partly excavated as its eastern section continues below the neighbouring plot; a long corridor (G) mainly decorated with geometric mosaics; a small paved yard (L); parts of two rooms (K and M); part of a room (D) with no remaining floors; another yard (N); an almost square room (H) with geometric patterns; and part of a large room (O) with a huge threshold leading to a corridor (G) and containing a representation of a Nereid riding on an ichthyo-centaur playing the cithara.

That the two sets of rooms are indeed part of the same building is indicated partly by the western walls of room (F) and the corridor (G) which coincide with the eastern walls of Newton's rooms (B) and (D), and partly by the correspondence in style, composition and choice of motifs of the mosaic floors.[4] Including the Roman villa excavated by Newton, the building covers a total area of more than 1,400 sq. m. According to the style of the mosaic floors and the contents of the inscriptions, the large building was constructed somewhere around the mid-fifth or second half of the fifth century AD. So far it has been impossible to determine when or why this late Roman building was abandoned. There are no traces of fire, but in the apsidal room (F) fallen tiles and bricks mixed with stucco were observed. Since, however, only a few utensils and fragments of the interior embellishment have been found during the excavation, the building seems to have been abandoned before it collapsed. This lack of finds in the recently excavated part may also be due to the later disturbances on the site.[5]

Sculptures in the British Museum

Together with other finds including sculpture, Newton brought about half of the best-preserved mosaic floors back to the British Museum.[6] The part of the villa excavated by Newton does not seem to have produced a great amount of finds and, as will appear, none of the fragments of sculpture found can be dated to the period when the late Roman villa was constructed. In addition to the torso of the draped female statue already mentioned, Newton apparently brought only a winged female statue, a male portrait and a small fragment of a relief from the Roman villa to the British Museum.

Draped female torso

The lower part of a draped female torso (Figs 95–6) was found in the field of Hadji Captan, immediately south of room C, west of passage A.[7] The torso is made of white marble with fine grey veins. It is preserved from the waist downwards, and its height is 143 cm including the base, thus being larger than life. The upper part of the statue, the left hand and the right foot are missing. In the upper surface of the torso is preserved an almost square dowel hole for the piecing of the upper part of the statue.[8] The figure stands on a low base, 4.5 cm high, which follows the lower out-

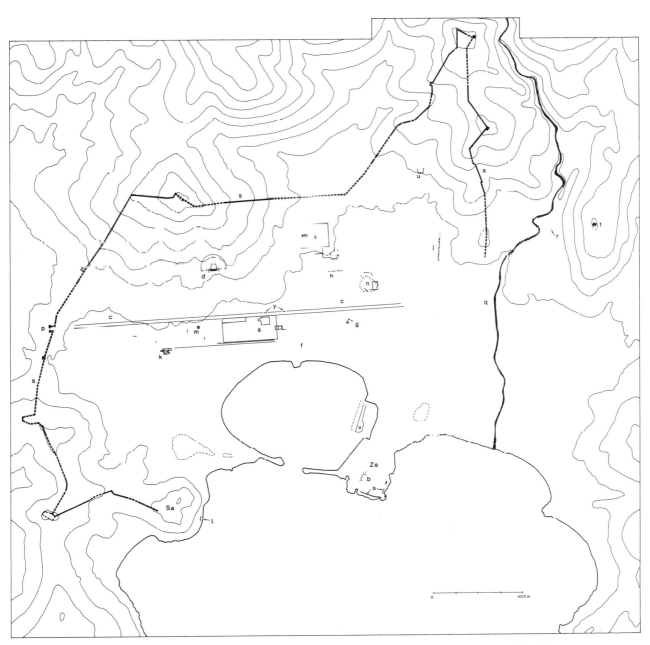

Plan of Halicarnassus after O. A. Hansen, showing the Mausoleum (a) and the late Roman villa (k).

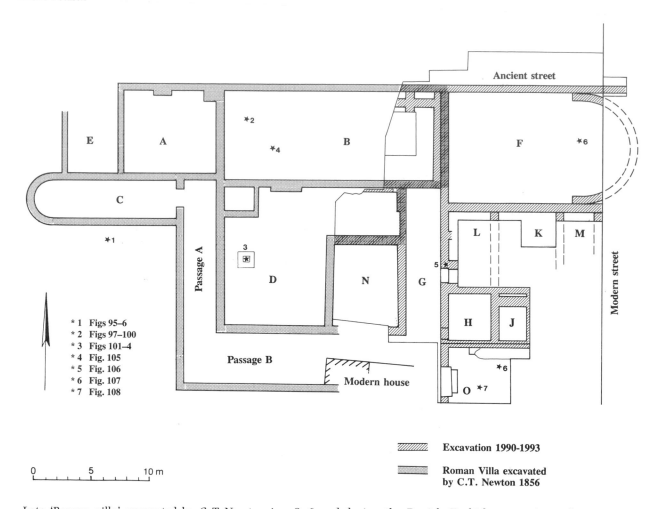

* 1 Figs 95–6
* 2 Figs 97–100
* 3 Figs 101–4
* 4 Fig. 105
* 5 Fig. 106
* 6 Fig. 107
* 7 Fig. 108

///// Excavation 1990-1993

▓▓▓ Roman Villa excavated by C.T. Newton 1856

0 5 10 m

Late 'Roman villa' excavated by C. T. Newton in 1856 and during the Danish–Turkish excavations of 1990–93. (Inger Bjerg Poulsen.)

line of the statue. The front of the statue is finely executed whereas the back is only roughly shaped. The female figure stands resting on her left leg with her right set back. The slightly bent left arm is held down along her side but the hand, originally attached with a dowel, is missing. The remains of the right elbow indicate that the right arm was bent diagonally across the breast. The woman is dressed in a chiton and, seen from the front, a thin and transparent himation is wrapped tightly around the hips and both arms. The end of the himation can be seen below the missing hand and a finely executed border can be observed along the edge, with a similar one on her left hip and thigh. Small transverse folds can be seen between the larger diagonal folds on her right thigh. The himation reaches below the knees, where the columnar folds of the chiton appear, only broken by the movement of the right foot and by the left foot projecting below the edge of the drapery. The left foot wears a sandal with a thick sole.

The folds of the drapery on the back of the statue are broad and flat (Fig. 96). The surface is unfinished, only worked over with a claw chisel. A flaw in the marble runs from the upper part of the back down below her left hand and fades out on the front. Two vertical modern blocks of cement have been added at the bottom for stability.

In his catalogue of sculpture in the British Museum, A. H. Smith did not propose a date for this torso, but A. Linfert compared it to the so-called Arete from the Library of Celsus in Ephesus,[9] and considered them both to be originals from the late Hellenistic period.

The female torso from Halicarnassus actually belongs to the well-known type of the 'small Herculaneum woman'.[10] The type was popular for honorary statues,[11] and innumerable replicas are known, covering the period from the creation of the original in the early Hellenistic period to around AD 300. The version now in Dresden is considered to be one of the replicas closest to the original.[12] This woman stands resting on her left leg with her right leg relaxed. She wears a chiton but is almost completely wrapped in a himation. Her right arm is carried across the chest as she is in the process of pulling the end of the himation over her left shoulder, and thus the end of the himation is draped over her left arm and ends below

the hand. The left foot can only be detected in a curling of the lower edge of the chiton, and the right foot is wearing a sandal.

Some of the later replicas of the 'small Herculaneum woman', however, show the feature of the transparent himation, e.g. the statue in Oxford dated to the second century BC,[13] and some of the Roman replicas. The type of torso found in Halicarnassus may be compared to the statue of a certain Viciria, the mother of M. Nonius Balbus, found in the building of the Augustales in Herculaneum, and presumably erected some time during the second quarter of the first century AD.[14] Although she is characterised as *palliata*, the prototype is clearly the 'small Herculaneum woman'. There are several similarities between the drapery of the two replicas, e.g. the diagonal folds of the thin himation under which the folds of the chiton are indicated by short lines; the edge of the himation which stretches over her left arm to below her hand; and the lower edge of the himation, a part of which is folded up above her right foot. Furthermore, the folds of the chiton are arranged in much the same way, the toes of the left foot protruding below the edge of the chiton.

Although the quality of the marble is rather poor, the workmanship of the torso from Halicarnassus is much better than that of the Herculanean statue. The whole treatment of the drapery of the female torso from Halicarnassus is much more organic than that of Viciria, and the many finely executed details, such as the borders on her left hip and below the hand, likewise emphasise this impression. Furthermore, the folds visible through the himation are less mechanically and schematically executed than on the statue from Herculaneum. Stylistically the torso from Halicarnassus may thus seem earlier, and it is in fact closer to, for instance, the statue of Baebia from Magnesia dated to 62 BC;[15] the folds of the dress visible through the transparent himation are represented in a similar way, and there are identical details, such as the small transverse folds on the right hip and thigh. Such characteristics as the concentration of folds on the non-accentuated parts of the statue may also be observed. A date during the second half of the first century BC may therefore be indicated for the draped torso.

Nike

In connection with his investigations of the Roman villa, Newton found a winged female figure, made of coarse-grained white marble (Figs 97–100).[16] The height is 144.5 cm including the base and thus approximately life size. It was found under the mosaic floor of room B when the representation of the hunting scene with Meleager and Atalanta was lifted. The winged female figure was then in two pieces, as shown in one of the photographs made by B. Spackman (Fig. 97).[17] The join immediately below the breasts with some restored parts is clearly visible. Several parts are missing: the outer parts of both wings (Figs 98–100), her left arm from above the elbow, the right arm from below the elbow, the feet, and the head which was inserted into a cavity in the torso following the neckline of the peplos. The left foot had been inserted in a recess within the drapery. The outer part of her right wing and several parts of the drapery are damaged.

The statue stands on an approximately triangular plinth. It represents a winged female figure in rapid motion, flying rather than running, and in a forward leaning position (Figs 98–9). The upper part of the torso is twisted slightly backwards towards her right, the arms are kept at a distance from the body, the right arm presumably bent outwards, the left upwards. Her right leg is pushed forwards, whereas the left is drawn back. She is dressed in a peplos with a long apoptygma girdled beneath the breasts, and under this she wears a chiton of which only the sleeves buttoned on the upper arms can be seen.[18] The drapery is violently agitated by the movement, and deeply undercut. The folds of the overfold are grouped in three larger clusters, forming the shape of omegas at the lower edge. This clustering may in fact also be observed on the lower part of the peplos, forming deep S-shaped arches along the sides of the legs. However, the folds between the legs run across her left leg immediately below the knee. On the upper part of the legs the peplos creates numerous small, rather flat folds. The contour of her body, and especially that of her legs and her navel, can be clearly distinguished through the clinging, wet-looking drapery which arches up over the feet. The wings were apparently widely spread, since no remains are seen further down the back.[19] They are characterised by large rounded scales indicating feathers. Above her right wing a small part of what seems to be a drapery with vertical folds remains, presumably from a himation forming an arch above her head, part of which appears from behind and lies over her right arm. The area between the drapery and the neck is only roughly worked with a pointed chisel, as is the back of the statue, and there is a deep undercutting beneath the wings and the drapery (Fig. 100).

The combination of wings and arching drapery is most unusual and the statue seems to represent a unique type of Nike or Victory. A similar feature may, however, be observed on one of the acroteria on the

east pediment of the temple of Asclepius in Epidaurus, in which drapery is distended behind and between the wings of the Nike.[20] The position of the wings suggests that she is flying or perhaps landing. It is uncertain what she held in her hands, but the left was perhaps grasping part of the drapery.

Newton at first dated the Nike to the time of Mausolus, but later attributed it to Praxiteles and expressed the hope that 'on removing the tesselated pavements, more statues will be discovered in the foundations, of a good period of art'. Smith characterised the treatment of the statue as 'hard and rough' and dated it 'not earlier than the 2nd century AD'.[21]

At first sight the sculptural representation, the execution of the drapery, the proportions, and the rough and unfinished back seem to indicate a late Roman date.[22] Most of the Nikes or Victories of the Roman period are, however, dressed in a peplos open on one side and leaving one of the legs bare. But like the Hellenistic Nikes, they often carry a trophy, a wreath, a palm of victory or a shield.[23]

It is understandable that Newton considered the Nike from Halicarnassus to be a work of the fourth century BC. However, the mannered representation, the drastically changing surfaces of the drapery, the narrow and high-waisted proportions, and the exaggerated long legs, may be more successfully compared with the classicising trends known in the late Hellenistic period.[24] Statues in such forward-striding or dancing positions and with clinging wet-look drapery may be observed among several female representations from the second and first centuries BC, for instance a 'Nike' from Pergamum[25] and a statue now in Philadelphia from the vicinity of Rome.[26]

A classicising Nike of late Hellenistic date has been found near Knossos.[27] She is dressed in a semi-transparent, high-girdled chiton which reveals the contour of the body, and a heavier himation running in diagonal folds on the back of the figure to the right hip. On stylistic grounds it may be dated to the first half of the first century BC.[28]

Two acroteria from Tyndaris[29] have much in common with the Nike from Halicarnassus. Although the upper parts of the statues are missing, they have been interpreted as Nike because they are clearly represented in a flying position. The thin chiton is pressed by the wind against the body so that the contour of the legs becomes clear. The frontal emphasis is similar, with the 'walking' legs and the many small rather flat folds on the upper part of the legs in contrast to the large S-formed folds of the drapery at the sides of the legs. They were presumably made by an eastern workshop and are dated to around 100 BC.[30]

A slightly curved relief from Corinth[31] has a representation of dancing maenads dressed in a similar type of sleeved chiton worn under a peplos with a long overfold. The lower edge of the peplos also forms arches above their feet in much the same way. The relief shows many affinities with the so-called neo-Attic monuments, and is dated to the late first century BC–early first century AD.[32]

To this category also belong the reliefs with female dancers found on the Via Prenestina.[33] The representations are less lively and articulated, but two of the dancers may be compared to the Nike from Halicarnassus; the folds of the overfold of the peplos are arranged in three clusters in the middle and at each side, and the lower edge of the peplos forms an arched recess above the advanced foot. The contour of the body can be seen clearly through the semi-transparent material of the peplos, and the himation forms an arch above the head. On the basis of the acanthus frieze on the upper part of these reliefs they are dated to the mid-first century BC.[34]

The bold folds and the whole appearance of the Nike from Halicarnassus are, however, much more lively than the neo-Attic representations, and the comparative material seems to support a date in the late Hellenistic period, perhaps around 100 BC.

As regards the original function of the Nike, there are of course several possibilities. The triangular base together with the forward-leaning position of the statue and the unfinished back indeed seem to indicate that the statue was placed high up and meant to be seen from below. This is also emphasised by the unfinished parts of the statue (the back, and the back of her upper left arm), the drapery, and the curiously backwards-drawn left leg. A function as an acroterion would therefore seem plausible; it was probably meant to be seen in three-quarter view from the right, which seems to indicate that it was a lateral acroterion placed on the left side of the building. There is a long tradition for Nikes being used as acroteria,[35] and among the late Hellenistic examples may be mentioned the lateral acroteria from the Hieron in Samothrace.[36] The use as acroterion has also been suggested for the Nike found near Knossos,[37] and for the Nikes from the theatre in Aphrodisias.[38]

Male portrait

A male portrait was found when the well in room D was investigated (Figs 101–4).[39] It is made of a fine-grained white marble, and measures 35.5 cm from the surface of the modern base. The surface of the head is chipped, the nose is missing and the top of the head

has been cut off obliquely. The back of the head and the ears were never carried out in detail.

The head is held erect, tilted slightly backwards to its left. The face forms an oval with softly moulded features. The forehead is high and the eyes are rather deep set; the mouth is closed and the lips are separated by a straight line; the upper lip is finely modelled, and the transition from lower lip to chin is indicated by a small horizontal groove. The neck is strong and finely modelled with a depression indicating the meeting of the collar-bones. On the left side of the neck, traces of drapery can be seen, and below it part of the original rounded edge is preserved; the bust was apparently made for insertion into a draped statue.

Although the back of the head and the ears are only treated superficially, it is possible to make out the hair-style. It consists of small coarse locks brushed towards the forehead with a single lock in front of each ear. At the back (Fig. 104) the hair is arranged in six vertical rows below a horizontal division line, and the locks in each row have been combed towards the centre of the nape of the neck.[40] Around the ears a broad, drilled furrow can be observed, and only the main features of the ears are indicated. The back of the neck has not been polished like the front and has only been treated with claw chisel.

Smith suggested a date in the mid-first century AD for this head, but A. Giuliano placed it in his group 'stile Rodio', covering the period 89–27 BC.[41] The heads in this group are characterised by a lively modelling and short irregularly arranged locks, and they appear quite different from the over-dressed hair-styles of the Augustan age. Like the other heads in this group, the head from Halicarnassus still shows an idealising tendency and is firmly rooted in the Hellenistic portrait tradition.

According to Newton a few other objects were found together with the male portrait in the well, among them a bronze lamp.[42] The lamp does not create a more precise date for the head since, according to D. M. Bailey, it may belong to the fifth-sixth century AD.[43] Newton was convinced that the well was dug into the mosaic floor of room D at a later date than the construction of the villa, thus confusing or disturbing the original design.[44] It is not clear, however, if the well had actually destroyed the floor or if the mosaic floor had allowed for the well. In fact the evidence from the recent Danish excavation seems to suggest that this well was originally located in the open peristyle of the house around which the passages a and b, the upper mosaic border of room D (which corresponds exactly to passage b), and the recently excavated corridor G formed porticoes. The open peristyle yard may have been paved with mosaics at a slightly later date thus actually incorporating the well, which may have originated at the same time as the earliest building remains on the site.[45]

Relief sculpture

Apparently only one small fragment of a marble relief (Fig. 105) was found during Newton's investigations of the villa and brought to the British Museum.[46] The relief has a preserved height of 18.5 cm, a maximum preserved width of 19.5 cm, and is 4.5 cm deep. It is not specifically mentioned by Newton in his publication, but it is presumably identical with 'a small fragment from a low relief of the Roman period' found below the mosaic floor of room B.

Only part of the original upper edge is preserved, but along that edge there is a 2.8 cm broad, crudely worked band, perhaps the remains of an erased moulding. The relief is embedded in plaster and the back cannot be studied. Only a small part of the representation is preserved. To the left can be seen the arms of a person turned to the right and playing the double flute, and in front of this person is the head of a panther turned to the left. The representation was probably part of a Dionysiac scene, perhaps a satyr playing the double flute. However, the size of the panther compared with the size of the preserved arms may indicate that the flute-playing person is a child or an Eros. The erased moulding may indicate that the fragment belonged to the upper edge of a sarcophagus.[47]

Newton tells us that the winged female statue and the small fragment of a relief were found together with several other pieces of statuary, and that they – as well as column drums – had been employed in making an artificial level for the mosaic floor of room B. In his letters Newton mentions that he found 'some fragments of a colossal figure, in a very fine style, near one of the walls of the villa', and further a cubical base with remains of an inscription in two lines,[48] but none of these fragments ever apparently reached the British Museum.[49]

Sculptures from recent excavations

During the recent excavations of the late Roman villa only small fragments of marble sculpture have been found, and they are equally difficult to relate to the mid-fifth-century building. A total of around ten fragments have been found, including several tiny sculptured pieces like fragments of hair, a fragment of a relief with a leg, a head of a dolphin, and a relief with a feline paw. Since these sculptural fragments will

appear in the forthcoming publication of the excavations, only the three best-preserved pieces will briefly be presented here.

A fragment of a marble head, apparently from a relief, was reused as a building stone in one of the walls east of room G (Fig. 106). It forms part of a three-quarter view of a female head facing left.[50] The head may have formed part of a grave relief, perhaps to be dated to around 400 BC.[51]

Two joining fragments of a right hand with part of the wrist made of fine-grained white marble were found in two different years and in two different parts of the recently excavated rooms, F and O (Fig. 107).[52] The hand is slightly smaller than life, and all the fingers are broken. A dowel hole at the end of the wrist shows that the hand was added, and so were the forefinger and thumb. Remains of a metal dowel are still preserved in the drilled hole of the forefinger. Around the wrist is a bracelet in the shape of a spiral. The composite nature of the hand may indicate that it belonged to one of the late Roman statues characterised by a great amount of piecing.[53]

During the excavation of room O a small Herakles herm was discovered (Fig. 108).[54] It lay above the mosaic floor in what has provisionally been considered an undisturbed layer. The head together with the lower part of the tapering pillar is missing. It is made of a fine-grained white marble. In his left hand Herakles holds the club against his shoulder and his right arm rests across his chest. Herakles' body is draped in a lion-skin which, like a himation, envelops the whole figure. One of the paws can be seen on his left shoulder, and the feline character is indicated by incisions consisting of semicircular lines.

Such hip-herms of Herakles are preserved from the end of the fourth century BC to the late Roman period.[55] These herms are fully sculpted down to the hip, below which they are substituted by a tapering pillar. They are normally enveloped in a lion-skin which generally covers both arms and hands, and the lion's head may hang down by the side. Herakles' right arm is often placed across the chest, sometimes grasping one of the lion's paws, and the left hand may hold the club. The size may vary from miniature to over life-size, and they are found as free-standing figures as well as in relief.

The Herakles hip-herm enveloped in a lion-skin presumably originates from a Herakles statue known as the Kavala type, of which several replicas are known.[56] This statue type is characterised by a beard, by the lion-skin used as a himation, by a club over the left shoulder, and by the right arm pressed against the chest. Although no remains of a beard can be distinguished on the preserved part of the neck, the general

appearance of the Herakles found in the late Roman villa is characterised by a heavy stature and is thereby more like the type of the old Herakles.[57] Another representation of such a hip-herm is also known from Halicarnassus; thus on a grave relief in Berlin a Herakles hip-herm is depicted standing behind an altar between the deceased and a boy.[58] In fact such small Herakles hip-herms are often represented on the East Greek grave stelae of the Hellenistic period,[59] and a large number of similar sculptural representations has been found on Delos.[60]

Conclusion

To sum up, the statues from the late Roman villa may be grouped in two categories. The first consists of sculpture which we know for certain never formed part of the sculptural setting of the villa. Since both the Nike and the relief fragment were found below the mosaic floor of room B, they must have adorned buildings pre-dating the construction of the late Roman villa. To this category belongs also the fragment of a female head, reused as building stone.

To the second group belong the fragments which, judging by their date, are not in accordance with the general date of the construction of the late Roman villa, and which therefore should be expected also to have adorned earlier buildings. Since, however, the owner could easily have had older sculpture in his collection, we cannot exclude the possibility that they may have formed part of the late Roman villa's sculptural embellishment. This applies to the portrait and to the lower part of the draped female torso.

To the latter group also belong the recently found sculptures, the hand and the Herakles hip-herm. They were found in layers which seem to belong to the phase of decay of the villa but which may have been disturbed by later activities on the site.

To conclude, neither the sculptures in the British Museum nor the recently excavated ones can be clearly shown to have formed part of the sculptural setting of the late Roman villa in Halicarnassus.[61] The other embellishment of the building, especially the beautiful mosaic floors, certainly seems to indicate a wealthy owner. The iconography of the mosaics is wholly pagan in character, and this fact together with the inscriptions suggests that the dedicator, Charidemos, favoured a secular cultural sphere.[62] A similar attitude would presumably have dominated the sculptural setting, but regrettably only the many mythological representations of the mosaics give a vague impression of how the sculptural landscape of the late Roman villa in Halicarnassus should be visualised.[63]

ACKNOWLEDGEMENTS

I would like to express my gratitude to both Mette Moltesen, Ny Carlsberg Glyptotek, and Birte Lundgreen, King's College London. They read the manuscript critically and improved it, and Birte Lundgreen also revised it linguistically.

NOTES

1. For some reason the Roman villa was wrongly placed on Newton's map, *HCB* pl. I. For the correct location, see *RE* VII.2 (1912) 2253–64 s.v. 'Halikarnassos' (L. Bürchner) fig. on 2258; P. Pedersen, 'Town-planning in Halicarnassus and Rhodes', in S. Dietz and I. Papachristodoulou (eds), *Archaeology in the Dodecanese* (Copenhagen 1988) 98–103, fig. 3.

2. *Dispatches* (1858) 5–6, 34–44; *HCB* 280–310; R. P. Hinks, *Catalogue of the Greek, Etruscan and Roman Mosaics and Paintings in the British Museum* (London 1933) 125–43.

3. The excavations in Halicarnassus are directed by Associate Professor P. Pedersen from Odense University in co-operation with Bodrum Museum of Underwater Archaeology. The part of the late Roman villa was revealed through four campaigns from 1990 to 1993, and is going to be published by the present author. For preliminary reports B. Poulsen, 'The New Excavations in Halikarnassos. A Preliminary Report 1990–91', in Isager (1994) 115–33; S. Isager and B. Poulsen, 'Pagans in Late Roman Halikarnassos', *Proceedings of the Danish Institute in Athens* I (1995) 195–221.

4. For further discussion and arguments, cf. Isager and Poulsen (supra n. 3).

5. The area had been used as a cemetery before it became a private plot. Large foundation trenches, partly filled with concrete, had been laid out in the western and southern part of the field before a team from Bodrum Museum of Underwater Archaeology stopped the building activities.

6. Hinks (supra n. 2). However, Newton decided to have all the mosaics photographed *in situ*, and this photographic material is partly preserved in the British Library, partly in the Greek and Roman Department, British Museum. It will appear as documentation in the forthcoming publication of the villa. I should like to express my gratitude to Dr I. Jenkins who drew my attention to the existence of this documentation and also for having provided me with photographs of the sculpture in the British Museum from the Roman villa. For references, Jenkins (1992) 175–6; G. Feyler, 'Contribution à l'histoire des origines de la photographie archéologique', *MEFRA* 99 (1987) 1019–47.

7. The torso was discovered before Newton's excavations and purchased in 1846 by Viscount Stratford de Redcliffe who presented it to the British Museum, *Dispatches* (1858) 5; *HCB* 280–81 and 304; *BMCS* II, 1112. According to Smith, the height is 4 ft, 6½ ins (138.43 cm).

8. Approximately ⅚ cm³.

9. Linfert 35–6, figs 44–5, around the mid-second century BC. For the torso found in Halicarnassus, see Linfert 42, n. 104, fig. 64. For the so-called Arete, who is provided with a new head, W. Oberleitner et al., *Funde aus Ephesos und Samothrake* (Vienna 1978) 115, no. 10, fig. 95.

10. Bieber (1977) 148–62; H. Wrede, *Consecratio in formam deorum: Vergöttliche Privatpersonen in der römischen Kaiserzeit* (Mainz 1981) 213–14 with bibliography; B. S. Ridgway, *Roman Copies of Greek Sculpture: The Problem of the Originals* (Ann Arbor 1984) 101; B. S. Ridgway, *Hellenistic Sculpture* I (Bristol 1990) 92–3, pl. 56a–b. However, this type is also used for a Muse on the statue base from Mantinea (Arcadia), A. F. Stewart, *Greek Sculpture: An Exploration* (New Haven and London 1990) 177, 277–8, fig. 493.

11. The type was occasionally used for more statues in the same monument, R. Bol, *Das Statuenprogramm des Herodes Atticus-Nymphäums*, Olympische Forschungen 15 (Berlin 1984).

12. Bieber (1977) 148, figs 668–72; R. R. R. Smith, *Hellenistic Sculpture* (London 1991) 75, fig. 89. Cf. supra n. 10.

13. A Michaelis, *Ancient Marbles in Great Britain* (Cambridge 1882) 541, no. 2; G. Kleiner, *Tanagrafiguren* (Berlin and New York 1984) 235–6, pl. 57a. For a discussion of this appearance whereby the folds of the undergarment are visible through the outer garment, which is first seen in the second half of the third century BC, see D. Thompson, 'A Bronze Dancer from Alexandria', *AJA* 54 (1950) 371–81.

14. Now in the National Museum of Naples. Owing to the rather insufficient excavation report, it was originally believed that the statue had been found in the theatre together with statues of the wife and daughters of Balbus, Bieber (1977) 149–50, 195–6; M. Fuchs, *Untersuchungen zur Ausstattung römischer Theater* (Mainz 1987) 31–3 with references.

15. D. Pinkwart, 'Weibliche Gewandstatuen aus Magnesia am Mäander', *AntP* 12 (1973) 149–60, esp. 149–51 fig. 2, pls 49–51; Linfert 30, n.58a, 178–80, pls 22, 25–6 with references.

16. The surface of the statue is rather eroded and crystalline, *Dispatches* (1858) 6; *HCB* 305–6; *BMCS* II, 1111. According to Smith it is made of Parian marble, the height being 4 ft, 8½ ins (143.51 cm).

17. *BMCS* II, 1306, 'Statue from Hadji Captan's Field, Bodrum'. Identical with the photograph of R. Murdoch Smith, no. 158 (National Library of Scotland).

18. A similar dress, i.e. a thin chiton with sleeves buttoned on the upper arm and above this a peplos, is worn by some of the goddesses on the gigantomachy frieze of the Great Altar in Pergamon, e.g. the so-called Doris in the south frieze, and the goddess in front of Rhea on the left side of the staircase, H. Kähler, *Der grosse Fries von Pergamon* (Berlin 1948) pls 8 and 19 respectively, and a torso of a female statue in Berlin, F. Winter, *Die Skulpturen, Pergamon* VII. I (Berlin 1908) 112–14, no. 87.

19. Evidently similar to, for instance, the flying Nike on the great frieze of the Pergamon Altar, Kähler (supra n. 18) pl. 3; Smith (supra n. 12) fig. 196, 1; Goulaki-Voutira et al. no. 407.

20. Gulaki, 72–8, fig. 27; Goulaki-Voutira et al. no. 145; Yalouris (1992) 19, no. 2, pls 3–5.

21. *Dispatches* (1858) 6; *BMCS* II, 1111.

22. During the conference many scholars contributed suggestions concerning the date of this statue, which I first thought to be Roman due to such representations as e.g. a

Nike in Venice (Severan?), Gulaki, 184–5, fig. 143; R. Polacco and G. Traversari, *Sculture Romane: Collezioni e musei archeologici del Veneto* (Rome 1988) 21–2, no. 4 (Hadrianic). The many different opinions on the date of the Nike covered the time from the Hellenistic to the late Roman period.

23. Goulaki-Voutira *et al.* 902–4. Sometimes the Roman Victories also carry weapons, T. Hölscher, *Victoria Romana* (Mainz 1967) 132–5.

24. Some scholars suggested the attractive theory that the Nike, together with the lower part of the draped female statue and the male head found in the well (see infra xx), should belong to a group of statues from one single monument or architectural unit dated to the late Hellenistic period.

25. Apparently not a Nike, F. Winter (supra n. 18) 239, no. 293 (125–100 BC). For this type in general, Goulaki-Voutira *et al.* nos. 486–91.

26. Philadelphia University Museum; Gulaki 212–15, figs. 187–8, 193 with references. I thank Pia Guldager Bilde and Mette Moltesen for the reference to this statue. For the general type of this statue, Gulaki 193–217.

27. I am indebted to Professor Waywell for this reference. Published by G. B. Waywell, 'The Sculpture', in J. N. Coldstream (ed.), *Knossos: The Sanctuary of Demeter* (BSA Suppl. 8, 1973) 97–8.

28. Cf. Waywell (supra n. 27).

29. P. Zanker, 'Zwei Akroterfiguren aus Tyndaris', *RM* 72 (1965) 93–9, in Palermo and Syracuse; Goulaki-Voutira *et al.* nos. 581–2.

30. Zanker (supra n. 29) 95–6.

31. F. P. Johnson, *Sculpture 1896–1923, Corinth* IX (Cambridge, Mass. 1931) 131–2, no. 275.

32. First dated to the fourth century BC, R. B. Richardson, 'A Group of Dionysiac Sculptures Found at Corinth', *AJA* 8 (1904) 288–96, esp. 291–4; E. M. Gardiner, 'Sculptures from Corinth', *AJA* 13 (1909) 158–69, esp. 169, and 304–27, esp. 304. A date in the early first century AD was suggested by R. Carpenter, *Ancient Corinth: A Guide to the Excavations and Museum* (1928) 76–7, no. 16; G. Fuchs, 'Eine Basaltstatue in Palermo', *RM* 72 (1965) 100–15, esp. 110, pl. 46, 3.

33. H. Froning, *Marmorschmuckreliefs im 1. Jh. v. Chr.* (Mainz 1981) pl. 43 left and pl. 44 left. C. C. Vermeule, *Greek and Roman Sculpture in America* (Berkeley and Los Angeles 1981) 199, no. 165, dates the eighth relief from this monument to about AD 100.

34. Froning (supra n. 33) 125–31.

35. Gulaki 134–41; P. Danner, *Griechische Akrotere der archaischen und klassischen Zeit* (Rome 1989) 42–6. For the earliest use during the Archaic period, Goulaki-Voutira *et al.* nos 16–35.

36. P. W. Lehman, *Samothrace: The Hieron* II (London 1969) 113–31; Goulaki-Voutira *et al.* nos. 586–7.

37. Waywell (supra n. 27).

38. Dedicated by C. Julius Zoilos (38–28 BC); K. T. Erim and R. R. R. Smith, 'Sculpture from the Theatre: A Preliminary Report', in R. R. R. Smith and K. T. Erim (eds), *Aphrodisias Papers* 2 (JRA Suppl. 2, Ann Arbor 1991) 67–97, esp. 74–9.

39. *HCB* 307; *BMCS* III, 1941 (Parian marble); J. Inan and E. Rosenbaum, *Roman and Early Byzantine Portrait Sculpture in Asia Minor*, 2nd edn (London 1970) 168, no. 221, pl. 122, 3–4; Linfert 69, n. 216.

40. A similar hair-style is found on the portrait of Vespasian in the Capitol Museum, K. Fittschen and P. Zanker, *Katalog der römischen Porträts in Capitolinischen Museen* I (Mainz 1985) 33, no. 27, pl. 27.

41. *BMCS* III, 1941; A. Giuliano, 'La ritrattista dell'Asia Minore dall' 89 a.C. al 211 d.C.', *RivIstArch* n.s. 8 (1959) 146–201, esp. 151–3, no. 8, fig. 3. The head may also be compared to late Republican portraits, e.g. the 'Plastisch-idealistischer Stil' which B. Schweitzer, *Die Bildniskunst der römischen Republik* (Leipzig 1948) 91–114, dated to the third quarter of the first century BC.

42. *Dispatches* (1858) 43; reproduced by Newton, *HCB* 306.

43. I am indebted to Dr D. M. Bailey for this information. See *BMC Lamps* IV, Q3787.

44. *HCB* 296.

45. Isager and Poulsen (supra n. 3).

46. *Dispatches* (1858) 43; *HCB* 306–7; *BMCS* II, 1110, h. 7 in (17.78 cm).

47. Cf. an Eros standing in front of a panther on the Casali Sarcophagus, Ny Carlsberg Glyptothek, Copenhagen, F. Matz, *Die dionysischen Sarkophage* II (Berlin 1968) 183–6, no. 75, pl. 85. For double flute-playing Eros, N. Blanc and F. Gury, *s.v.* 'Eros/Amor, Cupido', *LIMC* III (1986) 952–1049, nos 463 and 583.

48. *Dispatches* (1858) 43 [[PTE]] STR [[ATOS]] and [[THY]] ATE [[RA]]. Found 'in the line of foundations on the north side of D, a.'

49. According to the registration lists of the British Museum, only the four pieces mentioned above derive from the Roman villa. A round base with representations of Muses was found in the vicinity of the 'Roman villa' in 1868, *BMCS* II, 1106; D. Pinkwart, 'Die Musenbasis von Halikarnass', *AntP* 6 (1967) 89–94.

50. Found in 1990, inv. RVF II.694. The height is about 12.5 cm and only parts of the hair, forehead, root of the nose and upper part of her left eye are preserved.

51. Like a head believed to stem from the west coast of Asia Minor, Pfuhl-Möbius 32, no. 78, pl. 20.

52. 1991 and 1993, inv. RVF VII.614. The preserved length is 12.3 cm.

53. A. Claridge, 'Ancient Techniques of Making Joins in Marble Statuary', *Marble: Art Historical and Scientific Perspectives on Ancient Sculpture* (Malibu 1990) 135–62, esp. 150–53.

54. Inv. RVF IX.254A. Now in the Bodrum Museum, inv. 17.93. The preserved height is 32.6 cm.

55. H. Wrede, *Die spätantike Hermengallerie von Welschbillig* (Berlin 1972) 82, 152–4; H. Wrede, *Die antike Herme* (Mainz 1985) 24–5, 35; Boardman *et al.* nos 1104–1220; O. Palagia, 'Seven Pilasters of Herakles from Sparta', *The Greek Renaissance in the Roman Empire* (BICS Suppl. 55, 1989) 122–9.

56. Presumably reflecting a model of the third century BC, Boardman *et al.* 770, nos 863–70.

57. Only a few such hip-herms of the young Herakles are swathed in the lion-skin, cf. young Herakles in the Vatican, to which, however, the head does not belong, G. Lippold, *Die Skulpturen des Vatikanischen Museum* III.2 (Berlin 1956) 134, no. 41, pl. 64; Boardman *et al.* no. 1255, and two pilasters in Ephesus, no. 1104.

58. Dated to the second century BC, Pfuhl-Möbius 86, no. 141, pl. 32; Boardman *et al.* no. 1114. Another Herakles from Halicarnassus is a bronze statuette from the Roman period in London, H. B. Walters, *Catalogue of Bronzes: Greek, Roman and Etruscan* (London 1899) no. 1291, pl. 30; Boardman *et al.* no. 1162. Both represent the type of the old Herakles with a beard.

59. Pfuhl-Möbius nos 138, 141–3, 161, 256, 646, 730 (second century BC); Boardman *et al.* nos 1112–13, 1115–16.

60. J. Marcadé, *Au Musée de Délos* (Paris 1969) 453–9; Boardman *et al.* nos 1125, 1127–9.

61. The late Roman building in Halicarnassus most closely resembles the late antique palaces or villas which have also been called houses. For discussions on 'palatial' architecture, N. Duval, 'Les maisons d'Apamée et l'architecture "palatiale" de l'Antiquité tardive', *Colloque d'Apamée de Syrie* 3, *Fouilles d'Apamée de Syrie, Misc.* 13 (Brussels 1984) 447–70; S. B. Downey, 'The Palace of the Dux Ripae at Dura-Europos and "Palatial" Architecture of Late Antiquity', in R. T. Scott and A. R. Scott (eds), *Eius Virtutis Studiosi: Classical and Postclassical Studies in Memory of F. E. Brown (1908–1988)* (Hanover and London 1993) 183–98; S. P. Ellis, 'The End of the Roman House', *AJA* 92 (1988) 565–76; idem, 'Power, Architecture, and Decor: How the Late Roman Aristocrat Appeared to his Guests', in E. K. Gazda, *Roman Art in the Private Sphere: New Perspectives on the Architecture and Decor of the Domus, Villa, and Insula* (Ann Arbor 1991) 117–34.

62. He may have belonged to the pagan provincial aristocracy, but the Proiecta Casket of the Esquiline treasure is an excellent example of Christian owners favouring secular and pagan motifs, K. J. Shelton, *The Esquiline Treasure* (London 1981) 31–5, A. Cameron, 'The Date and the Owners of the Esquiline Treasure', *AJA* 89 (1985) 135–45; idem, 'The Esquiline Treasure: The Nature of the Evidence,' *AJA* 89 (1985) 147–55.

63. A similar secular tendency and eclecticism characterised many of the late sculptural collections, cf. E. Bartman, 'Sculptural Collecting and Display in the Private Realm', in E. K. Gazda (supra n. 61) 71–88; N. Hannestad, *Tradition in Late Antique Sculpture* (Aarhus 1994) 105–49.

10

Sculpture in terracotta from Cnidus and Halicarnassus

Lucilla Burn

Figure 109 illustrates a terracotta figure less than 10 cm high; Figure 110 shows a half-life-sized marble figure with almost exactly the same stance and drapery. In their stance and the arrangement of their drapery, these two examples equally embody a fairly common sculptural type of the Hellenistic period. Yet while considerable effort has been, and will continue to be, expended on the discussion of the origin, diffusion and identification of the marble examples of this or comparable types, when a terracotta version enters the discussion at all, it is usually just to be dismissed – often in a footnote – as an insignificant small-scale copy of a large-scale original. Most people who study terracottas, particularly in the Hellenistic period, make valiant if not always successful attempts to assess their relationship with large-scale sculpture; but few students of sculpture 'proper' feel a reciprocal need to consider sculpture in terracotta. Most ancient sculptors, however, whether they worked in bronze or marble, must either themselves have been competent modellers in clay or else have operated in close association with coroplasts. The connection is immediately obvious with bronze, since with either the direct or the indirect method of casting, the first step was always the creation of an archetype in wax or clay, from which moulds could be made, and the further stages involved in the production of a finished bronze were basically technical and mechanical; in other words, the creative and artistic skills required of a bronze sculptor were essentially those of a coroplast. The links between the production of marble sculpture and terracotta are less direct: while the modeller in clay builds up the desired form by gradual additions, the marble-worker subtracts superfluous stone until only the form he is working towards remains. Yet even if some sculpture in relief could have been carved more or less freehand, most producers of three-dimensional marble figures would have needed small models in clay or wax from which to work (perhaps the *paradeigmata* or *typoi* occasionally mentioned in the epigraphic and literary sources); so marble sculptors too must either have been competent coroplasts themselves, or highly dependent on those who were.[1]

A rare and enlightened exception to the fairly widespread neglect of terracotta sculpture is found in the appendix to Bernard Ashmole's exemplary article on the Demeter of Cnidus, where he introduces a couple of the terracottas found in the Sanctuary of the Underworld Deities at Cnidus into his hypothesis as to the nature of the statue of Persephone assumed once to have accompanied the Demeter.[2] The aim of this paper is to build on the start made by Ashmole, and, by focusing on a small number of fragmentary Hellenistic terracottas excavated by Charles Newton at Cnidus and Halicarnassus, to draw attention to their extremely sculptural nature. 'Sculptural' here is not simply taken to indicate that their types – that is, their proportions, facial features, poses or the arrangement of their drapery – appear to replicate examples known in large-scale sculpture. It also means that these figures convey an impression both of the mass and forms of the body, and of the volume and texture of the drapery, that sharply distinguishes them from the ubiquitous 'Tanagras' of the Hellenistic world. Rather less objectively, perhaps, it may also be suggested that these 'sculptural' terracottas demonstrate a monumentality lacking in the slight but pretty 'Tanagras'. This is not, of course, to deny that many (if not most) 'Tanagras' also probably have connections with large-scale sculpture;[3] but very often mass production and repeated imitation have considerably weakened the original link. The most 'sculptural' terracottas, almost always striking aberrations from the 'Tanagra' style and types, are generally found in areas and periods of important large-scale sculptural activity. Mme Besques has identified a terracotta workshop in third-century Cyrene, whose practitioners seem to have been particularly familiar with contemporary developments in Cyrenaican sculpture,[4] while the most successfully deviant terracottas of the Hellenistic world, the flamboyant creations of Myrina, are probably related to the late third- and second-century flowering of sculpture at nearby Pergamon.[5] Few such terracottas, however, are likely to be exact copies of large-scale works; the question of how precisely one medium 'influenced' the other, or how their 'relationship' func-

tioned, is unresolved. Drawing attention to as many 'sculptural' terracottas as possible may be one way of eventually bringing us nearer to understanding the situation; and this seems adequate justification for presenting some of the terracottas from Cnidus and Halicarnassus here.

Charles Newton excavated at Halicarnassus between 1856 and 1858.[6] About two-thirds of the three-hundred-odd terracottas saved by his workmen and sent back to the British Museum were unearthed in 1856, in a field to the east of the Mausoleum, named after its owner the 'Field of Chiaoux'. The great cache of terracottas and lamps, stacked in layers by types, 'assorted like articles in a shop',[7] must almost certainly represent a sanctuary deposit; the types of the terracottas, which include large numbers of hydrophoroi, paralleled in Demeter sanctuaries throughout the Mediterranean,[8] suggested the strong probability that they had been offered to the underworld goddess and perhaps also her daughter Persephone, and this was confirmed by the discovery of an inscription naming these goddesses.[9] There is nothing particularly 'sculptural' about these figures. They were dated by Reynold Higgins to between about 500 and 330 BC, and along with twenty-three earlier, sixth-century animal figures discovered partly by Newton and partly by Alfred Biliotti in 1865 in the foundations of the Mausoleum itself, they were fully published by Higgins in volume I of his *Catalogue of Terracottas in the British Museum*.[10]

The fragmentary Hellenistic terracottas with which this paper is concerned came to light in the 1857 season, in the course of excavations in and very near the actual Mausoleum. In the British Museum registers their find-spot is usually recorded as either 'Mausoleum excavations' or 'deep diggings in Mausoleum peribolos', and attempts to discover more precise contexts for these figures have met with very limited success. It has to be remembered that terracotta figures aroused very little interest among scholars or connoisseurs before the early 1870s, when the widespread looting of the cemeteries at Tanagra in Boeotia unleashed a sudden flood of them on to the market and thence into the museums and private collections of Europe and the United States.[11] It is, in any case, hardly surprising that Newton was far less concerned to record the exact find-spot of every fragment of terracotta than he was to reconstruct the plan and architecture of the Mausoleum and recover its sculptural decoration. Given the time when he was working, the difficulties under which he laboured and the almost overwhelming complexity and importance of the monument itself, what is surprising is the fact that he found time to notice and preserve any terracottas at all. In his published accounts of the excavation, and in the dispatches he sent from the site, he does twice refer to finding terracottas; in both cases the reference seems to be to heads.

The first reference occurs in the context of the discovery of the western staircase leading down to the sepulchral chamber of the Mausoleum; here, along with two alabaster jars, were found, according to both an official dispatch written on 3 April 1857, to the Foreign Secretary of the day, the Earl of Clarendon, and to *HCB*, 'Several fragments of small terracotta figures ... one of which, a female head, is of exquisite beauty'.[12] Since it is illustrated in *HCB*,[13] the head may be identified as that shown in Figure 111. It is indeed very finely modelled: notable features are the heavy neck with its Venus rings, the sweetness of the expression and the elegantly waved and parted hair, and all these aspects find parallels in such late Hellenistic Aphrodite heads as the Aphrodite from Tralles or the Venus de Milo.[14] In *TD* the 'several fragments' have become 'two or three small terracottas',[15] but though it would be interesting to know which others were found with this head, it seems improbable that we shall ever find out. The second reference is found in the accounts of excavations on the east side of the Mausoleum, which revealed a rubble platform covered with splinters of marble and 'green stone', sometimes referred to as 'green rag stone'. Lying on this, wrote Newton to the Earl of Clarendon on 12 August 1857, were 'two fragments of small terra-cotta figures remarkable for their exquisite modelling and the fineness of the clay. These were probably votive offerings brought to the tomb, or, possibly, studies made by the sculptors employed on the Mausoleum.'[16] This account is repeated in both *HCB* and *TD*, except that the 'two' fragments become several, variously described as 'beautifully modelled in the same style as the sculptures of the Mausoleum' and 'exquisitely modelled, and probably of the period of Skopas'.[17] *HCB* illustrates four of the 'several'[18] (Figs 112–15), though it should be pointed out that the register entry for the last of the four disagrees about the find-spot, claiming instead that it was found in a mine under Hadji Nalban's house on the south-west angle of the Mausoleum. Those illustrated in Figures 112 and 113, though much less finely worked than the last, again resemble Aphrodite types, as does that shown in Figure 114, set very much at an angle to the neck and with long curls of hair escaping on to the shoulders; this is from an extremely large figure, over 30 cm tall when intact. These heads are very difficult to date, though affinities with other works in terracotta from Myrina and Priene would tend to suggest a date not before

200 BC. In general, it seems fair to suggest that all three have a fully Hellenistic appearance, and are likely to postdate the completion of the Mausoleum by one or more centuries. Only in the case of the last of the four heads (Fig. 115), is it immediately possible to see why Newton suggested they might have been studies made by the Mausoleum sculptors. This is an exceptionally finely modelled and well-preserved head; the shape of the head in its carefully detailed sakkos immediately recalls that of the best-preserved sakkos-wearer from the Mausoleum (Figs 116–17);[19] while the escaping curls are smaller and tighter than those of the marble version, there is also a remarkable similarity about the set of the head on the neck and the modelling of the eyes and nose, with both the sculpture and the terracotta exhibiting the same, very sharply chiselled single, sweeping line for the deeply marked brows and nose.[20]

The other Hellenistic terracottas found by Newton on the site of the Mausoleum include thirty-eight fragments of arms and legs, some of the hands holding phialai, two wrapped in the protective thongs worn by boxers, ten more female heads, and nine fragments of Dionysus masks, one of which is illustrated in Figure 118.[21] Of greater interest for our present purposes are the thirteen fragments of draped female figures, a small selection of which are discussed here. What is immediately striking about them is how very few are repetitions of 'Tanagra' types: the piece illustrated in Figure 119 is one exception, but when compared with versions of the same type found elsewhere,[22] it appears wonderfully crisp and fresh, and was obviously much touched up on its emergence from the mould. For actual Tanagra types such as this, repeated throughout the Hellenistic world, it is rarely possible to find precise parallels in sculpture, and I do not know of one for this.

The next three pieces, however, have little to do with 'Tanagras' and much with large-scale sculpture. The first (Fig. 120) preserves the lower part of a woman wearing a chiton and a himation, the himation of a thin material through which the folds of the chiton are visible. Her weight is on her left leg, while her right is bent a little at the knee, with the foot set slightly back, pulling the drapery with it. For this figure, although it is possible to find comparisons among the terracottas of Myrina or Priene, closer parallels are at hand in the large-scale marble sculpture of Cos and Rhodes, such as a fragment of a marble figure found in the Odeion at Cos (Fig. 121)[23] and dated by Linfert and Kabus-Preishoffen to around 150–40 BC. There are of course differences: the mantle of the Cos figure is clearly thinner, more transparent; and yet the

affinity appears to go beyond the general congruity of dress and pose – the broader fold over the weight-bearing leg, for example, is treated so similarly, even down to the way the left foot breaks it and pushes it to one side, or the way the chiton is drawn back by the position of the right foot, or the raised folds around the right calf. The next piece (Fig. 122) is harder to parallel so convincingly; it is a fragment from the left side of a figure, around waist level, wearing a himation whose loose end is wrapped around the left hand of the figure. The very deep undercutting is highly unusual in a terracotta, probably because it would have been impossible to achieve in a mould, and must have required careful building up by hand. This in itself gives the piece a sculptural quality, and again parallels can be found on Cos (Fig. 123).[24]

The last fragment (Fig. 124) preserves the thick roll of the himation dragged round the body below the stomach, a stylistic feature for which there is no shortage of marble parallels in Rhodes and Cos, although variations of it are so common throughout the Hellenistic world that it may not necessarily have a local origin.[25]

These few examples must suffice to give some idea of the sculptural richness of the terracottas excavated by Newton at Halicarnassus. Before turning to Cnidus, it may be pointed out that although dating Hellenistic terracottas is as hazardous an activity as dating large-scale Hellenistic sculpture, the majority of the pieces so far discussed seem on stylistic grounds to be considerably later in date than the completion of the Mausoleum in the mid-fourth century BC. With the possible exception of the sakkos head (Fig. 115), none would appear to be earlier than the late fourth century, some as late as the second. The question therefore arises as to what they were doing there. This is of course part of the wider and problematic question of what went on at the Mausoleum in the Hellenistic period; but if, as seems possible, these terracottas were offerings at the tomb, they and the others found in more recent excavations will have to be taken into account in any reconstruction of the monument's continuing role in antiquity.[26]

The Sanctuary of the Underworld Deities at Cnidus was excavated by Charles Newton in 1858.[27] Here, in addition to substantial quantities of marble sculpture and inscriptions, he discovered in and around various groups of small rectangular subterranean chambers, some walled with rough masonry and roofed with tiles, considerable numbers of lamps, pots, glass and terracotta figures. These chambers appear to have been constructed for the safe-keeping of votive offerings, but whether, as Newton suggested, they represented

makeshift arrangements following the destruction, per-haps by an earthquake, of a proper treasury, or whether they were constructed in anticipation of attack, remains uncertain.[28] The terracottas appear to have been found in two main groups. In two of the set of chambers discovered at the eastern side of the temenos, near the body of the Demeter, were laid a number of hydrophoroi, two examples of which are shown here (Figs 125–6). Newton reported finding 'seven or eight of these figures, exactly similar in type',[29] though in fact, including fragments of hydrophoros heads, he appears in the end to have dis-patched nineteen examples back to the British Museum – some may have been found elsewhere on the site. Stylistically the hydrophoroi fall into two main types: the first has slightly exaggerated swallow-tail drapery and looks perhaps a little later than the second, plainer type, which resembles the latest hydrophoroi from the Field of Chiaoux at Halicarnassus.[30] As was mentioned above, such hydrophoroi are found at Demeter sanc-tuaries throughout the Mediterranean, and must have had a special significance in her cult. Their probable role was in fact first suggested by Newton: when he first came across them at Cnidus he thought they might represent the Danaids with leaky pitchers, an appropriate theme for a sanctuary of underworld deities;[31] but he later suggested they might portray the daughters of Keleos, King of Eleusis.[32] These are described in the Homeric Hymn to Demeter, where they meet the goddess, mourning the loss of her daugh-ter, at the fountain where they have come to draw water in their bronze hydriai, and take her back to the shelter of their home. Newton commented that his Cnidian hydrophoroi were 'elegant in composition, but carelessly modelled, as was often the case with terra-cottas'.[33] If, as their find-spot may suggest, they should be considered as contemporary with the Demeter, they seem extremely conservative in style and technique, with their awkwardly modelled and positioned arms, high plinth bases, and not always fully cut-out back-ground. This conservatism may have resulted from their traditional function as dedications;[34] but what-ever its cause, it means that they appear to have very little in common with contemporary sculpture.

More terracottas were found in and around two more sets of underground chambers towards the west-ern edge and in the centre of the northern side of the temenos. It is tantalising that on the western edge of the site, near the spot where an inscription recording a dedication to Demeter, Persephone, Pluto Epimachos and Hermes was found, Newton records the discovery of 'a fragment of a terra-cotta relief' on which he identifies Pluto 'seated on his throne';[35] but this terra-cotta cannot be traced today. Among those which have survived are a double (male and female) herm, two 'doll' figures, a pig (Fig. 127), very similar to the marble pigs from the temenos, and a small figure of a satyr actor declaiming (Fig. 128). Reynold Higgins drew attention to the last piece, being one of four known examples of the type, the other three coming from Smyrna, Cyrenaica and Cumae in southern Italy: he suggested the type might have been invented at Smyrna, with examples exported to Cnidus, Cyrenaica and the west, where they were imitated and replicated by local coroplasts.[36] The connection of this figure, if any, with the cult of the Underworld Deities seems obscure; another fragment of a figure, consisting of the head of an old woman carrying a cista (Fig. 129), however, might surely be an image of some figure con-nected with the cult of Demeter.[37]

As was the case at Halicarnassus, it seems more profitable at Cnidus to search for examples of sculp-ture in terracotta among the heads and the fragments of draped female figures. The proportions, features, hair-style and expression of the large head shown in Figure 130, for example, strongly resemble those of the seated marble figure of Demeter (Fig. 131), sug-gesting it may have belonged to a similar, or at least contemporary image of the goddess. Many of the eleven extant fragments of draped female figures are mere scraps, so that it can be difficult to assess whether they belong to common 'Tanagra' types or to some-thing more exceptional. However, it does seem that, as at Halicarnassus, while there is the odd example of a 'Tanagra' (Fig. 132), several of the more complete examples do seem to relate quite closely to contem-porary sculptural styles.

Among the best examples of this phenomenon are the two figures shown in Figures 133 and 134, the two that Ashmole published.[38] Newton found these in the second set of underground chambers that he exca-vated, and was much impressed by their appearance:

Among the terracotta figures are several modelled with much freedom and vigour. They generally represent draped female figures, probably, in most cases, Demeter or Persephone. In one figure [Fig. 133] the drapery is beautifully composed, showing the form underneath with great skill. This terracotta probably represents Persephone, as the figure is too youthful for Demeter.[39]

It is indeed true that, by any standards, this figure does stand out from the normal run of Hellenistic terracottas. It is considerably taller than usual (23.5 cm extant, whereas more normal Tanagras are closer in height to the other version, 16.4 cm), and large amounts of the drapery have been not just retouched but actually built up by hand after the basic figure

was taken from the mould. Ashmole echoed Newton's enthusiasm for the figure, describing it as 'strongly sculptural both in design and execution. . . . it possesses the sharpness and crisp detail of a carving in marble; it is in fact that rare thing in terracotta – a direct, careful copy of a particular statue'.[40] As is well known, Ashmole hypothesised that this figure and its slightly inferior relation are copies of the statue of Persephone that he presumed accompanied the Demeter: the small marble statuette of Persephone found near the Demeter[41] he judged a more distant version of the same type. This terracotta is a version of a popular sculptural type which appears to have originated on the Greek mainland, probably in Attica, and is known as the 'Praxitelean Kore': it is embodied in the figure of one of the Muses on the Mantineia Base and in that of Persephone on a well-known type of Eleusinian votive relief, and free-standing versions of the type are also numerous.[42] Not infrequently, as is the case with the Eleusinian votive reliefs, and with three figures from the Coan Kyparissi Amaniu group, the type may definitely be used for Persephone. That she could, however, be used for other purposes too is perhaps suggested not merely by the Muse on the Mantineia Base, but also by the second terracotta example which, though obviously deriving from the same basic figure, seems less likely to have been a Persephone than a hydrophoros, since her right arm was apparently raised above her head. As regards the larger and finer of the two figures, given the context of the Sanctuary of the Underworld Deities, Newton and Ashmole may well have been right in identifying her as Persephone. It may, however, be asked whether Ashmole did not go too far in suggesting that she copies a statue that stood beside the Demeter. If the two are seen side by side (Figs 133–5), the resemblances between the treatment of the drapery in the upper part of the body – the feeling for volume stressed by Ashmole – are immediately obvious. But are they not *too* great? Might the figures have looked a little repetitious, even tedious, set side by side?

Just as there is no way of knowing whether the Demeter herself is a cult statue or a votive offering, so there is no certainty that she was ever accompanied by a full-sized image of her daughter. Supposing that she was, however, perhaps a more contrasting type might have been thought more suitable; and one possibility is presented by the terracotta shown in Figure 109. The type represented here is often referred to as a Hygieia, but by omitting the distinguishing snake of

that goddess it could perfectly well be adapted for other youthful deities too, including Amphitrite, as in the well-known example from Melos, or Persephone herself, as is demonstrated by an example recently excavated at Kallion.[43] Returning to the Cnidian version, it could be argued that her simpler, appropriately youthful-seeming and less tortured drapery would perhaps form an effective contrast with that of the Demeter.

A proper evaluation of the terracotta production of Halicarnassus and Cnidus will of course have to await the full publication of the later and continuing excavations of each site.[44] Even then, the exact nature of the links between these sculptures in terracotta and their marble counterparts is likely to remain obscure, though it seems probable that they were more complex than Ashmole claimed. It is possible that eventually properly recorded archaeological contexts of terracotta finds, either here or elsewhere, may throw some light on the production and original function of such terracottas as these. In the meantime we can do little more than speculate. Certainly at Cnidus and very probably at Halicarnassus, the terracottas discussed here were dedications or votive offerings, rather than sculptors' models. We might, however, imagine that terracottas like these, if not these particular pieces, could have been such models. We might, at all events, be prepared to consider that these cheap, easily portable, easily reproducible pocket-sized sculptures may have played an important part in the diffusion and familiarisation of sculptural types across the Hellenistic world. Such hypotheses are currently unprovable. But we should at least be prepared to consider the idea that some terracottas are sculpture too, and to accept that those illustrated here deserve to be included in any overall consideration of the late classical and Hellenistic sculpture of Caria and the Dodecanese.

ACKNOWLEDGEMENTS

I would like to thank my colleagues Peter Higgs and Ian Jenkins for their help and encouragement in the preparation of this paper, and in particular for drawing numerous sculptural parallels to my attention. I would also like to thank all the participants at the Colloquium who offered helpful remarks and criticism.

NOTES

1. For the techniques used for creating sculpture in bronze and marble, see A. Stewart, *Greek Sculpture* (New Haven and London 1985) 34–6; this includes a brief discussion of the question of models, and references to sources. Among the epigraphic sources is *IG* IV², I, 102, which records payments made to various sculptors working on the temple of Asclepius at Epidaurus, including 900 drachmas for *typoi* for one of the pediments, paid to the Mausoleum sculptor Timotheos; for further discussion of this inscription see G. B. Waywell in this volume.

2. B. Ashmole, 'Demeter of Cnidus', *JHS* 71 (1951) 13–28; for Appendix II, 'The Lost Statue of Kore', see pp. 25–8.

3. For a recent discussion of the origin of the 'Tanagra' style and the hypothesis of its derivation from the coroplasts' desire to tackle the same problems that preoccupied contemporary sculptors, see M. Bell, 'Tanagras and the Idea of Type', in *Harvard University Art Museums Bulletin* I no. 3 (Spring 1993), *Proceedings of the Symposium Greek Terracottas of the Hellenistic World, The Coroplast's Art* 39–53.

4. S. Besques, 'Un atelier de coroplathe à Cyrène au IIIᵉ siècle avant J.-C.', *RLouvre* 5/6 (December 1988) 370–77.

5. For a recent discussion of the terracottas of Myrina, with full bibliography, see J. P. Uhlenbrock in J. P. Uhlenbrock (ed.), *The Coroplast's Art* (New York 1990) 73–6. For a discussion of the relationship between sculpture and terracotta elsewhere in Hellenistic Asia Minor, see E. Reeder, 'Some Hellenistic Terracottas and Sculpture in Asia Minor', ibid., 81–8.

6. The best accounts of these excavations are to be found in *HCB* II, part I, *passim*, and in the dispatches written from the site contained in *Dispatches* (1858) and *Dispatches* (1859).

7. For excavations in the Field of Chiaoux see *HCB* II, part I, 325–32, with the quotation on p. 327.

8. Compare, for example, those excavated in a Demeter sanctuary in the town of Rhodes, published by E. Zervoudaki, 'Vorläufiger Bericht über die Terrakotten aus dem Demeter-Heiligtum der Stadt Rhodos', in S. Dietz and J. Papachristodoulou (eds), *Archaeology in the Dodecanese* (Copenhagen 1988) 129–37 (a hydrophoros is illustrated on 132, fig. 3); see also, with a list of Demeter sanctuaries where hydrophoroi occur, R. A. Higgins in J. N. Coldstream (ed.), *Knossos: the Sanctuary of Demeter* (Oxford 1973) 68–70.

9. This inscription is now in the British Museum, GR 1857.12–20.412; it is described by Newton in *HCB* II, part I, 330, and published and discussed by G. Hirschfeld, *The Collection of Ancient Greek Inscriptions in the British Museum* IV (Oxford 1893–1916) 79, no. DCCCCIII.

10. R. A. Higgins, *A Catalogue of the Terracottas in the Department of Greek and Roman Antiquities, British Museum* I (London 1954) nos 301–522. In the Catalogue (102) the deposit was dated 'roughly from 480 to 350 BC'; this estimate was slightly revised by Higgins in *Greek Terracottas* (London 1967) 66 to 'around 500 to about 330 BC'.

11. For the historiography of terracotta collecting and appreciation, see J. P. Uhlenbrock, 'The Study of Ancient Greek Terracottas: a Historiography of the Discipline', in *Harvard University Art Museums Bulletin* I, no. 3 (see supra

n. 3) 7–27; for the Tanagra phenomenon, see also R. A. Higgins, *Tanagra and the Figurines* (Princeton 1986), especially 163–78.

12. The quotation is from *HCB* II, part I, 93; see also *Dispatches* (1858) 12. F. Højlund, *The Maussolleion at Halikarnassos, I, The Sacrificial Deposit* (Copenhagen 1981) 41–3 discusses Newton's account of the discovery of these terracottas in the general context of the sacrificial deposit later excavated on this spot. Although Newton had thought the context undisturbed, the later excavators believe there had been some disturbance in antiquity, so that the find-spot offers no assistance with the date of the terracottas.

13. *HCB* pl. LX, fig. 5.

14. For illustrations of the heads of the Aphrodite from Tralles and the Venus de Milo, see A. Pasquier, *La Vénus de Milo et les Aphrodites du Louvre* (Paris 1985) 83, 13.

15. *TD* II, 99.

16. *Dispatches* (1858) 31.

17. *HCB* II, part I, 126; *TD* II, 203.

18. *HCB* pl. LX, figs. 1, 2, 3, 6.

19. GR 1857.12–20.259 (Sculpture 1051), Waywell (1978) pl. 16, no. 30.

20. The preserved copies of the contemporary Aphrodite of Cnidus present this same, very striking, characteristic; see, for example, Pasquier (supra n. 14) 57.

21. These will all be included in L. M. Burn and R. A. Higgins, *A Catalogue of Terracottas in the Department of Greek and Roman Antiquities, British Museum* III (in preparation).

22. Compare, out of numerous possibilities, an example of the type excavated at Troy, D. B. Thompson, *Troy, the Terracotta Figurines of the Hellenistic Period* (Princeton 1963) pl. XXXII, no. 154.

23. Cos Museum no. 18. Kabus-Preisshofen (1989) 251–3, no. 58, pl. 61, 3.

24. Cos Museum no. 13. Kabus-Preisshofen (1989) 233–6, no. 51, pls 19, 1–2 and 20,1.

25. For examples of this feature in Rhodian sculpture, compare Linfert 92, pl. 39, fig. 200, no. 307, or Rhodes Museum E 347, *ASAtene* 54 (1979) 75, fig. 48; compare also the figure of Isis found on Delos, R. R. R. Smith, *Hellenistic Sculpture* (London 1991) fig. 312.

26. For testimonia and discussion of the Mausoleum in antiquity and later history, see Jeppesen and Luttrell.

27. See *HCB* II, part 2, 375–425.

28. See *HCB* II, part 2, 411–12; also D. M. Bailey, *A Catalogue of Lamps in the British Museum* I (London 1975) 124–5.

29. *HCB* II, part 2, 379.

30. For these, see supra n. 10.

31. *Dispatches* (1859) 14.

32. *TD* II, 197–8. E. Diehl in *Die Hydria* (Mainz 1964) 187–93 discusses hydriai and hydrophoroi in the context

of Demeter and Persephone sanctuaries, and suggests the function of the hydria is to carry water for the bridal bath of Persephone.

33. *HCB* II, part 2, 378–9.

34. Compare, for example, the way that the black-figure technique was retained for the decoration of vases used in particular traditions and rituals long after it had been generally superseded by that of red-figure; black-figured lekythoi were placed in graves well into the fifth century BC, while black-figured Panathenaic amphorae were still made until the end of the fourth century BC.

35. *TD* II, 190.

36. R. A. Higgins, 'An Unusual Polychrome Vase', in U. Höckmann and A. Krug (eds), *Festschrift für Frank Brommer* (Mainz 1977) 175–7, pls 47–8.

37. For the place of the cista in the cult of Demeter, see F. Lenormant in DarSag *s.v.* 'cista'. Demeter is shown seated on a cista in various fourth-century BC representations, for which see H. Metzger, *Recherches sur l'imagerie athénienne* (Paris 1965) 34–6, 41–4.

38. Ashmole (supra n. 2).

39. *HCB* II, part 2, 396–7.

40. Ashmole (supra n. 2) 26; *BMCS* II, 1300.

41. GR 1859.12–26.43 (*BMCS* II, 1302), Ashmole (supra n. 2), pl. x,e.

42. The original of the 'Praxitelean Kore' is believed to have been the statue that, along with images of Demeter and Iacchos, stood in a temple near the Dipylon Gate of Athens, mentioned by Pausanias (1.2.4). For the Mantineia Base, see W. Amelung, *Die Basis des Praxiteles aus Mantinea* (Munich 1895), frontispiece; the type is embodied in the left-hand figure of fig. II; see also Stewart (n. 1) fig. 492. For the appearance of the type on an Eleusinian votive relief, see *ClRh* v.2, 184, fig. 155. For the Kyparissi Amaniu group, see R. Kabus-Preisshofen (1975).

43. For this type of Hygieia, see *LIMC* V (1990) *s.v.* 'Hygieia' nos 61ff. (F. Croissant); for the Melos Amphitrite (Athens, NM 236) see Linfert pl. 53, figs 279–80; for the Persephone from Kallion, as yet unpublished, see *BCH* 117 (1993) 443–4.

44. The terracottas, along with the pottery, found during the Danish excavations of the Mausoleum site are, as yet, almost all unpublished. Iris Love's excavations at Cnidus between 1967 and 1972 yielded large quantities of terracottas, some of which have been illustrated in her interim reports; for these see I. Love's last bulletin, *AJA* 77 (1973) 413–24 and n. 1 for bibliography of previous reports.

11

The Cnidian Aphrodite

Antonio Corso

Praxiteles was born around the year 395 BC. His artistic education in bronze and especially in marble sculpture in the workshop of his father Cephisodotus the Elder must be dated in the early 370s.[1] As is widely known, artists in antiquity began working when they were very young.[2] Praxiteles' work in sculpture is attested from 375 BC,[3] and the background to Praxiteles' future greatness in art and his consequent fame, culminating in the Cnidian Aphrodite, must be seen in the context of the years between the 370s and the 360s. In this period, Phokion, one of the most eligible and promising upper-class youths of Athens, married the sister of Cephisodotus the Elder and became Praxiteles' uncle.[4] Probably, already in this period, Praxiteles' family was quite rich and socially respectable because of its connection with Phokion's family. In fact, its workshop was, at the period when it produced Eirene with Ploutos, surely the most famous and prestigious bronze statuary workshop in Athens, and we know that Praxiteles was probably already one of the 300 richest men in Athens and obliged to pay the *leitourgiai* (public dues).[5]

Phokion became a follower of Plato when he was very young,[6] and it is clear that in classical Athens such connections were not purely personal, but were important for all the *oikos*. Thus, we can see the Platonic conception of deities as archetypes transcending mundane reality in the most famous creation of Cephisodotus, the Eirene with Ploutos (Fig. 136).

Another important characteristic of this family of sculptors was its oligarchical orientation, evidenced in the fact that the work of the most important masters of this workshop was commissioned by oligarchical institutions.[7] Already in Cephisodotus' day, one of the oligarchical centres related to this workshop was Thespiai. Cephisodotus made two sculptural paratactic groups of Muses for the Mouseion on Mt Helikon, then in the land of Thespiai. The first he made when young, in collaboration with Strongylion and Olympiosthenes, the second completely by himself. So, when the Thebans expelled the Thespian oligarchs in 371 BC or a little before, it was natural for a Thespian family that had fled to Athens to have close relations with a family which was even earlier considered to be a friend of the Thespians. One of these Thespian refugees was the young Phryne, who became the lover of Praxiteles towards the middle of the 360s.[8]

Praxiteles' love for Phryne was of central importance for his conception of art. This was not a unique occurrence: we cannot forget the importance for Polygnotus of his love for Elpinike, sister of Cimon, whom he depicted as the Trojan Laodike in the Painted Stoa,[9] and the importance for the art of Pheidias of his loves for Agorakritos in Athens and Pantarkes in Olympia.[10] But in the late classical period, the age of Pausias and Glykera,[11] Praxiteles and Phryne, Apelles and Lais and later Pankaspes,[12] the love affairs of the artists became a means of expressing through the figurative arts the results of their inner thoughts, feelings and experiences. In this period subjective experience and personal, inner spirituality were important foci of interest. Belief in the centrality of Love and Beauty in the cosmos and in human existence is related to the growth of a hedonistic spirit in the years between Aristippus of Cyrene and Epicurus. Aphrodite and Eros became important, accordingly, as personifications of forces operating in human society.[13]

We know from the written critical tradition that Praxiteles conceived of Aphrodite and Eros essentially as personifications of Beauty and Love, believing he was creating these absolute entities out of his personal experience, with his own feelings of Beauty and Love. Through his knowledge of his inner soul he gained access to these gods, and thus was able to define true images of these gods. They were true because they were consequences of his subjective knowledge of absolute archetypes. His Platonic education is shown by his attempt to surpass mere *mimesis* by translating the absolute forms of the gods into artistic representations.

Praxiteles' models, from which he selects what is closest on earth to ideal heavenly Beauty, are usually girls with whom he is in love. These real-life emotional experiences with actual beauty enable him through his art to approach the ideal beauty of the gods. Platonically, Praxiteles' incomparable abilities as sculp-

tor carry into the real world some traces of the eternal forms that pre-existed the reincarnation of his soul. Through *phantasia* (divine apprehension), it is possible to go from the traces and inner feelings, which form the basic knowledge of absolute entities, and from the choice of single fragments of beauty existing in the mundane world to the sapient forms of the gods.

Praxiteles' art is devoted much more to representations of the gods (*agalmatopoiia*) than to human images (*andriantopoiia*), and the artistic conception mentioned above is the reason for his working much more in marble sculpture than in bronze, in which respect he differed from his father. Marble-working is a process of removing superfluous material, in order to discover the form of a statue already contained inside the marble, while bronze sculpture involves the construction of a figure that did not exist before. In other words, marble sculpture is consistent with the idea of sculpture as a discovery rather than as a creation. This ambitious claim to be able to recognise the ideal forms of the gods can be connected with Praxiteles' character, as portrayed in written sources: he was proud and thought that the public would passively accept the creations of wise artists. This liberal conception of the arts, his proud character, his economic prosperity, and his fame as a well-established sculptor made it possible for Praxiteles often to work not only for specific clients, but also to make statues for sale in his workshop, or as gifts for those he loved, or simply to work on them in pursuit of his own inner searchings.[14] It is not surprising, given the importance of his feeling for *agalmatopoiia* and the centrality of the deities of Beauty and Love in religion and in the social life of this period, that Aphrodite and Eros are favourite themes of Praxiteles' spiritual explorations.

Eros with a Bow (Fig. 137) is already a very important statue described by Callistratus, and this description has made it possible to identify it as the prototype of the copies of the Farnese–Steinhäuser type.[15] Callistratus also tells us that Praxiteles portrayed Eros because he had fallen under his power and felt completely dominated by him, considering him to be a *tyrannos*. It may be suggested, therefore, that he started out from his personal inner feeling about the god in order to represent him, as we know from Callistratus, as a 'boy in the bloom of youth', 'dainty verging on plumpness', 'supple', 'with a glance that was at once ardent and gentle and showing passion', with a delicate S-shaped posture and luxuriant locks, showing the 'brightness of youth' and with a suggestion of 'softness'.

A clear antecedent, however, of the Cnidian Aphrodite was the paratactic group of Eros, Phryne and Aphrodite. Phryne was placed in the middle because she was the medium between the sculptor and the absolute personifications of Love and Beauty. Praxiteles knew Love through his personal feeling for Phryne, and he knew Beauty again through Phryne, who was considered the most beautiful girl in Greece: she was the least imperfect example of beauty in the mundane world, and thus the best medium by which to convey the heavenly beauty of Aphrodite. This composition, dated to 366–365 BC, was a gift of Praxiteles to Phryne, who dedicated it in the shrine of Eros at Thespiai.[16] Praxiteles composed an epigram inscribed on the base of Eros: he claimed to have represented exactly the Eros of his own suffering, taking the archetype from his own experience.[17] There is in the figure of Eros, in the reported words of Praxiteles, his entire internalised conception of the god as an emotion experienced by the subject. This is probably the idea of love as suffering, derived from Euripides. For this reason I believe the Thespian Eros is the prototype of the precious and sad Centocelle type of Eros (Figs 138–9).[18]

According to Leonidas of Tarentum, Praxiteles had known Eros through his relationship with Phryne and took his idea of the god from this archetypal experience.[19] The psychological effect of this statue on its viewers is well expressed by other epigrammatists, who claimed that it expressed love not as sex, but as desire,[20] and that Eros was represented as the most powerful god.[21] Both the hetaira Phryne and the goddess Aphrodite are represented on a coin of Thespiai (Fig. 141): the head of Phryne can be recognised in the type from the Street of the Tripods in Athens (Fig. 140), and her beauty clearly provided a model for the absolute beauty of Aphrodite as portrayed in the statue of the goddess which can be recognised in the Arles type (Fig. 142).[22] We know from Alciphron that Praxiteles was uncertain of the correctness of putting a hetaira between two gods, but Phryne had reassured him in a letter, justifying it with the claim that he and Phryne had made these two gods with their love, meaning that the experience of love and beauty was the point at which the discovery of these deities began.[23]

The time was ripe for a superb sculptor like Praxiteles to try to represent the goddess in all her beauty, as an absolute entity: the result was the Cnidian Aphrodite. The statue must be dated to the years 364–361 BC, the high point of Praxiteles' career. We know from Pliny that it was made at the same time as the Coan Aphrodite, which must be dated a little later than the new foundation of Cos in 366 BC, it being usual for the peak of an artist's career to be identified with his most famous work.[24]

Praxiteles' ambitious claim that the divine beauty of

the goddess could be translated into terms of human beauty was based on the notion that other men before him, like Paris, Anchises and Adonis, had seen Aphrodite in her true naked form. Particularly important for him was the example of the Judgement of Paris.[25] We have seen that in order to arrive at the beautiful form closest to divine perfection it is necessary to take the least imperfect example of earthly beauty and, because a personal knowledge of beauty is possible through one's inner feeling, it is better to employ examples which provoke this feeling. For this reason, Praxiteles used as his models two hetairai who were also his lovers: Phryne for the goddess' body and Kratine for Aphrodite's head.[26] Through these examples, and especially the *itinerarium in deam* described above, Praxiteles obtained direct inspiration for his goddess.[27] It is well known that the infusion of a divine or heroic subject into a statue was often obtained in classical antiquity through magical practices, which assured the epiphany of the subject portrayed into the portrayal.[28] In the case of Aphrodite, as we are told in an epigram attributed to Plato, this was supplied through the iron chisel used for making the statue and for representing the beauty of the goddess. Iron, it is perhaps worth remarking, was the symbol of Ares, Aphrodite's lover.[29] The marble used was Parian,[30] Praxiteles' favourite, especially for expressing figures of particularly high beauty, including the Thespian *Eros*,[31] and generally considered in classical antiquity to be of the best available quality.[32] The choice of this marble by Praxiteles perhaps also depended on a belief that, particularly in Parian marble, stone statues of deities were, so to speak, immanent, awaiting the sculptor's removal of superfluous material and the release of these natural works of art (see n. 32). The statement of Cicero, 'in omni marmore sit inesse ... Praxitelia capita', confirms that such an endeavour was already labelled Praxitelean in the middle Hellenistic period. (Cicero attributes a reflection about it to the academic philosopher Carneades.)[33]

The Cnidian Aphrodite of Praxiteles, identified from coin representations (Fig. 143), can be appreciated in copies, of which at least sixty-seven examples survive. The copies are divided into two sub-types, named after well-known examples, the Belvedere and Colonna (Figs 144-5, 157-9). The Belvedere is closer to the figure on the Cnidian coins than the Colonna sub-type, and may be seen as truer to the form of Praxiteles' creation, while the second would appear to be a later reinterpretation following the same iconography. Aphrodite is represented bending to pick up her garment after she has washed herself in a spring, probably in a forest, the *topos* where Praxiteles' deities are

usually placed. Bathing clearly has the function of purifying and regenerating the goddess, and her nakedness is also intended to express a state of primordial purity thus regained. Having completed her bath the goddess, returned to her primordial purity, becomes a *paradeigma* to mortal men. They, as we know from several sources (see nn. 14 and 25), especially the *Erotes* of Lucian, being themselves regenerated by a vision of absolute Beauty, can transcend vulgar love and turn to the heavenly one. The small kalpis on the left side of the goddess would probably have contained the perfumes with which she has anointed her skin, a very apparent symbol of purification. The act of covering her pubis with a hand is possibly related to her bathing in an open space, signifying her fear of the gaze of strangers such as the mythical inhabitants of the forest, or heroic personages such as Teiresias or Acteon, who have seen other bathing goddesses. The shielding of her pubis, the source of life, with her right hand could perhaps mean a very favourable *fecundatio mundi*.

From a formal point of view, the Cnidian Aphrodite is conceived as being viewed from the front and the back, but not from the two sides: the statue consequently lacks a sense of space and three-dimensional quality. This absence of space is typical of other sculptures attributed to Praxiteles: see for example, in the two decades 370 to 350, the Wine-pouring Satyr, the above-mentioned Thespian statues, the Eros with a Bow, the Apollo Sauroktonos and the Resting Satyr (Figs 146-8).[34]

In the case of the Cnidian Aphrodite, the absence of space emphasised the function of her complete nakedness, and particularly the importance of her back as suggestive of seduction. The goddess was conceived as standing at the same time on two different stages, pictured from the front and back. This conception of the figure reflects a theatrical approach, reducing the statue to two viewpoints only, clearly a more pictorial than sculptural idea of sculpture. It is possible that Praxiteles was influenced by his numerous commissions relating to the theatrical life of Athens, and especially for choregic monuments (see n. 34).

The stance of the goddess shows a sinuosity more pronounced than in the early works of Praxiteles – compare especially the Eros with a Bow, the Wine-pouring Satyr and the Thespian statues – but also less pronounced than works of his full maturity, such as the Apollo Sauroktonos and the Resting Satyr. Nor is the jar and drapery merely a static support for part of the figure – as in the cases of the leaning Sauroktonos and the Resting Satyr. This feature puts the Cnidian Aphrodite in the late 360s, later than the Eros with a Bow and Praxiteles' other early works of the early

360s, but before the two main works of his full maturity, the Sauroktonos and the Resting Satyr.

Concerning the anatomy, Alessandro Della Seta in particular, in his essential book *Il nudo nell'arte*, has shown the direct derivation of most of it from the actual young female body, confirming the ancient tradition of Praxiteles' inspiration from young female models.[35] However, a part of her anatomy, especially the back, is derived from the male body, the focus of the *Erotes* attributed to Lucian.[36] This mix of the principal female features with minor male ones perhaps has the function of achieving an ideal beauty, transcending both the sexes. From Lucian's *Erotes*, it is known that the lovers of boys also recognised their erotic taste in the Cnidian Aphrodite.

The stylistic rendering is quite different in the Belvedere and Colonna sub-types. The Belvedere shows a moderate softness of surface, while the Colonna shows a much more advanced rendering in treating the various surfaces as a continuous series of transitions. Consequently, the Belvedere sub-type fits in with Praxiteles' work of the late 360s BC, between the Wine-pouring Satyr and the Centocelle Eros on the one hand, and, on the other, the Resting Satyr and other later creations. The Colonna sub-type rendering cannot be dated before 340–330 BC, because the mutation of the body's structure is here too pronounced. On the basis of the numismatic evidence, I believe that the Belvedere sub-type gives the true features of Praxiteles' creation and that its treatment confirms the dating of the Cnidian Aphrodite I have proposed. The promising young painter Nicias probably coated the surfaces with wax, in order to produce a continuous mixture of light and shade, conveying the impression of flesh-colour.[37]

According to this interpretation, the goddess' appeal lay in her dreamy, magical sense of physical presence. Having completed it, Praxiteles put the statue up for sale in his workshop. The Coans, who had asked him for an Aphrodite, refused to take it for moral reasons, as we know from Pliny, preferring instead a draped Aphrodite which, in my opinion, was the prototype of the draped Richelieu Aphrodite, declared to be by Praxiteles in an inscription (Fig. 149).[38] The Cnidians, who had also asked the Athenian master for an Aphrodite, accepted this naked version, possibly because the bathing *topos* was taken as an allusion to Aphrodite as Euploia, and also perhaps because at Cnidus Aphrodite had already formerly been conceived in terms of the naked Phoenicio-Cypriot Astarte.[39]

The Cnidians placed this statue as a votive offering[40] in their shrine of Euploia Aphrodite. I accept the identification of this shrine with the site excavated by Iris Love: the configuration of the site in the Hellenistic and Imperial periods perfectly matches the literary allusions to the shrine, and especially the description of it in the *Erotes* attributed to Lucian. A cylindrical marble monument with a very damaged inscription was found at the shrine and seems to refer to Praxiteles, and to something 'naked' and 'standing above' (Figs 150–51).[41] The worship of Athena in the area immediately west of the round temple, identified as the shrine of the Praxitelean Aphrodite, does not immediately contradict this proposal, because the presence of Athena and Hera in the shrine of the Cnidian Aphrodite is indicated by the epigrammatical *topos* of these two goddesses as guests of Aphrodite in her Cnidian shrine and near her statue.[42] In the same area as the Hellenistic round temple of the Cnidian Aphrodite, limestone column drums were discovered belonging to an earlier phase of this building, probably of late classical times. There is also a late classical epigram about the Cnidian Aphrodite mentioning that it was possible to view the masterpiece 'completely, and in a place where it could be admired all around'.[43] Both suggest that the Cnidians built a circular temple and placed the statue in the middle of it. It is also probable that there was a protective wall around the statue, for the following reasons: first, evidence has been found for the existence of a protective wall around the statue in the Hellenistic period; second, the statue with its delicate refinement and its *ganosis* could hardly have stood without some protection; and third, the description of the temple in Lucian's *Erotes* makes clear reference to a wall around the statue. Moreover, Lucian's description comes into his story of a man's love for the statue, and this incident probably occurred before the building of the new temple in the middle Hellenistic period. The order of this temple was Corinthian, which in Callimachus' day was thought to express girlish beauty.[44]

Praxiteles' masterpiece received a very warm welcome, especially in Platonic circles: in two epigrams attributed to Plato, it is recognised that the concentration of the sculptor transcends *mimesis* to attain the true beauty of the goddess. This *topos* became traditional in later epigrams.[45] The statue's immediate fame perhaps led to the Athenian sculptor being granted Cnidian citizenship, because in a late tradition he is called Knidios.[46] After the Cnidian Aphrodite, however, Praxiteles increasingly turned towards a conception of Aphrodite in worldly terms. The hetairai were no longer simply the way by which he could make contact with Aphrodite, but the mirror through which it was possible to see the goddess present in earthly life, in her actual, constant role in human society.

A bronze Aphrodite, probably the Pseliumene,

identifiable in my judgement with the Pourtalès type (Fig. 152), and dated perhaps to the decade of the 340s BC, was refused by the Spartans, because of its hetaira-like features.[47] The Phryne-Aphrodite of Delphi, perhaps to be identified with the Townley type (Fig. 153), and dated to 336–335 BC, gives a coherent interpretation of the goddess of love as the permanent model of the hetairai and for this reason provoked the anger of the Cynics.[48] This conception of the goddess in worldly terms is also apparent in the case of the Leconfield Aphrodite, possibly related to the Aphrodite of Alexandria in Caria and accordingly dated to 334 BC (Fig. 154).[49] Art tourism to Cnidus to see its masterpiece started immediately after the erection of the statue (see n. 45). Sacred prostitution in the shrine of Cnidian Aphrodite,[50] moreover, attracted many lovers to Cnidus. The cult involved the assertion of love for the statue by distinguished men, usually of noble blood.

The first of these love affairs happened in Menander's time, when the famous courtesan Ischas, a symbolic name meaning 'vulva', was in the Cnidian shrine. It seems that some visitors were tempted not just to look at the statue, but to try to make love with it, forgetting the medium of the sacred prostitutes. Earlier Phryne herself had suggested such physical love between men and *agalmata* (probably still in the 360s, see n. 23). The declaration in the shrine of Eros at Thespiai of Phryne as a *synnaos* and a *synhieros* of Eros,[51] attenuating the distinction between an exceptionally beautiful hetaira and Aphrodite, indeed helped the full development of this conception of Aphrodite as a sort of permanent hetaira with whom it was possible to make love. Of course, the boldness of loving the goddess was possible only for the nobility. In Menander's age (320 to 290 BC), Macareus from Perinthos fell in love with the Cnidian Aphrodite and wanted to set fire to the naos of the Cnidian goddess, in clear imitation of Herostratos, who had set fire to the Ephesian Artemision in 356 BC. Macareus satisfied his desire, but with the sacred courtesan Ischas as a medium for Aphrodite.[52] A later epigrammatist was probably alluding to this episode when he claimed that Cnidian Aphrodite was able to set fire even to stone.[53]

In around 260 BC, Cnidus suffered from a huge financial deficit, and Nicomedes I, King of Bithynia, wanting to give artistic importance to his newly founded capital of Nicomedia, offered to pay the Cnidian deficit in exchange for Praxiteles' masterpiece. The Cnidians refused,[54] and the king commissioned another bathing, naked Aphrodite from the Bithynian sculptor Doedalsas (Fig. 155).[55] Cicero was probably alluding to this episode when he claimed that the Cnidians would never give up their Aphrodite for any price.[56]

It was probably in the second half of the third century BC that a man, having fallen in love with the statue and hidden inside the temple by night behind the door when it was locked, ravished the statue, leaving a stain on the goddess's thigh and, after this sacrilegious act, committed suicide.[57] The history of the statue and the gossip about it was finally collected by Poseidippus of Cnidus, in his antiquarian book on this city, dating perhaps to the beginning of the second century BC.

In about 200 BC the previous round temple was replaced by a more magnificent one, and the statue was placed on a large base. The cylindrical marble monument mentioned above, with an inscription apparently referring to Praxiteles and a naked figure standing above, was probably the base of a small votive offering dedicated by one of the many lovers of this goddess (see n. 41). This new temple of the Cnidians, which seems to have been in existence until late antiquity, made it impossible to walk around the statue and obliged visitors to view the goddess from just two viewpoints – frontally, upon entering the temple from the front door, and then, after having gone outside the temple and entered again through a rear door, behind, contemplating her back. These precautions, about which we are informed in Lucian's *Erotes*, were probably aimed at avoiding other possible incidents between men and the statue. The large high base would also have served not only to give an imposing presence to the statue, but also to distance visitors from the masterpiece.

In the middle Hellenistic period, the rise of the neo-classical conception of the figurative arts, and especially the tendency to see the early classical age as their high point, brought about a devaluation of the Cnidian Aphrodite. Epigrammatists of this period stated that the Praxitelean masterpiece was very much inferior to a Pheidian Athena on the Acropolis of Athens, identifiable with the Athena Promachos.[58]

I should place at this time the recreation of the Cnidian Aphrodite in copies represented by the Venus Colonna type, the first example of which, the Tralles' Head, should be dated to the third quarter of the second century BC (Fig. 156). The two fillets in the hair, which diverged in the original creation, are now arranged parallel to each other, more in accordance with neo-classical taste; the small kalpis now becomes a large hydria and is placed on a high base, a solution possibly responding to the baroque taste current in Asia Minor.

The treatment of the surfaces as a series of tran-

sitions is much more pictorial, possibly echoing contemporary Rhodian sculptural style. In this new interpretation, the goddess is no longer represented bathing at a spring, but in an artificial environment, suggested by the high base under the jar of water and by the idea that she is bathing not in running water but with water collected previously.[59] Thus the naturalistic meaning of the Praxitelean creation, typical also of Praxiteles' other important works (e.g. the Thespian triad; Sauroktonos; Resting Satyr), was lost in its modernisation.

In late Republican and early Imperial times this statue continued to be one of the most popular of those by the ancient masters, even if common opinion considered Praxiteles second after Pheidias in *agalmatopoiia*.[60] It is very significant that under Domitian, in the prevailing spiritual climate of that period, Apollonios from Tyana (if the notoriously untrustworthy authenticity of his activities is accepted) put an end to the phenomenon of the Cnidia's lovers. Considering it based on the vulgar mythology of goddesses in love with men and not on a spiritual conception of the deities, he persuaded the last lover of the statue to repent of his intentions.[61] During the so-called Second Sophistic (second century AD), the Cnidia was much loved, being considered a symbol of the beauty of ancient Greek art and in keeping with the widespread nostalgia for the so-called hetairai civilisation of the age of new comedy.[62] After the Severan period, during the great crisis of pagan culture, the Cnidian Aphrodite is rarely mentioned,[63] and we can presume that tourism to Cnidus to view the statue was interrupted.

However, after the Diocletianic restoration of the *securitas imperii* and with the so-called pagan renaissance of the Julian period, travel to Cnidus to see the statue was resumed.[64] In AD 382 Theodosius I ordered the pagan temples containing statues, admired more for artistic than for religious reasons, to be kept open.[65] Consequently the Cnidian temple would also have been open after that edict. But following the closure of the pagan temples, decreed at the end of the year AD 392,[66] the problem of moving statues thought to be of important artistic value from profane buildings became urgent. This statue and five other ancient Greek ones considered very important from an artistic point of

view were moved to Constantinople, the new imperial capital, and placed in one of the imperial palaces, the so-called Lauseion, probably in AD 393–4; the Byzantine historian Cedrenus refers to this collection in his tract on the last years of Theodosius' empire.[67] The Lauseion was founded by Constantine, as we know from the Pseudo-Codinus,[68] and was imperial property. The ruins north-west of the Hippodrome, sometimes identified with the Lauseion, have been convincingly interpreted as the great imperial triclinium, and it is possible to argue from Byzantine sources that the Lauseion was further west, perhaps on the west side of the Philoxenos cistern (Fig. 160).[69] Theodosius rearranged it as a museum. The six statues reported by Cedrenus were arranged according to the place of provenance: in front were two statues from Doris (the Lindian Athena of Dipoinos and Skyllis, and the Cnidian Aphrodite); then came two statues from Ionia (the Samian Hera of Athenis and Boupalos and the Eros from Myndos by Lysippos), and finally two statues from the Peloponnese (Pheidias' Zeus from Olympia and the Chronos–Kairos of Lysippos from Sikyon). Within each of these three groups of two statues the order was chronological: Dipoinos and Skyllis come before Praxiteles; Athenis and Boupalos before Lysippos; Pheidias before Lysippos). The inclusion of the Cnidian Aphrodite in this series shows that this masterpiece, already attacked by Christian apologists (see nn. 57, 62 and 63), was now preserved and regarded by at least a part of the Christian world as an important work of art. However, the alienness of this Aphrodite to the moral and artistic ideals of the early Byzantine age[70] explains the absence of references to it from the fourth to the ninth century. As we know from Cedrenus and Zonaras,[71] this collection of statues was destroyed by a fire in AD 476, although other antiquities, especially architectural and decorative pieces kept in the Lauseion, were saved (see n. 68. We do not know if the collection of models of fantastic and exotic animals also kept in this museum was saved; see n. 67). The myth of the Cnidian Aphrodite as a romantic symbol of classical beauty, lost for ever,[72] which has continued into modern times, began in the middle Byzantine age, with the rediscovery of ancient Greek art.

NOTES

1. See the reconstruction of this personality in A. Corso, 'Prassitele e la tradizione mironiana: storia di una bottega e di una concezione delle immagini scultoree', *NumAntCl* 18 (1989) 85–117.

2. See especially *IG* III², 9611.

3. *SEG* xxxiii (1983) 440 a-l.

4. See L. A. Tritle, *Phocion the Good* (London 1988) 46.

5. *IG* II², 3089 (inscription of the middle of the second century BC, referring to a choregic monument of Praxiteles, implying he was one of the people providing the leitourgiai. We probably have this monument dated to the 360s: see A. Corso, *Prassitele* i, 25–7 and the article (supra n. I) 103–4); *IG* II², 1628, lines 57–8, 68, 74–5, 111–12; 1629, 674–84, referring to the liturgical status of the elder son of Praxiteles, Cephisodotus the Younger (see H. Lauter, 'Zur wirtschaftlichen Position der Praxiteles-Familie im spätklassischen Athen', *AA* (1980) 525–31).

6. See Tritle (supra n. 4) 9–10, 30, 46, 50–52, 54, 141–3.

7. See supra n. I.

8. See Corso, *Prassitele* i, 224–5, n. 904.

9. Plutarch *Cimon* 4.5–6.

10. About Agorakritos as *cromenos* of Pheidias, see J. Overbeck, *Die antiken Schriftquellen zur Geschichte der bildende Künste bei den Griechen* (Leipzig 1868) 829–30 and 836–9; about Pantarkes as *eromenos* of Pheidias, see Overbeck 696, 740–43, 757.

11. Pliny, *Natural History* 35.125.

12. About Apelles and Lais, see Athen., 13.588 c; about Apelles and Pankaspes, Pliny, *Natural History* 35.86 and Ael., *Var.* 12.34.

13. It is, perhaps, superfluous to suggest quotations. the first clear acceptance of this centrality of Love and Beauty is, notoriously, in Plato's *Symposium*, while the spreading of the hedonistic mentality, focused on the erotic happiness in human society, is encountered in Attic middle comedy and, even more, in new comedy.

14. Sources (supra n. I) 99–100, nn. 61–5. See also, for the unrivalled position of Praxiteles, Iulian. Aeg., *Anth.Pl.* 4.203; Chor., *Decl.* 8.19. For the medium constituted by the phantasy, see Philostr., *Apoll. Tyan.* 6.19.

15. See *Prassitele* ii, 104–106.

16. See *Prassitele* ii, 56–82.

17. Praxit., in Athen., 13.591 a = *Anth.Pl.* 4.204.

18. See *Prassitele* ii, 56–82.

19. Leonid., *Anth.Pl.* 4.206.

20. See *Prassitele* i, inscr. 14; Antipatr. Sid., *Anth.Pl.* 4.167.

21. See Meleagr., *Anth.Pal.* 12.56–7.

22. Supra n. 18.

23. Alciphr. 4.1.3.

24. Pliny, *Natural History* 34.50 and 36.20–21.

25. Plat., *Anth.Pl.* 4.160–61; also 162, 168, 159, 170, 169; Even., *Anth.Pl.* 4.165–6; Luc., *Anth.Pl.* 4.163.

26. See Clem. Al., *Protr.* 4.47; Athen., 13.591 a; Arnob., 6.13; *Schol. Clem.*, *loc. cit.*

27. See especially Pliny, *Natural History* 36.21: effigies deae, favente ipsa, ut creditur, facta.

28. For Praxiteles, see Meleagr., *Anth.Pal.* 12.57; Callistr., 3; 8; 11.

29. Plat., *Anth.Pl.* 4.160; Auson., *Epigr.*, 55 Pastorino.

30. Luc., *Am.* 13.

31. See Meleagr., *Anth.Pal.* 12.56; Petron., *Sat.* 126; Quint. 2.19.3; Paus. 1.43.5.

32. See especially Pliny, *Natural History* 36.14.

33. See Cic., *De Div.* 2.21.48.

34. See my reconstruction of this personality and of his career (supra n. I).

35. See A. Della Seta, *Il nudo nell'arte* (Milan 1930) 307–49.

36. Luc., *Am.* 14–17 and 54.

37. See Pliny, *Natural History* 35.122 and 133.

38. See *Prassitele* i, inscr. 19, p. 31; Pliny, *Natural History* 36. 20–22.

39. See *Prassitele* i, 138, with previous bibliography.

40. Otherwise Nicomedes I could not have asked the Cnidians to buy it from them (see main text of this essay). Furthermore, we know from the coins that a Cnidia was the principal cult statue of Cnidus even before the late classical age (see H. A. Cahn, *Knidos* (Berlin 1970) 19–174), from around 530 BC, which implies the presence of a cult statue at least from late Archaic times.

41. Basic report of the excavation of this shrine: I. C. Love, 'A Preliminary Report of the Excavations at Knidos, 1970, 1971', *AJA* 76 (1972) 61–76 and 393–405; see also L. Closuit, *L'Aphrodite de Cnide* (Martigny 1978) and, for the inscription, *Prassitele* i, inscr. 12, 24–5.

42. Even., *Anth.Pl.* 4.165.

43. Plat., *Anth.Pl.* 4.160.

44. Vitruvius, *De Architectura* iv.1.8–10.

45. Plat., *Anth.Pl.* 4.160–61; see also *Anth.Pl.* 4.159, 162, 168.

46. See Cedr. 322 b. Concessions of citizenship to the artists who had made these cities famous with their works appear with Polygnotos, who enjoyed Athenian citizenship after having painted the Stoa Poikile (Painted Stoa) without payment (Harpocrat. *s.v.* 'Polygnotos').

47. See *Prassitele* iii, 45–108.

48. See *Prassitele* i, 117–22; ii, 14–17 and 35–6.

49. See *Prassitele* iii, 7–18.

50. See Luc., *Am.* 11–12 and Tzetz., *Chil.* 8, hist. 195, 378.

51. Plut., *Amat.* 9.

52. See Tzetz., *Chil.* 8, hist. 195, 378.

53. Antipatr. Sid., *Anth.Pl.* 4.167.

54. Pliny, *Natural History* 7.127 and 36.21.

55. I reconstructed this episode in my article 'Nicomede I, Dedalsa e le Afroditi nude al bagno', *NumAntCl* 19 (1990) 135–60.

56. Cic., *Verr.* 2.4.60.135.

57. See Val. Max. 8.11, *ext.* 4; Pliny, *Natural History* 7.127 and 36.21; Luc., *Am.* 15–17; *Imagg.* 4; Clem. Al., *Protr.* 4.51; Arnob., 6.22. See in *Prassitele* i and ii, the commentary on these passages.

58. *Anth.Pl.* 4.169–170.

59. Bibliography on the Venus Colonna in *Prassitele* iii, 74 and 175, n.1934.

60. For this hierarchy, Lat. Al. 7.3–9. Sources on the Cnidian Aphrodite of the first centuries BC and AD: Cic., *Verr.* 2.4.60.135; Even., *Anth.Pl.* 4.165–6; Val. Max. 8.11, *ext.* 4; Pliny, *Natural History* 7.127; 34.69; 36.20–22 and 26.

61. Philostr., *Apoll. Tyan.* 6.40.

62. See Luc., *Anth.Pl.* 4.163–4; *Am.* 11–17 and 54; *Imagg.* 4 and 6; *Pro imagg.* 8; 18; 22–3; *Iupp. Trag.* 10; Athenag., *Leg. Pro Christ.*, 17, 4; Philostr., *Apoll. Tyan.* 6.19.

63. Only by Arnob. 6.13 and 22.

64. Himer., *Or.* 64.4 and Auson., *Epigr.* 55 Pastorino.

65. *Cod. Theod.* 16.10.8.

66. *Cod. Theod.* 16.10.12.

67. Cedr. 322 b–c.

68. [Codin.], *Patr.Cons.* 2.36.27, B 37–8, 170 Preger.

69. See *Prassitele* iii, 138 and 199–200, n.2610.

70. Zosim. 5.24.6.

71. Cedr. 351 c and Zonar. 14.24.2.52 d.

72. See *Schol. Luc.*, *Iupp.trag.* 10; Areth., *Schol.* Luc., *Am.* 11–12; *Schol.* Clem. *Protr.* 4.47; Constant. Porphyr., *Them.* 1.14.37; Cedr. 322 b–c and 351; Zonar. 14.24.2.52 d; Tzetz., *Chil.* 8, *hist.* 195.368–80; *Cod. Vat. Graec.* 989, Xen., *ult. fol.* 110.

12

Neufunde hellenistischer Skulpturen aus Knidos

Christine Bruns-Özgan

Die Stadt Knidos besass nicht nur berühmte Statuen wie die – sicher verlorene – Aphrodite des Praxiteles, sondern eine stattliche Anzahl weiterer Meisterwerke, von denen ein Teil von Charles Newton im Demeter- und im sog. Musenheiligtum gefunden wurde und heute im Britischen Museum aufbewahrt wird; ein anderer Teil wurde (und wird) erst in neuerer Zeit ausgegraben.

Die hier erstmals vorgestellte Frauenstatue (Figs 161-4) wurde im Jahre 1969 auf der obersten Terrasse des von den amerikanischen Archäologen unter der Leitung von I. Love freigelegten westlichen Abschnittes des Stadtgebietes von Knidos gefunden, wo sie noch heute im Depot-Garten steht.[1] Der exakte Fundort ist ein kleiner rechteckiger Bau, ein 'Schrein', wie ihn I. Love bezeichnete. Seine Funktion ist unklar, doch er liegt im Westen auf derselben Terrasse wie der bekannte Rundtempel, in dessen näherer Umgebung weitere ähnliche Bauten zu verzeichnen sind.[2] Bei diesen könnte es sich um Schatzhäuser handeln, zumal sie ähnlich wie die Gebäude auf der Schatzhausterrasse von Olympia alle nach einer Seite (N-S) ausgerichtet sind. Während diese Schatzhäuser von Knidos allerdings hellenistisches Mauerwerk aufweisen, sind von dem 'Schrein' nur noch die Fundamente stellenweise erhalten, die zudem grösstenteils aus Spolien bestehen. Auch eine Basis aus hellem Kalkstein mit Plintheneinlassung ist dorthin sicher nur in sekundärer Verwendung gebracht worden (Fig. 165); Nachmessungen ergaben, dass sie jedenfalls nicht ursprünglich für die Frauenstatue gedacht war. Die Fundumstände geben also leider keine Auskunft über die originale Verwendung der Statue, sondern besagen lediglich, dass sie zu einer unbestimmten Zeit in diesem kleinen Gebäude aufbewahrt wurde.[3]

Die Statue ist mit 1.80 m erhaltener Höhe deutlich überlebensgross[4] und besteht aus feinem weissem Marmor, der an einigen Stellen rötliche Verfärbungen aufweist. Keine andere der bisher in Knidos gefundenen Skulpturen, einschliesslich der von Charles Newton entdeckten, ist aus diesem kostbaren Material gearbeitet. Der ausserordentlich gute Erhaltungszustand ist sicherlich dem Aufbewahrungsort zu verdanken.

Leider sind wohl beim Sturz der einst eingelassene Kopf zusammen mit grossen Teilen der Oberkörpers – diese sicher durch die Kraft der oxydierten, zum Befestigen der Arme dienenden mächtigen Eisendübel (Fig. 162) – und die Arme selbst fortgesprengt worden und bis auf ein kleines Fragment des Bausches, das im Depot wiederentdeckt wurde, in den Kalkofen gewandert.

Die Frau steht mit dem Gewicht auf dem linken Bein, das rechte ist nur leicht angewinkelt. Sie trägt einen feinen kreppartigen Chiton mit geknöpften Ärmeln, über den sie einen dicken Mantel so geschlungen hat, dass nur ein kurzer Teil des Oberkörpers und unten eine schmale Partie des Chitons unbedeckt bleiben. Die Füsse, von denen nur der linke erhalten ist, stecken in Sandalen mit hoher Sohle. Der Typus ist ungewöhnlich: der Mantel ist in einem dicken, mehrfach übereinander geschichteten Wulst oberhalb der Hüfte, aber deutlich unterhalb der Brust vorn herumgelegt, am Rücken zur linken Schulter hoch und über sie sowie sicherlich über den linken Oberarm geführt und dort zusammen mit dem anderen Zipfel vom linken Unterarm gehalten, von dem die langen Säume herabhingen, wie die Bruchstellen zeigen. Die Armhaltung links und das Gewandmotiv ähnelte also dem der Themis von Rhamnus oder dem einer Statue vom Artemision in Thasos.[5] Doch eine direkte Parallele für den Gewandtypus scheint es nicht zu geben: auch hier zeigt sich also wieder die herausragende Stellung der Statue von Knidos.

Nicht nur motivisch lässt sich die knidische Frauenstatue mit der Themis von Rhamnus vergleichen.[6] Ihre Gewänder sind auffallend ähnlich: der kreppartige, unten steif in senkrechte, z.T. tief hinterschnittene Faltenbündel gegliederte Chiton, und vor allem der schwere Mantel, der seine Dichte durch faltenlose Partien über dem Standbein unterstreicht, während er über dem Spielbein in zahlreichen Falten knittert. Bei beiden Statuen sind auf dem rechten Oberschenkel die gleichen augenförmigen Mulden in den Stoff eingetieft, und ebenso die typischen 'Liegefalten'. Auch der mehrfach geschichtete Mantelbausch kehrt bei beiden wieder, wobei der der Statue aus Knidos jedoch voluminöser ist und deut-

licher hervortritt. Unterschiede gibt es allerdings vor allem im Körperaufbau. Die knidische Figur ist sichtbar schlanker, gestreckter und entschiedener von hochrechteckigem Umriss, da auch ihre Bewegung verhaltener ist; beispielsweise ist die rechte Hüfte nicht in dem gleichen Masse abgesenkt wie bei der Themis, das Knie ist weniger gebeugt und auch der Wulst verläuft gerade. Gleichzeitig ist das Gewand voluminöser, gespannter und mehr von Licht – und Schattenkontrasten bestimmt. Zwischen beiden Werken gibt es also einen Zeitunterschied. Im Körperaufbau näher steht der knidischen Figur die schon oben erwähnte Statue aus Thasos und überhaupt solche Werke, die in das frühe 3. Jh. v. Chr. datiert werden wie die Nikeso von Priene[7] oder die drei Statuen vom sog. Neoptolemos-Bezirk in Delphi.[8] Interessant ist, dass sowohl bei der Frauenstatue aus Delphi als auch bei dem Philosophen ähnliche ovale Faltenmulden auf dem Spielbein wiederkehren, wie sie auch bei der knidischen Figur zu bemerken sind. Aufschlussreich ist auch ein Vergleich der Seiten – und Rückansichten des Philosophen[9] und der knidischen Frau: bei beiden bilden die vom Spielbein zum Rücken hochgeführten Mantelfalten tief hinterschnittene breite Stege, die wie Tellerränder übereinandergestapelt sind, wobei auch hier wieder die Knidierin die grössere Masse besitzt (Fig. 162). Auf der Rückseite (Fig. 163) fallen die sehr flachen Mantelfalten links im unteren Teil auf, während die rechte Körperseite durchaus sorgfältig bearbeitet worden ist. Durch diese Vergleiche ist der zeitliche Umkreis der knidischen Frauenstatue bestimmt worden: sie ist deutlich jünger als die Themis von Rhamnus, deren Datum zwischen 320 und 300 v. Chr. schwankt,[10] etwa gleichzeitig mit den delphischen Statuen, die zuletzt um 300 v. Chr. datiert wurden,[11] aber auf jeden Fall sicherlich früher als die starre, blockhafte Nikeso[12] mit ihren schlichten Falten entstanden. Die Vergleichsbeispiele sagen gleichzeitig etwas über den künstlerischen Umkreis aus, in den die Mantelstatue von Knidos einzuordnen ist. Sie ist allem Anschein nach wenn nicht eine attische Arbeit, so doch deutlich von festländisch-griechischen Werken beeinflusst.[13] Trotz der zeitlichen Entfernung ist eine Bezugnahme auf die Statue der Artemisia[14] sowohl im Typus als auch in der stilistischen Ausführung nicht zu übersehen. Den Gegenbeweis tritt eine etwa gleichzeitige Frauenfigur in Kos[15] an, deren ionischen Charakter R. Kabus-Preisshofen mit Recht betont hat, obwohl doch gerade auf Kos mit den Söhnen des Praxiteles[16] nachweislich attische Künstler belegt sind. Der steifen und spröden Ausführung der koischen Statue steht die lebendige Frische der knidischen Statue entgegen.

Das gut erhaltene Unterteil der folgenden überlebensgrossen[17] Mantelstatue (Figs 166–7) stand in den sechziger Jahren noch auf der mittleren Terrasse, wohl nicht unweit des Apollonaltares.[18] Der dreieckige Mantelüberschlag und vor allem die labile Haltung mit den beiden gebeugten Knien, die nur durch eine Stütze erklärbar sind, belegen, dass es sich um einen der zahlreichen Asklepios-Typen handelt, die seit dem frühen 4. Jh. v. Chr. auf Weihreliefs und in Variationen auch in der Rundplastik zu finden sind.[19] Da ein entscheidendes Merkmal zur Bestimmung des Typus, die eingestützte rechte oder linke Hand, zusammen mit dem ehemals angestückten Oberkörper verloren ist, ist die Zuordnung zu einem bestimmten Typus nicht leicht. Doch da das Körpergewicht eindeutig auf keinem der beiden Beine zu liegen scheint, sondern vielmehr auf einem Stab, der vermutlich den stark nach links geneigten Oberkörper auffing, ist dem Gedanken von E. Schwarzenberg zuzustimmen, der den Torso von Knidos mit dem nach der Statuette aus der Sammlung Este benannten Typus in Verbindung brachte.[20] Die ursprünglich mehr als 2 m hohe Mantelstatue von Knidos stellt also einen Asklepios dar.[21]

Der Typus Este ist tatsächlich noch in anderen Werken aus Knidos vertreten. Ein Kopf in Bodrum beispielsweise (Fig. 168)[22] besitzt die gleiche Haaranlage mit den kurzen Löckchen vorne am Mittelscheitel und den langen, an den Seiten herabfallenden Locken wie die anderen Köpfe der Statuen des Typus Este, deren bekanntester Vertreter der qualitätvolle Kopf aus Melos ist.[23] Auch die Kopfwendung nach links oben entspricht der Statuette Este in Wien.[24]

Die Beliebtheit dieses Typus nicht nur auf dem griechischen Festland und den Inseln, insbesondere in Kos, sondern auch in Knidos zeigt ein weiterer Neufund aus dem Jahre 1989. Der Torso einer grossen Statuette (erhaltene Höhe: 25 cm) (Fig. 169) fand sich verbaut in einer spätantiken Häuserstruktur unweit des Ortes, an dem der kolossale Manteltorso gefunden wurde. Auch dieses Stück ist ausserordentlich gut erhalten. Auffällig ist der aus weichen, zart ineinander übergehenden Muskelkompartimenten gebildete Oberkörper, der in Gegensatz zu dem etwas flüchtig angelegten Mantel steht. Der gleiche Kontrast begegnet bei einer Statuette aus Kos in Dresden[25] die mit 44 cm erhaltener Höhe ursprünglich ein wenig kleiner war als die knidische. R. Kabus-Preisshofen spricht hier von 'Porzellan' und 'gläserner Zartheit',[26] eine Charakterisierung, die auch auf das knidische Stück zutrifft. Es scheint sich um die Stileigentümlichkeit einer Werkstatt von Kos zu handeln, denn noch einige andere Asklepios-Torsen von

dieser Insel[27] lassen sich dieser Gruppe zuordnen. Dennoch gibt es geringfügige Unterschiede zwischen der Statuette aus Kos in Dresden und der in Knidos. Diese ist nämlich steiler aufgerichtet – sichtbar etwa am Nabel, der weniger nach rechts verschoben ist – und das Inkarnat ist ein wenig flächiger angelegt. Der knidische Torso ist daher offenbar später als der aus Kos entstanden.[28] Auf jeden Fall wird die enge Verbindung von knidischen und koischen Skulpturen, selbst in Konkurrenzunternehmen wie den Asklepios-Heiligtümern dieser beiden Orte, offensichtlich. Doch mindestens noch einen anderen Asklepios-Typus kannte man in Knidos. Ein etwas flächig und trocken ausgeführter Torso, der nach Cambridge gelangte,[29] gehört zu den Varianten, die die linke Hand mit ausgestrecktem Zeige- und Mittelfinger in die Hüfte stützten. Dieser Typus wurde von P. Kranz mit dem Asklepioskultbild des Phyromachos in Pergamon in Verbindung gebracht.[30]

Trotz der Fülle ähnlicher Gewandtypen ist die zeitliche Einordnung des kolossalen Statuenunterteils in Knidos (Figs 166–7) nicht einfach, denn eine direkte stilistische Parallele scheint es nicht zu geben. Das weiche, dicke, schwerfällig in wenige rundliche Falten gelegte, spannungslose Gewand ist von der barocken Phase des Hellenismus, die sich in dem von Licht- und Schattenkontrasten dominierten Gewand z.B. der Dresdener Statuette[31] bemerkbar macht, anscheinend noch nicht berührt. Ebensowenig lässt sich die typologische ähnliche Statue des bekannten sog. Zeus aus dem Hera-Heiligtum von Pergamon[32] mit seinem reich bewegten voluminösem Gewand vergleichen. Der eng anliegende Mantel der knidischen Figur mit seinen sanfte Bögen bildenden weich aus dem Stoff hervortretenden Gabelfalten erinnert eher an den Torso im Vatikan, offensichtlich ein Original aus dem Umkreis der Mausoleumskulpturen, vielleicht sogar ein Werk des Bryaxis selbst.[33] Auch die zahlreichen Knitterfalten des vatikanischen Torsos finden sich in den sonst glatten Stoffflächen des knidischen Asklepios wieder, sichtbar z.B. oberhalb und unterhalb des linken Knies und in der Seitenansicht (Fig. 167). Das fast übertrieben netzartig gestaltete Faltensystem hat Parallelen bei Statuen des frühen 3. Jhs. aus Milet.[34] Die Asklepiosstatue von Knidos ist anscheinend also ein Werk karischer, noch unter attischem Einfluss[35] stehender Künstler der 1. Hälfte des 3. Jhs. Hierfür spricht auch das einheimische Material, der grosskristalline hellgraue Marmor. Eine untere zeitliche Grenze markiert die typologische verwandte Mantelstatue vom Artemisaltar aus Magnesia in Berlin,[36] deren Gewand deutlich voluminöser, schwerer und gespannter ist.

Die nächste hier vorzustellende Skulptur aus Knidos ist ein unterlebensgrosser weiblicher Kopf im Museum von Bodrum (Figs 170–71).[37] Er ist so gut erhalten, dass an einigen Stellen noch rote Farbspuren zu sehen sind. Technische gesehen zeigt er mehrere Besonderheiten. Während das Gesicht sorgfältig geglättet ist, ist das Haar nur summarisch angelegt. Der Hinterkopf ist in einem gesonderten Stück senkrecht angepasst und nur sehr grob mit dem Spitzeisen aufgeraut. Die eine noch erhaltene lange Haarlocke links ist frei gearbeitet.

Die Frau hat ein volles, länglich ovales Gesicht mit grossen Augen, einer schmalen, leicht nach oben gebogenen Nase und einem kleinen vollippigen Mund. In der Seitenansicht (Fig. 171) treten diese Merkmale noch deutlicher hervor und damit wird erkennbar, dass es sich nicht um einen idealen Kopf handeln kann. Der Porträtcharakter des knidischen Kopfes wurde schon von I. Love[38] wahrgenommen und von A. Krug präzisiert, die in ihm ein Bildnis der zweiten ptolemäischen Königin, Arsinoe II Philadelphos, erkannte.[39] Tatsächlich stimmen die beschriebenen Merkmale mit den typischen Charakteristika der dieser Königin zugewiesenen Porträts überein, wie beispielsweise der Kopf in Bonn[40] zeigt. Die vollen Wangen mit dem schweren Untergesicht gibt ein Bildnis in Nikosia[41] und ein neuerdings ebenfalls für Arsinoe II in Anspruch genommenes Kopfvorderteil in Brooklyn[42] wieder. Auch die technische Zurichtung des knidischen Kopfes weist nach Alexandria. Der aufgeraute Hinterkopf ist sicherlich durch Stuckauflagen ergänzt worden, während das Gesicht mit den verschliffenen Formen offenbar Alabaster imitiert. Die Technik der Haardarstellung sowie der Flimmerstil haben ihre Parallele bei Werken aus Kos,[43] das enge Verbindungen zum ptolemäischen Königshaus pflegte. Schliesslich ist auch der Kopfaufsatz wohl als Attribut des Isis-Kultes zu verstehen.[44]

Bei einem weiteren unterlebensgrossen, zum Einsetzen bestimmten Kopf aus Knidos in Bodrum (Figs 172–3)[45] treten die genannten Merkmale noch prägnanter hervor. Abgesehen von den völlig verschliffenen, albasterähnlichen Formen und der wiederum aufgerauhten, zusätzlich mit einem Dübelloch versehenen Anstückungsfläche für den Hinterkopf begegnen auch hier die aufgerissenen Augen und der kleine Mund. Besonders aber fällt die hohe dreieckige Stirn, der lange Hals mit den ausgeprägten Venusringen und die betonte Wendung des Kopfes nach rechts oben auf, alles typische Merkmale der Porträts der Arsinoe II.[46]

An dieser Stelle soll ein Neufund des Jahres 1994 angeschlossen werden (Fig. 174). Auch er ist unterlebensgross und kam in den Füllschichten eines römis-

chen Hauses auf der Rundtempelterrasse zu Tage. Es ist eine feine Arbeit, bei der auch wieder nur andeutungsweise die Gesichtsdetails und die Haare angegeben sind. Die bewegte Gesichtsoberfläche und die tief verschatteten Augen sind ein Indiz dafür, dass auch hier ein Werk des 3. Jhs. v. Chr. vorliegt. Das Gesicht ist allerdings runder und grossflächiger, so dass es schwierig zu sagen ist, ob der Kopf ein ideales Gesicht oder ein Porträt wiedergibt. Für letzteres könnte aber die pathetische Kopfwendung sprechen. Vergleichbar sind wegen der hohen Wangenknochen zwei Porträts wahrsheinlich der Berenike II in Alexandria.[47] Trotz des offensichtlichen Zeitunterschiedes ist der Einfluss nachpraxitelischer Werke nicht zu verkennen.[48]

In diesem Zusammenhang muss auch die Jünglingsstatuette Karg-Bebenburg erwähnt werden, die möglicherweise aus Knidos stammt.[49] Stilistisch gehöhrt sie mit ihren verschliffenen Formen und der sfumatohaften Oberfläche zu der oben besprochenen Gruppe von Köpfen, die an Alexandrinisches erinnern. Schon P. Arndt hat diese Verbindung gesehen[50] und auch Kabus-Jahn weist darauf hin, vergleicht aber mit Werken des späten 2. Jhs. v. Chr.[51] Doch hier lässt sie sich kaum unterbringen. Der Kopf mit den schmalen Augen, der langen Nase und dem kleinen fülligen Mund erinnert sogar deutlich an ptolemäische Porträts,[52] wenn auch zugegebenermassen in idealer Herrichtung. Die Statuette ist vielleicht das Werk eines Künstlers von Kos, der später in Alexandria tätig war.

Knidos hatte im 3. Jh. v. Chr. nachweislich enge Beziehungen zum ptolemäischen Hof. Der Architekt Sostratos, der sich in seiner Heimatstadt durch die Konstruktion der *ambulationes pensiles*[53] einen Namen gemacht hatte, wurde mit dem Bau des Pharos für das neugegründete Alexandria beauftragt. Ein Alexandriner namens Agathoboulos liess irgendwann in den Jahren 240–220 eine Statue des berühmt-berüchtigten ptolemäischen Ministers Sosibios in Knidos aufstellen.[54] Offensichtlich gab es zu dieser Zeit auch bereits ein Heiligtum für Isis und Serapis in der Stadt, wie die entsprechende Weihung eines Apollonidas zeigt.[55]

Der letzte hier vorzustellende Neufund ist die unterlebensgrosse Statue einer Frau (Figs 175-6), die in einem noch nicht identifizierten Gebäudekomplex an einer der grossen, Ost–West verlaufenden Verkehrsadern zum Vorschein kam.[56] Obwohl die Extremitäten wie der eingesetzte Kopf und die Arme fehlen und die rechte Seite sowie die Gewandstege beschädigt sind, ist die Oberfläche insgesamt gut erhalten. Die Figur steht so auf dem linken Bein, dass die linke Hüfte deutlich nach aussen gedrückt wird. Ihr Gewand ist ein

ungegürteter offener Peplos, über den in einem schrägen Wulst ein kurzes Himation geschlungen ist, das ehemals von der linken Hand gerafft wurde. Ausserdem läuft quer über die Brust ein schmales glattes Band. In diesem befinden sich unten einige kleine Stiftlöcher, wohl zum Andübeln von Metallschlangen. Daher trifft die von I. Love geäusserste Deutung, dass es sich um eine Athena-Statue handele, sicherlich das Richtige. Der erhobene rechte Arm stützte sich dann sicherlich auf eine Lanze.

Der Gewandtypus ist für eine Athena mit Schrägägis ganz ungewöhnlich.[57] Der ungegürtete Peplos wird in der Regel nicht mit einem Himation verbunden. Eine Ausnahme stellt eine Statue aus Kyrene in London[58] dar, doch weder bei der Drapierung des Mantels noch in der Haltung gibt es Übereinstimmungen. Abgesehen vom Himation zeigt die knidische Figur Anklänge an den Typus, der gewöhnlich auf die Athena Hephaisteia zurückgeführt wird, obwohl auch dieser anscheinend nicht einheitlich überliefert ist.[59] Von Interesse ist diesem Zusammenhang eine grössere Statuette aus der Casa Romana in Kos, deren Körper eine Replik der Dresdner Artemis mit einem Athena-Kopf kombiniert.[60] Auch das Gewand der knidischen Figur erinnert mit seinen breiten Steilfalten ja deutlich an klassische Werke. Stilistisch gehört die knidische Athena mit dem gelängten Unterkörper, der sehr breiten, heftig nach aussen gedrückten Hüfte, auf der ein kurzer schmaler Oberkörper sitzt, jedoch schon in den fortgeschrittenen Hellenismus. Nicht nur in der Tracht, auch im Stil verwandt sind einige Figuren des Archelaos-Reliefs, wie die sog. Mnemosyne und der Apollon,[61] die trotz ihrer geringen Grösse auch den breiten wuchtigen Unterkörper aufweisen, dem ohne Übergang der kurze Oberkörper aufsitzt. In der Haltung und im Körperbau vergleichbar ist eine Mantelstatuette aus Halikarnassos in London,[62] der sich eine weitere, unpublizierte, im Museum von Bodrum anschliessen lässt. Alle diese Vergleichsbeispiele werden zu Recht der rhodischen Kunst zugewiesen. Ebenfalls in diesen Kunstkreis gehört eine weitere Statuette aus Knidos (Fig. 177), die einem Werk in Rhodos[63] fast geschwisterlich gleicht. Für das fortgeschrittene 2. Jh. v. Chr. ist also ein deutlicher künstlerischer Einfluss dieser Insel in Knidos und den Nachbarstaaten festzustellen.[64]

Zusammenfassend ist folgendes festzuhalten: im frühen 3. Jh. überwiegt noch der attische Einfluss in Knidos. Das fortschreitende 3. Jh. ist deutlich von der ptolemäischen Präsenz in dieser Region geprägt, um anschliessend von der rhodischen Vormacht verdrängt zu werden.

ACKNOWLEDGEMENTS

Dieser Beitrag stellt ein Zwischenergebnis der Untersuchungen zu den Skulpturen aus Knidos dar. Diese Forschungen wurden von der Gerda Henkel Stiftung gefördert, wofür ich ihr auch an dieser Stelle danken möchte. Die Vorlagen für die Abb. 161–4, 166–7, 169 verdanke ich W. Schiele; für Hilfe bei den übrigen Aufnahmen danke ich A. Baş (Konya).

NOTES

1. I. Love, *AJA* 74 (1970) 155; dies. *AJA* 76 (1972) 75, hier bringt sie das Gebäude in Zusammenhang mit dem Athena-Altar-Fundament östlich davon, doch dieses ist sicherlich älter; s.a. Taf. 82 Fig. 14; zur Topographie von Knidos s. *AJA* 77 (1973) 414, fig. 1.

2. S. Plan und R. Özgan, *XIII. Kazi Sonuçlari Toplantisi* 2 (1991) 186.

3. Zu einem solchen Statuendepot aus dem Heiligtum von Kyparissi auf Kos s. R. Kabus-Preisshofen, *AntP* 15 (1975) 31–3.

4. Die Beschreibung der Statuen beschränkt sich hier auf das Notwendige, da eine endgültige Publikation in Vorbereitung ist. Die Grössenverhältnisse demonstriert ein Photo der Zeitung *Die Welt* vom 3. Januar 1970, auf dem I. Love neben dem Werk posiert; ein weiteres Photo zeigt die Statue in Vorderansicht (Die Photokopie des Zeitungsausschnittes verdanke ich A. Linfert, der bereits damals die Bedeutung dieser Statue erkannte und mir gegenüber auch schon die jetzt von mir begründete Datierung äasserte).

5. Horn, pl. 6, 3; L. Alscher, *Griechische Plastik* IV (1957) fig. 5; B. Sismondo Ridgway, *Hellenistic Sculpture* I (Bristol 1990) pl. 31. Thasos: Horn, pl. 22, 2; Bieber (1961) fig. 518.

6. Schon I. Love bemerkte die Ähnlichkeit zwischen beiden Werken, s. *AJA* 74 (1970) 155.

7. Horn, pl. 8, 1; Alscher (supra n. 5) fig. 4.

8. M. Flashar und R. Von der Hoff, *BCH* 117 (1993) 407–33, figs 1–14; *FdD* IV (1927) pls 69–72; Alscher (supra n. 5) fig. 9a–b.

9. Ebda. 409 fig. 3.

10. W. Geominy, *Die Florentiner Niobiden* (Bonn 1984) 243–4 mit Anm. 646; 273–4, fig. 320.

11. Flashar und Von der Hoff (supra n. 8) 418–25.

12. Ebda. Fig. 17.

13. Hier sei daran erinnert, dass Skopas und Bryaxis Statuen für Knidos angefertigt haben sollen, s. Plin. *Hist.nat.* 36.22. Die bekannte sitzende *Demeter* von Knidos wird von B. Ashmole bekanntlich dem Leochares zugewiesen, *JHS* 71 (1951) 13–28; vergl. z.B. auch den Mantelwulst der männlichen Grabfigur in Budapest, *Horn*, pl. 1, 1. Für das 2. Jh. v. chr. ist jetzt durch den Neufund einer signierten Basis (unpubl.) auch die Tätigkeit des Atheners Peithandros in Knidos gesichert, der bisher nur für Rhodos belegt war, s. E. Löwy, *Inschriften griechischer Bildhauer* (1885) n. 199.

14. Bieber (1961) fig. 249.

15. Kabus-Preisshofen (1989) 85–90, Kat. no. 51, pl. 19, 1–2.

16. S. dazu ebda. 52–65.

17. Erhaltene Höhe: 79 cm, Breite: 68 cm, Tiefe: 50 cm.

18. E. Schwarzenberg, *Bjb* 169 (1969) 95, fig. 4; 96–7, fig. 5; zum Altar s. Verf., *Jdl* 1995.

19. S. Die Zusammenstellung im *LIMC* I (1981) s.v. 'Asklepios' (B. Holtzmann) nos 234–378; P. Kranz in *Festschrift N. Himmelmann* (Mainz 1989) 289–95; ders., *Jdl* 104 (1989) 107–55.

20. Schwarzenberg (supra n. 18); *Öjh* 23 (1926) 8, fig. 3; *LIMC* I a.O. no. 320. Die heute in Wien befindliche Statuette wird von Kabus-Preisshofen (1989) 34. 45–51 mit Anm. 137 in Übereinstimmung mit anderen Autoren als Original des 4. Jhs. v. Chr. bezeichnet.

21. Schwarzenberg a.O. möchte in ihr eine private Ehrenstatue für einen Asklepiaden sehen. Dieser wäre dann im Typus des Gottes dargestellt worden. Gegen eine solche Deutung scheint aber doch das kolossale Format zu sprechen.

22. I. Love, *AJA* 77 (1973) 415; dies. *TürkArkDerg* 21, 2 (1974) 87. 101, fig. 19; dies. (1978) 1122 pl. 358, 10 ('Hades').

23. *BMCS* I, 550; B. Ashmole, *BSA* 46 (1951) 3ff., pl. 1ff.; weitere Lit. s. Kabus-Preisshofen (1989) 34 Anm. 101; *LIMC* I (supra n. 19) no. 345.

24. Supra n. 20. So auch schon Kabus-Preisshofen (1989) mit Anm. 152; der Kopf aus Kos, ebda. pl. 1, 2 ist dagegen sehr grossflächig angelegt. Stilistisch erinnert der knidische Kopf an Sarapis-Köpfe aus Alexandria, I. Castiglione in *Alessandria e il mondo ellenistico-romano*, Studi in onore di A. Adriani I, Studi e materiali 4 (1983) no. 18.

25. Kabus-Preisshofen (1989).

26. Ebda. 36.

27. L. Laurenzi, *ASAtene* 17/18 (1955–6) nos 82–4.

28. Kabus-Preisshofen (1989) 36 Anm. 106 weist ihn derselben Werkstatt wie den Jüngling Karg-Bebenberg zu, den sie entgegen anderen Vorschlägen (um 300 v. Chr.) in die 2. Hälfte des 2. Jhs. setzen will, was aber, wie unten erläutert wird, aus ikonographischen und stilistischen Gründen zu spät erscheint.

29. L. Budde und R. Nicholls, *A Catalogue of the Greek and Roman Sculpture in the Fitzwilliam Museum Cambridge* (Cambridge 1964) no. 58, pl. 16; *LIMC* I (supra n. 19) no. 304 (seitenverkehrt).

30. P. Kranz, *JdI* 104 (1989) 107–55; ders. in *Festschrift N. Himmelmann* (Mainz 1989) 289–95; vergl. auch römische Münzen aus Knidos, Ch. Blinkenberg, *Knidia* (Kopenhagen 1933) 195–8, figs 71–3.

31. Kabus-Preisshofen (1989) pl. 1, 1.

32. Horn, pl. 20, 3; P. Kranz, *JdI* 104 (1989) 133, fig. 25.

33. Kabus-Preisshofen (1989) 46f. mit Anm. 139 pl. 4, 1; Helbig 4 I no. 252 (W. Fuchs). Er ist aus dem typischen kleinasiatischen grosskristallinen hellgrauem Marmor gearbeitet wie übrigens der knidische Torso auch.

34. Linfert 20–23, figs 4–7. Vergl. auch den Mantel eines Philosophen aus Klaros in Izmir, R. Özgan, *IstMitt* 32 (1982) Taf. 48, 4. Linfert macht auf den Zusammenhang

mit der alexandrinischen Kunst aufmerksam macht, ohne eine Erklärung zu finden. Die Beziehungen sind nur so zu erklären, wie auch im folgenden gezeigt wird, dass insbesondere karische und inselgriechische Künstler in Alexandria tätig waren.

35. Die rundlichen Gabelfalten des Überschlags erinnern an die des Philosophen von Delphi (supra n. 8) und des Hippokrates von Kos (Kabus-Preisshofen (1989) no. 19, pl. 16).

36. Linfert, figs 18–19; Özgan (supra n. 34) pl. 47.

37. Inv. Nr. 3183. Anscheinend ein Oberflächenfund, I. C. Love, *TürkArkDerg* 17, 2 (1968) 128, 143, fig. 32; M. Mellink, *AJA* 73 (1969) 218, pl. 61, fig. 23; Love, pl. 360, 31. H: 31 cm.

38. *TürkArkDerg* 17, 2 (1968) 128.

39. A. Krug in N. Bonacasa and A. di Vita (eds), *Alessandria e il mondo ellenistico romano: Studi in onore di A. Adriani* (Rom 1983) 193, Anm. 7.

40. Kyrieleis 1, 76f.

41. Ebda. pl. 73.

42. M. Prange, *AM* 105 (1990) 205, pl. 44, 1–2. Er scheint von einem Künstler aus Kos angefertigt worden zu sein, vergl. Kabus-Preisshofen (infra n. 43) figs 12–13.

43. R. Kabus-Preisshofen, *AntP* 15 (1975) pl. 11, figs 12–13; s.a. dies. *AntP* 11 (1972) 46f. Auch der Kopf in Berlin, C. Blümel, *Die klassisch griechischen Skulpturen der Staatlichen Museen zu Berlin* (Berlin 1966) no. 114, fig. 182–5; L. Thommen, *AntK* 35 (1992) pl. 18–6, der aus Athen stammen soll, ist hier zu nennen. Trotz der Herkunftsangabe scheint er wegen seiner weichen strukturlosen Formen kein attisches, sondern eher ein ionisches Werk zu sein.

44. So auch A. Krug (supra n. 39).

45. Inv. Nr. 6991; H: 16 cm; nach der Beischrift zu urteilen auf der Rundtempelterrasse gefunden; hellgrauer, grosskristalliner Marmor.

46. M. Prange (supra n. 42) 197–211, pls 38–46 und z.B. das Münzbildnis Kyrieleis, pl. 70, 1.

47. Kyrieleis, K 2. K 3, pl. 85.

48. Vergl. z.B. die Köpfe aus Kos vom Altar, Kabus-Preisshofen (1989) Kat.Nr. 1–4, pl. 10–11 (von ihr wird ein solcher Einfluss allerdings bestritten).

49. BrBr 650; R. Kabus-Jahn, *AA* (1968), 446–58, figs 1–14; B. Sismondo Ridgway, *Museum of Art, Rhode Island, School of Design, Classical Sculpture* (1972) n. 19.

50. Text zu BrBr 650.

51. Ebda. 453ff., doch betont sie immer wieder (zu Recht) den Zusammenhang mit praxitelischen Skulpturen.

52. Z. B. Kyrieleis, pl. 18. 19. 22.

53. Es handelte sich wohl um Terrassen mit Aussichtsplattform, ideal für das knidische Gelände, s. B. Fehr, *MarbWPr* (1969), 31–67 mit Anm. 39.

54. E. Löwy, *Inschriften griechischer Bildhauer* (Leipzig 1885) no. 160; Blümel, *Inschriften* no. 112.

55. Blümel, *Inschriften* no. 186.

56. Inv. Nr. 6269; H: 89 cm; I. C. Love, *AJA* 77 (1973) 416, pl. 73, 4. Der hier abgebildete behelmte, von ihr als zugehörig erwogene Kopf pl. 73, 1, ist leider zu sehr beschädigt, um dies entscheiden zu können.

57. Zu diesem Statuentypus s. P. Karanastassis, *AM* 102 (1987) 369–81, pls 50–51.

58. Horn, pl. 11, 1.

59. Bieber (1977) figs 372–85; A. Delivorrias in *AKGrP* II, 149–54, pls 133–5.

60. L. Laurenzi, *ASAtene* 17–18 (1955–6) 69–71, no. 3.

61. D. Pinkwart, *AntP* 4 (1965) pls 33–4; vergl. auch die Hera (?) auf einem Rundaltar aus Alexandria, A. Adriani, *AAS* 21 (1971) 171–5, pl. 47.

62. Linfert, fig. 214 mit Anm. 315.

63. R. Gualandi, *Rodi* 80–81, n. 39, fig. 55.

64. Vergl. auch Verf., *JdI* 110 (1995), 239 ff. *passim*, 270 ff.

13

Il rilievo dal Bouleuterion di Iasos: proposte di lettura

Simonetta Angiolillo

Durante lo scavo del Bouleuterion di Iasos (Fig. 178), sul lato meridionale dell'Agora, nel riempimento del corridoio anulare furono rinvenuti alcuni frammenti di un interessante rilievo di grandi dimensioni (Figs 179–81).[1] Vi è raffigurato un personaggio maschile barbato seduto su una kline con il braccio sinistro poggiato su un cuscino (fr. a). L'uomo indossa un chitone manicato e un himation visibile solo sul cuscino e, in minima parte, sul braccio sinistro, l'unico parzialmente conservato; una serie di fori nel panneggio, uno ancora con il perno, assicura che l'avambraccio era lavorato separatamente. I capelli, lunghi, con scriminatura centrale, rigonfi sulle tempie e sulla fronte, scendono dietro le orecchie, dando alla fronte una sagoma triangolare, e ricadono sul petto. Un piccolo foro accanto alla testa, proprio in corrispondenza del punto di passaggio tra i capelli aderenti al capo e le ciocche rigonfie, conserva ancora tracce di un perno e suggerisce l'ipotesi che il personaggio portasse una corona. Gli occhi infossati hanno palpebre spesse, gli zigomi sono evidenziati; il labbro inferiore, il solo integro, è carnoso e poco modellato. La testa è inquadrata da uno scudo, visibile solo nella sua parte inferiore, appeso alle spalle del personaggio. Gli altri frammenti consistono in un piede destro (Fig. 182), sollevato contro un tendaggio, scalzo e reso con accuratezza nei particolari, le unghie e una vena (fr. b); in un frammento di arto (Fig. 183), forse un braccio, lavorato ad alto rilievo (fr. c); nella parte inferiore di una zampa di letto (Figs 184–5), a tutto tondo, che nasconde, in rilievo piuttosto basso sul fondo, l'estremità di un ingrossamento cordiforme (fr. d); nella base (Fig. 186) di una seconda zampa di letto (fr. e). D. Levi attribuisce a questo rilievo anche un frammento 'conservante due gambe maschili',[2] ma tutti i pezzi scultorei esistenti a Iasos che possono corrispondere a questa descrizione sicuramente non appartengono al rilievo. Si tratta della raffigurazione di un simposiasta sdraiato su una kline, ma purtroppo la lacunosità del monumento non ne consente una lettura sgombra da dubbi. I frammenti superstiti, infatti, hanno conservato tutti gli angoli del pannello a eccezione di quello in alto a sinistra; l'esame dei bordi permette di ritenere che il rilievo fosse concluso e non

continuasse su altre lastre adiacenti. Il frammento b presenta l'estremità sinistra della kline, con parte del piano superiore dal quale scende in larghe pieghe un drappo; esso lasciava però scoperto il piede del letto, conservato nel fr. d, di tipo rettangolare a doppia voluta, molto vicino, per citare qualche esempio, a quello del rilievo di Thasos, ora al museo di Istanbul, con banchetto funebre e a quello del sarcofago di Belevi.[3] L'intera scena doveva dunque essere compresa nella lunghezza del letto stesso.

Se abbiamo i limiti esterni della rappresentazione, la parte centrale è purtroppo tutta da ricostruire. L'uomo (Fig. 187) siede in posizione frontale, con il volto lievemente girato verso la sua sinistra. Il braccio sinistro poggia su un cuscino; a quello destro è possibile che appartenga il frammento di arto conservato (fr. c): in questo caso, potrebbe reggere un rhyton, secondo l'iconografia più consueta, mentre è probabile che il sinistro tenesse una patera.[4]

Per quanto riguarda il frammento con il piede scalzo (fr. b), l'unico fatto certo, a mio avviso, è la sua collocazione: infatti la presenza del piano superiore della kline e l'andamento del panneggio sullo sfondo garantiscono che questo si trovava alla estremità sinistra del letto e che doveva essere completato dalla zampa del letto stesso.[5] Non è invece altrettanto sicuro a quale personaggio appartenga il piede. Infatti, se, come probabile, è da riferire al simposiasta, dobbiamo immaginare che questi poggiasse la gamba sinistra sulla kline, accavallasse la destra sull'altra e la lasciasse ricadere davanti al letto. Di una simile posizione, obbiettivamente piuttosto innaturale, non ho trovato un riscontro puntuale sugli altri *Totenmahlreliefs*, ma sono attestati schemi vicini: così su un rilievo di Apollonia (Fig. 188) il banchettante ha la gamba destra accavallata con il piede che scende di poco davanti al materasso.[6]

Potremmo altrimenti pensare che il rilievo di Iasos raffigurasse un uomo seduto sul bordo della kline con la gamba sinistra poggiata a terra e la destra sollevata, in una posizione in qualche modo simile a quella del rilievo del museo di Istanbul, inv. 2226 (Fig. 189),[7] ma il risultato sarebbe ancora più innaturale.

Se viceversa attribuiamo il piede a una seconda figura, dobbiamo pensare che questa sedesse alla destra dell' uomo e fosse rivolta verso destra, quindi gli volgesse le spalle. Si tratterebbe dunque di una posizione molto poco consona, a meno di ipotizzare un terzo personaggio che costituisca il fulcro della scena: se infatti è frequente verificare sui rilievi con banchetto la presenza di una donna seduta ai piedi della kline, su questa stessa o su una sedia, essa però non dà mai le spalle al personaggio principale.[8] Ma per un eventuale terzo personaggio nel nostro rilievo manca lo spazio. Resta, è vero, la già citata testimonianza di D. Levi sull'esistenza di un frammento con 'due gambe maschili', ma, in mancanza di un effettivo riscontro, non ritengo la notizia vincolante. Senza ipotizzare un errore da parte del Levi, ma in assenza di qualsiasi sua precisazione sul pezzo, si potrebbe anche pensare a una di quelle figure di dimensioni ridotte che compaiono così spesso sui *Totenmahlreliefs*.

Resta ancora da esaminare il frammento d, che conserva evidenti tracce del bordo laterale sinistro della lastra. In esso la parte inferiore della zampa della kline nasconde un elemento cordiforme aderente al fondo: non può essere parte di un piede umano, un alluce come in un primo tempo mi era sembrato,[9] perché sarebbe stato eseguito in modo troppo sommario – non è nemmeno indicata l'unghia – in stridente contrasto con l'accuratezza del resto del rilievo. Al contrario questo trattamento ben si addice all'estremità della coda di un animale, verosimilmente un serpente che, secondo l'iconografia nota, si avvolge in spire sollevandosi verso l'eroe banchettante. Nonostante le incertezze e mantenendo una certa prudenziale cautela, ritengo che la ricostruzione più plausibile debba contemplare un solo personaggio recumbente sulla kline, con un rhyton nella destra e una patera nella sinistra, e un serpente che si protende verso di lui.

Resta da esaminare l'inquadramento cronologico del rilievo. Esso presenta alcuni tratti di arcaismo, come gli zigomi accentuati, la pettinatura, rigonfia su fronte e tempie con trecce sulle spalle e sul petto,[10] e il panneggio appiattito, con pieghe schiacciate e quasi in negativo, secondo la maniera ionica della metà del v secolo: quella che conosciamo, per esempio, dalla stele di Nea Kallikrateia o dalle figure del frontone dell'Amazzonomachia nel tempio di Apollo Sosiano a Roma.[11] Accanto a questi caratteri, però, la morbidezza del modellato e soprattutto la resa degli occhi, infossati, ricordano piuttosto esperienze del iv secolo. È dunque in questo ambito, e in particolare nella prima metà del secolo, che penso possa essere collocato il rilievo in discussione.[12]

A questo punto dobbiamo tentare di precisare l'i-dentità del personaggio raffigurato. D. Levi aveva suggerito che si trattasse di Dioniso: la presenza dello scudo potrebbe allora essere giustificata dalle numerose epiclesi belliche del dio.[13] Ma l'iconografia si presta anche ad altre letture. È innanzitutto compatibile con Zeus, del quale sono note, pur se non frequenti, raffigurazioni come banchettante.[14] La collocazione di Iasos in Caria permette di avanzare la possibilità che il personaggio raffigurato sul rilievo sia Zeus Karios, o Stratios, o Labrandeus.[15] Una simile interpretazione risulterebbe del tutto coerente con la politica religiosa degli Ecatomnidi: una sicura testimonianza del loro interesse per tale culto è infatti costituita dal rilievo di Tegea (Fig. 192) con l'immagine del dio tra quelle di Ada e di Idrieo.[16] Ma non è l'unica: è verosimilmente sotto gli Ecatomnidi che l'immagine del dio perde il suo carattere xoanizzante per assumere, sulle monete di Mausolo (Fig. 190), un aspetto ellenizzato;[17] lo stesso che ritroviamo nella testa di Milas (Fig. 191) identificata appunto con questa divinità. Anzi, taluni tratti iconografici – in particolare la acconciatura, con i capelli rigonfi sulla fronte e sulle tempie e le trecce che passano dietro le orecchie, e la presenza originaria di una corona, in entrambi i casi metallica e inserita[18] – sembrano suggerire che sia il rilievo di Iasos che la testa di Milas siano pertinenti a uno stesso personaggio. Del resto, l'identificazione del banchettante di Iasos con lo Zeus Karios sarebbe confortata anche dall'individuazione, al centro dell'Agora di Iasos, di un sacello che ha restituito un gran numero di lamine di piombo ritagliate a forma di doppia ascia, l'attributo che caratterizza il dio cario.[19]

Di fronte a questa serie di concordanze, costituisce però una difficoltà difficilmente sormontabile il fatto che dall'iconografia di Zeus Karios, oggetto di numerose ricerche e pertanto ben nota, sia per il momento assente il tipo del simposiasta.[20]

Ma resta anche un'altra possibile lettura. Di fatto l'iconografia del monumento di Iasos è la stessa usata nei rilievi votivi e funerari per eroi e per anonimi defunti, o meglio, è quella tipica degli eroi che viene usata anche per gli dei e che, dopo il iv sec. a.C., viene estesa ai defunti.[21] Ma, prescindendo dal problema cronologico, sappiamo che la destinazione funeraria non è praticamente mai attestata per i rilievi oblunghi:[22] il ricco catalogo del Dentzer ne include, in modo dubitativo, un solo esemplare.[23] Al contrario il dato epigrafico, dove è presente, permette, nella maggioranza dei casi, di individuare il banchettante come eroe, altrimenti come dio.[24]

Il rilievo di Iasos, anche se lacunoso e privo di iscrizioni, conserva due attributi, lo scudo e forse il serpente, che gli conferiscono una connotazione di tipo

eroico. Le armi, pur non essendo prerogativa degli eroi, sono infatti, per usare una espressione del Dentzer, 'un véritable attribut des héros',[25] e non è certo necessario soffermarsi sullo stretto rapporto esistente tra gli eroi e il serpente, il *drakon* di cui parlano le fonti.[26] In effetti a Iasos conosciamo l'esistenza di un culto eroico: quello dedicato al fondatore eponimo, IACOC KTICTHC, come è chiamato su monete di età imperiale che costituiscono l'unica testimonianza in nostro possesso di un simile culto (Fig. 193).[27] Nonostante le lievi differenze riscontrabili nel tipo monetale – l'eroe, che pure è barbato e ornato da un diadema,[28] ha i capelli raccolti – la sicura valenza eroica della iconografia rende, a mio avviso, degna di approfondimento l'ipotesi che il rilievo del Bouleuterion costituisca una nuova, importante, testimonianza del culto dell'eroe Iasos. Ma le caratteristiche tecniche del monumento mi sembrano suggerire una destinazione particolare. Innanzitutto le dimensioni sono decisamente maggiori rispetto a quelle medie dei *Totenmahlreliefs*;[29] inoltre, il rilievo è molto alto, in alcuni punti arriva addirittura al tutto tondo, fenomeno che sugli *ex voto* si manifesta nel tardo IV secolo,[30] dunque in epoca successiva rispetto al nostro esemplare. Infine quello di Iasos rappresenta uno dei rarissimi casi in cui la lastra con scena di banchetto è priva di una cornice architettonica e possiede solo un plinto di base.[31] Ritroviamo tutte e tre queste caratteristiche, peraltro eccezionali per i *Totenmahlreliefs*, sul rilievo dell'Archilocheion di Paros,[32] cioè su un rilievo che costituiva la decorazione architettonica di un monumento dedicato al poeta Archiloco. E una simile destinazione, a mio avviso, è del tutto plausibile anche per la lastra di Iasos.

A questo proposito non si deve sottovalutare il fatto che sul lato orientale dell'Agora di Iasos è stato individuato un monumento di piccole dimensioni, interpretato da D. Levi come heroon.[33] Purtroppo lo scavo non è stato completato e lo studio è solo agli inizi, quindi nessun contributo per il momento può venire dall'analisi di esso, ma trovo seducente l'ipotesi che nell'Agora si praticasse un culto riservato all'eroe fondatore della città, quello appunto di IACOC KTICTHC.

Non sono oggi in grado di decidere tra queste due interpretazioni, anche se personalmente sarei tentata di privilegiare quella che vede l'eroe Iasos nel personaggio raffigurato. In ogni caso, entrambe le identificazioni sembrano adeguate al contesto storico della Iasos di IV secolo. Tra i documenti iasei contemporanei troviamo due iscrizioni di grande importanza. Nella prima, *boule* e *demos* condannano all'esilio e alla confisca dei beni i cittadini che 'avevano cospirato contro Mausolo e contro la città di Iasos e i loro discendenti'; il decreto è datato dal Blümel al periodo tra il

367/6 e il 355/4.[34] Nella seconda, in onore di un certo Theodoros e purtroppo assai mutila, è ricordato il culto di Zeus Idrieus. Si tratta di una epiclesi finora sconosciuta, che W. Blümel ha messo in rapporto con la figura di Idrieo, fratello di Mausolo, arrivando a datare il decreto al periodo del suo regno.[35] Infine, se esaminiamo i monumenti della città, vediamo che la cinta muraria, almeno nel suo impianto originario, è stata attribuita al periodo degli Ecatomnidi[36] e anche la costruzione del teatro risale al IV secolo.[37]

L'impressione che se ne ricava è dunque quella di una città in grado di intraprendere iniziative edilizie di notevole peso; inoltre la menzione del culto di Zeus Idrieus suggerisce, in certa misura, che i rapporti esistenti tra Iasos e gli Ecatomnidi non dovevano essere limitati al mero aspetto politico e amministrativo, ma anzi dovevano incidere sensibilmente sulla vita culturale e religiosa della città. Del resto quanto conosciamo dell'attività degli Ecatomnidi in Caria sembra confortare tale ipotesi interpretativa. Per limitarci alle località più vicine a Iasos, essi dedicano offerte di vario tipo e di diverso impegno nel santuario di Sinuri e in quello di Zeus Labrandeus a Labranda, dimostrando una notevole attenzione nei confronti degli antichi culti locali.[38] Mi chiedo allora se non sia da interpretare in questa chiave anche il rilievo del Bouleuterion: nulla, ovviamente, ci garantisce che si tratti di una dedica ecatomnide, ma mi pare che esistano tutti i presupposti perché si possa vedere anche in questo monumento il riflesso del forte impulso dato dai satrapi ai culti locali.

L'istituzione di un culto dell'eroe fondatore si adatterebbe anche alle notizie che ci sono state tramandate sui funerali di Mausolo. In tale occasione Artemisia organizzò un agone oratorio e uno poetico: quest'ultimo fu vinto dal poeta Theodektes che rappresentò la propria tragedia dal titolo *Mausolus*.[39] In essa, secondo l'ipotesi di S. Hornblower, si sarebbe esaltata la discendenza del satrapo dal suo omonimo, figlio del dio Sole ed eponimo di un fiume della Caria, in seguito chiamato Indos, da identificare con l'attuale Dalaman Çay:[40] ancora una volta una operazione in ossequio alla politica di 'carianizzazione' perseguita dagli Ecatomnidi.

NOTES

1. Numeri di inventario: I.1126, I.1127, I.1128, I.1129, I.1130, I.1131, I.1142, I.1785. La testa (I.1130) misura m 0.185 di altezza e m 0.24 di larghezza, il torso (I.1129) m 0.425 di altezza e m 0.39 di larghezza. Marmo bianco. Levi (1967–8) 550, fig. 14.

2. Levi (1967–8) 550, n. 1: di questo frammento non ho trovato traccia neppure nel registro di inventario.

3. Cfr. Richter (1966) 59s. figg. 317 e 325.

4. È anche attestata, ma molto meno frequente, la variante con la patera nella mano destra: si vedano a mo' di esempio Thönges-Stringaris, nn. 15, 56, 85, 87, 88, 128, 138, 140, 154, 156, tavv. 9, 14, 15, 16, 17, 21, 23, 28, 29 (rhyton) e nn. 17, 34, 65, 66, 134, 145, 191, tavv. 5, 7, 10, 13, 17, 19, 26 (patera). Su questa iconografia cfr. Dentzer 314.

5. Non è possibile precisare se con l'inserzione di un ulteriore gruppo di pieghe, come appare nel disegno ricostruttivo.

6. Dentzer R 76, 577, fig. 340. La stessa posizione si ritrova in una stele del II sec. d. C. al Museo di Bursa (cfr. Pfuhl-Möbius II, n. 1621, 397, tav. 236), mentre su piatti d'argento sassanidi e post-sassanidi il personaggio seduto o sdraiato lascia cadere la gamba ben oltre il piano del letto (cfr. Dentzer 63, figg. 96 e 98).

7. Cfr. Dentzer R 349, 609, fig. 594 (= Pfuhl-Möbius II, n. 1859, 446s. tav. 267).

8. Si veda Dentzer *passim*.

9. Si veda Angiolillo.

10. Troppo note sono queste caratteristiche nella scultura di età arcaica e severa per soffermarcisi: basterà ricordare opere come i tirannicidi di Kritios e Nesiotes, o l'erma dell'Agora Harrison, n. 159; e su un rilievo del museo di Istanbul tra gli altri elementi che caratterizzano la figura del banchettante in modo più arcaico rispetto a quelle degli altri personaggi ci sono i capelli lunghi: Dentzer R 350, fig. 595, 384s.

11. Cfr. La Rocca 59-71.

12. Stilemi analoghi – trattamento degli occhi, forma delle labbra – sono presenti nel rilievo votivo del Museo Rodin che J. Frel identifica con Dionysos Lenaios e data agli inizi del IV secolo: J. Frel, ΔΙΟΝΥΣΟΣ ΛΗΝΑΙΟΣ, *AA* 82 (1967) 28-34.

13. Cfr. Bruchmann, *s.v.* 'Dionysos:' *Akontister, Aptolemos, Areiomanes, Areios, Doratophoros, Enyalios, Polemokelados, Giganthophonos, Gnotophonos, Doriktetos, Euthorex, Indophonos, Lipoptolemos, Meneptolemos, Synaspistes, Phygoptolemos, Chalkochiton.*

14. Cfr. E. Paribeni, in *EAA* VII (1966) 1263, *s.v.* 'Zeus', nonché Dentzer 503-5 (Zeus Epiteleios Philios).

15. Su questo culto si veda Laumonier 57-62.

16. Fleischer (1973) K3, 311 tav. 138.

17. Cfr. Métraux 157.

18. Una corona di alloro è spesso presente sulle monete con raffigurazione dello Zeus Cario: cfr. Cook (1925) 573 e 597, figg. 472, 475, 500. Per lo Zeus di Milas si veda M. B. Comstock e C. C. Vermeule, *Sculpture in Stone: The Greek, Roman and Etruscan Collections of the Museum of Fine Arts Boston* (Boston 1976) n. 44, 33s.

19. Il santuario è attribuibile a età classica: si veda Berti 236.

20. Cfr. Laumonier 45-101; Akarca 33-45; Fleischer (1973) 310-24.

21. Cfr. Thönges-Stringaris 48-54 e Dentzer 347-63, 453-527.

22. Le dimensioni ipotetiche del rilievo di Iasos (*c.*120 × 110 cm) sembrano escludere che esso appartenesse a una stele; e tra i rilievi oblunghi, distinti dalle stele funerarie sviluppate più in altezza che in larghezza, il Dentzer inserisce anche R 157, di forma pressoché quadrata, cfr. Dentzer 302.

23. Cfr. Dentzer 353-63 e 390s.: il rilievo oblungo per il quale J.-M. Dentzer non esclude una destinazione funeraria è R 348.

24. Si veda in merito Thönges-Stringaris 48-58 e 453-9.

25. Si veda Dentzer 489. Esattamente la stessa posizione dello scudo, dietro la testa dell'eroe, si ritrova su un rilievo di Çanakkale (Mitropoulou, n. 74, 62s. = Pfuhl-Möbius II, n. 1841, 442) e su uno a Bignor Park, di provenienza sconosciuta, ma ritenuto greco-orientale (Pfuhl-Möbius I, n. 2009, 483s. = Thönges-Stringaris n. 147, 90), entrambi datati alla prima metà del II sec. a.C.

26. Cfr. Dentzer 495-501; Thönges-Stringaris 57 definisce il serpente 'ein Teil des Heros-Wesens'.

27. Si veda R. Vollkommer in *LIMC* V (1990) 638, *s.v.* 'Iasos,' con la bibliografia precedente.

28. Sulla presenza di corone sui *Totenmahlreliefs* si veda Dentzer 484.

29. Si veda Dentzer 567-626.

30. Cfr. Dentzer 311.

31. Dentzer 304 cita due soli casi analoghi in tutta la produzione attica del periodo compreso tra il 420 e il 300 a.C., R 221 e R 393, dei quali R 221 'de qualité exceptionelle, et de grandes dimensions ... prenait place peut-être dans un cadre architectural indépendant'.

32. Si tratta del rilievo Dentzer R 286; la attribuzione all'Archilocheion è di Kontoleon 348-418; sull' Archilocheion si veda Mayo.

33. La notizia è in Levi (1972-3) 530, nonché in Berti 220.

34. Blümel n. 1.

35. Blümel n. 52, 61s. G. Pugliese Carratelli, 'Nuovo supplemento epigrafico di Iasos', *ASAtene* 47-8 (1969-70) n. 1, 371s. mette in relazione l'eponimo Idrieus con un culto documentato in quella parte della Caria chiamata da Herodot. 5.118 'Idrias'.

36. Cfr. C. Franco, 'Le mura di Iasos. Riflessioni tra archeologia e storia', *REA* 96 (1994), 177s.

37. Cfr. Johannowsky 451.

38. In questo modo S. Hornblower interpreta anche la dedica di Zeus Idrieus (Hornblower 113 e 115, n. 71).

39. La testimonianza è in Aul. Gell. 10.18 (= *TrGF* 72 T 6, F 3b Snell).

40. La notizia è in Plut. *Moralia* 7, p. 327 Bernardakis; cfr. Hornblower 333-6. Per altre ipotesi sull'argomento della tragedia si veda Hornblower 335, n. 19; diversa è l'opinione di B. Snell (*TrGF* 72 T 6, p. 228): 'haec tragoedia separanda vid. esse a "laudibus Mausoli dicundis" ... et fortasse inter eas tragoedias numeranda est quae Athenis actae sunt.'

Non ho potuto tenere conto dell' articolo di R. Bonifacio uscito nelle more della stampa su *Ostraka* 3 (1994) 455-65.

14

Sculpture from Labraynda

Pontus Hellström

The focus of this chapter is on the Hekatomnid period at Labraynda[1] and especially on the sculpture related to the Andron of Mausolus, the so-called Andron B (Fig. 194).[2] This was apparently the first building to be erected within the large mid-fourth-century BC building project at the site. It is both for this reason and because of its unique architectural and functional features a key monument for our understanding of the Hekatomnid project.

The side and back walls of the Andron were of gneiss, whereas the front was entirely of marble with two Ionic columns *in antis* carrying a Doric entablature (Fig. 195).[3] The building is fortunately securely dated, thanks to the dedication by Mausolus on the architrave. There are no indications that the building was unfinished by the end of Mausolus' reign or that there was any important rebuilding. It can therefore safely be dated not later than 352 BC.[4] A few pieces from this temple-like front merit special attention from a sculptural point of view, namely an anta capital, a column capital and a possible corner acroterion with a fragment of a second one.

In the mid-fourth century BC a new symmetrical design for Asiatic Ionic anta capitals was created.[5] The earliest example of this new symmetrical type so far known appears to be the one connected with the temple of Zeus at Labraynda, presumably designed by Pytheos (Fig. 196). A little later a similar capital was designed by the same architect for the temple of Athena at Priene. The two propylons at Labraynda, which are presumably slightly later than both the Andron and the temple, also have similar symmetrical designs.[6] As already observed by Voigtländer, the Andron capital is typologically of the older type, the design of which is more directly connected with Archaic anta capitals.[7] This traditional capital type differs from the one created for the temple of Zeus as regards both the fronts and the returns. On the front both types have three superimposed registers: Lesbian leaf, hanging palmettes and an ovolo. On the new capital type, however, there is a perfect axial correspondence between all three registers, whereas the Andron capital lacks correspondence between the middle register and the ones above and below (Fig. 197). Here there are seven ovolo eggs to six palmettes and seven Lesbian leaves. The reason for this is the respective difference in height given to the middle register. To achieve an axial correspondence between the registers either the proportions of the individual palmettes had to be changed, or the middle register had to be made lower than it is in the Andron specimen, permitting seven palmettes instead of six. The heights of the registers are, however, directly related to the size of the acanthus volutes on the return of the capital. To change the height of a front side register one would have had to change the design on the return. This leads to the observation that the basic difference between these capitals is the design of the return. On the Andron capital there is an asymmetrical acanthus pattern with three volutes towards the front (Fig. 198). On the temple capital the acanthus is not only symmetrical but the connection between acanthus spirals on the return and the registers on the front has been completely given up.

The column capital of Andron B has a rich *pulvinus* decoration, consisting of alternating lotus flowers and hanging palmettes (Fig. 199). This design has Archaic predecessors in Ionia, like that of the anta capital. The capital of the Polycrates temple of Hera on Samos is one of them.[8] It can be noted that the Labraynda capital has a reverse version of the Samian design. The Samian column, furthermore, had a rich neck decoration with the same kind of pattern, which is missing at Labraynda, but occurs at fourth-century BC Halicarnassus, for example.[9] There is also a second very similar capital at Labraynda, which probably belonged to the second andron, the Andron of Idrieus, or Andron A, on the upper terrace.[10]

In 1953 a male seated sphinx (h. 1.08 m) was found (Bodrum museum; Figs 200–203).[11] It was found just south of the Andron of Mausolus, in the Roman building called Andron C. At the moment of discovery, the sphinx was believed to have been a corner acroterion of the Andron of Mausolus, from where it may have fallen into the lower-lying building to its south, although this cannot be definitely proved.

The head of a second similar or identical sphinx was found in 1960 in front of Andron C, a short distance to the south-east of the Andron of Mausolus (Fig. 204).[12] If the complete sphinx belonged as a corner acroterion to the south-west corner of the building, the head must come from another corner, possibly the north-west one. Or the complete one was at the back of the building, and the head from the front, south-west corner. A few wing fragments of a sphinx were further found to the south-west of the Andron in 1953, probably not in their original fallen position. The underside of the sphinx has a tenon-like step, perhaps shaped to fit in an acroterion base. There are no cuttings for dowels. No acroterion base from the Andron has been found, but one base preserved from the temple of Zeus shows that no dowelling was used at that contemporaneous building.[13] The front legs are missing, and so are the back paws. The tail was partly self-supporting and this is also missing. The area between the chest and the wing feathers is flat and undifferentiated. Only the right wing is preserved. The feathers are formed by nineteen parallel curving lines. The left wing was repaired in antiquity. This is shown by two half-clamps, widening slightly towards the ends. At the top of the right wing there is a small vertically drilled hole. This may indicate another ancient repair, or an attachment, since the edge is only very slightly damaged at this point. Below the broken wing the body is slightly modelled to indicate four ribs. On top of the polos there are the remains of a tenon. The head of the sphinx has long hanging moustaches and a full beard. The hair is long and kept in a chignon at the back of the head, but two long strands of hair are falling down the chest. On the forehead is a diadem-like crown, a stephane, hiding the lower part of the cylindrical polos. The stephane ends just in front of the ears. Above the ear, between the stephane and the polos, there is a horizontal fillet, which ends in the chignon. The beards on both the complete sphinx and on the second head are horizontally grooved. The complete sphinx has no grooves between the hanging moustaches, which may show that it was not finished in this respect, since those grooves are present on the other head.

That the Labraynda sphinxes are male indicates that the inspiration is partly Eastern, since Greek sphinxes are female. Male sphinxes are, on the other hand, the rule in the East, where the sphinx and the lion are the most important symbols of royal power. In Greek art the function of sphinxes in architecture would appear primarily to have been apotropaic. In the Labraynda sphinxes we might perhaps be permitted to see a combination of Western and Eastern ideas, a combination of apotropaic function and royal power symbols. In this connection it is, of course, interesting that three very similar fragmentary male heads from Sidon have been identified as sphinxes by Stucky.[14] They belonged to the Ionic temple of Eschmun. According to Stucky they are slightly older than the sphinxes at Labraynda, and the Sidon specimens may either have served as acroteria or been placed between the columns of the temple in the same way as human figures at the Mausoleum and the Nereid Monument. If Stucky's identification is correct, which is reasonable, this is important evidence for the tracking down of the sources of inspiration for Hekatomnid sculpture.

The inside of the building has an almost square cella, 10 m wide and 11 m deep, where apparently couches for ritual banqueting lined the walls. In the back wall, a rectangular niche 4.8 m wide and 1.4 m deep was placed about 2 m above the floor level. Since niches, large or small, in classical architecture were always used for statues, one may assume that this function was also valid for the Andron niche. The dedicatory inscription mentions the Andron and what is inside, *kai ta eneonta*. These words may refer to sculptures in the niche. Since the size of the niche would permit three statues, it is tempting to assume that there was a statue group similar to the one depicted in the Tegea relief, i.e. in this case a large Zeus in the centre, surrounded by the ruling couple, Artemisia and Mausolus (Fig. 192). No traces or certain fragments of such statues have, however, been found. One marble fragment might, however, belong here. This is an over-life-sized marble foot, which was found to the north of the Andron (Figs 205–6).[15] The sandal type of this foot has close parallels with several male figures at the Mausoleum.[16] Unfortunately, its find-spot does not help us to establish the original position of the statue. It may have belonged inside the Andron but it is equally possible that it could have fallen from the temple terrace. Regarding the size of the statue to which this foot belonged, a rough estimate indicates a height of about 2.5 m. There was also found inside the cella, in 1991, a fragment of a marble sculpture, which may very well have belonged to a statue in the niche. It is a fragment of a draped figure, showing a thigh with a protruding knee. It is, however, not large enough to permit a safe definition of its scale, but it is not impossible that it belonged to a draped male figure like the so-called Mausolus from Halicarnassus. A few pieces of bronze sheet were also found in the cella in 1991. The largest of them is about 20 cm long. It shows no details that permit us to define its use, but its thickness is 4 mm, which would make it a possible sculpture fragment. There is a possibility that the sculptures

were in fact acrolithic, with feet, hands and heads of marble and drapery of bronze. In that case, however, the thigh fragment could not belong.

The width of the niche is 4.8 m. Its height is not preserved. What may be a fragment of its lintel, 60 cm high and 50 cm deep, was, however, found in the cella in 1991. This block has two large dowel cuttings in its front, presumably for separately attached ornaments, possibly of bronze. The most probable suggestion for the level of the lintel of the niche is at the same height as the lintel of the entrance to the cella, which we believe should be restored in accordance with the preserved lintel of Andron A. This would make the niche 3.5 m high.

At the top of the back wall, above the niche, was a gneiss apex block with a large cutting on the inside for the main beam of the roof (Fig. 207). On the outside, i.e. the exterior face of the block, looking westwards there is a simple horizontal moulding, a roundel, which does not run across the full width of the block. There are traces indicating that the roundel turned downwards, seemingly to frame a rectangular opening. This seems to indicate a window at the top of the back wall framed by this simple moulding. On the underside of the block there is an inset, 64.5 cm wide, which appears to be the top edge of the window itself (Fig. 208). This hypothetical window was placed so high in the wall that it was not visible from inside. With a height of *c.* 80 cm, its lower edge would have been on the level of the horizontal geison top. It would thus have been placed high above the lintel of the niche. The only conceivable use for such a window would be to light from above what was in the niche. Since the width of the lintel is 50 cm and the total depth of the niche is 1.4 m, there would be more than sufficient room for permitting light to enter from above, even with a 50-cm-wide backer behind the lintel. By the opening of shutters on the inside of the window, statues might in this way have been illuminated by sudden beams of light. Or, with the door and the windows of the cella closed, the cella could have been kept completely dark, with only the niche illuminated (Fig. 209).

About the interior decoration of the cella very little is known. One fragment of a marble frieze was found during the last excavation campaign, in 1991. It shows hanging, or standing, acanthus leaves and a bead-and-reel.[17] It is reasonable to think that this was part of the decoration of the cella, but I am inclined not to see it as belonging to the original fourth-century BC decoration. Two other small fragments found in the cella in 1991 belong to a meander frieze that probably also decorated the interior of the cella.[18]

At first this was thought to indicate that the many meander frieze fragments, actually thirty-six fragments in all, found at Labraynda originally all belonged here, but this is apparently not the case.

An unusual statue base was found in 1949 on the temple terrace, to the east of the temple. It is 92 cm long and 48.5 cm high. On the best-preserved side of the block there is a relief showing a racing team with a chariot drawn by two horses (Fig. 210).[19] The heads of the horses are missing. They were raised above the top of the base and sculpted in the round. The chariot has a large eight-spoked wheel. On the opposite side of the base there was an identical team, which today is almost completely weathered away. While the back end of the base was left plain, the front end has a draped female figure, which is presumably a Nike (Fig. 211). What is left of this figure is her body, dressed in a wind-blown garment. The head of the figure is missing. Since the head was projecting above the top of the base, it must also, like the horses' heads, have been sculpted in the round. The bottom of the base has a square dowel hole. It is placed midway between the short ends. The top, where a statue was presumably standing, is not horizontal. To the right it follows the top line of the chariot. Then it drops to continue along the line of the back of the horses. To the left it rises again, still following the bodies of the horses. There are three cuttings in the top surface. One is in the centre of the stone, above the backs of the horses. This is a quite deep, oblong cutting. The other two cuttings are in the right-hand part of the stone, at the top of the chariot. Of these, one is quite well preserved (the left-hand one). It consists of a squarish cutting that continues towards the left in a triangular termination, roughly the shape of a foot. The other one is at the far edge and is only partly preserved. The two cuttings above the chariot would seem to be for the feet of a statue. In that case the figure would have been standing above instead of in the chariot. An alternative would be to restore here the upper part of the body of a charioteer, or only the part that would be expected to be visible above the top edge of the chariot. The left-hand cutting might be for the fastening of the reins, although it is of very substantial size for such a use.

This base with its very special combination of bodies in relief and raised heads sculpted in the round has few parallels in Greek art. This way of combining the two techniques occurs in Late Hittite art and is exemplified much later in the sculptural decoration of the early second-century BC Qasr el Abd at Araq al-Amir near Amman in Jordan.[20] We can therefore imagine some eastern Anatolian inspiration for this

piece, although stylistically it looks perfectly Western. The base was found on the temple terrace, in the open area to the east of the temple of Zeus. This area was apparently surrounded by stoas in the Roman period. To the north lay the so-called North Stoa, erected in the beginning of the second century AD by a priest named Poleites. For the antas, blocks from a Hekatomnid stoa dedicated by Mausolus were reused. There are now indications that the Roman North Stoa used the foundations of an older stoa for its back and side walls – presumably the Stoa of Mausolus.[21] We can then presume that the pre-Roman statue dedications found here were already in the fourth century BC lined up in front of a stoa. Among these was a third-century BC exedra decorated with a number of small figures, presumably of bronze. In the south-eastern part of this area the chariot base was found, probably placed in front of another stoa facing north. Presumably the chariot base was placed on a high podium well above eye-level, which means that the statue on top was to be seen from below.

The local style is exemplified by a fragmentary relief found to the east of the South Propylon. This relief fragment shows the head and right hand of a female figure (Fig. 212).[22] To the right is the upper termination of what looks like a bow and to the left an arrow is being pulled out of its quiver. The figure represented is apparently the goddess Artemis. This relief is certainly not a major piece of art. Its main interest lies in the role it may have played at Labraynda. Artemis is not epigraphically attested at the site, and there is no other evidence for a cult of this goddess. It is true that, of the terracotta figurines found at the site, many depict females. But it is difficult to interpret these figurines as sufficient evidence for a cult of any female deity at Labraynda, especially when the breast ornaments on representations of Zeus Labrayndos (such as the Tegea relief) are no longer regarded as evidence for a polymastic and thus female aspect of the main god.[23] Previously, the 'breasts' of Zeus were regarded as evidence for an original female main goddess at the site, who had been dethroned by Zeus but remained as a female aspect of the god. In accordance with current opinion concerning the Ephesian Artemis as carrying a removable pectoral, the androgynous character of Zeus is at present not considered as very probable.

In this situation, I would like to suggest that this relief may have played the same role as that suggested by Geoffrey Waywell for the Tegea relief, namely a decree stele.[24] If the Artemis stele was originally a decree stele with an inscription below the relief-decorated panel, I would feel much less concerned about the find-spot of this object. If this was actually a decree stele, one of course thinks first of all of Amyzon, the sister sanctuary of Artemis further into the Latmos Mountains. Nothing would be more natural than to put up at Labraynda a decree of the city of Amyzon concerning any matter that involved the Carian people.

NOTES

1. The spelling of the name of the site, and of the epithet of the god, has a number of forms both in ancient sources and in modern works. As pointed out long ago by some scholars (cf. J. Crampa, *Labraunda* III:2 (Stockholm 1971) 191), the proper spellings have to be Labraynda (neuter plural) and Labrayndos, respectively. That the Greek *au* was not a diphthong but two separate vowels and that the word was thus a four-syllable one is made clear both by Pliny's Latin spelling Labraynda (*Natural History* 32.16) and by the early Roman spelling Labraiynda in inscriptions on stone at the site, none of which would make sense if the word were a three-syllable one. The stress was, so far as I understand, most probably on the second syllable and the y short and unstressed. The spelling Labranda (e.g. Strabo, *Geography* XIV.659) can best be explained in this way.

The use of the spelling Labraynda does not mean, however, that the name of the publication series can now be changed. Here, the old, seemingly incorrect 'Labraunda' has to remain unchanged.

2. For a full report on the marble sculpture from the Labraynda excavations 1948–60 see Ann C. Gunter, *Labraunda: Swedish Excavations and Researches* II:5. *Marble Sculpture* (Stockholm 1995). In the present paper I am relying heavily on her work.

3. P. Hellström and T. Thieme, 'The Androns at Labraunda: A Preliminary Account of their Architecture', *MedMusB* 16 (1981) 58–74.

4. For the date of Mausolus' death, see Hornblower 39f.

5. Cf. F. Rumscheid, *Untersuchungen zur kleinasiatischen Bauornamentik des Hellenismus* (Mainz 1994) 325.

6. K. Jeppesen, *Labraunda* I:1 (Lund 1955) pl. VII.

7. W. Voigtländer, *Der jüngste Apollontempel von Didyma* (Tübingen 1975) 36–43.

8. G. Gruben, *Die Tempel der Griechen*, 3rd edn (Munich 1980) 337.

9. P. Pedersen, 'Zwei ornamentierte Säulenhälse aus Halikarnassos', *JdI* 98 (1983) 87–121.

10. P. Hellström and T. Thieme, 'The Temple of Zeus at Labraunda: A Preliminary Note', *Svenska Forskningsinstitutet i Istanbul. Meddelanden* 4 (Stockholm 1979) fig. 8.

11. Gunter (supra n. 2) 21–30, cat. no. 2.

12. Gunter (supra n. 2) 24–30, cat. no. 3.

13. P. Hellström and T. Thieme, *Labraunda: Swedish Excavations and Researches* I:3. *The Temple of Zeus* (Stockholm 1982) 97: no. RB 1.

14. R. Stucky, 'Sidon–Labraunda–Halikarnassos', *Kanon: Festschrift Ernst Berger*, AntK-BH 15 (1988) 119–26.

15. Gunter (supra n. 2) 19–21, cat. no. 1: W. 0.15 m, pres. L. 0.205 m.

16. Waywell (1978) 153, esp. nos 217 and 218f.

17. P. Hellström, 'Labraynda 1991', in *XIV. Kazi Sonuçlari Toplantisi*, II, 25–9 Mayis 1992, Ankara (Ankara 1993) 131, fig. 1.

18. Gunter (supra n. 2) 47, cat. nos 18r–s.

19. Gunter (supra n. 2) 38–41, cat. no. 12.

20. R. A. Stucky, 'Hellenistisches Syrien', in *Akten des XIII. internationalen Kongresses für klassische Archäologie: Berlin 1988* (Mainz 1990) 30.

21. P. Liljenstolpe and P. v. Schmalensee, 'The Stoa of Poleites at Labraynda', forthcoming in *OpAth*.

22. Gunter (supra n. 2) 42f., cat. no. 14.

23. G. Seiterle, 'Artemis Die Grosse Göttin von Ephesos', *AntW* 10:3 (1979) 14.

24. Waywell (1993) 80.

15

Zwei hellenistische Werke aus Stratonikeia

Ramazan Özgan

Fragment einer männlichen Gewandstatue

Das Fragment (Figs 213–16) wurde im Sommer 1979 während der Grabung in der Exedra des hellenistischen sog. Gymnasium[1] in einer byzantinischen Mauer verbaut gefunden und befindet sich heute im Grabungsdepot in Eskihisar. Weisser bis cremfarbiger Marmor mit festen kleinen Kristallen. Höhe des Erhaltenen 74 cm, Breite 74 cm. Erhalten ist der Torso von der Hüfte bis oberhalb des rechten Knies. Das linke Bein ist etwa bis zur Mitte des Oberschenkels erhalten. Die obere Seite des Torsos ist ganz eben und waagerecht geglättet. In der Mitte dieser glatten Fläche befindet sich ein Dübelloch von 5×4×11 cm. Dieser Umstand bedeutet, dass der ganze Oberkörper der Statue angesetzt war. Sonst ist der Torso überall abgebrochen. Nur der untere Teil des linken Beines ist hohl und eine Stelle dort von 38.6×11.8×8.2 cm gepickt gelassen. Auf dem linken Oberschenkel gibt es zwei flache ovale Vertiefungen schräg gegeneinander versetzt, die gepickt sind. Die Rückseite der linken Körperseite ist ausgearbeitet, während die rechte Seite als Bosse gelassen ist. An der Aussenseite des linken Oberschenkels ist ein breites Stück abgeplatzt. Ansonsten gibt es kleine Bestossungen an den Faltenstegen.

Dargestellt ist eine männliche Figur im Hüftmantel. Sie steht auf dem rechten Bein und hat das linke Bein hochgestellt. Der waagerecht liegende Oberschenkel wurde von unten mit einer Stütze gestützt, wie die erwähnte Höhlung an der linken Kniekehle zeigt.

Die Falten des Mantels straffen sich von dem rechten zum linken Oberschenkel und dem Bausch über der Scham, einige von ihnen laufen unter den Mantelwulst. Über diesem ist oben in der Mitte ein kleiner dreieckiger Zipfel mit einem Gewicht zu sehen. Der Mantelbausch ist um die rechte Hüfte über den erhobenen linken Oberschenkelansatz gelegt; seine Fortsetzung ist abgebrochen.

Vermutlich zugehörig ist ein Gewandfragment mit breiten, tiefen Falten, das aus dem gleichen Material wie der Torso besteht und von der Schulter- u. Oberarmpartie stammt. Der Mantelstoff des Torsos liegt einerseits dicht über dem rechten Oberschenkel an und bildet grosse faltenlose Flächen, andererseits aber ist derselbe Stoff dick und schwer, infolgedessen wollig, wie man an den tiefen Falten zwischen den Beinen und am Bausch sieht. Ein breiter Faltenring ist plastisch über dem rechten Oberschenkel abgesetzt. Der sich unter dem Gewand abzeichnende Oberschenkel zeigt schwere, fleischige und wuchtige Körperformen.

Die summarisch ausgearbeitete Rückseite deutet darauf hin, dass die Statue wahrscheinlich an einer Wand aufgestellt war. Wie wir oben erwähnt haben, beträgt die jetzige Höhe des Fragmentes 74 cm. Das bedeutet, dass die Gesamthöhe der Statue etwa 2.70–2.80 m gewesen sein dürfte.

Wen diese Statue darstellte, ist ungewiss. Nur der Typus und auch die Grösse der Statue lassen entweder an eine männliche Gottheit oder an einen Herrscher denken. Wie die gesamte Statue ausgesehen hat, lässt sich auch nicht mehr genau rekonstruieren. Nur das hochgestellte linke Bein, der Mantelzipfel mit dem Gewicht über dem Mantelwulst und auch die auf dem linken Oberschenkel befindlichen, fast kreisförmigen gepickten Stellen könnten einen Anhaltspunkt bieten. Den Zipfel beispielweise, der bei vielen stehenden Statuen vorkommt, könnte dafür sprechen, dass die Statue aufgerichtet war. Die gepickten Stellen auf dem linken Oberschenkel dienten wahrscheinlich zur Stützung eines Gegenstandes, den möglicherweise die linke Hand gehalten hatte. Aus technischen Gründen kann der getrennt gearbeitete Oberkörper nicht nach vorn gebeugt gewesen sein, wie etwa bei dem Typus des vorgelehnten Poseidons,[2] der allerdings nackt ist und aus einem Stück gefertigt wurde. Denn der Dübel des Torsos war zu klein, um den Oberkörper in dieser Stellung tragen zu können. Falls unsere Statue eine männliche Gottheit darstellte, wäre am ehesten an Asklepios zu denken, da er auf den kaiserzeitlichen Münzen Kariens dargestellt ist und in Kleinasien fast überall verehrt wurde.[3] Dass es sich bei der überlebensgrossen Statuen in Stratonikeia um eine vorgebeugte und sich mit den Armen auf den linken Oberschenkel stützende Frauenstatuette mit nacktem Oberkörper handeln könnte, wie wir es bei einer

Frauenstatue in Rhodos vorfinden,[4] wäre auch nicht auszuschliessen. Aber dagegen sprechen allerdings einige Punkte. Es kann sich bei unserem Torso nicht um den gleichen Typus handeln wie bei der rhodischen Statue, denn die rhodische Frau stützt sich auf ihren rechten Oberschenkel. Auch den Zipfel mit einem Gewicht, die der Torso zeigt, finden wir nicht bei solchen vorgebeugten Frauenstatuen. Wichtig ist auch, dass die nicht ganz ausgearbeiteten Mantelfalten, hinten, auf der rechten Seite gerade weiter nach oben laufen, d.h. höchstwahrscheinlich auf die linke Schulter der aufrecht stehenden Statue.

Diese Darstellungsweise, die wir an dem Poseidon von Melos[5] und an anderen Statuen vorfinden, weist auf eine männliche Statue hin. Nicht zu vergessen ist auch die robuste, wuchtig-kräftige Wiedergabe des Oberschenkels des Dargestellten in Stratonikeia. Für einen Herrschertypus gibt es zu wenige Anhaltspunkte, als dass man den Torso als einen solchen rekonstruieren könnte. Eine ähnliche Statue Alexanders des Grossen in Wilton House,[6] die ebenfalls das linke Bein aufgestellt hat, hilft hier nicht weiter, da ihre Kleidung völlig anders ist. Motivisch ähnliches kommt bei den Reliefs des Altars von Magnesia a.M. vor.[7] Sowohl die Körper als auch die Gewandstruktur unseres Fragment begegnet häufig in der hellenistischen Plastik. Besonders die wuchtigen Körperteile und die schwerweiche Stoffwiedergabe sind Stilcharakteristika seit dem späten 3. Jh. v. Chr. Solche Stileigentümlichkeiten finden wir vor allem bei den bekannten pergamenischen Statuen, wie bei der Tragodia,[8] der sitzenden Statue Nr. 62,[9] bei den Figuren des Grossen Altars und auch bei den Relieffiguren des Artemis-Altars in Magnesia a.M. Jedoch zeigt unser Fragment nicht die kräftig durchgeprägten Körperwölbungen und den dicken, wollig locker zusammengeschobenen, gedrehten und vor allem mit tiefen Bohrungen kompliziert aufgelockerten Gewandbausch, d.h. unser Torso zeigt nicht mehr den sog. Barocken Stil des Hochhellenismus. Unser Fragment hat vielmehr ein durchscheinendes Gewand, V-förmige, einen dicken und weichen Stoff vortäuschende Falten an der Seite, dazwischen liegende, grosse faltenlose Flächen und vor allem einen flächig gestalteten Mantelbausch. Dies sind die Stilelemente des späten Hellenismus mit einer noch hochhellenistischen Formensprache. Auch der Faltenverlauf spricht für eine Entstehung unseres Torsos in der späthellenistischen Zeit. Die von der rechten Hüfte und von dem rechten Bein zur linken Hüfte gespannten Falten laufen in einen Punkt zusammen, wie bei den Statuen des Zentrifugalen Stils.[10]

Ein stilistischer Vergleich mit den Werken aus dem späten 3. Jh. und frühen 2. Jhs v. Chr. zeigt deutlich,

dass unser Torso etwas später entstanden ist. Die schwer, aber wohl schwungvolleren und dynamisch kräftig ausgeprägten Falten der beiden pergamenischen Götterstatuen oder Figuren des Grossen Frieses fehlen bei unserem Torso. Das Gewand ist bei jenen noch in der Art des Barocken Stils dick und schwer, setzt sich kräftig von Körper ab und ist locker drapiert. Ebenso ist der Mantelbausch viel kraftvoller und wulstig gedreht. Gegenüber den in die 80er Jahre des 2. Jhs v. Chr. datierten pergamenischen Statuen zeigt unser Torso eine steifere, lineare, trockene und flachere Gewandfältelung, die keine Räumlichkeit und Plastizität besitzt. Der Querwulst zwischen den Oberschenkeln besteht aus den flach übereinander gelegten Falten, die sich voneinander durch tiefe und breite Furchen trennen. Ein Blick auf die Mantelbäusche einiger Figuren des Grossen Frieses von Pergamon, wie z.B. der Eros (auf dem Süd-), des Nereus (auf dem Nord-) und der Nyx (auf dem Nord-Fries)[11] zeigt deutlich, wie flacher und schwungloser das Gewand des Torsos ist. Gut vergleichbar in motivischer und stilistischer Hinsicht ist hingegen das Gewand einer Statue aus dem Odeion von Kos, die von J. Schäfer kurz vorgestellt wurde.[12] Ihr Typus ist anscheinend seit dem 3. Jh. v. Chr.[13] geläufig und wurde z.B. auch für die Frauendarstellungen verwendet.[14]

Die stilistischen Unterschiede zwischen der Statue von Kos und der des Poseidon von Melos hat Schäfer zwar richtig gesehen, doch nicht chronologisch ausgewertet. Gegenüber dem verhaltenen, starren, reliefmässig in der Fläche ausgebreiteten Poseidon mit seiner 'abgehackten Rhytmik der Gewandanlage' hat der Torso in Kos einen kräftig gedrehten, 'spiralähnlich schwingenden' Körperaufbau voller Unruhe und Dynamik. Die kräftige Drehung des Körpers um die eigene Achse wird von allen Körperteilen mitgetragen; in dem Masse, in dem die rechte Seite stark abgesenkt ist und nach vorn stösst, ist die linke Körperseite weit nach oben gezogen und weicht nach hinten zurück. Der nach aussen gewölbte rechte Körperkontur und der eingezogene linke verdeutlichen auf diese Weise zusätzlich die Körperschwingung, die ausserdem noch von dem bogenförmig geschwungenen Gewandbausch unterstützt wird.

Die Unterschiede lassen sich weiterhin in der Darstellung des Inkarnats fassen: bei der Statue von Kos ist es weich und fleischig, kleinteilig-bewegt aufgefasst, beim Poseidon hingegen ist es kantig-hart und ohne Bewegung.

Schliesslich macht auch der Gewandstil die zeitliche Differenz zwischen beiden Werken deutlich: der Mantel der Statue von Kos ist weicher, voluminöser,

fliessender, hängt schwer nach unten, der des Poseidon hingegen ist sperrig, ohne stoffliches Volumen, leblos um die Hüfte gezerrt. Die schwere, weiche Stoffstruktur des Mantels mit dem durch Bohrungen aufgelockerten und geschwungenen Mantelbausch zusammen mit dem fleischig-bewegten Körperbau charakterisieren die Statue von Kos als ein Werk in der Nachfolge des Grossen Frieses von Pergamon.

Die Stilmerkmale der Statue von Kos kennzeichnen in beschränkter Weise auch den Torso aus Stratonikeia, wobei dieser sicherlich etwas später entstanden ist, da die Oberflächenbehandlung nicht weich-fliessend wie bei der Statue von Kos, sondern etwas härter, stumpfer wiedergegeben ist. Auch der Mantelbausch ist hier nicht mehr so kompliziert gedreht, nicht mehrschichtig zusammengeschoben und auch nicht fliessend geschwungen; vielmehr ist er in einer Ebene ausgebreitet. Die Fältelung ist flächiger, starrer und schwungloser. Daher zeigt der Torso aus Stratonikeia auch enge Beziehungen zum Poseidon von Melos. Einen absoluten zeitlichen Ansatz für die Torsen aus Stratonikeia und Kos ergibt sich aus dem Vergleich mit der festdatierten Statue der Megiste, die in den Jahren 147/46 v. Chr. geweiht wurde.[15] Die Drehung ihres Körpers ist zurückhaltender, weniger dynamisch und weniger schwungvoll. Das Gewand ist viel dünner, durchsichtiger und knittriger geworden. Die beiden, von der rechten Hüfte geführten und von der linken Hand festgehaltenen Mantelbäusche sind flächiger und haben den stofflich-lockeren Charakter verloren. Daher müssen die beiden Torsen aus Kos und Stratonikeia früher als die Statue der Megiste, d.h. früher als 150 v. Chr. entstanden sein.

Wie wir oben kurz aufgezeigt haben, sind sie andererseits auch später als der Grosse Fries von Pergamon zu datieren. Dass die Statue aus Kos spätestens um 160 v. Chr. entstanden ist, zeigt der letzte stilistische Vergleich mit einer Relieffigur[16] vom Telephos-Fries aus Pergamon, bei der der Mantelbausch und die Falten zwischen den Beinen ähnlich wiedergegeben sind wie bei dem Torso aus Stratonikeia; d.h. also die Statue von Kos ist in die 60er Jahre des 2. Jhs v. Chr. und der Torso aus Stratonikeia in die 50er Jahre zu datieren.

Wenn die Datierung des Torsos in die 50er Jahre des 2. Jhs v. Chr. richtig ist, dann könnte man die kolossale Statue möglicherweise mit dem Bau, in dem der Torso aufgefunden wurde, dem sog. Gymnasium, in Zusammenhang bringen. Durch die in den letzten Jahren unter der Leitung von Y. Boysal durchgeführten Grabungen konnten die prachtvolle Exedra und ihre seitlichen Räume freigelegt werden. Die teils bis zum Architrav erhaltenen, mit Halbsäulen und korinthischen Kapitellen geschmückten Wände sind aus festen, kräftig-cremfarbigen Marmorblöcken gebaut und zeigen eine hervorragende, künstlerische Qualität und handwerkliche Fähigkeit. Die dort erhaltenen korinthischen Kapitelle und andere Architekturblöcke mit verschiedenen Ornamenten weisen stilistische Beziehungen zu denen des im Jahre 164 v. Chr. gebauten Bouleuterions[17] in Milet auf. Wie der Grabungsleiter in seinem Vorbericht kurz gesagt hat,[18] ist dieser hervorragende Bau spätestens um die Mitte des 2. Jhs v. Chr. zu datieren. Daher ist es wohl möglich, dass die Weihung der kolossalen Statue mit der gesamten Bauanlage zusammenfällt.

Wenn alle diese Annahmen richtig sein sollten, dann könnte man wahrscheinlich weitere Aspekte hinzufügen. Denn Stratonikeia war höchstwahrscheinlich von 197 v. Chr. bis 167 v. Chr. unter rhodischer Herrschaft;[19] danach konnte sich die Stadt selbständig und frei machen. Es wäre dann anzunehmen, dass der Baukomplex, das sog. Gymnasium, mit einer Statuenausstattung für die Erneuerung der Autonomie dieser Stadt geweiht wurde.

Durch die Charakteristika des Gewandstiles auch durch die V-förmigen starren Gewandfalten auf dem rechten Oberschenkel und die unter dem rechten Knie zum linken Oberschenkel geführten Falten und Faltentäler liess sich unser Torso stilistisch mit der Statue des Poseidon von Melos in Verbindung bringen. Aber nicht nur die Gewandbehandlung, sondern auch die technischen Eigenheiten der beiden Werken zeigen Gemeinsamkeiten. Denn auch die Statue von Stratonikeia war, wie Schäfer es beim Poseidon beschrieb, 'aus zwei Hauptteilen zusammengesetzt, deren Naht den Querwulst des Mantels durchschneidet.' Diese technischen und stilistischen Übereinstimmungen deuten nicht nur auf eine zeitliche Zusammengehörigkeit der beiden Werke, sondern auch auf eine künstlerischen Zusammenhang. Bei der Untersuchung der Plastik aus Tralleis hatten wir versucht,[20] die beiden berühmten Werke von der Insel Melos, Poseidon und Aphrodite, einem karischen Kunstkreis zuzuschreiben. Diese These von der Herkunft des Künstlers der beiden melischen Werke aus Karien wird durch unseren Torso aus Stratonikeia nun untermauert. Weder der Poseidon von Melos noch die vermutlich von derselben Künstlerhand stammende Aphrodite konnten bisher einer bestimmten Kunstlandschaft zugeschrieben werden. So stellt Schäfer in seiner Untersuchung über den Poseidon folgendes fest:

Hier bestehen freilich erhebliche Schwierigkeiten, da die Forschung noch nicht über summarische Feststellungen zur Charakterisierung landschaftlich gebundener Stil-

richtungen innerhalb der Plastik des Hellenismus vor-
gedrungen ist ... Trockenheit der Modellierung verbun-
den mit Linearität der Gewandbehandlung, besonders
aber die Verwandschaft des Hauptes mit der kleinasia-
tisch–pergamenischen Formensprache schliessen attische
Herkunft aus. Eine enge Verbindung mit der perga-
menischen Kunst ist jedoch unwahrscheinlich, da sich das
Werk als ganzes dem Bilde der pergamenischen Plastik in
der Zeit nach dem Telephos-Fries nicht einfügen lässt.

Auch Melos selbst besass in späthellenistischer Zeit
offenbar keine eigene Bildhauerwerkstatt. Schäfer
schlug daher hypothetisch eine kykladische Werkstatt
vor, ohne diesen Gedanken aber näher präzisieren zu
können, da zu wenig inselgriechische Werke dieser Zeit
existieren. Eine Verbindung des Poseidons und der
Aphrodite zur samischen Kunst schloss anderseits
Horn aus.[21]

Die Untersuchung der Plastik von Tralleis hat
gezeigt, dass im ausserpergamenischen Kleinasien, ins-
besondere in Karien, bedeutende Bildauerschulen
schon seit dem späten 3. Jh. tätig waren. Eine von
ihnen war in Tralleis ansässig, deren Bildhauer nicht
nur Aufträge in Pergamon oder Melos ausführten, son-
dern auch in der südkarischen Stadt Stratonikeia, wie
der Torso nahelegt.

Die Charakteristika der Statuen von Melos, des
Poseidon und der Aphrodite, die von Schäfer heraus-
gestrichen wurden, 'die effektvolle Trennung von Ober-
und Unterleib, die Öffnung der Form, eine gewisse las-
tende Schwere der Gewandhülle, ferner der gleichar-
tige Verlauf der Stückungsnaht des Rumpfes' finden
sich nicht nur bei diesen Werken, sondern auch bei
dem Torso aus Stratonikeia. Eine weitere Statue, näm-
lich der kolossale Apollon[22] aus Tralleis in Istanbul,
lässt sich in dieser Hinsicht den erwähnten Werken
anschliessen. Der Torso ist also ein weiteres Beispiel
dafür, welch künstlerisch bedeutende und überlebens-
grosse Werke von der Bildhauerschule in Tralleis
geschaffen wurden.

Isis-Kopf in Izmir

Wann und wo der Kopf in Stratonikeia gefunden
wurde, ist unbekannt. Nach seiner Auffindung wurde
der Kopf in einer Grundschule in Milas (Sakarya
Ilkokulu) aufbewahrt und dann im Jahre 1961 ins
Museum nach Izmir überführt und bekam die Inv. Nr.
4354. Aus feinkristallinem, cremfarbigem Marmor.
Gesamthöhe: 41 cm; Höhe des Gesichts: 24 cm; Breite:
21 cm (Figs 217–19).[23]

Von der rechten Kopfseite aus unter dem rechten
Auge über die Nase hin schräg zum linken Halsansatz
ist der Kopf in zwei Teile gebrochen. Eine andere
Bruchlinie verläuft wiederum senkrecht auf der

rechten Kopfseite hinter dem rechten Ohr bis zum
Halsansatz herunter. Beide Bruchteile wurden wieder
zusammengesetzt. Ein grosses, abgebrochenes Stück
vorn an der Büste mit einem Gewandknopf ist wieder
angeklebt. Kinn und Nasenspitze sind abgeschlagen.
Die ganze Oberfläche, besonders ihre rechte Seite ist
sehr stark versintert. Sonst ist der Kopf einigermassen
gut erhalten.

Der in Büstenform separat gearbeitete Kopf war für
eine Gewandstatue bestimmt. Dies zeigt ausser dem
dünnen Schleier auch der vorn erhaltene Knoten.
Dargestellt ist ein mädchenhaft jugendlicher, blühen-
der Frauenkopf mit vollen, ovalen und rundlichen
Formen, der nach seiner linken Seite leicht hingeneigt
ist. Das Haar ist in der Stirnmitte zweigeteilt und an
die Seite gekämmt, so dass die Stirn eine Dreieckform
bekommt. Die Haarwellen sind seitlich über die
Schläfen und die obere Hälfte der Ohren in weichem
Gelock und lappenartig hingeführt, um das zurück-
liegende Kopfband herüberlegt und verschwinden
unter der Kopfbedeckung. Der Kopf war also mit dem
Mantel bedeckt, wie die unbearbeitet rohgelassene
gesamte Rück- und Nebenseite zeigen. Ausserdem ist
der Rest der Haarnadel auf dem Kopf noch sichtbar.
Der ihn bedeckende Mantelstoff wurde dann an beiden
Seiten der Büste auf die Schultern heruntergeführt.
Unser Kopf erinnert typologisch an den der bekannten
sitzenden Frauenstatue aus Pergamon in Berlin.[24] Ob
unsere Frauenstatue als sitzende oder stehende
dargestellt war, ist nicht mehr festzustellen. Der
rundliche, weich und lang modellierte Hals und die
Wendung des Kopfes und auch der in die Ferne
gerichtete ziellose Blick sprechen vielmehr für eine ste-
hende Gewandstatue. Auch der Gewandknopf weist
typologisch auf ein Standmotiv hin.[25]

Einen Hinweis auf die Interpretation des Kopfes gibt
der sog. Isisknoten.[26] Für ihn gibt es Parallelen in der
Plastik. Daher dürfen wir wohl annehmen, dass es sich
bei dem Kopf aus Stratonikeia um eine Isisstatue oder
Priesterin für sie gehandelt hat.

Wie oben beschrieben, zeigt der Kopf genügend
Stilmerkmale für seine Entstehungszeit, nämlich für die
hellenistische Zeit. Sein rundlich-verschwommener
ganz zarter, jugendlicher Gesichtsausdruck mit der
dreieckigen Stirn, dem weich-fülligen, fleischigen und
nach vorn gezogenen Orbital mit den kleinen,
träumerischen Augen und den fleischigen, klar abge-
setzten, feinen Augenlidern weist das Werk zweifels-
ohne in die mittlere hellenistische Zeit. Die etwas
weichen, aber lappenartig fülligen Schläfenhaare erin-
nern uns an die bekannten pergamenischen Werke
die sicherlich in die Grosse Altarzeit gehören.[27]

Nicht nur typologisch, sondern auch stilistisch ver-

gleichbar ist unser Kopf mit den vorhin erwähnten weiblichen Sitzstatuen in Berlin und auch mit dem Kopf des Hermaphroditen im selben Museum.[28] Bei diesen Werken treffen wir besonders die gleichen Haarschemata. Nun ist das Haar bei den pergamenischen Werken viel lockerer, bewegter und voluminöser und nervös-lebhafter dargestellt. Die innere Spannung des Gesichts mit den geschwollenen Gesichtspartien und den in die Tiefe eingebetteten Augen ist gut betont. Die schwellende Gesichtsform und innere Spannung sind bei unserem Kopf aufgegeben. Vielmehr hat das Gesicht einen ruhigeren, ausgeglichenen und träumerischen Ausdruck. Dies bedeutet, dass unser Kopf die pergamenischen Stilmerkmale besitzt, besonders an den Haarwellen über den Schläfen.

Der stilistische Unterschied zwischen den Werken der Altarzeit und dem Kopf aus Stratonikeia fällt sofort auf, wenn man unseren Kopf an die Seite des Kopfes der Nyx[29] des Grossen Frieses stellt. Mit dem fleischig hängenden Orbital, dem kugelig gedrehten und feurigen Augapfel und der inneren drängenden Gespanntheit ist der Kopf der Nyx dem pergamenischen Barockstil verhaftet, der bei unserem Kopf schon überschritten ist.

Anderseits zeigt der Kopf der Aphrodite von Melos,[30] die allgemein um die Mitte des 2. Jhs v. Chr. oder kurz danach datiert wird, einen spannungslosen Gesichtsausdruck, einen leeren Blick und eine leblose Gesichtsoberfläche. Obwohl das Orbital und die Augenlider bei beiden Werken sehr ähnlich sind, sieht man flächig-leblose und eintönig gekämmte-Haarwellen bei der melischen Aphrodite. Ähnliche stilistische Unterschiede stellt man ebenfalls an einem rhodischen Frauenkopf[31] fest, der ja auch typologische Übereinstimmungen zu unserem Kopf zeigt.

Diese stilistischen Vergleiche zwingen uns, für den Isiskopf aus Stratonikeia einen Platz noch vor der Mitte des 2. Jhs v. Chr. zu finden. Die dicken wellenförmig verlaufende Schläfenhaarsträhnen sind durch tiefe Bohrungen voneinander abgesetzt und lappenartig aufgelockert im Gegensatz zu den Stirnhaarsträhnen, die mit dem Meissel in dünnen Linien voneinander flächig und übersichtlich getrennt sind. Mit einem ähnlichen Bohrkanal sind die kleinen, füllig-fleischigen Lippen voneinander abgetrennt, somit ist die Mundspalte entstanden. Die Gesichtsmodellierung ist grossflächig, bevorzugt gleitende Übergänge und vermeidet scharfe, lineare Akzente. Die ungegliederte Glätte der Wangen und die dreieckige Stirn bestimmen den Ausdruck. Das Knochengerüst ist nicht zu sehen, aber zu erahnen. Unter leicht geschwungenen Brauen sitzen die Augen mit dicken und schweren Oberlidern. Im kurzen und rundlich vollen Untergesicht sitzt der kleine, leicht geöffnete Mund mit kleinen vollen Lippen

über dem runden Kinn mit ganz leichten Grübchen. Die Lippen trennt eine harte, leicht geschwungene brutale Bohrung voneinander. Das sind auch die gleiche Stilmerkmale, die wir bei einigen Köpfen des Telephos-Frieses Nr. 59, 121 und 123 vorfinden.[32] Etwa in der gleichen Zeit angesetzt wurden die Philikos-Musen. Mit Recht betont Frau Pinkwart den Zeitstil –

Die für den Kopf der aufgelehnten Muse charakteristische Mischung aus Sentimentalität und kindlicher Weichheit ist auch charakteristisch für die Köpfe am Telephosfrieses. Die zarte, füllige untere Gesichtshälfte, die runden Bäckchen, der kleine in Fettpolstern weich gebettete Mund verbinden den Musenkopf eng mit den Köpfen des [Telephosfrieses].[33]

– und auch mit dem Isiskopf aus Stratonikeia.

Der etwa in die Jahre 170–160 v. Chr. datierte Kopf aus Stratonikeia kann schon die Göttin Isis selbst darstellen, oder eine Heroine, oder Priesterin, wofür auch die für eine metallene Krone oder Stephane bestimmten drei Löcher über der Stirn in der Stoffbinde sprechen.

Der seit dem 3. Jh. v. Chr. durch die Seleukiden nach Kleinasien eingedrungene Isiskult darf für Stratonikeia in dieser Zeit nicht Fremdes sein. Denn ein kulturell einiges Reich zu schaffen wurde schon unter Alexander begonnen und von den Diadochen weitergeführt. Durch diese Ideologie wurde z.B. der griechische Hades in Alexandria zum Serapis umgewandelt. Wegen der engen auch kulturellen Beziehungen zwischen den Ptolemäern und den Seleukiden hatte Ptolemaios III Euergetes eine Isis-Statue nach Antiocheia für ein dortiges Heiligtum gespendet. Eine zusammenhängende Kulteinführung mit Isis und Arsinoe ist aus Halikarnassos bekannt.[34]

ACKNOWLEDGEMENTS

Die archäologischen Forschungen und Grabungen in Stratonikeia in Karien begannen im Jahre 1976 unter der Leitung von Prof. Dr Yusuf Boysal und werden heute noch fortgesetzt. Ich nahm in den Jahren von 1978 bis 1986 an den Grabungen teil und bearbeite die Skulpturenfunde der Stadt.

Die bisher gefundenen Skulpturen aus Stratonikeia werden zur Zeit in fünf Museen und Depots in der Türkei aufbewahrt, nämlich in Izmir, Milas, Bodrum, Mugla und im Grabungsdepot der antiken Stadt. Die genaueren Fundorte der vor der Grabung gefundenen Skulpturen in Stratonikeia sind leider nicht bekannt und auch nicht sicher lokalisierbar. Anderseits ist mir kein Skulpturenstück in ausländischen Museen aus dieser Stadt bekannt. Doch die älteren Bewohner der Stadt bzw. des Dorfes Eskihisar erzählen, dass die

Italiener während der türkischen Befreiungskriege viele Stücke aus Stratonikeia abtransportiert hätten. Wenn dies keine Erfindung ist, dann müssen einige Skulpturenstücke in italienischen Museen oder Privatsammlungen wiederzuentdecken sein.

Für die Publikationserlaubnis bedanke ich mich sehr herzlich bei Prof. Dr Y. Boysal und ebenso dem Museumsdirektor von Bodrum O. Alpözen und dem Vizedirektor A. Özet.

NOTES

1. Z. B. Y. Boysal, *Kazi Sonuçlari Toplantisi* 4 (Ankara 1982) 196–7; ders., *Kazi Sonuçlari Toplantisi* 7 (Ankara 1985) 520–21; ders., *13. Internationale Kongress für klassische Archäologie: Berlin 1988* (1990) 501–2.

2. Typus Lateran: Helbig 4 1, Nr. 1118; C. Rolley, *Die griechischen Bronzen* (1984) 190, fig. 172.

3. P. Kranz, *JdI* 104 (1989) 107–55; *LIMC* II (1984) *s.v.* 'Asklepios I' 882–4 (Typus Eleusis) figs 234–64 (B. Holtzmann).

4. Rhodos, 13635; G. Jacopi, *ClRh* 6, 16, nr. 2, pl. 2, figs 9–12; A. Giuliano, *ArchCl* 5 (1953) 213, pl. 103 b; Linfert 91, fig. 199.

5. J. Schäfer, *AntP* 8 (1968) 55–67, pls 38–41; Linfert 177–8; R. Özgan, *Die griechischen und römischen Skulpturen aus Tralleis, Asia Minor Studien* 15 (1995) 32, pl. 6, 3–4.

6. M. Bieber, *Alexander the Great in Greek and Roman Art* (Chicago 1964) 78, pls LII–LIII.

7. R. Özgan, *IstMitt* 32 (1982) 196–209, pls 44–8; W. Hoepfner, in *Hermogenes und die hochhellenistische Architektur: 13. Intern. Kongress für kl. Archäologie: Berlin 1988* (1990) passim.

8. *AvP* VII, 1 (1908) nr. 47; G. Krahmer, *RM* 38/39 (1923/4) 172–3; Horn 39, 51, pl. 18, 2, Linfert 109.

9. *AvP* VII, 1 (1908), nr. 62; A. Schober, *Die Kunst von Pergamon* (1951) 110, fig. 73; R. Özgan, *IstMitt* 32 (1982) 199–200, pl. 44, 1.

10. G. Krahmer, 'Stilphasen der hellenistischen Plastik', *RM* 38/39 (1923/4) 138.

11. W. Müller, *Der Pergamon-Altar*, pls 35, 41, 54; E. Schmidt, *Le Grand Autel de Pergame* (Leipzig 1962), pls 23, 29, 36; E. Rohde, *Pergamon, Burgberg und Altar* (Munich 1982), figs 55, 86, 97.

12. J. Schäfer, *AntP* 8 (1968) 65, Abb. 22; Linfert 77 mit Anm. 238.

13. Wie z.B. der qualitätvolle Torso, der in Claudischer Zeit angesetzt wurde. *ClRh* II (1932–40). Der Torso wurde jetzt von Frau Preisshofen ausführlich behandelt und ins späte 3. Jh. datiert. *ClRh* 9 (1938–46) 31, fig. 15; 34, fig. 18 und auch Poseidon von Melos.

14. *ClRh* 9 (1938–46) 50, Abb. 31; Linfert fig. 390 auch z.B. die Statue der Megiste. s. Anm. 15; auch bei den Friesplatten von Lagina, A. Schober, 'Der Fries des Hekateions von Lagina', *IstForsch* 2 (1933) pl. 10.

15. W. Geominy, *AM* 100 (1985) 367, pl. 81.

16. W. Müller, a.O. fig. 68, linke Figur; E. Schmidt, a.O. fig. 60, E. Rohde, a.O. fig. 101.

17. H. Knackfuss, *Milet* I, 2 (1908) 73; K. Tuchelt, *IstMitt* 25 (1975) 91–120.

18. s.O. Anm. 1.

19. Liv. 33.18, 22; Polyb. 30.21, 3; 31, 6 B–W. *RE* IV A 1, 322–4 *s.v.* 'Stratonikeia' (*s.v.* 'Ruge'); *RE* Supl. 5 (1931) 790, 797 *s.v.* 'Rhodos' (Hiller v. Gaertringen); Hans von Aulock, *JNG* 17 (1967) 13.

20. R. Özgan, *Die griechischen und römischen Skulpturen aus Tralleis, Asia Minor Studien* 15 (1995) 152–5.

21. J. Schäfer, a.O. 64–7; R. Horn, *Hellenistische Bildwerke auf Samos, Samos* XII (1972) 66; noch dazu, Linfert 98–100.

22. M. Flashar, *Apollon Kitharodos: Arbeiten zur Archäologie* (Wien 1992) 136, fig. 104; R. Özgan, a.O. TR. 20, 50–54, pl. 10.

23. Der Kopf wurde von Linfert 88, Anm. 334 e, erwähnt.

24. *AvP* VII 1, 82 nr. 50 pl. 18 und nr. 62 pl. 22; A. Schober, *Die Kunst von Pergamon* (1951) 108, 110, figs 68, 73.

25. Vergl. Horn 39f., pls 16–18.

26. s.O. Anm. 25; Linfert 102.

27. s.O. Anm. 24.

28. *AvP* VII 1, 132f., nr. 115, pl. 10, Beibl. 16; A. Schober, *Die Kunst von Pergamon* (1951) 106, fig. 60.

29. H. Winnefeld, *Die Friese des Grossen Altars, AvP* III. 2 (1910) 66, pl. 17 und 25, 1; W. Müller, *Der Pergamon-Altar* (1964) pls 54, 55, 56; J. P. Niemeier, *Kopien und Nachahmungen im Hellenismus* (Bonn 1985) 21, fig. 14.

30. R. Horn, 'Hellenistische Köpfe', *RM* 5 (1938) pls 15–16; R. Lullies, *Griechische Plastik* (1979)[4], 138, pl. 284; Linfert 98–100; *LIMC* II 1 (1984) 73, nr. 643 (A. Delivorrias); J. P. Niemeier, a.O. 20, fig. 10.

31. G. Konstantinopoulos, *Die Museen von Rhodos I, Das Archäologische Museum Athen* (1977) 69, nr. 121, fig. 104.

32. H. Heres-von Littrow, *FuB* 16 (1974) 191, 197, pl. 21.1–2; nr. TF 153, 202, pl. 22.4 nr. TF 59; 203, pl. 23 nr. TF 123, 124, 125, 130.

33. D. Pinkwart, *Das Relief des Archelaos von Priene und die Musen des Philiskos* (1965) 124, pl. 9 unten. Solche Gesichtsform und Ausdruck erinnert uns auch an die Koroplastik. Vgl. hierzu: S. Mollard-Besques, *Terrakotten Katalog Louvre* II (1963) Myrina, pl. 18, MYR 18 pl. 23 MYR 31, 834; pl. 24 MYR 29 usw.

34. *RE* IX, 2 (1916) 2102, *s.v.* 'Isis' (Roeder).

16

An example of domestic garden statuary at Cos: the Casa Romana

Marina Albertocchi

The so-called Casa Romana (Fig. 220) was discovered by L. Laurenzi during the archaeological researches which followed the earthquake in 1933.[1] We have only some records of that excavation, from the brief report published by Laurenzi himself[2] and from a few photographs. In addition to the scarcity of the documentation there are also some difficulties in 'reading' the monument, owing to its reconstruction in the years 1938–40.

A series of interventions affected the building (which covers an *insula* of 2,300 sq. m.) over a period of six centuries, and we have distinguished three principal phases. The first one is placed in the Hellenistic period (third-second century BC); in the second half of the second century AD, following the earthquake of AD 142 that destroyed Cos,[3] the *insula* was formed as one inhabited unit corresponding to the visible arrangement. Some intervention, relating to the renewal of the decoration, is dated a century later. The *terminus post quem* for the destruction of the house (probably caused by a fire) is datable to the middle of the fourth century AD.[4]

Many bronze fragments were found in the excavation, but these were lost during the German occupation of the island. So among the objects recovered in the house only the marble statuettes have been preserved, published by Laurenzi in 1955–6.[5] These statuettes have been partly damaged during World War II. The Asclepius, for example, hidden in a case in 1941 at the Odeion, was then stolen. Laurenzi asserts that, in addition to the little head of Alexander the Great, he found several body fragments, lost during the war.[6]

The aim of this chapter is the reintroduction of the statuettes of the Casa Romana, after the recent publication of valuable studies about Coan sculpture[7] and domestic statuary.[8] On the basis of these studies, I intend to suggest an analysis of the whole sculptural unit, that will give the measure of the stylistic homogeneity and peculiarity of the collection.

The statuettes

The marble statuettes number thirteen: five come from the minor peristyle (no. XXVIII on the plan), six from the main peristyle (no. XVIII) and one from a room near the entrance (no. XVIII). Laurenzi does not give any indication of the find-spot of the lost Asclepius. In the excavation a fragmentary herm was also found, but we do not have any information about it.[9] Almost all the sculptures are slightly less than half life-size, around 70 cm high. This feature finds a comparison in the production of several other centres in the Hellenistic age: in Cos, too, small sculpture appears to be typical of the domestic and votive private areas.[10] The statuettes are carved from the local marble, except for the armed Aphrodite, carved from a large-crystalled white marble, perhaps Parian, and the Athena, made in a fine-grained marble ('marmo ... alabastrino' as Laurenzi would have it).

The sculptural types of the Casa Romana have parallels with the most common ones among the domestic sculpture of the Hellenistic age. In fact, Aphrodite is the most frequent subject,[11] represented by four statuettes. Two of them (Figs 221–2), belonging to the same type and discovered in the minor peristyle, have been explained by Laurenzi as Nymphs, being found near the basin.[12] Recently, some scholars[13] have explained that the presence of the stephane in the well-preserved figures and the gesture of the right arm clearly identify these statuettes as Aphrodite, either pointing out a target to Eros or arbitrating a fight between Eros and Pan. The two fragmentary statuettes of the Casa Romana, however, cannot be connected with other characters, so we cannot exclude the possibility that their identity may have been changed into generic female types, suitable for gardens.[14] They belong to a typical Rhodian production;[15] the best comparisons are two statuettes from Priene and Rhodes.[16] From these parallels and the stylistic features we can date both fragments to the end of the second century BC.

Another statuette from the minor peristyle can be attributed to the so-called *au pilier* Aphrodite type (Fig.

223).[17] Apart from the likeness to a statuette from Priene, as Laurenzi reminds us, we have to consider the similarities with other late Hellenistic replicas from Cyrene, Crete and Delos.[18] According to these comparisons we can date our statuette to the late Hellenistic period (end of the second to beginning of the first century BC).

The last female figure of the minor peristyle is sitting and cloaked (Fig. 224).[19] According to Laurenzi it was again a Nymph, but Pinkwart rightly considered this piece a replica of the Frankfurt Ourania Muse.[20] Other statuettes belonging to the 'Muses of Philiskos' cycle have been found isolated, like these ones, but they must have been recognised as Muses, symbols of intellectual culture, as their frequent representation testifies until late antiquity.[21] Their presence in the garden celebrates the owner of the house as *mousikòs anér* and constitutes a moral *exemplum*, an important value for the ancient collector.[22]

The Casa Romana statuette is part of a group of replicas surely created in Asia Minor;[23] the similarity of our piece especially with the Priene relief[24] and the Aydin torso,[25] together with the plastic rendering of the cloak, dates the statuette in the late Hellenistic period, probably at the end of the second century BC.

The satyr with the syrinx (Fig. 225) completed the minor peristyle decoration.[26] The subject, a variant of a first Hellenistic Pan with the pipe,[27] had a limited success.[28] The support with birds and the attribute of the right hand demonstrate the creativity of the artist who carved the piece (Fig. 226). The use of the drill to define some details (lachrymal gland, nostrils, syrinx), the crescent-shaped umbilicus and the decoration of the support fit comfortably into the sculptural production of the first Imperial period. The parallel with some small late Hellenistic heads[29] shows how badly the model has been interpreted by the sculptor of our satyr, without any precise parallel.

The last Aphrodite statuette comes from the main peristyle; the presence of a baldric on the back suggests it is an armed Aphrodite (Fig. 227).[30] Among the sixteen replicas collected by Flemberg, three come from Cos.[31] The success enjoyed in the island by this type made Laurenzi initially think that it probably reproduced the statue of Aphrodite located in the sanctuary near the harbour. Nevertheless, in a second stage of research, he rightly rejected his supposition.[32] The type seems to be, instead, a decorative variant of Praxiteles' Pselioumene;[33] its creation can be attributed to a local artist, as an *Umbildung* of the clothed one,[34] in the late Hellenistic period. The presence of the statuette in the garden of the Casa Romana forms the *Normprogramm* of the Coan aristocracy: also the

other replica comes from a house decorated with a middle Imperial mosaic, not far from the Casa Romana.[35] The refined theme of the love goddess, decorated with Ares' adornments, could offer a pleasant topic for discussion to the owner and his guests.

The stiff torsion and the nude treatment with angular outlines allow us to date the sculpture to the end of the first century BC, on the basis of a comparison with similar *anadyomenai* from Cyrenaica.[36]

Laurenzi has suggested the Eros statuette (Fig. 228) be seen as a replica of the famous Eros statue carved by Praxiteles for the town of Parion; the attribution based on numismatic evidence is reliable.[37] The evident differences (and the many supports) of the few replicas of the type suggest that they are not copies so much as *Umbildungen*,[38] and this makes more interesting the presence of the statuette in the decoration of the house. The piece was probably ordered because of the fame of the original by an erudite connoisseur.

The Eros of the Casa Romana seems to be datable to the first century BC, from its unitary and soft treatment of the torso. It is a late Hellenistic replica created in an eclectic milieu, which can be compared with young figures from Rhodes and Priene.[39]

The Hellenistic creation of the Herakles herm (Fig. 230)[40] links the apotropaic value of the herm with that of the god, considered *alexikakos* even in the classical period.[41] However, it is clear that in time the decorative value became increasingly important. In Cicero's letters herms of Herakles were considered *ornamenta gymnasiode*,[42] evoking the gymnasium as a specific symbol of Greek culture. The god, with Apollo, is the guardian deity of the gymnasium at Cos.[43] The presence of the herm in *domus* decoration assumes therefore several values; among them the most meaningful is the relationship of the garden to the gymnasium. Herakles' herm, without the god's club, belongs to a familiar variant from eastern Greece, represented by a similar model on Cos.[44] We find, for example, a close stylistic affinity with two funerary reliefs from Smyrna dated to 150 BC.[45] Our piece is probably contemporary with or slightly later than these reliefs.

The head of Alexander the Great (Fig. 229) is related to the group of small portraits of this ruler, in which the facial features are ordinary.[46] Athenaeus records the dedication of an *andrias* to the deified Alexander the Great at Cos in the second century BC,[47] linked with an anecdote celebrating the immortality of the king. The tradition of Alexander's divinity flourished in the Imperial period, as is testified by Pseudo-Callisthenes' novel of Alexander's apotheosis at the beginning of the fourth century AD. It is, therefore, possible that the Casa Romana portrait was connected

with the idea of salvation evoked by the immortal king. Small images of Alexander the Great for private cult use are conventional in Egyptian Alexandria, where we can find the best parallels for our little head,[48] related to the type with the lance. The parallels go back to the late Hellenistic period.

Laurenzi's identification of the female figure carrying a cornucopia on the left forearm as a Tyche (Fig. 231) is correct,[49] even if the presence of the *patera* is not specific to the goddess' iconography. The association of the two attributes is inspired by the representation of Berenice–Tyche on Ptolemaic oinochoai.[50] The statuette is stylistically different from the other sculptures of the house: it belongs to the archaistic tradition common in representations of Tyche, as the mannered and decorative stylisation of the dress shows.[51] The statuette holds special interest for its expression of an archaistic sculptural manner on Cos, so far not much considered by scholars,[52] and contributes to the variety of artistic genres of the Coan workshops. We have no precise parallels for this eclectic piece; the upper part, showing a classicising inspiration, and the expressionless face (Fig. 232) are comparable with some late Hellenistic statuettes in New York, Rhodes and Cos.[53] The style of the work dates to the end of the first century BC or to the first century AD.

The heroic relief, showing a banquet for the deceased (Fig. 233), comes from the main peristyle too.[54] The presence of a deity (identified as Cybele) sitting on the left of the banqueter is uncommon. The horse-shoe shape of the relief is also unusual, recalling the sandal-shaped stele of Silon in Athens, that has been interpreted as an *ex voto pro itu et reditu*.[55] This interpretation does not, however, explain the presence of Cybele. It is better to think, with Naumann,[56] that the relief represents the memory of the heroisation of the initiate to the goddess' mysteries. Sherwin-White has devoted some pages to 'private cult foundations' that could be found in the south-east Aegean from the end of the fourth century BC and which consist of the heroisation of the familiar cult founder and his heirs.[57] Placing our relief in this group, as a memory of Cybele's protection demanded by the heroised private cult founder, we find a justification for the presence of the relief in the sculptural decoration of the house. If the relief is an ancient heirloom, this also justifies its dating to the beginning of the third century BC. We cannot, however, deny the difficulties related to the hypothesis that the relief was preserved for so long in the family, and we cannot exclude the possibility that the piece was bought simply to be included in the collection.

The statuette of Athena found in a room of the house (Fig. 234)[58] is unique among the sculptures found on Cos, even if the goddess' cult, with different title, was practised in the island.[59] Moreover, it is a pastiche of a type somewhere between the Dresden Artemis and the Athena 'Cherchel/Hephaisteia',[60] not merely an ordinary replica of the latter type,[61] for it lacks the transverse aegis. The lengthened proportions of its body and the drapery, far from the cold symmetry of the other replicas of the Dresden Artemis, seem to go back to the late Hellenistic period, and the eclectic features of the statuette would seem to preclude a precise dating. Very accurately worked, the head (Fig. 235), seems to resemble the 'Velletri' type,[62] although the horse-tail treatment is the outcome of the artist's creativity.

Finally, the protection of Asclepius, the main deity in the island pantheon, is invoked by the dedication of a small effigy. The statuette of Asclepius from the Casa Romana[63] is a simplified version of the Este type, without the triangular edge and with the cloak's folds roughly carved. For those characteristics we can link the statuette with other Hellenistic ones[64] and with some replicas found in Rhodes and Cos, that reproduce the cult statue recently attributed to the Temple A of the Asklepieion.[65]

Find-spots

Almost all the statuettes come from the two peristyles of the house, which belong to the 'Rhodian' type according to Vitruvius' definition.[66] The arrangement of the sculptures in the peristyles dates back to a Hellenistic tradition widespread in Greece, where most domestic sculpture has been found in open areas and close to water.[67] This style has been reproduced in villas in Italy.

The visible arrangement of the minor peristyle of the Casa Romana (Fig. 236) corresponds to the late Imperial period. In this phase the courtyard was decorated by a U-shaped mosaic 'carpet', dated by style to the second half of the third century AD,[68] at the sides of a large basin. Connected to the peristyle there is an exedra (room XXVI), facing its southern side.

Laurenzi gives detailed information on the find-spots of the statuettes. He asserts, in fact, that the *au pilier* Aphrodite and the satyr have been found 'nella piscina del peristilio', while the upper part of the sitting Aphrodite was discovered 'presso la piscina'. The remaining two statuettes were found 'insieme alle altre'.[69] So it appears clear that the statuettes, found inside and mostly around the basin, were placed near to it.

Notwithstanding the fact that the central panel of the mosaic faces north, suggesting a privileged view of the peristyle–exedra unit from that side, it is reasonable to think that the sculptures would be viewed, in the guise of a picture, by the spectators from the exedra. It is therefore unlikely that the statuettes showed their backs to that room; they were located probably on the edge of the mosaic (or along the sides of the basin) to allow them to be observed both from the exedra and from the ambulatory of the peristyle. At least in their original setting, the backs of the statuettes would not have been seen: the rear part of the sitting Aphrodite, in fact, is roughly carved, and the Aphrodite *au pilier* and the satyr show some fixing holes. In this phase, however, we are sure that the statuettes were placed on the mosaic, probably in front of the pillars to let their backs be partly hidden.

In Laurenzi's words, the lower and upper part of the two Aphrodites 'non si suturano'.[70] It has not been possible physically to put one piece on the other, but given the fact that the upper part has four dowels, and that the lower fragment has four dowels also, we can reasonably suppose that the two pieces belong to the same statuette. The fact that the two fragments have the same dimensions and the same stylistic features goes to confirm this hypothesis. The possibility that Laurenzi was right, however, cannot be precluded: the Hellenistic practice of producing double copies of a type had a great success in the Roman period;[71] the preferred method of creating a pair is two copies oriented in the opposite way. But here, if they had been placed facing each other at either end of the courtyard, they would suggest the illusion of opposites. This image would have a double effect when seen reflected in the pool.

The main peristyle is the core of the inner part of the *domus* (Fig. 237), and around it are social and service rooms. The relevant phase of occupation in the house has been 'interpreted' in a process of anastylosis: the colonnade was erected and an upper floor rebuilt. The central courtyard was used as a garden, with a pool in the centre, as it appears today. The dating of this last setting, as for the minor peristyle, is the second half of the third century AD.[72]

The original positions are known of two sets of sculptures adorning this peristyle. One is the 'angolo S.E. del peristilio', where there came to light the Tyche and the heroic relief. The other is 'lo strato sconvolto dalla trincea per il passaggio dei tubi dell'acquedotto' whence came statuettes of Aphrodite, Eros and Alexander the Great; the herm is from the peristyle, without a more specific designation.[73] The trench, opened during World War I, cut diagonally through both the Thermae beside the house and the main peristyle. From a photograph[74] we can reconstruct the course of this trench (1–1.5 m wide), which could not have penetrated the earlier layers.

It is safe to say that the statuettes would have been placed along this line, very probably in the garden. The *viridarium* probably contained the herm of Herakles; the rear, roughly worked part was perhaps hidden by a hedge. In pendant with this herm there was perhaps the one of Hermes, as recorded by Laurenzi in the excavation report.[75] The sculptural ensemble served, with the marble *crustae*, to impress visitors walking along the porticoes or sitting in the reception rooms facing the peristyle.[76]

The only statuette that does not come from the two peristyles is the Athena. Laurenzi says it was found 'in una stanza con pavimento musivo presso il cortile fenestrato'.[77] No doubt he was writing about room XVII, which preserves a rich floor in *opus sectile* (Fig. 238). The centre of the floor was adorned by an *emblema* with fishes, dated around 100 BC.[78] The statuette should have been placed on the shelf of the south wall of the room.

The collection

The arrangement of the minor peristyle centres upon the water motif, as testified by the marine genre mosaic which surrounds the basin. The decoration recreates a 'natural setting', as in the fresco decoration of the pillars, where vine leaves and grape bunches are painted, as well as in the statuettes: Aphrodite and the Muse are sitting on a rock and the support of the satyr is enlivened by two birds. Every element contributes to create an artificial garden, with a strong decorative character.

In the main peristyle there is no clear homogeneity between the figures; their display, eclectic in subject, resembles a gallery, now really placed in the midst of the vegetation. The group includes the replica of a famous sculpture, the Eros of Parion, and an epigrammatic subject, the armed Aphrodite. Beside these pieces, which display the owner's refined artistic taste, there is the relief that, in keeping with our interpretation, forms an important religious symbol for the family. The herm, the Tyche and the Alexander belong to the common repertoire of sculpture collections, as we have seen, and remain independent. The statuette of Athena, placed alone in a room, would have been particularly appreciated by the owner for its aesthetic value.

The discovery of the statuettes in the context of the late third-century AD phase of the *domus* confirms that,

beside mosaics, marbles and frescoes, the decoration of the Casa Romana included some 'antique' marble statuettes, dating from the third century BC to the first century AD. These either belong to the ancient decoration of the house (prized as family heirlooms) and were reused in a new setting, or were bought by the owner when the house decoration was renewed. In support of the first hypothesis there is the chronological homogeneity of the pieces; there are no portrait-statues or Imperial copies. The hypothesis that later, life-sized statues were taken away after the abandonment of the house must be excluded because the building does not seem to have been sacked. The same supposition could be formulated for the presence of the late Hellenistic *emblema* in room XVII; it is probable that the mosaic has been recovered from an earlier decorative scheme and inserted in the middle Imperial marble floor, as remarked by Bruneau.[79]

Notwithstanding the great number of sculptures found on Cos, few sculptural groups could be attributed to a specific *domus*;[80] and it is interesting to note that these Roman houses are mostly decorated with Hellenistic statuettes. To the Coan evidence we must add Rhodian examples: here we know of some Roman houses adorned by small Hellenistic sculptures, interpreted as a 'reuse' from the ancient phase of the house.[81] This phenomenon is particularly interesting because uncommon, at least in the eastern Mediterranean. Actually, it is quite difficult to find a sculptural collection of the Roman Imperial period constituted only by Hellenistic sculptures, without any contemporary piece.[82]

In any case, whether the sculptures belong to the former decoration or were acquired in the market, they must have had a great value for the owner as antiques, and their age was a prestige factor for the collector.[83] The collection, whatever principles have guided its composition, has an antiquarian feature that betrays a certain sensibility towards the flourishing glyptic traditions of the island, which goes further than simple reuse of the decoration. Local traditions, although entangled in a growing process of Romanisation, were always kept alive, as can be noted in the mosaics, often representing the myths of Cos' ancient past.[84]

ACKNOWLEDGEMENTS

I wish to thank Dr I. Jenkins and Prof. G. B. Waywell for their generous invitation to this Colloquium. I am indebted to Prof. A. Di Vita, who entrusted me with the study of the Casa Romana for my specialisation thesis at the Italian Archaeological School. I am also grateful to the Ephor of the Dodecanese, Dr I. Papachristo-doulou, and to Dr E. Brouskari for having helped me in this work at Cos.

NOTES

1. For the earthquake see L. Morricone, 'Scavi e ricerche a Coo (1935–1943): relazione preliminare', *BdA* 35 (1950) 54.

2. Laurenzi (1935–6) 138–40.

3. Paus. 8. 43.4.

4. See M. Albertocchi, *La 'Casa Romana' di Coo*, Tesi di Specializzazione SAIA (Rome 1993) 202–4. Two statuettes show the marks of this fire: Athena and the sitting Muse, see infra.

5. Laurenzi (1955–6) 64–80.

6. Laurenzi (1955–6) 79.

7. Kabus-Preisshofen (1989), and Stampolidis (1987).

8. Other scholars' publications include: M. Kreeb, *Untersuchungen zur figürlichen Ausstattung delischer Privathäuser* (Chicago 1988); R. Neudecker, *Die Skulpturenausstattung römischer Villen in Italien* (Mainz 1989). See also E. J. Dwyer, *Pompeian Domestic Sculpture: A Study of Five Pompeian Houses and their Contents*, Archaeologica 28 (Rome 1982).

9. Laurenzi (1935–6) 139; Laurenzi (1955–6) 64.

10. Kabus-Preisshofen (1989) 21; E. Bartman, *Ancient Sculptural Copies in Miniature* (New York 1992) 4.

11. See V. J. Harward, *Greek Domestic Sculpture and the Origin of Private Art Patronage* (Ann Arbor 1987) 119; Kreeb (supra n. 8) 58–9, 73.

12. Laurenzi (1955–6) 74–5, nos 6, 7.

13. W. Neumer-Pfau, *Studien zur Ikonographie und gesellschaftlichen Funktion hellenistischer Aphrodite-Statuen* (Bonn 1987) 230–32; H. H. von Prittwitz und Gaffron, *Der Wandel der Aphrodite* (Bonn 1988) 30–60.

14. Prittwitz und Gaffron (supra n. 13) 59–60.

15. Gualandi 57–61; Linfert 87–8 (our piece is no. 183 pl. 34, wrongly assigned to Rhodes).

16. Priene: Prittwitz und Gaffron (supra n. 13) 33–4, fig. 8; Rhodes: Gualandi 61–3, fig. 35.

17. Laurenzi (1955–6) 73–4, no. 5.

18. *LIMC* II (1984) *s.v.* 'Aphrodite' (A. Delivorrias) 67, pls 56–7, nos 571 (Crete), 572 (Cyrene). Delos: J. Marcadé, *Au Musée de Délos* (Paris 1957) 230–32, pl. XLIII, A 5438; pl. XLIV, A 382, A 1604, A 5415, A 1873. See also Gualandi 96–9, 102, 235–7.

19. Laurenzi (1955–6) 75–6, no. 8.

20. D. Pinkwart, *Das Relief des Archelaos von Priene und die 'Musen des Philiskos'* (Kallmunz 1965) 139–43, 205–7. Contra: S. Sismondo Ridgway, *Hellenistic Sculpture* I, *The Styles of ca. 331–200 BC* (Wisconsin 1990) 254–5. See also in this volume R. Özgan, 'Zwei hellenistiche Werke aus Stratonikeia'.

21. E.g. G. M. A. Hanfmann, 'The Continuity of Classical Art: Culture, Myth and Faith', in K. Weitzmann (ed.), *The Age of Spirituality: A Symposium* (Princeton 1980) 75–100.

22. See P. Zanker, 'Zur Funktion und Bedeutung griechischer Skulptur in der Römerzeit', in *Le classicisme à Rome aux Iers siècles avant et après J.-C.*, EntrHardt 25 (Geneva 1979) 284–9.

23. B. Ridgway, in E. D. Reeder (ed.), *Hellenistic Art in the Walters Art Gallery* (Baltimore 1988) 100–101, no. 24;

eadem, 'Musing on the Muses', in *Festschrift in Honour of N. Himmelmann*, BJb-BH 47 (Frankfurt am Main 1989) 265–72.

24. Carter, *Priene* 193, 196–7, pls XXIX-XXX.

25. Pinkwart (supra n. 20) 206, pl. 8c-d.

26. Laurenzi (1955–6) 77–8, no. 11.

27. See E. Kunzl, 'Eine antike Tonform aus Mogontiacum/Mainz', *RdA* 9 (1985) 35–7.

28. Stuart Jones, pl. 22, no. 60; E. Paribeni, *Catalogo delle sculture di Cirene* (Rome 1959) 118, pl. 156, no. 334. See also W. Wohlmayr, *Studien zur Idealplastik der Vesuvstädte* (Salzburg 1989) 67, fig. 51, no. 60 (from Pompeii).

29. For example Marcadé (supra n. 18) 450, pl. XXVII, A 4290.

30. Laurenzi (1955–6) 64–6, no. 1.

31. J. Flemberg, 'Venus armata. Studien zur bewaffneten Aphrodite der griechisch-römischen Kunst', *SkrAth* 10 (1991) 62–100, especially 80–86, nos 8–10.

32. L. Laurenzi, 'Echi della grande arte greca in sculture minori', *AAM* 5 (1959) 8-11. The armed goddess has no relation with the *epiclesis* of the worship of Aphrodite in Cos: Sherwin-White 304-5.

33. Of this opinion is V. Machaira, *Les Groupes statuaires d'Aphrodite et d'Eros: Étude stylistique des types et de la relation entre les deux divinités pendant l'époque hellénistique* (Athens 1993) 137–9.

34. For the word *Umbildung* see J. P. Niemeier, *Kopien und Nachahmungen im Hellenismus: Ein Beitrag zum Klassizismus des 2. und frühen 1. Jhs v. Chr.* (Bonn 1985) 154–7. For the clothed, armed Aphrodites see Flemberg (supra n. 31) 43–61.

35. L. Laurenzi, 'Nuovi contributi alla topografia storico-archeologica di Coo', *Historia* 5 (1931) 615, fig. 6.

36. G. De Luca, 'Piccolo torso femminile a Genova', *ArchCl* 16 (1964) 211–15, 217, pls XLVIII-LI (Genoa), LII, 3 (Cairo).

37. Laurenzi (1955–6) 66–9, no. 2; idem, 'Il prassitelico Eros di Parion', *RivIstArch* 5–6 (1956–7) 111–18; Corso, *Prassitele* i, 93–5. See also Todisco (1993) 73, fig. 124.

38. *LIMC* III (1986) *s.v.* 'Eros' (A. Hermary) 856.

39. Rhodes: Gualandi 197, fig. 250, no. 200; Priene: R. Kabus-Jahn, 'Der Jüngling Karg-Bebenburg', *AA* (1968) 446–58, especially pls 18–19.

40. Laurenzi (1955–6) 77, no. 10; *LIMC* IV (1988) *s.v.* 'Herakles' (O. Palagia) 782, pl. 522, no. 1131.

41. H. Wrede, *Die antike Herme* (Mainz 1985) 24–5; Harward (supra n. 11) 128–31.

42. Wrede (supra n. 41) 59–61.

43. Sherwin-White 317–20.

44. Laurenzi (1955–6) 136, no. 175.

45. Pfuhl-Möbius I 92, pl. 35, no. 161; 182–3, pl. 98, no. 646; 198, pl. 110, no. 730.

46. Laurenzi (1955–6) 79–80, no. 12. R. R. R. Smith, *Hellenistic Royal Portraits* (Oxford 1988) 11, 88–9.

47. Sherwin-White, 78–9. For Alexander portraits at Cos see also: A. M. Nielsen, 'Portraits of Alexander the Great in the Dodecanese: Some Questions, Some Answers?', in

S. Dietz and I. Papachristodoulou (eds), *Archaeology in the Dodecanese* (Copenhagen 1988) 219–24.

48. C. Watzinger, *Die griechisch-ägyptische Sammlung E. Von Sieglin*, I. *Malerei und Plastik*, II, 1 B (Leipzig 1927) 3, fig. 1; K. Gebauer, 'Alexanderbildnis und Alexandertypus', *AM* 63–4 (1938–9) 39–41, 87, pls 7–8.

49. Laurenzi (1955–6) 71–3, no. 4.

50. D. Burr Thompson, *Ptolemaic Oinochoai and Portraits in Faience: Aspects of the Ruler-Cult* (Oxford 1973) 149–50, pl. XXVI, no. 75; 153–5, pls XXXI–XXXIII.

51. M. D. Fullerton, *The Archaistic Style in Roman Statuary*, suppl. to *Mnemosyne* (Leiden 1990) 85–102.

52. See M. A. Zagdoun, *La Sculpture archaïsante dans l'art hellénistique et dans l'art romain du haut-empire* (Paris 1989) 117, pl. 37, no. 160; 181, pl. 56, no. 161; 184, pl. 56, no. 239.

53. New York: Horn 92, pl. 43. Rhodes: Gualandi 86–7, fig. 64. Cos: Laurenzi (1955–6) 93, nos 49–50.

54. Laurenzi (1955–6) 80, no. 13; Dentzer 380–81, pl. 90, fig. 544.

55. Ibidem n. 169; E. Mitropoulou, *Five Contributions to the Problems of Greek Reliefs* (Athens 1976) 61–4, fig. 1.

56. F. Naumann, *Die Ikonographie der Kybele in der phrygischen und der griechischen Kunst*, IstMitt-BH 28 (1983) 193–4.

57. S. M. Sherwin-White, 'Inscriptions from Cos', *ZPE* 24 (1977) 205–17; eadem, 363–6.

58. Laurenzi (1955–6) 69–71, no. 3.

59. Sherwin-White, 293–5.

60. Bieber (1977) 84–7, pls 57, no. 338; 58, no. 349; 59, no. 350; B. Vierneisel-Schlörb, *Glyptothek München: Katalog der Skulpturen*, II. *Klassische Skulpturen des 5. und 4. Jahrhunderts v. Chr.* (Munich 1979) 199, n. 9.

61. P. Karanastassis, 'Untersuchungen zur kaiserzeitlichen Plastik in Griechenland, II. Kopien, Varianten und Umbildungen nach Athena-Typen des 5. Jhs v. Chr.', *AM* 102 (1987) 370, n. 214.

62. E. B. Harrison, 'Alkamenes' Sculptures for the Hephaisteion: Part I, The Cult Statues', *AJA* 81 (1977) 137–78; *LIMC* II (1984) s.v. 'Athena' (P. Demargne) 980.

63. Laurenzi (1955–6) 76, no. 9.

64. Paribeni (supra n. 28) 84, pl. 115, no. 207; *LIMC* II (1984) s.v. 'Asklepios' (B. Holtzmann) 887, pl. 663, no. 343. See also L. Laurenzi, 'Piccole sculture inedite di Rodi', *ArchCl* 10 (1958) 175–7.

65. Laurenzi (1955–6) 104–5, no. 82; Kabus-Preisshofen (1989) 25–51, 228–9, pl. 1, no. 46.

66. Vitruvius, *De Architectura* vi. 7.3.

67. B. Sismondo Ridgway, 'The Setting of Greek Sculpture', *Hesperia* 40 (1971) 352–3; Wohlmayr (supra n. 28) 16–19, 63–70. Also D. Kent Hill, 'Some Sculpture from

Roman Domestic Gardens', in E. MacDougal and W. Jashemski (eds), *Ancient Roman Gardens, Dumbarton Oaks Colloquium on the History of Landscape Architecture 7* (Washington 1981) 84–94.

68. M. Albertocchi, 'Un mosaico con nereide dalla Casa Romana di Cos: Relazione preliminare', in *I° colloquio AISCOM* (Rome 1994) 13–31.

69. Laurenzi (1955–6) 73–5, 78. See also the excavation report: Laurenzi (1935–6) 139.

70. Laurenzi (1955–6) 75.

71. Recently: E. Bartman, 'Decor et Duplicatio: Pendants in Roman Sculptural Display', *AJA* 92 (1988) 211–25; eadem, 'Sculptural Collecting and Display in the Private Realm', in E. K. Gazda and A. E. Haeckl (eds), *Roman Art in the Private Sphere: New Perspectives on the Architecture and Decor of the Domus, Villa and Insula* (Ann Arbor 1991) 79–82.

72. See M. Albertocchi (supra n. 4) 145–6, 180–84.

73. Laurenzi (1955–6) 64, 67, 71, 77, 79–80.

74. Archives of the Ephoria of the Dodecanese (Rhodes): no. B 11.

75. See supra n. 9.

76. See L. Bek, 'Questiones Convivales: The Idea of the Triclinium and the Staging of Convivial Ceremony from Rome to Byzantium', *AnalRom* 12 (1983) 81–107.

77. Laurenzi (1955–6) 70.

78. P. G. P. Meyboom, 'I mosaici pompeiani con figure di pesci', *Meded* 39 (1977) 67, n. 188.

79. P. Bruneau, *Les Mosaïques*, Délos XXIX (Paris 1972) 76. A similar situation was found in a house in Rhodes: G. Daux, 'Chronique des fouilles et découvertes archéologiques en Grèce en 1967', *BCH* 92 (1968) 976.

80. Beyond the 'Casa del Ratto di Europa' (for which see F. Sirano, pp. 134–9 in this volume), see the house in G. Konstantinopoulos, 'Ikopedo Tsocha', *ArchDelt* 43 (1980) B'2 637, and the house near the Odeion where the armed Aphrodite came to light (see n. 35). One recent discovery concerns a Roman house west from the Odeion (ikopedo Chatzithomas), where some fragmentary Hellenistic statuettes were found. See also G. Dontas, 'Eine kleine Bronzebüste Caligulas aus Cos', in *Festschrift J. Inan* (Istanbul 1989) 51–8.

81. G. Konstantinopoulos, *ArchDelt* 22 (1967) B'2 531–3, pls 388–9 (also G. Merker, *The Hellenistic Sculpture of Rhodes*, SIMA 40 (Göteborg 1973) 23); idem, *ArchDelt* 23 (1968) B'2 438–9, pl. 405.

82. See Neudecker (supra n. 8) 117; also H. W. Catling and G. B. Waywell, 'A Find of Roman Marble Statuettes at Knossos', *BSA* 72 (1977) 91–9.

83. Bartman (supra n. 71) 75.

84. F. Sirano, 'Il mosaico della casa cosiddetta del Ratto di Europa a Coo', in *I° colloquio AISCOM* (Rome 1994) 541–77.

17

Women in public space:
Cos *c.* 200 BC to *c.* AD 15/20

Kerstin Höghammar

This chapter deals with women in public space on the island of Cos in the Hellenistic and Augustan periods. In it I hope to come a little closer to the human beings behind the material remains, by way of putting the portraits into their social context. The material used in the investigation consists mainly of inscriptions on the statue-bases, and to some extent sculpture in the form of portraits. Since the sources are merely the chance remains of what once existed, the results are necessarily hypothetical.

I shall start by presenting the three different categories of portrait I have discerned in the material and the particular significance of a portrait statue voted by the *demos*, the people's assembly. Then I will contrast the impression of the ratio between marble portraits representing men and women respectively, gained from Kabus-Preisshofen's monograph on Coan sculpture, with the picture obtained from the inscriptions on the statue-bases.[1] Next I shall discuss what some of the figures in the tables may signify and present a few of the women behind the statistics. This section will concentrate on official portraits voted by the *demos*. Finally I shall look more closely at two citizen women, Delphis and Aischron, who lived *c.* 200 BC and trace some of their connections, their activities and their possible public importance.

Background

Cos is rich in inscriptions. Roughly 1,500 of various categories have been published so far, and most of them date to the Hellenistic and early Imperial periods. Close to a hundred of those dated to the Hellenistic and Augustan periods are inscribed on the bases of statues, and they form the foundation for the tables presented in this chapter. As understood from the inscribed bases, some of the statues are predominantly honorary in character, others are almost exclusively dedicatory, and a third large group is of mixed type, being both honorary and dedicatory in intent.[2]

It is generally accepted that most of the dedicatory statues were made of marble, a material locally at hand on Cos. When looking at the marble sculpture presented by Kabus-Preisshofen, one can see that of fifty-five statues and fragmentary statues presumed to be portraits, seventeen (possibly nineteen) represent women and thirty-eight men.[3] This gives a ratio of almost 1:2, and I am as struck by the relatively large proportion of women in this material, as by the information that most of the extant marble sculpture of about life-size or larger consists of portraits.[4]

I should guess that most of these marble portraits were dedicatory, or honorary and dedicatory, statues in sanctuaries rather than funerary sculpture.[5] The portraits dedicated by private persons stood on inscribed bases, and thus these dedications, often in a famous sanctuary, displayed the piety, wealth and public standing of both dedicant and honorand.

Women as honorands

About 80 per cent of the inscriptions that I have analysed come from the bases of portrait statues, many of which were voted by the *demos* of Cos.[6] From decrees and other inscriptions, as well as from literary sources, we know that a likeness was a major honour only relatively seldom voted, and conferring considerable prestige on the honorand. When a woman was honoured with a sculpture, and this portrait was not only set up in a public space but also approved by the *demos*, this statue was in both respects a public mark of distinction.

As can be seen from Table 1, women also commissioned sculpture, both votive and honorary statues.[7] Consequently they were in control of enough money to pay for such a commission.[8] Eighteen of the honorands were female[9] and fifty-three male (see Table 2), and this gives us a ratio of about 1:3, a smaller proportion of women to men than that gained from the statues.

Many more women were honoured in the Augustan era than in any of the earlier periods. Altogether there are only eight inscriptions in honour of women in the 300 years before 30 BC, and ten in the period of fifty to seventy years after the victory of Octavian at

Table 1 Female dedicators

Dedicator	Period											Total
	1	2	3	3–4	4	4–5	5	5–6	6	6–7	7/later	
	330–242	242–210	210–190	210–150	190–150	190–70	150–70	150–30	70–30	70–AD 20	30–AD 50	
female	1	3	1	1	0	0	1	0	0	0	1	8
male & female	0	1	0	0	0	0	1	0	2	0	2	6

Table 2 Sex of the honoured person

Sex	Period											Total
	1	2	3	3–4	4	4–5	5	5–6	6	6–7	7/later	
	330–242	242–210	210–190	210–150	190–150	190–70	150–70	150–30	70–30	70–AD 20	30–AD 50	
0 (god etc.)	6	2	1	0	0	2	0	1	3	3	5	23
male & female	0	0	0	1	0	0	0	0	0	0	0	1
female	0	1	3	0	1	0	1	0	2	0	10	18
male	3	5	5	1	1	0	5	0	4	2	27	53
unknown	2	0	2	0	0	0	1	0	1	0	3	9
total	11	8	11	2	2	2	7	1	10	5	45	104

Actium. Surely these figures indicate a drastic change, despite the fact that the total number, eighteen, is much too small to form the basis for a more general quantitative analysis.

In brief, one can say that during the one hundred years between 250 and 150 BC, there is evidence of one female statue voted by the *demos*, that of queen Arsinoë III of Egypt, dated to shortly before 200.[10] Three statues of women were private dedications and one was probably a funerary sculpture.[11] Between the years 100 and 30 BC a few female relatives of high Roman magistrates occur,[12] and from about 30 BC to around AD 15 to 20 or somewhat later, we have two private dedications[13] and eight statues voted by a public body,[14] altogether ten statues representing women.

In this last group three of the statues commissioned by a public body were likenesses of Iulia, daughter of Augustus and wife of Agrippa, voted by local demes on the island.[15] Another, commissioned by the *demos*, was a statue of Cornelia, wife of Titus Statilius Taurus, Augustus' friend and general.[16] Cornelia is described as being married to a patron of the *polis*, and she is given no characteristic traits of her own. This is typical of the texts on the statue-bases of the Roman women. It appears as if they were honoured because of their relationship to powerful men, i.e. their fathers, their husbands or both.

There is a marked difference when we turn to inscriptions honouring Coan women who now, for the first time, appear as honorands of the *demos*.[17] They, like many of the men honoured, were characterised by their *arete* (virtue) and their *eunoia* (benevolence) as well as by their *sophrosyne* (temperance) – this last a term used only for women.

The particular words describing the honorand's character in positive terms signal that the person concerned had made a contribution of a certain magnitude to the *polis*. I believe that the words chosen to describe the honorand correspond well with whatever deed the individual had performed, or, perhaps, was expected to perform.

The base with the inscription honouring one of the Coan women, Kottia Melissa, is remarkable in that neither her father, nor her husband, has been named.[18] One receives the impression that at the time of the

voting of her portrait statue, Kottia Melissa was a woman of consequence in her own right.[19]

Judging from the material presently available it appears that no Coan women were honoured with a statue by the *demos* before 30 BC. If this surmise is correct, it corresponds to the case of the male Coans. Before 30 BC we know of only one Coan citizen honoured by the same body with a portrait statue, actually in marble, perhaps around 40 BC.[20] With the advent of Augustus there is a leap to thirteen male Coans being honoured by the government.

The impression given is one of drastic change taking place, and I would attribute that change to the Coans' loss of political and economic independence.[21] The island became incorporated into the Roman Empire and the leadership of the state changed to that of a local government. Before 30 BC the Coans were loath to vote the extraordinary honour of a portrait statue to one of themselves – this in order not to give too much prestige, and consequently power, to any single person. Once the island had become part of the Roman Empire, the need to restrain individual ambition lessened.

Delphís and Aischron

About two hundred years earlier, *c.* 200 BC, some Coan citizen women were honoured with statues in public places, among them Delphís, an affluent poetess, the dedicatory statue of whom was set up in the famous sanctuary of Asclepius situated about 3 km outside Cos town.

There are three inscriptions with the name Délphis or Delphís from the later third century BC; two of these occur on statue-bases and one in a war-time subscription list, Paton and Hicks (PH) no. 10.[22] One is a two-line epigram on the base of a statue dedicated to Kore by a woman, Delphís.[23] The second is a five-line epigram on the base of a statue in the Asklepieion, in which a female poet is honoured.[24] The base is, as far as I know, lost and only the transcription in Paton and Hicks' volume *The Inscriptions of Cos* remains.[25] Paton judged the honorand to be a man, and thus both Sherwin-White and Fraser and Matthews have the name as a male one in their onomastika.[26]

Dr P. Nigdelis at the Department of Classics at the University of Thessaloniki proposed that the pronoun in the feminine form on line 3, ἁ (δὲ) = ἡ, 'she who', should refer to the person mentioned in the fourth line, Delphís, who consequently was a woman![27] To me this appears correct and therefore I accept his proposition. Also, we know of a number of female poets from the early Hellenistic period, viz. Anyte, Nossis, Moero,

Erinna, Parthenis, Moschine and her daughter Hedyle. These poets are known to have written epigrams, and this fits in nicely with the Delphís inscription.[28] One poetess, Aristodama from Smyrna, was honoured by the Aetolians of Lamia in 218, for having praised the Aetolians in her poetry.[29]

Paton suggested that Délphis in the epigram was a poet and perhaps identical with a Délphis in the third Coan inscription with this name, PH no. 10, a long list of almost 250 persons donating money to the Coan war effort in one of the years between 205 and 201.[30] Paton suggested that this Δέλφις Φιλίνου – son of Philinos – was the same as the poet: 'in this case line 1 may refer to the athletic successes of Philinus of Cos'.[31] This Philinos was a famous Coan athlete in the middle of the third century BC.

The obvious reason why previous scholars have thought Délphis to be a man is because 'he' is listed among almost 250 other men contributing to the same cause.[32] In his recent volume *Les Souscriptions publiques dans les cités grecques*, the Canadian scholar Léopold Migeotte has pointed out that a few women were listed with all the men. There are not many, just three, but listed in their own name and without mention of any tutor. These women contributed 3,000, 500 and 100 drachmas respectively. All three sums, and particularly the first which is actually one of the highest of all contributions, bear direct witness to the affluence of these women.[33] Migeotte discusses Délphis and opts for this person being a man. He does not say why, but the obvious reason that once again comes to mind is the overwhelming number of men in the inscription.[34]

According to Migeotte, women donating money in their own name, without the mention of a tutor, are a rare phenomenon in the Greek world. With the publication of the volume *Iscrizioni di Cos* we know of another two subscription lists with *only* female donors given, without any mention of a tutor. Neither of these two belong to the category of inscriptions treated by Migeotte, i.e. subcription lists organised by the *demos*. The collections are for the benefit of the *temene* of the goddesses Aphrodite and Demeter. In the first, ED 178, which presumably is somewhat the earlier of the two with a date in the very beginning of the second century BC, the sums donated to the temple of Aphrodite Pandemos and Pontia are fairly small, ranging between 10 and 30 dr. The second inscription, ED 14, dated to somewhere in the second century BC, concerns a collection for the temple of Demeter and the sums involved range between 100 and 500 dr.[35]

When considering Délphis in the inscription PH no. 10, we have to bear in mind that the Coan state had made an appeal not only to its male citizens, but also

to the female citizens – τῶν τε πολιτᾶν καὶ πολιτίδων,[36] and knowing that at least three affluent women answered this appeal, it might well be possible that Délphis Philinou was a woman – Delphís. If this were so, it would mean that we have a female poet, a female dedicant, daughter of Mnesiánax and, possibly, a woman donor Delphís, daughter of Philinos, all three with the same name. These inscriptions are – as far as I know – the only ones, of the 1,500 or so published Coan inscriptions, where this name occurs.[37]

We thus have at least two wealthy women belonging to the Coan upper classes, both called Delphís, one honoured in the Asklepieion and one setting up a dedicatory statue in a small rural shrine of Demeter. Could these two be one and the same person? Then there is a third homonym perhaps also indicating a woman. Maybe the poetess, whose patronymic we do not have, instead should be identified with the donor of 500 dr. in PH no. 10?

I will first investigate the date of Delphís the dedicant. The base was found without its statue in a small shrine of Demeter at Kyparissi about 16 km west of Cos town on the slope of the Dikhaios massif (Fig. 239). Another seven bases and their respective marble statues were found with it *in situ* and excavated by the Italians in 1929. The missing statue belonging to the base here discussed was presumably the finest of them, as it was salvaged after the catastrophe that destroyed the sanctuary, and the base is by far the most elegant. All the statues have been dated to before 200 BC, and the base here discussed, EV 235,[38] was given a date in the fourth century BC by Laurenzi and Segre.[39] Neither of them presented any arguments for this date. Kabus-Preisshofen has also treated the base, and she dated it to somewhere in the middle of the fourth century BC, comparing the letter-forms with those in three inscriptions from Lindos of that date.[40]

However, when checking this inscription again because of the name Delphís, I noted that Sherwin-White dated the people mentioned in it to the third century BC in her onomastikon.[41] The letter-forms as such could indeed date to the later third century, as Coan inscriptions from that period share several characteristics with EV 235 from the Demetreion, i.e. *sigma* with sloping hasta, a small *theta* and *omikron*, both placed above the base-line.[42] As far as I am able to judge, the lettering allows a date in the later third century BC as well as an earlier one.

The next question is whether the names can give any indication of the date of the base. All four of them – Delphís, Nébros, Dorkás and Mnesiánax – are unusual. Delphís has already been discussed. The name Mnesiánax occurs only in the epigram here discussed

and thus cannot help us any further. A Nébros is listed five times in Sherwin-White's onomastikon, once for the inscription here discussed and once for an occurrence in the *Hippocratic Corpus*, where he is given a date in the sixth century BC. Consequently this Nébros can be disregarded. The remaining three occurrences are in inscriptions dating to around 200 BC.[43] Dorkás appears twice, once in the Demetreion inscription and once in an inscription dated to *c.* 200.[44]

The three factors just described – the compatibility of the letter-forms with those of inscriptions from the later third century, the fact that all other occurrences of the names in the epigram date to *c.* 200, as well as the names being rare – indicate a date in the later third century BC for EV 235. Further, the fact that the inscription takes the form of an epigram may also suggest that it was made in the later third century. This is something rare in Coan statue-base inscriptions. Apart from EV 235 there is the dedication honouring Delphís from the Asklepieion, as well as another two, one probably dating to the decades just before 200, the other to the early second century BC.[45] This would mean that the dedicant was about contemporary with the poetess Delphís.

A third possible Delphís, the donor from PH no. 10, requires us to return to Paton's hypothesis that the poet and the giver of the 500 dr. were the same person, and that line 1 in the epigram on the Asklepieion base may refer to the athletic successes of Philinos of Cos. I find this a plausible hypothesis. Philinos, son of Hegépolis ('leader of the *polis*'), surely belonged to one of the leading families of Cos. According to Pausanias he won five victories in running at Olympia, four victories at Delphi, many at the Nemean games and eleven at the Isthmian games.[46] Further, Eusebius tells us that two of Philinos' victories at Olympia were gained in 264 and 260 BC.[47] These dates would suit the father of Delphís in the epigram from the Asklepieion, as well as the father of Délphis or Delphís in PH no. 10, if this person was around fifty years old in 205–201 BC.

It would also be fitting for a man who has won four victories at Delphi to name one of his children Delphís.[48] This hypothesis would also explain why the name occurs only in this particular period, and – at least on present knowledge – never again on the island.

Paton's reading of the first line of the epigram makes good sense, as the base was for a poet:[49]

> Not only [excellent athletes] for you, Golden Cos,
> nor just [...] has this famous house [given],
> but see also her [...] who rose up, famous in song,
> Delphís, after adhering to the Olympian muses
> and [... A [?]] skra brought forth[50]

Thus, the probable reference to the athletic successes of a progenitor of the poetess, combined with the rarity of the name Delphís, and this in combination with the patronymic Φιλίνου in PH no. 10 makes an identification of the poet and the donor of PH no. 10 plausible. If correct, this would mean that Delphís, daughter of Philinos, gave 500 dr. to the war funds in one of the critical years between 205 and 201 BC.

What about the other Delphís, the dedicant in the Demetreion at Kyparissi? At present I am inclined to believe that she lived in the second half of the third century BC, that she moved in the same layer of society and that she happened to have the same name. Perhaps she also was related to Philinos, and if so, most likely through a sister of his. Whatever the identity of the poetess Delphís, it would not surprise me if she had commissioned the monument herself to be set up in her own honour, just as the flautist Ariston did, perhaps somewhat later.[51]

In summary, Delphís belonged to one of the prosperous and prominent families on Cos. She had also made herself a reputation as a poet and I suggest that she was wealthy and independent enough to be able to respond to the appeal made by the Coan state to its male and female citizens in the crisis of the war years.

The second lady, Aischron, daughter of Autophon, dedicated a portrait statue of her husband, Hermias, son of Emmenidas, at the Asklepieion (see Figs 240–42).[52] As only part of the inscription remains, it is somewhat difficult to interpret it, but I believe that the base also supported a second statue, that of Aischron herself.

The monument was placed on the western side of the monumental staircase leading from the middle to the upper terrace, i.e. well visible and close to the altar and the main temple of the sanctuary, declaring the piety, wealth and high standing of both Aischron and her husband Hermias.

A lady with the same name, Aischron, daughter of Autophon, is also listed together with other women as donor to a fund for the temple of Aphrodite Pandemos and Pontia in an inscription already mentioned, ED 178. She, like the others, is listed in her own right without a tutor, and the 20 dr. she gave were perhaps equivalent to one month's pay for a skilled worker. On the basis of prosopography, I date this inscription to the early second century BC.[53]

Aischron's husband, Hermias, was a doctor, and he is known from several decrees dating to the last two decades of the third century BC. The decrees found on Cos are copies of the originals sent to Cos by the city-states where Hermias had been working. They declare that he did his work well and tell of the honours conferred upon him.[54] We know that Hermias also gave money to the war-effort as he is listed in PH no. 10, together with his brother.[55] Unfortunately we do not know the amount given, as that part of the inscription is unreadable. About ten lines before the listing of Hermias a certain Philippos, son of Autophon, is recorded as having donated 1,000 dr., and in an inscription from the deme of Halasarna, dated to c. 200 BC, there is mention of an Autophon, son of Philippos.[56] The name Autophon occurs relatively rarely – there are only five instances in Sherwin-White's onomastikon. The name Aischron also occurs only five times. Considering that all these inscriptions are contemporary, it is likely that the wife of Hermias was identical with the donor of the 20 dr. and that she was related to Philippos, son of Autophon, perhaps as his sister. It is also possible that the family hailed from Halasarna: witness the inscription mentioning Autophon, son of Philippos, from that deme.

Aischron's family thus belonged to the Coan élite and she married a renowned doctor. She could afford to commission statues of herself and her husband and was permitted to have them erected on the principal terrace of the Asklepieion close to the temple. She also donated money to the temple of Aphrodite in Cos town, in this way taking part in official religious life. She has, thus, provided us with a few rare glimpses of the public actions of a well-to-do Coan lady.

These two women were not the only ones honoured with a statue in the late third to second centuries BC. A third base, found on the middle terrace in the Asklepieion, belonged to a statue depicting Kallistrate, daughter of Kleumachos, set up by her relatives. She was a priestess of, among other gods, Asclepius, Hygieia and Epione sometime in the period 190 to 160 BC.[57] Added to these three bases there are seven statues or fragmentary statues of draped women judged by Kabus-Preisshofen to be portraits, and dated by her to the second century BC on stylistic criteria.[58] One of these statues was built into a wall of the castle, one is of unknown provenance and five were found in the ancient storerooms of the Odeion.[59] Three of these, K–P cat. nos 53, 56 and 57, are illustrated to give an idea of what the portraits belonging to the bases may have looked like (see Figs 243–5).[60] If the dates are correct this would show that women were honoured with statuary portraits both in the Asklepieion and in Cos town.[61] These chance remains of what once existed indicate that, in the second century BC, honorary portrait statues of women were a not uncommon sight as you walked in Cos town or the Asklepieion.

Thus citizen women on Cos in this period were por-

trayed and honoured by other citizens in the sanctuaries and perhaps also in other public places. The state counted on their contributing their own resources in various areas when necessary, and women answered this need, probably even to the extent of personally attending at least one public meeting in the agora in an emergency situation. The Coan citizen women in the middle Hellenistic period were present in the public sphere, both in the form of portraits and in reality, taking part, at least to a certain extent, in civic life.

NOTES

1. Kabus-Preisshofen (1989); Höghammar.

2. Höghammar 59.

3. Kabus-Preisshofen (1989), women: nos 51–61, 63, 89, 90, 94(?), 102 and 116. If nos 92 and 93 portray *heroised* queens the number will be nineteen; men: nos 19–24, 28–30, 32–43, 50, 76–80, 82–7, 104, 110–13.

4. Kabus-Preisshofen (1989) 20.

5. This because of the provenance of the statues. Most were found in three storerooms in the Odeion in Cos town and thus they appear not to have come from cemeteries.

6. Höghammar 81.

7. Höghammar nos 6 (hon.), 64 (hon. and ded.), 84–7, 89 (ded.); Segre (1993) EV 235 (ded.).

8. The figures presented in the tables are based on the inscriptions treated in *Sculpture and Society*, published in 1993 (in Table 1 EV 235 has been added). Consequently, the even more recently published inscriptions in *Iscrizioni di Cos* are not included. Further on, I will discuss some inscriptions from this volume, and the numbers then given are always preceded by the letters ED or EV as in the original publication.

9. Höghammar nos 60 (*c.*242–210 BC), 2, 4, 63 (*c.*210–190 BC), 65 (*c.*190–150 BC), 46 (*c.*150–70 BC), 8, 52, (*c.*70–30 BC), 18, 24, 25, 31, 32, 56, 68, 77, 78, 79 (*c.*30 BC-AD 15/20 or somewhat later).

10. Höghammar no. 63.

11. Höghammar nos 2, 4 (funerary) 60, 65.

12. Höghammar nos 8, 46, 52.

13. Höghammar nos 24, 25.

14. Höghammar Coan women: nos 18, 31, 32, 68; Roman women: nos 56, 77, 78, 79.

15. Höghammar nos 77, 78, 79.

16. Höghammar no. 56.

17. See above, n. 14.

18. Höghammar no. 32.

19. Höghammar 78.

20. Höghammar no. 7. Very probably there were other statues of the tyrant Nikias who ruled Cos presumably in the late forties and the thirties. Any such portraits would have been destroyed almost immediately after his death, when his tomb was desecrated. See Höghammar 31.

21. Höghammar 86f.

22. The name is the same for both men and women, and only the stress in the pronunciation differentiates between the sexes. As stresses are not given in inscriptions it is not always easy to decide whether the name is that of a man, pronounced with the stress on the first syllable, Délphis, or that of a woman, pronounced with the stress on the second syllable, Delphís.

23. *Iscrizioni di Cos*, EV 235:
Δελφὶς ἄγαλμα, γυνὴ Νέβρου, Κούρηι με ἀνέθηκεν Δορκάδος ἐγ μητρος· Μνησιάναξ δὲ πατήρ.

24. KH 60 (= PH 137):
Οὐ μόνον [ἀθλητῆρας ἀμύμ]ονας, ὦ χρυσέα Κῶ, ὑ[μ]ῖν ο[ὐ]κ [——— φαίδι]μος οἶκος ἔχει ἀλλ' ἰδὲ καὶ θ[———]ἀοίδιμος ἁ<δ>ε ἀνέτειλε, Δελφὶς ἐπεὶ Μου[σ]ᾶν [ἦψ]α[τ]ο 'Ολυμπιάδων καὶ [———" Α (?)]σκρα τέτευκε
ρ

25. Henceforth abbreviated to PH in the text.

26. Sherwin-White, Δέλφις; P. Fraser and E. Matthews, *A Lexicon of Greek Personal Names* I (Oxford 1987) Δέλφις.

27. This suggestion was made during one of our discussions on the inscription.

28. See J. McIntosh Snyder, *The Woman and the Lyre: Women Writers in Classical Greece and Rome* (Bristol 1989) 64–98.

29. IG 9.2.62; S. B. Pomeroy, *Goddesses, Whores, Wives and Slaves* (London 1976) 126.

30. This inscription is securely dated to one of the war years 205–200 BC, presumably 201/200. See R. Herzog, 'Κρητικὸς πόλεμος', *Klio* 2 (1902) 317f.; Sherwin-White 120f.

31. Paton and Hicks 156.

32. Migeotte 155.

33. If the pay of 4 obols to a drachma a day for a skilled artisan on Delos in the middle Hellenistic period is used, this would mean that 100 drachmas is equivalent to three to four months' pay. See W. W. Tarn and G. T. Griffith, *Hellenistic Civilization* (1966) 120 with a reference to *OGIS* 1–2, no. 218, 36 for wages.

34. Migeotte 158, n. 76.

35. The relative dating of these two inscriptions is based on the use of different categories of signs for the sums in the respective inscriptions – the acrophonic system in the first and the alphabetic system in the second. The absolute dating of ED 178 is based on the occurrence in it of several names also occurring in other inscriptions dated around 200 or the immediately following decades; ED 178 is dated by the *monarchos* Theodoros (cf. *TC* 88, 17, 105, date *c.*180); other names, Kleumachos, son of Phanomachos (cf. Klee 8 and 10, II B, 1 and 35, priest of Asclepius in the 190s and 180s, and PH no. 10c 47); Aischron, daughter of Autophon (cf. Herzog and Schazmann 22f; Höghammar 53, no. 64, date *c.* 200–150).

36. PH 10a 9–10.

37. The name appears to be generally uncommon in all the Greek world. I have only found a few references in the two volumes of *A Lexicon of Greek Personal Names* and in the indexes of *Bulletin Epigraphique* and *Supplementum Epigraphicum Graecum*.

38. Segre (1993) 235f.

39. Laurenzi (1932b) 157; Segre (1993) 235.

40. Kabus-Preisshofen (1975) 60f. With reference to C. Blinckenberg and K. F. Kinch, *Lindos: Fouilles de l'Acropole 1902–1914* II (Berlin and Copenhagen 1941) 233–8, nos 42, 45 and 46. The letter-forms are indeed close, and for this reason I accepted the late classical date of this base and did not include it in *Sculpture and Society*.

41. No arguments are presented for these datings.

42. PH 13, *sigma* with sloping hasta; Höghammar no. 61, small *theta* and *omikron*; Segre (1933) 365, decree, date 205–200 BC, small *theta* and *omikron*, *sigma* with sloping hasta.

43. Sherwin-White, onomastikon, Nebros, son of Nebros, PH 387, 27 (*c.* 200); Nebros, son Gorgias, Maiuri 675, 24 (iii/ii).

44. Pugliese Carratelli 196, no. XXVI B, v, 72.

45. Höghammar nos 23 and 71.

46. Pausanias, *Guide to Greece* VI.2.17,2.

47. Eusebius, *Chronicles* I, 207 (ed. Schöne).

48. A parallel case, though much earlier, is that of Themistokles, who in the early fifth century BC gave three of his daughters names of topographical origin, viz. Asia, Italia and Sybaris. Plutarch, *Lives* II, 'Themistokles' 32.2.

49. Text in Greek supra n. 24.

50. Translation by the author. We do not know whether the statue depicted a god, a muse or a portrait of the poet herself. Note, however, the text line 3, 'but see also her', probably implying that the viewer saw a portrait of the poet on the base.

51. Höghammar 80 and no. 23.

52. Höghammar 53, 61 and no. 64:

 [Αἴσχρον] Αὐτοφῶντος Αἴσχρον Α
 ['Ερμίαν]'Εμμενίδα Γ
 [τὸν αὐτᾶ]ς ἄνδρα. Θεοῖς
 Γ

53. See supra n. 35.

54. Hermias honoured by Halicarnassus, PH 13 and Maiuri no. 438, see Robert 163–5. Honoured by Gortyn, *ICr* IV, 230–32, no. 168. Honoured by Knossos *ICr* I, VIII, 62, no. 7.

55. PH 10, b.57.

56. Philippos, PH 10b. 45–46; Autophon, Pugliese Carratelli 188, XXVI, B.I.52.

57. Herzog 10; G. Patriarca, 'Iscrizioni dell Asclepieio di Coo', *BMusImp* 3 (1932) 3–34 *apud BullCom* 60 (1932) 28, no. 25; Höghammar (1993) 54, 61 and no. 65. The Kleumachos, priest of Asclepius in the 190s and 180s, occurring in the same inscription as Aischron, ED 178 (supra n. 35) could possibly be her father. If so, this would mean that Kallistrate was a generation later though married to an older man, as a Parmeniskos, son of Hieron, presumably her husband, is listed in PH 10.b.1 as a donor of 100 drachmas. For Parmeniskos, son of Hieron, see also Sherwin-White 1978, 219.

58. Kabus-Preisshofen (1989) nos 53–9.

59. Castle, Kabus-Preisshofen (1989) no. 54; unknown provenance, no. 55; the Odeion, nos 53, 56, 57, 58 and 59. For those from the Odeion, see also Laurenzi (1932a) 113–39.

60. No. 53 (Kabus-Preisshofen (1989) pl. 55, 1–3; 56, 1–2), is dated *c.* 180–170 BC. The quality of the work of this statue is excellent, and the delicate rendering in hard marble of what must be the famous diaphanous Coan silk is as fresh and breathtaking every time you look at it. The high quality of his work led this sculptor to gain commissions not only on Cos, but also on Samos and at Magnesia-on-the Maeander, as has been noted by, for instance, Kabus-Preisshofen. The statue has often been interpreted as a Muse, but I agree with Kabus-Preisshofen when she presents it as a portrait. Apart from the arguments put forward by her, I think it is more likely that the introduction of the silk gown as part of the dress worn by women took place on a portrait statue of a wealthy Coan lady wearing such a garment and proud of it, rather than in the more conservative religious genre.

61. I assume that the statues found in the Odeion are more likely to have come originally from public spaces rather than private houses and areas, as the Odeion was a public building. Private statuary was presumably taken care of by the respective owners of the areas where it was placed.

18

A seated statue of Hermes from Cos: middle Imperial sculpture between myth and cult, a new proposal of identification

Francesco Sirano

The subject of this chapter is a seated Hermes found on Cos in June 1937 in the so-called House of the Rape of Europa, excavated by L. Morricone between 1936 and 1940.[1] Situated on the southern slope of the acropolis, near the decumanus, the house takes its name from a mosaic discovered in one of its rooms (room XI), showing the well-known myth of the Rape of Europa by Zeus in the form of a bull.[2] Although the excavations are not complete, the house covered some 550 sq. m. It represents one of the clearest examples of a dwelling of a well-to-do Coan family and was occupied, probably without interruption, from the third century BC to the third century AD (Fig. 246). At this time the house was destroyed, probably by a ruinous landslide from the overhanging hill of the acropolis.[3]

Pictures taken during the excavation show how the statue was discovered in the *pastas* (room VIII) of the house, in line with the central entrance to the main room (the andron: room IX) (Fig. 247). A female portrait statue[4] was discovered nearby and, on the opposite side of the room, five more sculptures were found. The overall study of the house and its disruption indicates that these five sculptures had been placed only temporarily in the *pastas*, awaiting their final location. It seems likely, however, that both the Hermes, at the entrance of the andron, and the female portrait were *in situ*.

The Hermes is a monolithic statue of white marble (Proconnesian?) placed on a trapezoidal plinth. It represents Hermes sitting on a rock seat (139 cm high), accompanied by a standing ram (57 cm high) (Figs 248–9).[5] The body of Hermes is polished except for the back; the ram and the rock seat are carved to receive colour. A moderate use of a drill was made to shape the coiffure and pubic hair, to engrave the lachrymal canal of the eyes and the angles of the mouth (Figs 250–53) and to create the undercutting in some folds of Hermes' chlamys. A single prop was left between chlamys and seat.

The god is naked but for the petasos, winged boots, and the chlamys passing over the chest and held on

the thigh by the right arm. This arm also held the caduceus, now lost, which, as traces of rust indicate, was made partly of metal. Hermes' left arm is stretched out to the side with the hand placed on the rump of the ram (Fig. 249), the head of which is raised to look at him. The shapes are rounded and schematic: short legs, exiguous head, small spiral horns, sharp snout. The fleece, expressed by means of circular red paint-strokes, is rendered in relief only on the forehead and the jaws.

Dating the sculpture to the second half of the second century AD, Morricone underlined its classicising aspects and unsuccessful stylistic effect.[6] The statue is characterised by a certain coolness, emphasised by the surface polish. This characterisation is associated with a great attention to detail, for example in the careful treatment of the fingers and toes, where wrinkles and nails are reproduced, or in the careful delineation of the scrotum.

The strong muscular masses, although carefully rendered both in contour and relief, do not blend into a unitary whole (Fig. 250). On the contrary, their disjointedness results in incongruity and heaviness, clearly evident in the frontal and lateral views of the torso. The modelling of pectoral muscles is almost negligible compared with the powerful structure of the thorax. Mention may also be made of the blank fixity of the glance, as well as the isolation of the area around the eyes, nose and mouth on the broad, smooth surface of the face. The partial redemption of the whole figure in the profile view of the right-hand side of the statue (Fig. 248), the position from which the movement of the head and the slight torsion of the chest can be better observed, clearly reveals the artisan's intended impression.

The success of the work depends on the chromatic contrast between the smoothness of the naked flesh and the shadows: these are deep under the legs, less intense on the chlamys, and produce a sharp chiaroscuro effect on the chest and under the petasos. These stylistic features are typical of the copying tradition of the Antonine age.[7] The technical examina-

tion of certain details, such as the treatment of the eyes and the extended lachrymal canal, confirms a dating into the second half of the second century AD.

There are few stylistic comparisons which can be made between our sculpture and other seated representations of Hermes. A headless statue from the great Thermae of Cyrene,[8] in a different and more relaxed position than the Cos example, has both a similar nude posture and treatment of the chlamys. A good comparison is also offered by a seated Mercury in the Vatican Museum,[9] heavily restored, which has the same weighty and lax forms of the abdomen, the same coarseness and disproportion of the legs. The head freely imitates Polycleitan models. The head of the so-called Eroe Farnese in London and that of the Hermes from Troïzen in Athens, together with a standing Hermes preserved in Copenhagen,[10] and another Hermes/Mercury head preserved in Boston,[11] the shapes of which are rather more gentle, share similar characteristics. A late Hadrianic–Antonine version of the Polycleitan Discophorus, preserved in the Atrio dei Quattro Cancelli[12] at the Vatican Museum, offers a good comparison as to the head structure, as do an Apollo in the Capitoline Museums,[13] Sala delle Colombe, and a Herakles in Berlin,[14] respectively dating to the middle and late second half of the second century AD.

Particularly useful for defining the chronological range of the subject is the comparison of the head with two examples of the Discophorus type, preserved in Berlin[15] and Dresden.[16] The Berlin example, a double herm of Hadrianic date,[17] presents a similar square head and an extreme attention to detail (eyes, mouth). The half-open mouth and the 'hallucinated' glance reappear on the head in Dresden, which is a copy of the Antonine age[18] and carries more pathos than our example. The Dresden head shares the superciliary arch and the squaring of the nasal septum, but not the simplification of the hair lock, nor the ear treatment. The same wealth of detail can be found in ideal female heads, like Athena[19] and Nike[20] from Cyrene, or Artemis in Berlin.[21]

Particularly interesting are the concrete, not merely stylistic, comparisons with some small bronze statues of the end of the second century AD, among which is a Mercury from Montorio (Verona), preserved in Vienna.[22]

The overall strength of our Hermes' body structure does not allow it to be dated after the very first years of the third century AD, as is clearly confirmed by comparison with the sculptures dating to the early Severan age coming from the House of Europa.[23] The third quarter of the second century AD seems the most appropriate date, taking all the stylistic features of the sculpture together.

From a typological point of view the Hermes of the House of Europa appears to be quite isolated. This is perhaps due to the eclectic nature of the work, as originally pointed out by Morricone.[24] The statue combines a head that makes clear reference to classical Polycleitan models, and a body that, both in the position of the limbs and the structure of muscular masses, shows at least traces of Lysippus' influence. The winged petasos, a detail normally absent in Greek iconography of the god,[25] is probably a Roman feature. Is it therefore a pastiche of the Imperial age, a unique product of a workshop of 'interior decorators'? It is perhaps so, but there are elements which suggest the existence of a prototype of which our sculpture should be a copy or a replica: stylistically evident is the contrast between the precision in attention to detail, on the one hand, and the generally loose treatment of form, on the other.

Even the isolation pointed out by Morricone may prove, in a deeper analysis, to be in favour of the identification of the Cos statue as a replica. The question is an important one, not only because of the art historical aspect, but also because of the social and religious considerations.

The representation of Hermes seated on a rock had perhaps already been introduced by the end of the fifth century BC.[26] It finds widespread diffusion, together with the development of other seated types, like the Tyche of Antioch, between the end of the classical and Hellenistic ages.[27] In a fundamental study of a small bronze coming from Montorio (Verona), preserved today in the Kunsthistorisches Museum in Vienna,[28] Beschi outlined the art historical evolution of Hermes' seated image and the related aesthetic issues.[29] Under the guidance of an overall re-examination of the documentation relating to small bronzes, Beschi differentiates the various types of Hermes relaxing on a rock.[30] The position of the limbs, the head, and the winged petasos, make it possible to refer the Cos statue to the Montorio type;[31] however, the Coan statue differs in the absence of tortoise or lizard, and, above all, in being the only known life-size marble example.[32]

Beschi looks for the prototype of the Montorio example in the western part of the classical world, on account of the religious meaning of the lizard and tortoise in the western regions of the Roman Empire.[33] For the archetype of the statuary type, Beschi suggests remote and faded echoes of Greek models.[34] A careful comparison with the Walters Art Gallery type is illuminating. This example has no petasos, holds

the chlamys around the left arm and is considered by Beschi to be a late Hellenistic or early Imperial creation,[35] deriving from the *poimen* Hermes, seen in Corinth by Pausanias on the way to Lechaion.[36] In Greek territory, this statue is known to us only from Antonine coin types of Corinth and Patras, reproducing a standing ram looking forward, near the god.[37]

Few and unsatisfactory comparisons are to be made between such small bronzes and marble versions of the seated Hermes. The seated Mercury in the Vatican Museum[38] has the limbs in the opposite position to the Coan statue. The arrrangement of the chlamys varies slightly from the Walters Art Gallery type, with which the Vatican sculpture can also be compared.[39]

Extremely general are the iconographic comparisons which can be made with the Cyrene Hermes;[40] closer similarities can be seen in Beschi's type, Vienna 420.[41] Finally, one further statue belongs to this last group, from Merida, where the god, completely nude, is sitting on a high rock with the legs in the opposite position to the Cos Hermes.[42]

As far as the attributes are concerned, both the caduceus and the ram are widely attested in representations of Hermes. The standing ram is usually represented in the standing versions of the god: one example with infant Dionysus comes from the Agnano Thermae,[43] another from Trento[44] and another from Catajo.[45] In the first two examples the animal turns its head toward Hermes.

The little Montorio bronze statue[46] and the above-mentioned Corinthian coins[47] represent the only comparisons associating a standing ram with a representation of a relaxed Hermes. In both cases, however, there is no direct connection between the image of the god and the animal. This link is instead established in Cos through the placement of the left hand on the ram – a gesture emphasised by the presence, on the animal's rump, of a piece of chlamys held by Hermes' hand. It is a refined movement, reinforcing the feeling that there must be a model from which the Cos statue originates.

What is the archetype and what information is available to determine the prototype? As far as the former is concerned, the relationship with Beschi's Montorio type only partially redresses the isolation of the statue, since we are dealing with small bronzes originating far away from Cos. On the basis of the undeniable analogies between them and the statue under discussion we can, however, reasonably assume not only the existence of the archetype, but also recognise with Beschi the influence of Lysippean figurative language, even though no statue of a seated Hermes by

a master of that period is recorded in the written tradition.[48]

As far as the problem of identifying the prototype of the Cos statue is concerned – as well as its style and provenance – the local, probably middle Hellenistic workshops are a likely source, despite the lack of other replicas of the type. In Cos some links can be pointed out with two male half-nude sculptures, which can be dated, one (Kabus-Preisshofen no. 21)[49] to the end of the third century BC, the other (Kabus-Preisshofen no. 22)[50] to the beginning of the second century BC. Although they have different postures, they show considerable similarities with the statue from the House of Europa, in such features as the powerful trunk, the width and modulation of muscular masses, and the light-and-shade area adjacent to the rendering of the pectoral muscle relief (Fig. 250).

As to the classicism of the head, similar features can be recognised in middle Hellenistic Coan production, as a statue from the Odeion shows, preserved in the courtyard of the Castle of the Grand Master in Rhodes (Kabus-Preisshofen no. 33),[51] dating to around 160 BC. The idealising concept, the large surface of the forehead, the metallic cut of the eyebrows, the large horizontal septum, the rounding of the chin in the Odeion portrait clearly express the presence in Cos of classicising trends in the middle Hellenistic age.

The body structure and the posture of the Hermes is definitely late classical–early Hellenistic. The head shows an evident classicising intention, which could be well adapted to a middle Hellenistic *Nachschöpfung*.[52] It is extremely difficult to pinpoint the precise moment of the middle Hellenistic period to which we could relate the model of the Coan Hermes, but since the beginning of the *Nachschöpfung* phenomenon is dated by Niemeier approximately in the second quarter of the second century BC,[53] and given the quantitative and qualitative abundance of Coan sculptural documentation between the third and the second centuries BC,[54] we could generally think of the middle second century BC and the period of great growth in Coan workshops.[55]

The iconographic rarity of our Hermes gives a further indication, in my opinion decisive, for the identification of the prototype. We have already underlined the static nature, the solemnity, of the statue, as well as the emphasis of the gesture made by Hermes placing his hand on the ram. A specific value must be recognised in these features. Together they act as a direct reference to a specific aspect of the god and only to that one. The distance from the abundance of small bronzes and coins reproducing statuary types similar to ours cannot be filled. The former present a simple

and linear image, where only the ram is added to the god's attributes; the latter embodies the overall presentation of Hermes'/Mercury's prerogatives.

On this basis I do not believe there is any doubt that the specific reference is pastoral, a very well-known aspect of Hermes. However, in the incomplete Coan mythological and religious record there are elements which might give a deep and meaningful value to the subject, a value which is strictly connected with the peculiarities of the local culture.

Through the epigraphical and literary documentation, L. Robert reconstructed the existence in Cos of a cult of Hermes Eumelios, of at least Hellenistic origin and certainly known up to the early Imperial age.[56] According to Robert, the *epiclesis* would demonstrate the superimposition of Hermes on a local deity Eumelios, related to mythical Eumelos, son of Merops. A confirmation of the pastoral nature of the god, inherent in the formulation of the epithet, and of the close relationship between Hermes and Eumelios/Eumelos, is found in the fifteenth Metamorphosis of Antoninus Liberalis,[57] an obscure author of the mid-Imperial age, which narrates the legend of the transformation into birds of Meropis, Byssa and Agron, Eumelos' daughters and Merops' niece.[58] The punishment was inflicted because of the impiety shown by the girls toward Hermes, Athena and Artemis, who had gone to Eumelos' house to convince them to sacrifice in their honour. A detail to be mentioned is that the gods carried out their mission under false guises: Athena and Artemis as Korai, Hermes ποιμένος ἔχων στολήν (wearing the dress of a shepherd).[59]

Both Robert and Sherwin-White have clearly shown the ekphrastic nature of the myth originating in three important Coan cults.[60] We are interested in underlining the Hellenistic level of the source declared by Antoninus (a certain Boios or Boio),[61] the local nature of the myth, unknown except in Cos, and its connection with some of the oldest and more important genealogies, directly descending from Merops.[62]

Now if, as there is no reason to doubt, a statuary image was also connected with the Hermes Eumelios cult, it is possible to think that it clearly alluded to the epithet distinguishing Eumelios from other cults of Hermes practised on Cos. Therefore, I do not believe it is too rash to recognise in the statue from the House of Europa clear reference to Hermes Eumelios and, given the chronology of the work and its stylistic features, see in it the influence of a cult statue. The lack of other statuary types of Hermes Eumelios does not allow us to specify whether our sculpture is a replica or a copy, as the dating and the stylistic features would lead us to think; great prudence is required in determining the period in which to locate the creation of the prototype of our statue.

The links which can be traced between it, Coan plastic art of the end of the third century BC, and the Hellenistic dating of Merops' myth, could lead us towards the mid-Hellenistic age. However, we cannot exclude a later dating in the late Hellenistic or early Imperial ages, both because of the typological similarities with the statues of Hermes in Corinth and Patras, which Beschi realistically supposed to be early Imperial creations, and the presence of the petasos. Whatever the dating of the prototype, the identification of Hermes Eumelios could allow the retrieval of a precious testimony of Coan ideal plastic art, giving evidence for the originality of local workshops. Finally, assuming a date for the creation of the model around the mid-second century BC, the presence of a *Nachschöpfung* movement seemingly particularly developed in Pergamum,[63] would enrich the stylistic movements of Cos in the Hellenistic age with a new element, up to now considered lacking.[64]

To conclude, I should like to underline one further piece of data in favour of the identification here proposed, which comes from the find-context of the sculpture. As I mentioned at the beginning, the Hermes was found with other statues (besides the female portrait) dating to the Trajanic age.[65] We have the pair of Asclepius[66] and Hygieia,[67] an Artemis of the so-called Seville/Palatine type,[68] a group of Dionysus with Satyr, Pan and Panther[69] and an idealised portrait of a young girl.[70]

All these sculptures are smaller than life-size and are datable during the second half of the second century AD, except for the Hygieia which should be dated to the first/second quarter of the third century AD. Now, for each of these identities it is possible to find a correspondence in the mythological and cultural context of Cos: the pair of Asclepius and Hygieia, who are rather rare in private houses both in the west and the east Mediterranean,[71] are well represented on Cos.[72] The private cult of Dionysus in Cos is also well known elsewhere;[73] finally Artemis participated personally in the mythical legend of Merops' descent, as we illustrated above, and was worshipped accordingly in the Hellenistic age.[74]

The presence of these sculptures might therefore not be accidental, but could reflect a precise choice by the house-owner, who would have decorated his residence with works recalling myths and local cults. Further confirmation of this 'personal' taste is given by the choice of the Rape of Europa for the mosaic of room XI, which is to be identified as a *thalamos*. In a recent study I suggested that a minor mythological tradition

existed connecting Europa to Cos and Merops' descent. The mosaic theme would not only harmonise with the location (in the *thalamos*), since it narrates Zeus' love affair, but would also allude with refinement to the Coan mythological tradition.[75]

ACKNOWLEDGEMENTS

Since 1989 the Italian Archaeological School in Athens has initiated, together with the twelfth Ephoria of the Dodecanese, a publication programme of the archaeological material and monuments discovered in Cos during the period of Italian rule over the region. I wish to thank particularly the Ephor Dr I. Papachristodoulou and Prof A. Di Vita, Director of the Italian Archaeological School in Athens, for entrusting to me the publication of the material presented here.

NOTES

1. Morricone 236–40, figs 61–74; for the sculpture see: 238–9, fig. 74; *Musée de Kos* 22, no. 91.

2. Morricone 237–8, fig. 64; G. Assimakopoulou-Atzaka, Ἐατάλογος ρωμαίκων Ψηφιδότων δαπέδων με ἀνθρώπινες μορφές στον Ἑλλήνδικο χόρο', *Hellenika* 26 (1973) 223, no. 27, pl. 16a; M. Roberston, *LIMC* IV I (1988) 85 *s.v.* 'Europa' no. 161; C. Lochin, *BullAIEMA* XIII (1990–91) 465–7; F. Sirano, 'Il mosaico della casa cosiddetta del Ratto di Europa a Coo', *Atti del I Colloquio dell' AISCOM, Ravenna 29 Aprile–5 Maggio 1993* (Ravenna 1994) 541ff.

3. On the house and its history: F. Sirano, *La casa cosiddetta del Ratto di Europa a Coo*, Tesi di Specializzazione SAIA (Rome 1993); idem, *La casa cosiddetta del 'Ratto di Europa', La presenza italiana nel Dodecaneso tra il 1912 e il 1948. La ricerca archeologica. La conservazione. Le scelte progettuali* (Rome 1996) 136ff.

4. Archivio SAIA M/F (ordered chronologically) 627, 630, 626, 629, 631, 636, 639.

5. Cos Archaeological Museum inv. no. 91: during the excavation, Hermes, in good condition as a whole, emerged without the frontal and left side of the petasos, most of the nose, caduceus, forefinger and thumb of the right hand, and without the big toe of the right foot (Archivio SAIA M/F 627, 629, 636); some fragments were then discovered and reattached, while the missing side of the petasos was completed in plaster. Remains of red paint are visible on Hermes' hair and eyes, on the ram and the rock; apparently colour was not employed for the skin or the chlamys of the god.

6. Morricone 239.

7. Zanker 117–19; *Kaiser Marc Aurel* (1988) 199–201.

8. Paribeni 129, no. 364, pl. 164; Manderscheid 102, no. 280, pl. 36.

9. Lippold 182, no. 38, pl. 85.

10. For the 'Eroe Farnese': Todisco (1993) 51, fig. 38; Troïzen Hermes in Athens: Todisco (1993) 53, fig. 46; Copenhagen Hermes: Siebert 367, no. 946d.

11. Siebert 367, no. 948c; *Sculpture in Stone* (1976) 102, no. 157.

12. Kreikenbom 144, no. I.6, pl. 16.

13. Stuart Jones 177, no. 87, pl. 40.

14. Blümel (1931), 15, no. 43, pl. 26.

15. Kreikenbom 156, no. I.47, pls 69–70.

16. Kreikenbom 156, no. I.48, pl. 71.

17. Kreikenbom 42, n. 105.

18. Kreikenbom 42, n. 106.

19. Paribeni 62, no. 136, pl. 80.

20. Paribeni 62, no. 137, pl. 81.

21. Blümel (1931) 40, no. 178, pl. 71.

22. Siebert (1990) 368, no. 965; Beschi 31–43, figs 10–12.

23. See Cos Museum inv. nos 97, 98 (unpublished).

24. Morricone 239.

25. Beschi 33, 42.

26. M. Bieber ('Drei attische Statuen des v. Jahrhunderts', *AM* 37 (1912) 174–9, pl. XIII) provides a date of the third quarter of the fifth century BC for a torso of a seated Hermes from the Acropolis.

27. On the seated Hermes see Siebert 290, 369–70.

28. Siebert 368, no. 965; Beschi 31–43, figs 10–12.

29. Beschi 31–60.

30. Beschi 43–53. On the type: F. Smith, in P. Moreno (ed.), *Lisippo* (Rome 1995) 130–31.

31. Beschi 40–43.

32. Two African terracottas (second-third centuries AD), presumably from the same mould, show the general structure of our Hermes: S. Besques, *Catalogue raisonné des figurines et reliefs en terre cuite grecs, étrusques et romains* IV 2 (Paris 1992) 154, pl. 95c.

33. Beschi 42.

34. Beschi 60.

35. Beschi 50, 60.

36. Pausanias II.3.4.

37. Imhoof-Blumer and Gardner (1885) 72, no. 26 pl. LII E, figs CX, CXI (Corinth); Imhoof-Blumer and Gardner (1886) 86, pl. LXVII R, fig. IV (Patras: Hermes holding a *marsupium*).

38. Lippold 182, no. 38, pl. 85.

39. Beschi 48, I, fig. 17.

40. Paribeni 129, no. 364, pl. 164.

41. Beschi 43, I, fig. 15.

42. Beschi 46, XV; A. Garcia y Bellido, *Esculturas romanas de España y Portugal* (Madrid 1949) 84ff., no. 66, pl. 61; Moreno (supra n. 30) 138, 4.16.6.

43. V. Macchioro, 'Hermes con Dioniso di Cefisodoto', *ÖJh* 14 (1911) 89ff., fig. 94.

44. *Répertoire* II, 151, fig. 8.

45. *Répertoire* II, 159, fig. 7.

46. Beschi 32, figs 10–12.

47. Supra n. 37.

48. Beschi 56–9.

49. Kabus-Preisshofen (1989) 191, no. 21, pl. 32, 1–2.

50. Kabus-Preisshofen (1989) 193, no. 22, pl. 33, 1–3; on these statues and their importance in the sculptural panorama of middle Hellenistic Cos see Kabus-Preisshofen (1989) 311–14.

51. Kabus-Preisshofen (1989) 207, no. 33, pls 44, 1–3; 45, 1–4.

52. I quote this term according to Niemeier's use for Hellenistic replicas (Niemeier 154–7).

53. Niemeier 145–6, 155.

54. Kabus-Preisshofen (1989) 19–21, has pointed out how, especially around the middle of the second century BC, we could add the epigraphical testimony of the rich sculptural documentation. For a different point of view emphasising the discontinuity of knowledge of sculpture in the Cyclades and Asia Minor between the third and the first half of the second century BC see Linfert 137–40.

55. Kabus-Preisshofen (1989) 123ff.

56. Sherwin-White 313–14.

57. *Ant. Lib.* xv. 1–5 (ed. Belles-Lettres, Paris 1968).

58. Recently on Antoninus: F. Celauria, *Antoninus Liberalis' Metamorphosis* (London 1992) 1ff.

59. *Ant. Lib.* xv. 3 (ed. Belles-Lettres, Paris 1968).

60. Sherwin-White 290–91, 313–14.

61. Sherwin-White 291–2.

62. Testimony and myth: Kruse, *RE* xv 1 (1931) 1065-7 *s.v.* 'Merops'.

63. Niemeier 155–7.

64. Kabus-Preisshofen (1989) 178; Linfert 82. See also Gualandi 26.

65. Cos Museum inv. no. 100: Morricone 238, figs 68, 71; *Musée de Kos* 24, no. 100; Kruse 102–3 and n. 101; K. Fittschen, in *GGA* 225 (1973) 63.

66. Cos Museum inv. no. 101: Morricone 238–9, fig. 66; *Musée de Kos* 24, no. 101; G. Putscher, 'Das Bildnis des Asklepios in Kos', *Marburger Sitzungsberichte* 87 (1966) 26ff., pl. 6; G. Strohmaier, 'Asklepios und das Ei: Zur Ikonographie in einem erhaltenen Kommentar zum hippokratischen Eid', *Beiträge zur alten Geschichte und deren Nachleben, (Festschrift für Franz Altheim zum 6.10.1968* II (Berlin 1970) 149, fig. 28; V. Uhlmann, 'Wandel einer Göttergestalt: Zu einer Asklepiosstatuette der Bernischen Abguss-Sammlung', *Hefte des Archäologischen Seminars der Universität Bern* 8 (1982) 36, no. 17; see also F. Sirano, 'Considerazioni sull'Asclepio "tipo Nea Paphos": Ipotesi su un gruppo di sculture di età imperiale', *ArchCl* 46 (1994) 199ff., fig. 7a–b.

67. Cos Museum inv. no. 98: Morricone 238, fig. 73; C. Kerenyi, *Der göttliche Arzt: Studien über Asklepios und seine Kultstätten* (Darmstadt 1956) 62, no. 62, fig. 3 (incorrect provenance); *Musée de Kos* 22, no. 98; E. Mitropoulou, 'Η Τυπολογια της θεας Ὑγεια με φυδι (Athens 1984) 2–26, 48, 61, no. 70a; Kabus-Preisshofen (1989) 64, n. 196; F. Croissant, *LIMC* v 1 (1990) 570 *s.v.* 'Hygieia'; H. Sobel, *Hygieia: die Göttin der Gesundheit* (Darmstadt 1990) 96, no. 6, pl. 9a.

68. Cos Museum inv. no. 97: Morricone 238–9; *Musée de Kos* 22, no. 97.

69. Cos Museum inv. no. 94: Morricone 238–9, figs 66, 72; *Musée de Kos* 22, no. 94.

70. Cos Museum inv. no. 95: Morricone 239, figs 66, 69–70 with different chronology; see Kruse 102, n. 110; Kabus-Preisshofen (1989) 156.

71. R. Neudecker, *Die Skulpturenausstattung römischer Villen in Italien* (Mainz 1988); for the Orient see bibliography quoted by F. Sirano, supra n. 66. Neudecker lists only four cases in Italy of Asclepios, without Hygieia; in the East the association goes back to Alexandria, and Asclepius is present in the house of Theseus in Cyprus.

72. For the history of Asclepius' cult between the Hellenistic and the Roman period: Sherwin-White 334–58.

73. For Cos: Sherwin-White 314–17; more generally, AA.VV. *L'Association dionysiaque dans les sociétés anciennes* (Rome 1986) passim.

74. Sherwin-White 303–4.

75. F. Sirano, supra n. 3. See in general: J. P. Darmon, 'Les Images dans la maison romaine', *Bulletin de liaison de la Société des amis de la Bibliothèque Saloman Reinach* v (1987) 57ff.; R. Neudecker, 'Weitere Prolegomena zur römischen Kunst', *JRA* v (1992) 319ff.

19

Ptolemy or Artemis?
A Hellenistic sculpture from Cos

Nicolas Stampolidis

In 1955–6 when Laurenzi studied and published the sculpture from Cos, he described a small head made of granite as follows: 'piccola testa di Artemide Efesia. Altezza 0.17 m. Di granito. Il modio é spezzato sul davanti; é una piccola reproduzione di un' Artemide Efesia.'[1] Laurenzi seems not to have seen the sculpture itself but was working from a photograph (Fig. 254). Its recent rediscovery in the storerooms of the Castle of Cos provides the opportunity for a closer study and reidentification of the piece. Let us first examine it in detail.

The material is a light, grey-coloured granite; there is a low headdress, polos or better modius; the head is slightly broken in front and is clearly identical with the head that Laurenzi published and illustrated (Fig. 254). The head (Figs 255–8) is broken off on an almost level plane at the upper part of the neck. Breaks and damage occur on the chin, the tip of the nose, the brow, the curls above the forehead on the vertical projection at the front of the polos, and on the taenia on the top. There is a larger break on the upper right nape of the neck. Traces of mortar or stucco survive, mainly on the left side of the face. Traces of corrosion appear on the nose, hair at the forehead and polos, and mainly at the left and back part of the hair. A larger stain covers part of the right jaw and the tenons of the neck.

Measured in front the head is 12 cm high and the polos is 5 cm high (totalling 17 cm) whereas at the back the total height of the head with polos is 14.5 cm, owing to the fact that the upper surface of the polos slopes down toward the back. The head has short hair arranged above the forehead, temples and the nape of the neck rendered with well-defined pearl traces. A relatively deep, wide groove separates the last row of curls at the nape of the neck from the remaining three rows above. The groove narrows markedly as it comes round to the front of the head, isolating the curls at the temples and separating the two rows of forehead curls.

Although the stone is very hard, the modelling of the lips and nostrils is rendered in considerable detail. The eyelids and the almond-shaped eyes are also carefully rendered, the inner corners of the eye penetrating the inside edge of the deep eye sockets. The lower part of the forehead is slightly bulky especially where the arched brows meet the root of the nose. The cheeks are wide and also relatively bulky, as is the chin and the flesh just below. The polos widens out and ends above in a narrow relief taenia, about 1 cm high. The broken surface on the front of the polos, when seen in a good light, displays a relief of a coiled snake, probably a cobra to judge by the broad contour of the head. The entire surface, wherever it has not suffered damage, is extremely well worked and smooth, especially the face.

The above description makes it clear that this is a male head which Laurenzi took to be female, obviously because he did not base his observations on the head itself. Judging from the state of preservation, the head was severed from the body with a blow, probably on the nape of the neck (Fig. 258), and it fell to the ground face downwards. The large stains are due to the composition of the soil where it fell, unless they were caused by a later reuse as building material, as is indicated by traces of plaster on the left side of the face. Reckoning from the dimensions of the head without the polos, one may estimate the height of the figure, assuming that it was standing, at around 1.0 m. If the whole statue was made in one piece with the base, as is the case with certain examples from Cos,[2] the statue will not have been more than 1.3 m high.

The main clues for interpreting the little granite head are the deep narrow groove around the cranium and the low polos with the relief of a snake in front. The groove will have held a diadem, taenia or wreath, indicated either in paint or in another material. One might consider whether painted stucco or something made of metal had been placed in the groove, but metal is unlikely because there are no drill holes for attachment, and no traces of staining, as would be the case if the object had been made of bronze.[3] Was it a diadem, taenia or wreath? The last of these seems the least probable, because there is nothing to indicate a wreath with leaves. A taenia also seems unlikely, given that one would expect the ends to be indicated either with carving or in relief; there is, admittedly, the pos-

siblity of indicating the ends of the taenia with paint on the lower edge of the hair and/or on the nape of the neck. On the whole, a diadem seems the most likely. No matter what one prefers, diadem, taenia or wreath, all three indicate that the head is that of a ruler or of a god.

The polos worn by males is, in certain cases, a diagnostic feature of high officialdom and priesthood but also of male divinity, in particular chthonic deities such as Sarapis or Hades.[4] These divinities are, as far as we know, always represented bearded, in contrast with the head under discussion and the statuette of the god of the underworld from the sanctuary of Demeter at Kyparissi on Cos, which was perhaps represented with a low polos.[5] This particular polos, however, rather resembles the modius worn by Sarapis, in respect to size and shape, being low, widening upwards, and having the slightly projecting taenia at the top.[6] As far as we know, up until now the polos of the above-mentioned deities is not known to have been adorned with a snake. On the basis of the species, the form of the coils and the position, this snake may be identified as the *uraeus* worn on the crown of Egyptian kings. The combination of diadem and polos indicates an Egyptian origin.

Unfortunately the material, on the one hand, and the small size of the head, on the other, do not allow much leeway for making an indisputable identification of a specific person. The contour of the face and the volumes of the cheeks, the chin and the fleshy part below, taken together with the profile, bear a certain resemblance to the early Ptolemies (II, III or IV) as known from sculpture and coins.[7] The difficulty of making an identification is increased by the fact that the facial features are generalised with a touch of idealism.

Thus only the material and size of the head are of help in determining which one of the early Lagid kings this head represents; or are there other ways of interpreting the tendency to idealise and enhance the facial features?

A knowledge of the place of manufacture would doubtless be helpful, but the size and the material do not appear to provide reliable criteria in determining the place of origin, at least not in the Hellenistic period. At this time it was easy to transport even very large architectural members for long distances.[8] Thus a work of the estimated size of this statue (1.0–1.3 m) could easily have been transported from one place to another; or the statue could have been carved anywhere from a block of stone transported far from the place where it had been quarried. The workmanship of an extremely hard stone such as granite might be

thought to provide evidence concerning the place of origin, given that one might expect the sculptor to be thoroughly acquainted with the stone and the difficulties of working it. But this too does not provide a safe criterion, considering that light-coloured granite is found not only in Egypt but also in the Aegean islands such as the Cyclades, for example Delos.[9] In the Hellenistic period, furthermore, a sculptor could have picked up knowledge of working granite in one of several ways, including experience gained in travelling to various places.

Taking all these factors into consideration, it appears that there are two possible interpretations of the lack of individuality of the features: (1) If the stone and the sculptor were Egyptian in origin, which seems highly likely in view of the fact that the stone has the typical rosy tinge of Egyptian granite, and the statue was sent from Egypt to Cos, then it is very probable that the idealising style was done deliberately with the aim of representing a ruler-god – no matter which Ptolemy it was intended to represent. The polos, like the modius of Sarapis, supports this view. (2) If, on the other hand, apart from the question of where the stone was quarried, the work was carved on Cos, and the sculptor had only a vague idea of the personal appearance of his subject, then it is quite possible that the lack of individuality was not deliberate. The mixture of a diadem and the polos with the *uraeus* motif would fit this explanation.[10]

Either of the above alternatives concerning the place of manufacture affects the final interpretation of the little head, especially if we take into account other similar works from Cos.[11]

If the second solution is deemed preferable, then the head is more likely to represent Ptolemy II Philadelphos or Ptolemy III Euergetes. The mixture of elements with an attempt to render an idealised portrait of the deified king would fit very well, especially if we have to do with Ptolemy II who was born on Cos c. 309/308 BC when his father, Ptolemy I Soter, used the island as a base.[12] If the head is identified as Ptolemy II, the earliest date for the work would be before 260 (258?)-245 BC,[13] as far as one can judge from the published inscriptions from Cos recording the relations and alliances of the Coans with the Ptolemies and other leading powers of the Hellenistic world. If the head is identified as Ptolemy III Euergetes, the work would date some time between 245 and 235 BC, when Cos had resumed close relations with the Ptolemies.[14]

If, however, one were to accept the first solution, then an identification with Ptolemy IV Philopator seems more likely, given that much of the evidence would favour such a solution.[15] The cult of Ptolemy

IV on Cos was most probably established by the end of the third century BC, almost certainly as a demonstration of gratitude on the part of the Coans for incorporating the island of Calymnus in their state, as K. Höghammar has recently shown.[16] The inscription from Cos mentioning Arsinoe III, the wife of Ptolemy IV, as a goddess seems to point in the same direction.[17] A Ptolemaic cult, however, even if it had been founded during the reign of Ptolemy IV or immediately after his death, does not rule out the possibility of the creation of statues of his ancestors, similarly deified, a fact that would again point to the first alternative.

As in the case of other sculpture found on Cos relating to the Ptolemies or to Egyptian deities,[18] the exact find-spot of this head is, unfortunately, not known, so that there are no clues as to the site of the cult of the Ptolemies. Nonetheless, the information presently at our disposal permits a tentative division of the finds into two groups which, in turn, leads to further reflections. Works relating to the Ptolemies executed in basalt or granite, and apparently coming from within the city of Cos, are currently kept in the medieval castle and its storerooms. Related works in marble and bronze coming from the Asklepieion are today gathered together in that area. If this distinction in fact obtains, what does it mean? In my opinion, the works in marble and bronze may well have been those dedicated in the Asklepieion to honour the kings as rulers or benefactors (ἀρετάς καί εὐνοίας ἕνεκα ἐς τον δήμον)[19] and there, in the sanctuary of Asclepius, both the material (marble, bronze) and the representation of the Ptolemies or their queens was carried out in a purely Greek manner. The works found in the town, by contrast, made of Egyptian basalt or granite (or material such as the light-coloured granite which could be considered Egyptian), are almost all smaller than life-size and bear features which indicate the deification of the Egyptian kings.[20] They appear to have another function and were probably set up in an area directly associated with the cult of the Ptolemies (temple, altar, precinct with altar, heroon (alone or in a gymnasium), etc.).

The statue in question may have been set up in a sanctuary belonging to an Egyptian divinity, such as a Sarapeion. It would have been about the same height as the statue of Arsinoe III on the basalt base[21] and perhaps also similar to the third piece from the castle of Cos,[22] if it does, in fact, represent a Lagid king. Taking into consideration that the little head may well represent one of the early Ptolemies, the ancestors of the deified Ptolemy IV and his wife Arsinoe III, one may conjecture that the three works formed a group like the one set up in the 'Philippeion' at Olympia.[23] A 'heroon' for such a display would, consequently, be an indication of the external policy and propaganda of the Ptolemies on the island where the second of the deified Lagids was born, set up a few years after his death. The 'heroon' of the Attalids on the Acropolis of Pergamum is an analogous example.[24] The excavation finds and epigraphical testimonia available today furnish no indication that there was a Sarapeion on the island.[25] Two fragmentary inscriptions from Cos reinforce the probability that the statues were set up in a sanctuary (a simple precinct with an altar or a temple) or in a cult area (heroon?).[26] The decree PH no. 8 which refers to the cult of the Ptolemies mentions contests and a gymnasium of ephebes.[27] There is further evidence for a cult of the Ptolemies celebrated in public areas: the inscription set up in honour of Arsinoe III by the *agonothetes* Kallimachos. The commentary puts forward the hypothesis that there was a festival directly linked to the Ptolemies (Ptolemaia or Arsinoiea)[28] who were known to have borne the entire expense or to have contributed to public structures.[29]

NOTES

1. Laurenzi (1955–6) 90, no. 42. This little head, inv. Γ 192, caught my eye while reorganising and compiling an inventory of the Hellenistic sculpture in the storerooms of the castle of Cos.

2. Stampolidis (1982) 297 and figs 1–2, drawing and 305, 307, fig. 3.

3. On the other hand it is quite possible that drill holes were not made because the head is so small and that the absence of traces of staining indicate that the object was made of some precious material (gold or silver, or gilded or silvered metal).

4. For the former, see L. Vlad Borrelli, *EAA* VIII (1966) 204–7. For the latter, see R. Linder *et al.*, *LIMC* IV 1 (1988) 367–94 and IV 2 (1988) 210–36.

5. Kabus-Preisshofen (1975) 56: 'Es fehlt auch der Polos oder Modius, der wohl in Stuck auf abgeflachter und gerauhter Stückungsfläche auf dem Scheitel modelliert war.'

6. Becher, *RE* XV 2 (1932) 2328, nos 2 and 3. For an early representation of the 'polos'–modius reported as a diadem by Krauskopf, *LIMC* IV 1 (1988) 397, no. 18 and IV 2 (1988) 228, see the red-figured phiale in Ferrara (Mus. Naz. 29307).

7. Ptolemy II or Ptolemy III are perhaps more probable according to H. Kyrieleis, whom I wish to thank for discussing this head with me. For the portraits of Ptolemies II, III and IV, see Kyrieleis 17ff., 25ff. and 42ff.

8. For example, the columns of the Stoa of Eumenes on the Acropolis south slope, according to Korres 201–7.

9. There are traces of granite quarrying at the little harbour of Fourni, and large granite blocks were used in the foundations and construction of certain buildings on the island. For granite on Delos and the location of the inlet of Fourni, see Zapheiropoulou (1983) 5, map on p. 7 and fig. on p. 52.

10. Of course nothing rules out a combination of the two interpretations in respect of various features.

11. Stampolidis (1982) 297ff., especially 306.

12. Höghammar 20.

13. Höghammar 21 and 33.

14. Höghammar; Sherwin-White 90ff.

15. For example, the gold octadrachms of Ptolemy IV which circulated in Alexandria (Kyrieleis 42–3, pl. 30, 1–2) are similar to the head in respect of the treatment of tresses and the taenia–diadem.

16. Höghammar 88ff. For the cult of the Ptolemies in general, see Kyrieleis 138ff.

17. Stampolidis (1982) 300ff.

18. Stampolidis (1982) 302f., 305.

19. Höghammar 173, no. 63.

20. On the basis of certain symbols and/or idealised features or inscribed bases.

21. Stampolidis (1982) 297f.

22. Supra n. 17.

23. See also Kyrieleis 139.

24. Akurgal 74–6.

25. Laurenzi (1931) 603ff.; Neppi-Modona 1ff.; Kantzia 140ff.; Höghammar 16ff.

26. Segre (1937) 286 and Sherwin-White 135–6.

27. Paton and Hicks no. 8, ll. 8ff.

28. Stampolidis (1982) 306ff.

29. For this kind of donation etc., see Stampolidis (1987) 250, n. 902.

20

An early fifth-century BC grave stele from Rhodes

Eriphyle Kaninia

Rescue excavations during the opening of trenches for the installation of the city of Rhodes' main sewage-duct have brought to light important new finds in the last ten years.[1] In 1986, 700 m to the west of the outlet of the main sewage-duct at Cape Vodi (about 5 km from the city of Rhodes, on the east coast of the island), pieces of a late Hellenistic relief were found. The lower part was found *in situ*, having been reused as part of the southern of two parallel retaining walls, which have not yet been fully excavated. The composition had been worked in three joining marble slabs and shows, in the centre, a frontal figure of a hero-warrior holding his sword and standing in front of his horse between two servant boys. The upper part of the composition, which would have been worked on one or more separate slabs, is missing.[2] Two years later, in 1988, three pieces of a large marble grave stele were found buried under a huge accumulation of earth a few metres away from the site where the late Hellenistic composition had been discovered; the stele dates to the second quarter of the fifth century BC and represents in a fine, tender allegorical scene a young man offering a rooster to a boy (Figs 259–62).[3] The stele was brought to the storerooms of Rhodes Museum and, following its restoration, is now exhibited in the Grand Master's palace in Rhodes.[4]

The stele narrows elegantly upwards; its preserved height is 2.135 m. It was crowned by a pediment, most of which is now missing except for its right-hand corner and a poor remnant of the left-hand corner; the lower part of the right-hand lateral akroterion is also preserved. A small socket for an iron dowel suggests that some mending of the broken pediment had occurred in antiquity. The missing part of the left-hand side of the stele had been loosened along a flaw in the marble and was eventually broken off by a final stroke of the bulldozer. The vertical edges of the slab are slightly raised forming a faintly concave background which accentuates the sense of depth around the carved figures. Extensive traces of tool marks are preserved on the background. Along the left-hand vertical raised edge of the stele a fillet had been carved in shallow relief; no trace of such a fillet is visible along the smooth surface of the right-hand edge, except for an uneven band of some red colour which is preserved along its upper half, most probably an oxidisation effect. The sides and back of the stele have been evenly smoothed; its coarser lowest part, that was once embedded in the socket of a base, is separated from the main shaft by a narrow projecting ledge on which the relief figures stand. We observe that in the architectural form of our stele the concave background, typical for the stelai of the archaic period, is combined in an eclectic manner with a moulding (cyma reversa) that runs below the horizontal geison of the crowning pediment. This moulding, linking pediment and shaft, is a common innovation in the Ionian stelai of the fifth century BC. It is to be found in the Giustiniani stele in Berlin,[5] dated to 460–450 BC and thus gives a point of reference for the date of the Rhodian stele. The crowning pediment is justified by the considerable width of the stele (0.91 m at its lower part, for the accommodation of the two opposing figures of the composition), although its proportion to the height axis would permit a palmette crowning.[6]

The largest part of the stele is occupied by the figure of a young man, 1.83 m tall, represented in profile to the right with his left leg advanced; traces of repair are visible on the back of the supporting right leg, along the fracture of the missing part of the slab. The sandals of the young man were painted, as is suggested by the slight carving of the right sandal sole. His beautiful body, although the rendering of the muscles is rather soft, has an athletic appearance, and his countenance is noble with a hint of voluptuousness about the mouth. His almond-shaped eye is set obliquely in an attempt at proper perspective and there is some sense of depth beneath the linear modelling of the eyebrow. Below the binding fillet his hair is left as a smooth mass (perhaps originally differentiated by paint), except for a conventional rendering of the wavy outline of the curls in front of the ear; above the fillet the hair is left roughly carved by the point, probably for stucco or for the application of colour. He holds in his raised left hand a staff which, as it passes behind the boy's body, defines its theoretical axis. His neatly

folded mantle is slung over the left shoulder following the 'suave' contour of the upper part of the back and the lowered right arm. In front of the body, the mantle falls with two soft straight folds and is overlapped by the central iconographical motif of the rooster. The drapery continues below ending in zig-zag folds in front of the young man's left thigh. The right arm of the young man is lowered; his right hand tenderly touches the back of the rooster as he passes it with an indiscernible push towards the boy, who seems already to have accepted it in his arms. This boy is nude and, measuring some 1.3 m in height, is placed opposite the young man in considerably smaller scale. We may guess the age at around 12 to 14 years. He stands with the lower part of his body in profile to the left. His advanced right leg supports the body, while the left is lifted off the ground, toes barely touching it, thus accentuating the ambivalent motion of his body with the torso shown frontally, turning from the hips. The head of the boy returns to a typical profile to the left and is tilted up in an expressive rendering of the tender relationship between the boy and the young man, their gaze meeting. The upper part of the boy's face is unfortunately missing; on the broken surface an even smoothing suggests that some mending had occurred in antiquity. The rendering of the boy's hair is similar to the young man's: a conventional smooth mass, that most probably was originally differentiated by paint. The rooster in the boy's arms has been carved in shallow relief and the details of its plumage were most probably painted on. We observe that on this part of our relief there is an overlapping of the various levels (we can discern at least six) that reminds us of earlier examples, such as the multi-level rendering of the symposium relief from Cos,[7] dated to about 510 BC, or that of the lower part of the Attic stele with the figures of two warriors in Copenhagen,[8] dated to about 500 BC. A further illusion of depth is created by the deeply incised rendering of the boy's hands that appear to be sinking into the rooster's feathers.

The provenance of the Rhodian stele puts it among a group of the east Ionian grave reliefs of the first half of the fifth century BC.[9] The dominant figure of the young man belongs to a series of standing male figures represented in Ionian grave stelai that range chronologically from the fourth decade of the fifth century

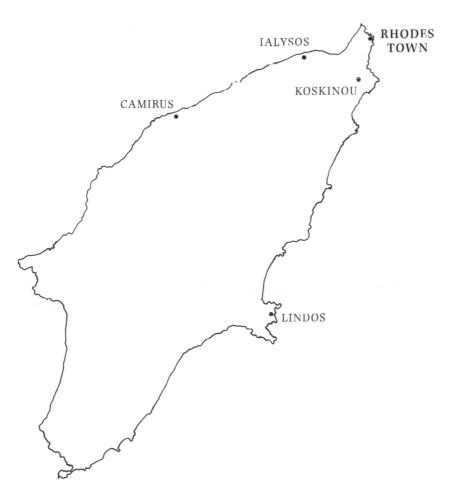

Map of Rhodes.

down to 440 BC. The figure of the young man in our stele has its closest parallels in the figures of athletes shown in the grave stelai in the Museum of Çanakkale[10] on the one hand, and in that from Nisyros[11] in the Museum of Constantinople, on the other. Professor R. Özgan has already compared these two reliefs and has dated the Çanakkale stele to about 460 BC, while the Nisyros stele is placed somewhat earlier.[12] The soft modelling of the young man's body in the Rhodian stele, shown in proper profile, has its counterpart in the rendering of the slender body of the athlete in the Çanakkale stele; for both figures, a comparison with the sculptures of the temple of Zeus in Olympia (470–455 BC) provides a common point of reference in terms of absolute chronology.[13] As far as the dominant figure of the young man in the Rhodian stele is concerned, we observe that the soft and simple zigzag folds of his mantle are reminiscent of the folds of Sterope's peplos in the east pediment as well as of those of Athena's peplos in the Atlas metope. The massive rendering of the hair of the young man, as well as that of the boy, is also to be seen on the head of Kladeos in the east pediment and, in a more sophisticated variation, the head of Deidamia in the west pediment. The texture of the flesh, the linear eyebrow and the voluptuous mouth of the young man's face in the Rhodian stele also reminds us of the head of the Apollo from the centre of the west pediment. However, an archaising conservatism is to be seen in the heavy rendering of the lower part of the young man's body in our stele, with closest parallels not only in the Nisyros and Çanakkale stelai but also in that of the athlete of the Vatican grave relief,[14] which is later than the series of the other three. The Rhodes stele must be dated alongside the Çanakkale stele, about 460 BC, in accordance with Professor R. Özgan, who places the Nisyros stele a little earlier.[15] For a more accurate dating, however, it would be useful to take into account the secondary figure in the scene of our stele, that of the boy who accepts the rooster. In the profile rendering of the lower part of the boy's body, there is a sense of a somewhat uncertain balance; the left foot, shown in three-quarter view to the front, suggesting sculpture in the round, is slightly lifted off the ground. This action accentuates the twisting movement of the whole figure and reminds us of the figure of a youth in the Thasos 'Totenmahlrelief' (dated to 460–450 BC, now in the Museum of Constantinople).[16] The figure of the Thasos relief, shown in profile with a correct perspective, has a more slender modelling, and its fluid motion upwards suggests a more advanced development and a later date than our relief. In the Rhodian stele the backwards tilt of the boy's head and the lively twisting of the torso mitigate an otherwise conventionally archaic posture. The staff held by the young man creates the illusion of the boy's body extending upwards. The frontal rendering of his torso presents an intermediate level between the background of the stele and the central motif of the rooster, which is carved – almost incised – in very shallow relief. Here we see the same attempt at arranging the overlapping levels of the representation, as we find in earlier reliefs, such as those of the Copenhagen warriors[17] and the Cos symposium.[18] The comparison with the Thasos relief favours a somewhat earlier dating of the Rhodian stele, but certainly not before the second half of the decade 470–460 BC.

Since only a few grave reliefs of the first half of the fifth century BC are recorded from Rhodes, the attribution of our stele to a local Rhodian stylistic group or workshop does not seem possible. Here may be mentioned very briefly those reliefs which are known. First, the lower part of a weathered marble stele preserving the legs of a figure in profile to the left, dated to the second quarter of the fifth century BC.[19] Noteworthy is the deeply incised rendering of the contours of the legs, reminiscent of that of the figure of an athlete in the Nisyros stele. Second, the lower part of a marble stele preserving the legs of a draped figure in profile to the left, dated to 460–450 BC.[20] Finally, the upper part of a stele with the representation of a bearded man, the torso shown frontally, the head in profile to the right. This is dated to the middle of the fifth century BC.[21] A possible stylistic connection can be traced between our stele and this relief through a softness in the modelling of the muscles and in the neck and shoulder contours.

The few surviving grave reliefs of the second quarter of the fifth century BC may, however, be taken together with two pieces of sculpture in the round: a Severe Style head of a woman,[22] dated to the first quarter of the fifth century BC, and the lower part of a peplophoros,[23] dated to the middle of the fifth century BC. This corpus of early classical sculpture testifies to the fact that by the second quarter of the fifth century a tradition had already been created in the island by local sculptors, who probably travelled between the Dodecanese and the opposite coast of Asia Minor. This tradition extended to the late fifth century BC and can be traced in the creation of the Krito and Timarista stele.[24] Christos Karouzos in his illuminating guide to Rhodes had already noted the existence of such a formative tradition, developing under the influence of the Parthenon sculptures.[25] A thorough comparison of the new relief and the Krito and Timarista stele exceeds the scope of this paper. Suffice it to say that, although

pathos is typical of Ionian grave reliefs, in these two stelai an invisible line seems to connect the unusual intensity of their sentiment.

Although there is much scope for a comparative stylistic analysis of the Rhodian stele, the iconographical parallels are not so numerous. Until very recently there was only one certain parallel, the fragmentary relief from Cos,[26] dated to 500–490 BC. The interpretation of this relief may now be reconsidered through comparison with another recent find, the exquisite grave stele from Akraiphia, also dated to the first decade of the fifth century BC. Still unpublished, it was found in 1992 by Mrs Angeliki Andreiomenou. According to the short report published in *Ergon*,[27] the Akraiphia stele is intact, crowned by a palmette, and shows a boy in profile to the left, holding a rooster in the left hand, while the other holds a lotus flower up to the nose. An inscription carved in the Boeotian alphabet throws ample light on the erotic symbolism of the representation, hinted at by the presence of the rooster. Another parallel with a less obvious iconographical function, dated to the early fifth century BC, is worth mentioning here. This is the stele fragment of the Cycladic–Ionian group from Karystos, Euboea, now lost, but known from a drawing by Schaubert.[28] This shows the frontal view of a man's chest draped in a mantle, and with a rooster. This relief is iconographically related to a later Thessalian grave relief, the stele of Ekkedemos, dated to about 440 BC.[29] This provincial grave stele represents a young man wearing a mantle, in three-quarter view to the right. He holds a rooster with his left hand near his chest, while with the right he holds two spears.

The erotic symbolism suggested by the presence of the rooster has already been sufficiently discussed by Koch-Harnack, mainly on the basis of vase painting.[30] Erotic scenes with symbolic offerings of usually small animals (and roosters or hens) from the lover (*erastes*) to the beloved (*eromenos*) are quite common in the iconography of black- and red-figured vases.[31] An expressive parallel from Rhodes is a small black-figured olpe found in 1916 in Ialysos, by Maiuri (Drakidis lot, Grave XXIII);[32] on the vase, an Athenian import, dated to about 540–530 BC, a nude boy (or rather a youth) is depicted in profile to the left holding a rooster, which has been rendered with added white, while a nude and bearded man opposite him is making a characteristic gesture of erotic approach; a dog is also depicted between the two figures. It should be noted that the youth holds the rooster as though having already accepted it, as in the representation of our stele. Besides being iconographical parallels, the relevant scenes on black- and red-figured vases contribute to the inter-

pretation of the cultural and social background of the Rhodian stele: it seems that in Rhodes too the relationship between *erastes* and *eromenos* had social and paedagogical importance although, until now, we have no literary, epigraphical or any other evidence connecting this relationship with the instructive education of the *eromenos* for his formal acceptance into the society of adults.[33]

In comparison with earlier parallels, and more precisely with the Akraiphia relief, the Rhodian stele gives, in a less condensed way, the immediate feeling of the narrative character of the symbolic scene represented. This narrative property is not uncommon in Ionian funerary reliefs of the first half of the fifth century. It is found especially in multi-figured compositions, such as the Ikaria stele[34] or the Leukothea relief,[35] whose iconographical function is more complicated and not easily comprehensible. In the case of the Rhodian stele, however, the overlapping levels of the main iconographical motif, that of the rooster offering, seem to symbolise its many levels of meaning. Here the narrative is transformed by a simple gesture into a continuous exchange between the two human figures, as the young man lightly touches the back of the rooster while pushing it almost indiscernibly into the arms of the boy. The expressive strength of this movement is accentuated by the lively twisting of the upper part of the body of the boy, who holds the rooster as though he had just accepted it. This dialogue extends to a reverse interpretation: the ambivalent movement of the boy creates an impression that the iconographical motif may also be seen as though the offering is directed to the dominant figure of the young man. This observation strengthens the identification of the dead in the scene, namely the life-size figure of the young man (1.83 m tall) occupying more than half of the field. The gentle gesture of pushing the rooster into the arms of the boy, beyond the immediate meaning of erotic tenderness, also gives the feeling of a departure or farewell. His right hand still remains on the back of the bird but, at the same time, is ready to withdraw. This attitude, typical of the Ionian character of our stele, recalls the withdrawing movement of the left hand and foot of the dead Timarista in the Krito and Timarista relief. This was noted by Christos Karouzos[36] and may be considered among the obvious Ionian characteristics of this stele, although a product of the mature, classical post-Parthenon style. It is noteworthy that the opposing figure of the *eromenos* in our stele is that of a boy rather than a youth, following the typical usage in contemporary Ionian grave reliefs regarding the secondary figures of boys as, for example, in the doctor's

relief in Basle[37] or the Vatican stele.[38] Vase painters, by contrast, depict the *eromenoi* as youths, in natural size. The figure of the boy in our stele should not be identified as a παῖς (slave companion), but a social equal, who is receiving an erotic present.

Beyond the limits of objective interpretation, the Rhodian stele may be seen to reveal a hidden rapture, expressive of the sculptor's artistic attitude towards his subject. Through the naïve conception of the composition, we can see his familiarity with the enthusiastic spirit of his age, a time of discovery of new aesthetic values that were to be fulfilled in the classical Parthenon. No doubt, at this time the prosperity of some aristocratic families of the Ialysia offered encouragement. Such were the Diagoridae or Eratidae, who contributed towards the ripening of the political ideology of a synoecism of the three old poleis of the island, Ialysos, Lindos and Camirus.[39] Their patronage must have given an impetus to artistic creativity, although until now the finds are few. Our stele may in all probability be connected with the necropolis of the first half of the fifth century BC, part of which has recently been excavated in the village of Koskinou,[40] about 2.5 km west of the site where the stele was found. It was carved at about the same time Pindar was writing his VIIth Olympian Ode, commissioned by Diagoras to celebrate his victory at Olympia. These two works of art, each in their own way, are expressive of an allegorical conception, providing remote echoes of the spiritual grandeur of the Rhodian synoecism in its formative years.

ACKNOWLEDGEMENTS

This paper is dedicated to the memory of my friend and colleague Charis Kantzia.

οτὲλνοντας χαίρε στα κρυφά
δάση των περαμένων

I should like to express my warmest thanks to Dr I. Papachristodoulou, Ephor of Classical and Prehistoric Antiquities, for his kind permission to present grave stele Γ 1640 at the British Museum colloquium, in which I participated at his suggestion and with his encouragement. Also I am particularly indebted to my friend and colleague Anna-Maria Kasdagli for her invaluable assistance in revising and improving my English text.

NOTES

1. For a general account, see preliminary reports in *ArchDelt* 43 (1988); *Chronika* 589–93 and 610–11.

2. *ArchDelt* 43 (1988); *Chronika* 610, pl. 369β. For colour prints, see the magazine ΑΡΧΑΙΟΛΟΓΙΑ 37 (December 1990) 54–5.

3. *ArchDelt* 43 (1988); *Chronika* 611, pl. 370α.

4. The difficult task of assembling the pieces of stele Γ 1640 was undertaken by the experienced conservators of the 22nd Ephorate, A. Gatsaras, M. Vassilaras, M. Kaikis and E. Avgenikos. I thank them all for their patience, skill and co-operation.

5. Blümel (1928) 21–4 (K 19), pls 27–8; also Hiller (1975) 175–6 (K 8), pls 17.2 and 30.3

6. For the pedimental crowning of the Ionian stelai see A. Kostoglou-Despini, *Προβλήματα της Παριανής γλυπτικής του 5ου αι. π.Χ.* (Thessaloniki 1979) 92ff.

7. Without inv. no., most probably of sepulchral character: Laurenzi (1938) 73–80, pl. VI; C. Karouzos, 'Ασπιλ' εν νέοισι', *AM* 77 (1962) 121, pl. 35. Also see Hiller (1970) 59, fig. 59 and Pfuhl-Möbius I, 10–11 (7), pl. 3.

8. Ny Carlsberg Glyptothek inv. no. 2787; G. Richter, *The Archaic Gravestones of Attica* (London 1961) 50–51 (77), fig. 172.

9. Hiller (1975) *passim*.

10. Inv. no. 2039; Özgan 27–30, pl. 89.

11. Inv. no. 1142. Mendel I, 73–6 (11); Berger 38, fig. 37; Pfuhl-Möbius I, 14 (14) pl. 5; Özgan 28–30.

12. Supra n. 10.

13. Cf. Özgan 30; for illustrations of the Olympia sculptures see R. Lullies, *Griechische Plastik* (Munich 1956) pls 105–23; also A. Stewart, *Greek Sculpture: An Exploration* (New Haven and London 1990) II (plates) pls 262–84.

14. W. Fuchs, *Die Skulpturen der Griechen* (Munich 1969) 480–81, fig. 564; Berger, fig. 136; Özgan 29–30 and n. 11 with further bibliographical references.

15. Özgan 30.

16. Inv. no. 1947. Mendel II, 304–307 (578); also Berger 44, fig. 54; Özgan 30 and n. 13 with further bibliographical references.

17. Supra n. 7.

18. Supra n. 8.

19. Rhodes Museum inv. no. Γ 206; Hiller (1975) 160–61 (O 15), pl. 10,1; Pfuhl-Möbius I (19) pl. 5

20. Rhodes Museum inv. no. E548; Berger 38, fig. 33; Pfuhl-Möbius I, 22 (44) pl. 12.

21. Basle Museum; its recorded provenance is not certain; Berger 38, fig. 34; Hiller (1975) 162–3 (O 17), pl. 11, 1; Pfuhl-Möbius I, 18–19 (31) with full bibliographical references, pl. 7.

22. Rhodes Museum inv no. Γ 130; G. Constantinopoulos, *AAA* 6 (1973) 118–19, pl. 7. Also see T. Dreliossi-Herakleidou, 'Παλαιά και νέα ευρήματα προ τον συνοικισμού από την πόλή της Ρόδου,' in the forthcoming Proceedings of the International Congress 'City of Rhodes: From its Foundation to the Turkish Conquest (1523)', Rhodes 1993.

23. Rhodes Museum without inv. no.; J. A. Papapostolou, 'Eine Peplophoros in Rhodos', *AA* 86 (1971) 19–29.

24. Rhodes Museum inv. no. 13638; G. Jacopi, 'La stele di Crito e Timarista', *ClRh* IV (1929–30) 36–42, figs 10–11, pl. I, Pfuhl-Möbius I, 22–3 (46) with full bibliographical references, pl. 12.

25. C. Karouzos, Ῥόδος. Ἱστορία, μνημεία, τέχνη (2nd edn, Athens 1973) 40.

26. Cos Museum without inv. no.; Laurenzi (1938) 80; L. Morricone, 'Frammento di bassorilievo arcaico da Coo', *BdA* 44 (1959) 1–5 and fig. on p. 3; Berger 120–21, fig. 140; Hiller (1975) 158–9 (O 12), pl. 8,1; Pfuhl-Möbius I 17–18 (26), pl. 7.

27. A. Andreiomenou, *Ergon* (1992) 58–9, fig. 79.

28. Hiller (1975) 176–7 (K 9), pl. 18.1

29. Athens National Museum inv. no. 734; H. Biesantz, *Die thessalischen Grabreliefs* (Mainz 1965) 16–17 (K 26), pl. 12.

30. Koch-Harnack 97–105.

31. Some examples cited by Koch-Harnack are quite explicit: the earliest is to be found on the black-figured lekythos from Kerameikos (without inv. no.), dated to 570–560 BC, where a bearded and nude man is represented in profile to the left offering with his right hand a rooster to a youth, while with his left hand making a characteristic gesture towards the youth's genitals. *Bibl.*: *ABV* 58 (127); Haspels, *ABL* II, pl. 4,1a–1c; Koch-Harnack 65 fig. 1. On a red-figured krater fragment from Tübingen, ascribed to the Leningrad Painter and dated to about the same period as the Rhodian stele, i.e. to 470–460 BC, a nude bearded man is depicted offering a rooster to a youth whose figure has only partly survived. *Bibl.*: *ARV*² 568 (31); C. Watzinger, *Griechische Vasen in Tübingen* (Reutlingen 1924) pl. 28 (E 96); Koch-Harnack 97. On the tondo of the red-figured kylix 517 in the Ashmolean Museum a bearded man is represented offering a rooster to a youth, ΠΑΙΔΑ ΚΑΛΟΝ, by the painter of Euaichme of the Douris cycle, dated to 470 BC; the figures are fully dressed in himation but their arrangement, facing each other, as well as the characteristic staff held by the man make it quite a close iconographical parallel to our stele. *Bibl.*: *ARV*² 785 (8); *CVA* Great Britain 3 (Oxford 1) pls 3,1 and 8,1–3; Koch-Harnack 99, fig. 32. The staff is a very common attribute of the *erastes* figure as we see in another example, the red-figured pelike 134 in the Boulogne Museum of Beaux-Arts by the Tyskiewicz Painter, dated to about 470 BC: the *erastes*, a young man

(of about the same age as the one on our stele), is depicted in profile to the right wearing a himation and supporting the left part of his body on a staff while his right hand offers a rooster to the *eromenos*, a youth who accepts the present, with an open gesture: a pard, another erotic symbol, and a dog are also depicted. *Bibl.*: *ARV*² 293 (47); Koch-Harnack 109, fig. 44. Quite close to our stele is the arrangement of figures that we find on the exterior of the earlier black-figured kotyle A 479 in Paris, Louvre Museum by the Amasis Painter, dated to 550 BC: here a nude bearded man offers a hen to a nude woman, a hetaira: although the iconographical subject varies, the disposition of the opposed figures, and particularly that of their legs, as well as the slight twisting of the upper part of the hetaira's body, are reminiscent of the arrangement of the relief figures of the Rhodian stele and set a precedent for it. *Bibl.*: *ABV* 156 (80); S. Karouzou, *The Amasis Painter* (Oxford 1956) pls 12–14; Koch-Harnack 91, figs 24–5.

32. Rhodes Museum inv. no. 1350; A. Maiuri, 'La necropoli arcaica di Ialisos (Scavi del 1916 e 1922)', *ASAtene* 6–7 (1923–4) 278–9 (5), fig. 177; *ABV* 450; *CVA* Italia 9 (Rodi 1) III He 7 (5) pl. 13; also see C. Fournier-Christol, *Contribution à la connaissance des olpes attiques à figures noires de 550 à 475* (unpublished Ph.D. thesis), Université de Paris X (Nanterre 1985) I, 46 and 72, II, fig. 263.

33. K. J. Dover, *Greek Homosexuality* (London 1978) and Koch-Harnack; also see A. Lembessi, Το ἱερό του Ἑρμή καὶ τῆς ᾿Αφροδίτης στη Σύμη Βιάννου Ι. Χάλκινα Κρητικὰ τορεύματα (Athens 1985) 188–98.

34. N. Kontoleon, *Aspects de la Grèce préclassique* (Paris 1970) 1ff., fig. 2B, pls 1, 2 (1); 5, 10 (2); 21 (1); Hiller (1975) 172–4 (K 6), pl. 16, 1–2.

35. Hiller (1975) 186–8 (I 2), pl. 24. 2; also see Berger, 124–6, fig. 144.

36. Karouzos (supra n. 25) 97–8.

37. Berger *passim*.

38. Supra n. 14.

39. For the political and administrative organisation of the Rhodian state and the topographical identification of the ancient demoi of the Ialysia, see I. Papachristodoulou, Οἱ ἀρχαῖοι ῥοδιακοί δῆμοι. Ἱστορική ἐπισκόπηση – Ἡ ᾿Ιαλυσία (Athens 1989).

40. For a very short preliminary report see *ArchDelt* 39 (1984); *Chronika*, 328.

21

Ionian sculpture of the Archaic period on Dorian Rhodes

G. Kokkorou-Alevras

In 1970 the late Professor N. Kontoleon showed con-
clusively that it is not possible to connect Dorian or
Ionian art solely with the Dorian or the Ionian cities
and tribes respectively. Rather a complex of factors –
geographical vicinity, economic and political connec-
tions – played a decisive role in the formation of a
style in any given centre or school of Archaic art.[1]
The island of Rhodes, the exact date of the Dorian set-
tlement of which remains problematic,[2] provides a
good example of this situation.

The three main city-states of the island, Lindos,
Camirus, Ialysos, flourished during the Archaic period
as a result of the island's favourable position on the
ancient trading routes. A minimal amount of sculp-
ture was produced in these centres, and it was not
homogeneous in style. Nonetheless, in the art of the
coroplast and in the gold jewellery of the seventh cen-
tury BC a Rhodian Daedalic style has been recognised
and considered to be one of the most important of
the period. Also a group at least of sixth-century BC
terracottas and plastic vases has been ascribed to
Rhodes.[3] It is remarkable, but by no means unique,
that an Archaic city-state, with an important produc-
tion of small-scale sculpture in terracotta and bronze,
contributed little in the way of monumental stone
sculpture, at least to judge from what survives. One
reason must surely have been the lack of marble; but
the attitude of the citizens of these city-states towards
expensive votive offerings will also have played a part.[4]

Today a total of eighteen Archaic sculptural works
in stone, mostly in the round and monumental in char-
acter, have been found in Rhodes. The addition of two
more Archaic statues, one found on the island, the
other (fragmentary) acquired through trade, gives us
the opportunity to discuss some parameters of the early
sculpture of Rhodes.

The upper torso of the kouros we present here (Figs
263–6), was in the possession of a man who assures
us that he himself found it in his courtyard in the old
town of Rhodes. If this is so, the statue will have been
transported there from elsewhere, perhaps from one of
the Rhodian sanctuaries in later times, as the town
was founded in 408 BC.

The torso, at present displayed in the Castle of
Rhodes, is of white, extremely fine-grained and com-
pact marble. It has been analysed at the laboratory of
Archaeometry of N.C.S.R. 'Demokritos' and shown to
come from Asia Minor.[5] The surface is very well pre-
served with only a few scratches and breaks. An
incrustation of yellow-beige colour adheres to the left
shoulder, the outer side of the left breast muscle and
the back. A large piece of the chest from the breast
down has split away, as if sliced off. The head is miss-
ing, and the neck has broken along a semicircular line
at the upper part of the back, along the line of the
hair, of which there are some barely discernible traces
(Fig. 264). This shows that the hair descended only to
the top of the back, and has broken away. Both arms
are missing from below the shoulder, the left having
broken off higher than the right. Preserved in the bro-
ken surface of the right arm is part of a thin, cylin-
drical, iron dowel (Fig. 265). In the corresponding
position on the left, part of a dowel hole with bits of
oxidised iron is visible (Fig. 266). Marks on the broken
outer surface of this arm appear to have been made
much later, most probably in an effort to remove the
iron dowel, traces of which remain in place.

There is another rectangular dowel hole
(1.5×0.8 cm and 2.5 cm deep) on the left side of the
torso under the broken arm. It seems that both arms
have been damaged and subsequently repaired, or pos-
sibly replaced in antiquity. It was probably in con-
nection with this repair that a stone tenon with a
rectangular dowel hole was added to support the
reconstructed left arm. A piecing technique, however,[6]
is most unlikely to have been used for the arms, as
fine point marks are to be found only above the rec-
tangular hole beneath the left armpit and not under-
neath or around it. These were probably made in the
course of working down the remains of the broken left
arm. If, instead, the left arm had originally been pieced,
the whole surface of the left side should have been
worked in the same way and by the same tools.
Moreover the right arm, preserved in greater length
than the left, does not show a corresponding dowel
hole under the armpit, as should have been the case,

had both arms been originally constructed by the piecing technique.

A drill hole in the lower part of the right shoulder-blade (Fig. 264) is problematical. A bronze attribute may well have been attached here, but of what sort it is difficult to say. If this were for attaching the end of a helmet crest, the head of the man must have been turned strongly to his left. Yet there is no indication of such a turn. The slight asymmetries between both halves of the figure are common enough in Archaic statues. They are known as the 'λανθάνουσα κίνησῃ' or 'latent movement'.[7]

Another possibility is that a quiver strap was attached here. In this case the figure could be identified as Herakles or the god Apollo, for example, though no Archaic free-standing statue or statuette of either figure with a quiver strap is known to me. The additional support of the broken left arm as well as the slanting direction of the dowel hole in it, suggest that the left arm was somewhat bent, holding an attribute which could be a bronze bow. Be that as it may, the preservation of our torso does not allow any firm conclusions about its identification. The only certainty is that an Archaic athletic man in the basic schema of a kouros was represented.[8]

A first look at this torso gives the impression of a late Archaic sculpture. This is due to the soft and delicate modelling of some of the anatomical details, such as the breasts and the clavicles, and to the fine quality of the marble epidermis of the torso. Nonetheless, the derivation from a squarish block of marble is quite clear in our torso. The sides are flat, chest and back slightly modelled, and the vertebral column is rendered as a thin, straight, sharp groove. The shoulder-blades swell slightly, each outlined by a shallow semicircular groove. Even the finely modelled clavicles are suggested by upward-slanting ridges, as is the canon in G. M. A. Richter's Early and Ripe Archaic groups down to the Melos Group of kouroi (555–540 BC). All the characteristics of our kouros are common to kouroi of this last group and point to a date of about this same time. Later kouroi, such as the Anavyssos, Kea and Ptoon 12 statues, all three dated by most scholars around 530 BC, show much more organically rendered and plastically advanced forms.[9] A more profound chronological difference becomes apparent when we compare the Rhodian torso with the Acropolis torso no. 692, attributed to an Ionian workshop and dated around 590 BC.[10]

The swelling of the deltoids of our torso is slight, and the wide groove of the median line and the end of the sternal notch are just discernible. In general we may say that the anatomical details of the Rhodian torso are gently modelled so that one form flows organically into the other; only occasionally are they separated in linear fashion by grooves, ridges or lines. The skeleton of the figure beneath the flesh is nowhere intimated.

This sort of modelling is characteristic of the kouroi of the East Ionian workshops. Comparison of the Rhodian upper torso with the Samian Leukios kouros[11] or the torso of an offering-bearer of the same school[12] shows that they share the same main stylistic traits. Yet a number of differences – a narrower waist, sloping shoulders, more pronounced rendering of the vertebral column, a fleshier looking body modelled with greater emphasis on the third dimension seen in the Leukios kouros, or the more pronounced and harder rendering of anatomical details on the offering-bearer – make an attribution of the Rhodian upper torso to the Samian school less probable.

The exceedingly fine finish of the surface of the Rhodian kouros is, moreover, not to be found on any of the Samian statues. This last feature is a notable characteristic of the upper torso of a kouros in the Boston Museum of Fine Arts, attributed by some scholars to Paros.[13] Closer comparison, however, of the Parian upper torso in Boston with the Rhodian one, reveals a superior quality of workmanship, an even finer finishing of the surface, more delicate modelling and the pronounced homogeneity of the Parian statue.

Closer to the Rhodian upper torso are the two offering-bearers from the Milesian school of sculpture, namely the well-known figure in Berlin (Figs 267–8)[14] and the more recently published figure in the Miletus Museum.[15] Even the rendering of the vertebral column and the clavicles, and the way the hair hangs down only to the beginning of the back are common in all three figures. The stylistic affinity of these sculptures is so marked that not only are they similar in general appearance, but also in the very good quality of the surface finishing. Indeed, the probability that the Rhodian upper torso comes from a Milesian workshop seems to be a strong one.[16] Chronologically they should be close together, the offering-bearer in Berlin of 550–540 BC being the earliest, the offering-bearer in the Miletus Museum a few years later, around 540–530 BC. The Rhodian upper torso with its more advanced plasticity may be dated to around 530 BC.

The second sculpture to be presented here is the head of a kore (Figs 270–73). It was found in Asia Minor, and reached Rhodes through the trade route via Syme.[17] It comes from an under-life-sized statue. Marble analysis showed that this marble could have come either from Paros or from Proconnesus. The surface of the head is extremely weathered and the back

has a reddish colour due to oxidisation. Although the back of the head as well as the main features are battered, their outline is recognisable and the style can be made out.

The face is oval with a minimal depth. A veil is tightly drawn over the mass of the hair, which swells beneath the cloth over both temples. Beneath the veil a flat fillet, 2 cm wide, is bound tightly around the forehead, hiding the hair. The forehead is low, the nose was short, wide and triangular. The eyes are set horizontally, and were wide open and plastically rendered. This is evident particularly in their inner corners. That the mouth was smiling is apparent from the shallow, almost horizontal groove preserved between it and the right cheek. The chin is short and rounded. The head has a high dome which is cylindrical at the back. A stephane, 2 cm wide, encircles the hair and curves to pass over the ears; it is clearly visible through the thin, soft and transparent veil, as are the ears beneath it (Figs 272–3).

The head of this kore belongs to the very well-known East Ionian type of veiled women, standing or sitting. The type is known from heads, headless statues and relief sculpture found in Samos and in Asia Minor.[18] The preserved heads of this type are almost all under life-size and are datable in the third quarter of the sixth century BC.[19]

The differences between the head on Rhodes and the Samian heads of this same type are quite obvious. A kore head only 8 cm high from the Heraion in Samos, for example, has a spherical skull, round face, small fleshy cheeks and fluid, almost *sfumato* forms (Fig. 269).[20] The same features characterise a head in a private collection attributed to Samos.[21] Another example is provided by a Samian head (11 cm high) from the Heraion, datable around 540 BC and once in Berlin with inv. no. 1874, but now lost.[22] It has a cubic, bulky head and full face with facial forms that are clearly differentiated from each other, giving the impression almost of being swollen. The eyes are set obliquely, and the mouth has a broad smile. Chronologically these figures must be very close to each other.

The veiled head from Rhodes seems most closely related to the Milesian head from the temple of Athena, now in Berlin (Figs 274–5). This is the only one approaching life-size.[23] Both wear the veil in similar fashion, but the Milesian head has no stephane. Similar also is the swelling of the hair over the temples and the oval of the face, though the Rhodian face looks a little wider. The Milesian head, however, is of better quality, with fluid, almost taut facial forms, smoothness of the skin and of the covered hair, and a metal-

lic linear quality in the rendering of the facial features, with typically long and narrow East Ionian eyes. The head in Rhodes is characterised instead by a soft, spongy modelling of the flesh, which makes the skeleton beneath it disappear, a full rendering of the cheeks, rounded eyes, and a feeling of the softness and flexibility of the hair beneath the veil. Finally, quite different also is the form of the skull in side view, the skull of the head in Rhodes being longer and deeper than the Milesian one, and the face shallower (Fig. 275).

For Miletus, however, more than one stylistic trend and consequently workshop of sculpture is attested.[24] A workshop fond of flat planes, taut flesh and linear rendering of forms is responsible for the veiled head of the Athena temple, the relief figures of the sculptured columns of the Apollo temple at Didyma,[25] the head of a kouros in the British Museum (inv. no. B 283) from Didyma,[26] both offering-bearers that we have seen,[27] and some other less well-known sculptures. The style of another Milesian workshop is characterised by a spherical skull, rounded outline of the face, full and fleshy cheeks, and a softer and richer modelling of the figures, as seen in the kore head from Miletus (Fig. 276) now in Berlin (inv. no. 1634),[28] a little kouros head in Miletus[29] and some other Milesian sculpture put together by P. Hommel.[30] This stylistic group seems to be derived from the earlier statue of the 'Branchidae' with head preserved, in the British Museum (inv. no. B 271).[31] As the head in Rhodes has some common traits with this second Milesian stylistic trend – the softly modelled, fleshy facial features and rounded outline of the face – it could be regarded as a Milesian work. We cannot exclude, however, the provenance of the veiled head in Rhodes from one of the less well-known workshops of Ionia under Milesian influence.

The head in Rhodes is datable to approximately the same time as the Milesian head from the Athena temple in Berlin and the heads in Samos, that is the third quarter of the sixth century BC. The generally spherical conception of the head, the correct positioning of the ears, the lips that curve upwards to meet at the corners, the representation of the lachrymal caruncle at the inner corner of the eye, and the fact that there is no longer a pronounced curve of the upper eyelid, make this dating most probable.[32] This is indeed the date that has been proposed independently by most scholars for the Samian and the Milesian heads. Moreover, a comparison of the Rhodian head with the fragmentary kore heads in relief on the Croesus columns of the Artemisium of Ephesus in the British Museum, dated around 550,[33] shows a little progress in naturalistic rendering of the anatomical details on

the Rhodian head. This supports a date around 540–530 BC.

The problem of interpretation of the veiled Ionian korai remains. For B. Freyer-Schauenburg the veil is simply a local fashion. U. Kron believes that no general rule is valid for interpreting the function of such statues; for the meaning of each single statue, only context, attributes, extant inscriptions and other such concrete evidence can provide a clue.[34]

A simple statistical estimation of the kore type of Samos and Asia Minor, where the veiled type appears exclusively, shows that out of a total number of at least seventy-six statues and statuettes in marble and ivory, fifty-four are veiled and twenty-two unveiled.[35] All are dedications, most (but by no means all) coming from sanctuaries of female deities. There are very few statues of this type for which the provenance is unknown. In addition, some representations of the type occur on architectural reliefs. It is significant that all the East Ionian statues of seated women wear the veil over their head.[36] The seated pose in ancient Greek and Anatolian art signifies dignity, authority and political, social or sacred power.[37] The goddess Cybele is characterised as a divinity in East Ionian art by wearing the veil,[38] which is also the typical head covering for the nuptial rite from ancient times to the present. It appears that all the veiled female figures of East Ionia represent persons of special rank and position. This could be of divine or matronal character. The woman could also have held a special position as priestess, or as a maiden devoted to the service of a goddess.[39]

Both of the new fragmentary statues presented here are important for the history of East Ionian Greek sculpture. Most relevant, however, for the history of early Rhodian sculpture is the kouros fragment found in Rhodes. Both marble and quality bespeak an imported work of art, among the six sculptural works known until now to have been commissioned by Rhodians in important Greek centres of sculpture. These are the fragmentary head of an under-life-size kouros of very good workmanship and of Milesian rather than Samian style, datable around the middle of the sixth century BC,[40] two kouros torsos, one attributed to Naxos and dated around 550–540,[41] the other to Paros[42] and dated around 540 BC, and finally the very fragmentary kouros head (Fig. 277), tentatively attributed by L. Laurenzi to the Naxian kouros torso, mentioned above.[43] I believe, however, with G. Gualandi,[44] that we are dealing instead with an East Ionian origin, on the basis of the fleshy cheeks, rounded chin, cylindrical beads of hair, and the cylindrical and pointed hair locks hanging vertically over the forehead, a feature unusual in Naxian work. The

long, shallow face and high domed skull might argue in favour of a North Ionian workshop, the Chiot for example, but no kouros head has been found on Chios to verify such an attribution.[45]

There are, moreover, in Rhodes sculptural works in limestone and in local or imported marble which, as already postulated in their publications, most likely come from a local workshop with more or less obvious Ionian influence in typology and style.[46] Particularly noteworthy is a kore head found in Camirus and now in the British Museum (Figs 278–9).[47] It seems akin to the kore head from Lindos, now in the National Museum in Copenhagen (Figs 280–81),[48] despite the chronological difference between them (the Lindos head is dated around 560, the Camirus head around 540 BC). F. N. Pryce considered the head in the British Museum to be an Ionian Cycladic work. There are, however, differences between both Rhodian heads and Ionian Cycladic korai heads which argue against this attribution. Both Rhodian heads show a hard, full, almost swollen, rendering of the fleshy parts of the face, allowing the underlying skeleton to show (note the bony chin and flattish forehead), linear outlines of the facial features, and extremely slanting eyes. All these characteristics and the greater depth, seen in the side view on both the Rhodian heads, are quite different from the delicate modelling of a kore head in the Paros Museum (inv. no. 164), datable around 540–530 BC,[49] although the outline of the face and the rendering of the hair are not unrelated. A comparison of the Rhodian head with the Parian kore of the Siphnian treasury in Delphi[50] shows these same differences. The features of the Rhodian heads seem instead to be closer to those of the ex-Cnidian head in Delphi, attributed by some scholars to the Chiot school of sculpture,[51] and clearly of superior workmanship. Indeed a Rhodian origin under Chiot influence appears most likely for both these Rhodian heads.[52]

It is difficult to pronounce on the style of two fragmentary korai in Istanbul. One is a miserably preserved fragment of a kore head, the other the lower part of a late Archaic kore. Both share common traits with analogous statues from other Archaic schools of sculpture.[53]

This brief presentation of 'Ionicising' Rhodian sculpture makes it clear that over half of the Archaic sculpture found in Rhodes comes from a local workshop showing typological and stylistic affinity mainly with the Ionian style of a number of schools of sculpture.[54] The remaining pieces are imports from Cycladic and East Ionian centres which have obviously influenced the typology and style of the local marble

statuary. Rhodian sculpture was thus not dependent on any one school, but rather on a number of different centres. It is therefore not surprising to find that the style of local Rhodian sculpture varies rather than being entirely homogeneous.[55]

Returning to our original question about the Dorian or Ionian character of Rhodian sculpture, it should be emphasised that the only similarity between Rhodian sculpture and that produced in the Dorian centres of Archaic Greece is the scarcity of monumental statuary in all of them.[56] Compared with the Ionian city-states of Archaic Greece, the Dorian areas show a tendency to avoid expensive votive statuary. Recent suggestions may yield a possible interpretation of this phenomenon.[57]

ACKNOWLEDGEMENTS

This paper is dedicated to the memory of Charis Kantzia. I would like to thank M. Caskey for revising my English text.

NOTES

1. On Dorian Thera, for example, local sculpture in an Ionian Parian style was created, on Melos the sculpture is Naxian in style, and in the Peloponnesian Epidaurus art was obviously influenced by the Ionian art of the Cyclades: N. Kontoleon, *Aspects de la Grèce préclassique* (Paris 1970) 73–87; G. Kokkorou-Alevras, *Archaische naxische Plastik* (Diss. Univ. of Munich 1975) 48–52; V. Lambrinoudakis, Δείγματα μνημειώδους ἀρχαϊκῆς πλαστικῆς ἀπὸ τὴν Ἐπίδαυρο', in *Stele: Festschrift for N. Kontoleon* (Athens 1980) 484–6.

2. *RE* Suppl. V (1931) 731–840, *s.v.* 'Rhodes' (H. v. Gaertringen); *EAA* VI (1965) *s.v.* 'Rodi' (L. Morricone); C. I. Karouzou, Ῥόδος (Athens 1973) 16; G. Constantino-poulos, Ἀρχαία Ῥόδος (Athens 1986) 31–2; I. Papachristodoulou, Ἀρχαῖοι Ῥοδιακοὶ Δῆμοι (Athens 1989) 32.

3. R. J. H. Jenkins, *Dedalica: A Study of Dorian Plastic Art in the Seventh Century* (Cambridge 1936) 1, 28–9, 44, 48–9, 57–8; P. Knoblauch, *Studien zur archaisch-griechischen Tonbildnerei in Kreta, Rhodos, Athen und Böotien* (Diss. Univ. of Halle 1937) 131–63. R. Higgins, *Catalogue of the Terracottas in the Department of Greek and Roman Antiquities, British Museum* I (London 1954) 19–61, pls 1–21; II (London 1959) 9–31, pls 1–21; id., *Greek Terracottas* (London 1967) 28–32, pls 11–12; J. Ducat, *Les Vases plastiques rhodiens archaïques en terre cuite* (1966) 27, 46–7, 83, 172–3; F. Croissant in *Les Protomés féminines archaïques* (Paris 1983) 181–9 recognises instead a Cnidian but no Rhodian group of terracotta protomes.

4. About this phenomenon in Laconia, Crete and the entire Peloponnese see: B. S. Ridgway, *The Archaic Style in Greek Sculpture* (Princeton, New Jersey 1977) 47–8; G. Kokkorou-Alevras, Τμήμα Κούρου από το Τουρκολέκα Μεγαλόπολεως', in O. Palagia and W. Coulson (eds), *Sculpture from Arcadia and Laconia* (Oxford 1993) 22, and especially G. Parisaki, Ο τύπος του κούρου ερμηνεία και λειτουργία στην Ηπειρωτική και Νησιωτική Ελλάδα (Diss. Univ. of Athens 1995) 429–91 with a thorough discussion of the problem.

5. Inv. no. BE 2527–BE 161. I am grateful to the Director of the Archaeometrical Laboratory of 'Demokritos' Dr Y. Maniatis and to the Physicist Mrs K. Polykreti for the marble analysis of this torso. The results show that the marble came from Asia Minor although not from Proconnesus, Aphrodisias or the Usak quarries.

6. The possibility that the piecing technique was used was suggested by Dr I. Jenkins during the discussion of this paper. There is a similar hole in almost the same position below the right armpit of the Megara Kouros, whose arms hang down by the sides of the body (Richter (1970) no. 92, figs 297–9). This hole has been rightly explained as an ancient repair, since there is another round hole at the same side of the body to support the right fist which has broken off. Its outline is to be seen on the battered surface of the right thigh. I thank Prof. G. Despinis for the discussion we had about the technical problems of this statue.

7. K. Rhomaios, Οἱ κέραμοι τῆς Καλυδῶνος (Athens 1951) 101–44; I. Kleemann, *Frühe Bewegung: Untersuchungen zur archaischen Form bis zum Aufkommen der Ponderation in der griechischen Kunst* I (Mainz 1984) 16–17, 63–6, 107–20.

8. For Archaic statuary of Apollo see *LIMC* II (1984) *s.v.*

'Apollon', nos 40–48 (O. Palagia). For representations of Herakles in the round see *LIMC* IV (1988) s.v. 'Herakles', nos 26–31 (J. Boardman).

9. Richter (1970) no. 136, figs 395–8; no. 144, figs 419–22; no. 145, figs 425–7; Floren 255, pl. 20, 3; 182, pl. 13, 4; 315, n. 41.

10. Richter (1970) 160, figs 464–6; H. Payne and G. Young, *Archaic Marble Sculpture from the Acropolis* (London 1936) 46, pl. 108, 1–3; W. Schuchhardt in H. Schrader (ed.), *Die archaischen Marmorbildwerke der Akropolis*, text and plates (Frankfurt am Main 1939) 195–6, no. 300, pls 118–19.

11. Richter (1970) no. 77, figs 258–60; *Samos* XI, no. 35, pls 20–22; Floren 353–4, pl. 30, 6.

12. *Samos* XI, no. 45, pls 28–9.

13. Richter (1970) no. 69, figs 230–33; A. ϑKostoglou-Despoini, *Προβλήματα τῆς Παριανῆς Πλαστικῆς τοῦ 5ου αἰ*, π. X (Diss. Univ. of Thessaloniki 1979) n. 151; Floren 254, n. 15.

14. Blümel (1963) no. 60, pls 169–76; K. Tuchelt, *Die archaischen Skulpturen von Didyma* (Berlin 1970) K 16, pl. 18; Floren 378, pl. 32, 3.

15. V. v. Graeve, 'Neue archaische Skulpturenfunde aus Milet', in *AKGrP* I 26–7, pls 8–9.

16. Virtually the same similarities but also some differences (tautly rendered flesh, and a hard linear rendering of the anatomical details), are observable between the Rhodian fragment and the kouros of Mylasa in Caria, now in the museum of Halicarnassus dated *c.* 530–520 BC and attributed to the Milesian workshop (H. P. Laubscher, 'Zwei neue Kouroi aus Kleinasien', *IstMitt* 13/14 (1963/64), 84–7, pls 40–41). Milesian traits are observable likewise in a sphinx (?) head from Halicarnassus published by B. Ashmole ('An Archaic Fragment from Halicarnassus', in *Festschrift A. Rumpf* (Cologne 1950) 5–9, pl. 1–2; G. E. Bean and J. M. Cook, 'The Halicarnassus Peninsula', *BSA* 50 (1955) 94–5).

17. Inv. no. Γ 356. H. 16 cm; gr. width 13 cm; gr. depth 13 cm: G. Constantinopoulos, 'Προσκτήματα Μουσείων Δωδεκανήσου', *ArchDelt* 25 (1970) *Chronika* 2, 528, pl. 443b.

18. See for example the headless Cheramyes' Hera (Richter (1968) no. 57, figs 183–5; Floren 342–4, pl. 30,2) or the woman represented in a small naiskos-relief found in Miletos showing the type as a whole figure (v. Graeve (supra n. 15) 21–5, fig. 1, pl. 6, 1).

19. See infra.

20. *Samos* XI, no. 17, pl. 10 (with previous references).

21. B. Freyer-Schauenburg, 'Ein samischer Mädchenkopf', in *Opus Nobile: Festschrift U. Jantzen* (Wiesbaden 1969) 42–7, pl. 9, 1–3.

22. *Samos* XI, no. 19, pl. 10 (with previous references).

23. L. Alscher, *Griechische Plastik* II. 1. *Archaik und die Wandlung zur Klassik* (Berlin 1961) 157–60, pls 46 a–c; Blümel (1963) no. 58, pls 159–61; Richter (1968) no. 95, figs 293–5; Floren 383–4, pl. 33, 2.

24. P. Hommel, 'Archaischer Jünglingskopf aus Milet', *IstMitt* 17 (1967) 115–27; V. v. Graeve, 'Archaische Plastik in Milet: Ein Beitrag zur Frage der Werkstätten und der Chronologie', *MüjB* Dritte Folge, Band XXXIV (1983) 7.

12–22; id. (supra n. 15) pl. 24; U. Muss, *Studien zur Bauplastik des archaischen Artemisions von Ephesos* (Diss. Univ. of Bonn 1983) 172.

25. Blümel (1963) no. 59 a, b, figs 162–6; Richter (1968) no. 96, 97, figs 296–7, 298–300; Floren 386, pl. 33, 3. These Milesian sculptures have been otherwise connected with some of the relief fragments of the Artemis temple at Ephesus: Muss (supra n. 24) 170–79.

26. Richter (1970) no. 128, figs 371–2; Floren 377, pl. 33,1.

27. Supra n. 14 and 15.

28. Blümel (1963) no. 57, figs 156–8; Richter (1968) no. 94, figs 291–2; Floren 383, n. 40.

29. Hommel (supra n. 24) 115–27, pls 4, 1–2; 5, 1–3.

30. Supra n. 24, 122–7. Compare for example the Milesian heads of one Milesian workshop, shown one next to the other in Richter (1968) figs 289–90, 293–5, 296–7, 298–300, with figs 291–2 of the second Milesian workshop. To the same group belongs another unpublished veiled head in Miletus museum (no. 247).

31. Tuchelt (supra n. 14) K 43, pls 40–41.

32. About the rendering of structural and anatomical details in the subsequent phases of Archaic sculpture see Richter (1968) 18.

33. Richter (1968) no. 82, figs 263–5; no. 83, fig. 266; no. 84, figs 267–8. Floren 392, pl. 34.8, 9.

34. Freyer-Schauenburg (supra n. 21) 46–7; U. Kron, 'Eine archaische Kore aus dem Heraion von Samos', in *AKGrP*, 56, n. 30.

35. Cf. Freyer-Schauenburg (supra n. 21). Terracottas, being so numerous, are not counted.

36. For these statues see Tuchelt (supra n. 14) K 45, pl. 42, 1–2; K 60, pl. 59, 1–3; 60, 1–2; 62, 3; pp. 127–8, nos 87–101. In addition see v. Graeve (supra n. 24) 7–8, nos 1–2, figs 3–5, 7, 9–10, 15, 17–18. The recently found statues of seated women in the sacred way of Didyma are not well enough preserved to determine whether or not they had an epiblema: K. Tuchelt, 'Ausgrabungen in Didyma', *AA* (1989) 181–7, figs 42–57.

37. H. Möbius, 'Über Form und Bedeutung der sitzenden Gestalt in der Kunst des Orients und der Griechen', *AM* 41 (1916) 119–218, especially p. 200.

38. F. Naumann, *Die Ikonographie der Kybele in der phrygischen und der griechischen Kunst*, IstMitt-BII 28 (Tübingen 1983), 116, pls 12–19.

39. Note also that the bride *par excellence*, the goddess Hera, is shown veiled in the nuptial ritual and that the motif of lifting the veil, the motif of anakalypsis in ancient Greek art, has also a special and multiple meaning: see literature in Kron (supra n. 34) and *LIMC* IV (1988) s.v. 'Hera', 683 (Hieros Gamos) (A. Kossatz-Deissmann).

40. Inv. no. 13650. Richter (1970) no. 126, fig. 376; J. Gr. Pedley, *Greek Sculpture of the Archaic Period: The Island Workshops* (Mainz 1976) 51, no. 44: Samian work; R. Özgan, *Untersuchungen zur archaischen Plastik Ioniens* (Diss. Univ. of Bonn 1978) 36–7, fig. 10b: Milesian typological traits; Floren 329, pl. 31, 3: local work after Samian prototype.

41. Richter (1970) no. 124, figs 365–8; Floren 329; G. Kokkorou-Alewras, 'Archaische Naxische Bildhauerei', *AntP*

24 (1993) 75, 114 K 77.

42. Richter (1970) no. 154, figs 447–9; Floren 329 n. 11, 12.

43. Inv. no. E 338; Richter (1970) no. 124, n. 32.

44. Gualandi 37, fig. 1.

45. Similar locks above the forehead, but more elaborately worked, are to be seen on the Chiot kore Acropolis no. 682 (Richter (1968) no. 116, figs 364–7; Floren 338, pl. 29, 5), on the heads of Apollo and Artemis in the east and north Siphnian frieze at Delphi, attributed to Paros, and on the head of the Leukippide in the south frieze of the same building, attributed to a north Ionian workshop: C. Picard and P. De la Coste-Messelière, *Les Trésors 'Ioniques', FdD* IV, ii (Paris 1928) 107, 124, pls (hors-texte) X, XII. Similar locks occur also on some other kouroi of different workshops: Richter (1970) no. 139, figs 402–3; no. 140, fig. 415, 146, figs 430–31.

46. For these sculptures see: G. Kokkorou-Alewras, 'Neue archäische Skulpturen im archäologischen Museum von Rhodos', in *AKGrP* 79–91 with previous discussions.

47. Inv. no. B 326: F. N. Pryce, *British Museum: Catalogue of Sculpture* I, Part I (London 1928) B 326; Kleemann (supra n. 7) 17, pl. 3.

48. Inv. no. 12199. Richter (1968) no. 77, figs 244–7; H. Cahn, *Knidos: Die Münzen des sechsten und des fünften Jahrhunderts v. Chr.* (Berlin 1970) 116, fig. 15; Croissant (supra n. 3) 184; Floren 329.

49. N. S. Zapheiropoulos, 'Ἀρχαϊκές Κόρες τῆς Πάρου', in *AKGrP* 105, pl. 39.

50. Richter (1968) no. 104, figs 317–20; Floren 166, 173, pl. 10, 6; 11, 6.

51. Richter (1968) no. 86, figs 271–4; Floren 338. But see Cahn (supra n. 48).

52. It should be borne in mind that the kouros head on Rhodes, which we have already discussed, could be Chiot. According to Herodotus (2. 178) the Chians together with other Greeks and the Rhodians had a common sanctuary in Naucratis. About Chiot pottery on Rhodes, though limited in amount, see A. A. Lemos, *Archaic Pottery of Chios: The Decorated Styles* (Oxford 1991) 206.

53. V. Poulsen, 'Catalogue des sculptures', in E. Dyggve, *Le Sanctuaire d'Athana Lindia et l'architecture lindienne, Lindos* III, ii (Berlin and Copenhagen 1960) 541–2, no. 2, fig. 8, 9; 556, no. 13, fig. 29, 30; J. D. Kondis, *Lindos* III: Dyggve, 'Le Sanctuaire d'Athana Lindia', *Gnomon* 35 (1963) 404.

54. Compare Croissant (supra n. 3) 185. On the contrary Cahn (supra n. 48) 116–20, sees in the sculpture of Cnidus and Rhodes an island-Doric character. He does not, however, mention any concrete parallel to the statues he is discussing from any Doric centre (workshop). The marble lion of Cnidus in Berlin (Cahn (supra n. 48) figs 10, 11) shows clear typological, stylistic and chronological affinity to the Naxian lions on Delos (about these lions recently: G. Kokkorou-Alevras, 'Die Entstehungszeit der naxischen Delos-Löwen und anderer Tierskulpturen der Archaik', *AntK* 36 (1993) 91–102, pls 21–6) rather than to the Peloponnesian Kythera lion 97–8, pl. 23, 2. The style of the kore torso from the Cnidian treasury in Delphi furthermore can be termed Cycladic-Ionian (Richter (1968) no. 87, fig. 282; Cahn (supra n. 48) 112–16, fig. 14; Floren, 332), like the style of the entire building (G. Gruben, *Die Tempel der Griechen* (3rd edn, Berlin 1980) 82–5). See also J.-F. Bommelaer and D. Laroche, *Guide de Delphes*, Ecole française d'Athènes. Sites et Monuments VII (Paris 1991): Le Musée, 38–40; Le Site, 141–3.

55. Kokkorou-Alewras (supra n. 46) 90.

56. Cf. Croissant (supra n. 3) 185, who also finds no relationship between Rhodian and Peloponnesian art.

57. For literature, see supra n. 4.

Bibliography

The following works are referred to in the Notes in summary form only. Many other references are given in the Notes in full. Abbreviations used in the Notes and in this Bibliography for series and periodicals follow the conventions of the *American Journal of Archaeology*.

Add. Ms.
British Library, *Catalogue of Additional Manuscripts*

Akarca
A. Akarca, *Les Monnaies grecques de Mylasa* (Paris 1959)

AKGrP
H. Kyrieleis (ed.) *Archaische und klassische griechische Plastik* I–II (Mainz 1986)

Akurgal
E. Akurgal, *Ancient Civilizations and Ruins of Turkey* (Istanbul 1973)

Angiolillo
S. Angiolillo, 'La città di Iasos e la sua scultura', in *Iasos di Caria: Convegno di studi sui progetti e lavori di restauro: 30 April 1994* (in preparation)

ARV²
J. D. Beazley, *Attic Red-figure Vase-painters* (2nd edn, Oxford 1963)

Ashmole (1994)
D. Kurtz (ed.), *Bernard Ashmole 1894–1988: An Autobiography* (Oxford 1994)

Berger
E. Berger, *Das Baslerartzrelief: Studien zum griechischen Grab- und Votivrelief um 500 v. Chr. und zur vorhippokratischen Medezin* (Basel 1970)

Berti
F. Berti, 'Iasos di Caria', in F. Berti et al., *Arslantepe, Hierapolis, Iasos, Kyme: Scavi archeologici italiani in Turchia* (Venice 1993) 188–247

Beschi
L. Beschi, *I bronzetti romani di Montorio veronese*, Memorie Istituto Veneto di Scienze, Lettere ed Arti, Classe di Scienze Morali e Lettere XXXIII (Venice 1962)

Bieber (1961)
M. Bieber, *The Sculpture of the Hellenistic Age* (2nd edn, New York 1961)

Bieber (1977)
M. Bieber, *Ancient Copies* (New York 1977)

Biliotti
A. Biliotti, 'Diary of the Excavations on the Site of the Mausoleum in 1865', British Museum, Department of Greek and Roman Antiquities, Biliotti Papers

Birkenhead
Sheila Smith, Countess of Birkenhead, *Illustrious Friends: The Story of Joseph Severn and his Son Arthur* (London 1965)

Blümel (1928)
C. Blümel, *Die griechischen Skulpturen des fünften und vierten Jahrhunderts v. Chr.: Katalog der antiken Skulpturen im Berliner Museum* III (Berlin 1928)

Blümel (1931)
C. Blümel, *Römische Kopien griechischer Skulpturen des fünften Jahrhunderts v. Chr.: Katalog der Sammlung antiken Skulpturen in Berliner Museen* IV (Berlin 1931)

Blümel (1963)
C. Blümel, *Die archaisch griechischen Skulpturen der Staatlichen Museen zu Berlin* (Berlin 1963)

Blümel (1985)
W. Blümel, *Die Inschriften von Iasos* (Bonn 1985)

BMCS
A. H. Smith, *A Catalogue of Sculpture in the Department of Greek and Roman Antiquities*, British Museum, 3 vols (London 1892–1904)

Boardman et al.
J. Boardman, O. Palagia and S. Woodford, s.v. 'Herakles', *LIMC* IV (1988) 728–838

Burford (1969)
A. Burford, *The Greek Temple Builders at Epidauros* (Liverpool 1969)

Bruchmann
C. F. H. Bruchmann, *Epitheta deorum quae apud poetas Graecos leguntur*, in Roscher VII, suppl. 1 (Lipsiae 1893)

Carter, *Priene*
J. C. Carter, *The Sculpture from the Sanctuary of Athena Polias at Priene*, Committee of the Society of Antiquaries of London Research Report XLII (London 1983)

Cook (1925)
A. B. Cook, *Zeus: A Study in Ancient Religion* (Cambridge 1925)

Cook (1989)
B. F. Cook, 'The Sculptors of the Mausoleum Friezes', in T. Linders and P. Hellström (eds), *Architecture and Society in Hecatomnid Caria: Proceedings of the Uppsala Symposium 1987* (Uppsala 1989) 31–42

Corso, *Prassitele*
A. Corso, *Prassitele: Fonti Epigraphiche e Letterarie – Vita e Opere*, 3 vols (Rome 1988–91)

Curtius
L. Curtius, 'Redeat Narratio', *MdI* 4 (1951) 10–34

DarSag
C. Daremberg and E. Saglio, *Dictionnaire des antiquités grecques et romaines* (Paris 1875)

Dentzer
M. Dentzer, *Le Motif du banquet couché dans le Proche-Orient et le monde grec du VIIe au IVe siècle avant J.-C.* (Rome 1982)

Dickson
W. K. Dickson, *The Life of Major-General Sir Robert Murdoch Smith* (Edinburgh and London 1901)

Dispatches (1858)
C. T. Newton, *Papers Respecting the Excavations at Budrum*, being his official dispatches to the British Foreign Office (1858)

Dispatches (1859)
C. T. Newton, *Further Papers Respecting the Excavations at Budrum and Cnidus* (London 1859)

DNB
Dictionary of National Biography

Donaldson
T. L. Donaldson, 'The Temple of Apollo Epicurius at Bassae, near Phigalia, and other Antiquities . . .', in C. R. Cockerell et al., Supplement to the Antiquities of Athens by James Stuart, FRS, FSA and Nicholas Revett IV (2nd edn, London 1830)

Essays
C. T. Newton, Essays on Art and Archaeology (London 1880)

Fitton
J. L. Fitton, 'Charles Newton and the Discovery of the Greek Bronze Age', in C. Morris (ed.), Klados: Essays in Honour of J. N. Coldstream, BICS Suppl. 63 (London 1995) 73–8

Fleischer (1973)
R. Fleischer, Artemis von Ephesos und verwandte Kultstatuen aus Anatolien und Syrien (Leiden 1973)

Fleischer (1983)
R. Fleischer, Der Klagefrauensarkophag aus Sidon (Tübingen 1983)

Floren
W. Fuchs and J. Floren, Die griechische Plastik, I, Die geometrische und archaische Plastik (by J. Floren) (Munich 1987)

Fraser
P. M. Fraser, Rhodian Funerary Monuments (Oxford 1977)

Gardner
E. Gardner, 'Sir Charles Newton, K.C.B.', BSA I (1894–5) 67–77

Goulaki-Voutira et al.
A. Goulaki-Voutira, A. Moustaka and U. Grote, s.v. 'Nike', LIMC VI (1992) 850–904

Gualandi
G. Gualandi, 'Sculture di Rodi', ASAtene n.s. 38 (1976) 7–259

Gulaki
A. Gulaki, Klassische und klassizistische Nikedarstellung (Bonn 1981)

Harrison
E. B. Harrison, The Athenian Agora XI, Archaic and Archaistic Sculpture (Princeton 1965)

HCB
C. T. Newton with R. P. Pullan, A History of Discoveries at Halicarnassus, Cnidus, and Branchidae, 3 vols (London 1862)

Hellström and Thieme
P. Hellström and T. Thieme, Labraunda: Swedish Excavations and Researches, I.3, The Temple of Zeus (Stockholm 1982)

Herzog
R. Herzog, 'Vorläufiger Bericht über die archäologische Expedition auf der Insel Kos im Jahre 1902', AA (1903) 1–13, 186–99

Herzog and Schazmann
R. Herzog and P. Schazmann, Kos I, Asklepieion (Berlin 1932)

Hiller (1970)
H. Hiller, 'Zur Herkunft der Stele', in Berger, 49–60

Hiller (1975)
H. Hiller, Ionische Grabreliefs der ersten Hälfte des 5. Jahrhunderts v. Chr. (Tübingen 1975)

Hoepfner and Schwandner
W. Hoepfner and E.-L. Schwandner, Haus und Stadt im klassischen Griechenland (Munich 1986)

Höghammar
K. Höghammar, Sculpture and Society: A Study of the Connection between the Free-standing Sculpture and Society on Kos in the Hellenistic and Augustan Periods (Uppsala 1993)

Horn
R. Horn, Stehende weibliche Gewandstatuen in der hellenistischen Plastik RM-EH 2 (1931)

Hornblower
S. Hornblower, Mausolus (Oxford 1982)

Imhoof-Blumer and Gardner (1885)
F. Imhoof-Blumer and P. Gardner, 'Numismatic Commentary on Pausanias II', JHS 6 (1885) 50ff.

Imhoof-Blumer and Gardner (1886)
F. Imhoof-Blumer and P. Gardner, 'Numismatic Commentary on Pausanias II', JHS 7 (1886) 57ff.

Isager (1994)
J. Isager (ed.), Hekatomnid Caria and the Ionian Renaissance (Odense 1994)

Jebb
R. C. Jebb, 'Sir C. T. Newton' [reprint of his memorial address] JHS 14 (1894) xlix–liv.

Jenkins (1992)
I. Jenkins, Archaeologists and Aesthetes in the Sculpture Galleries of the British Museum, 1800–1939 (London 1992)

Jenkins, Gratziu and Middleton (1989)
I. Jenkins, C. Gratziu and A. Middleton, 'Dati preliminari sulle relazioni fra patine e policromia nei fregi del Mausoleo di Alicarnasso', Atti del convegno: Le pellicole ad ossalato – origine e significato nella conservazione delle opere d'arte (Milan, 25–6 October 1989) 317–26

Jenkins, Gratziu and Middleton (1990)
I. Jenkins, C. Gratziu and A. Middleton, 'Further Research on Surface Treatments of Architectural Sculpture in London', Superfici dell'architettura, le finature: Atti del convegno di Studi (Bressanone and Padua, 26–9 June 1990) 217–24

Jenkins and Middleton (1988)
I. Jenkins and A. Middleton, 'Paint of the Parthenon Sculptures', BSA 85 (1990) 89–114

Jeppesen (1958)
K. Jeppesen, Paradeigmata: Three Mid-fourth Century Main Works of Hellenic Architecture Reconsidered (Aarhus 1958)

Jeppesen (1977)
K. Jeppesen, 'Zur Grundung und Baugeschichte des Maussolleions von Halikarnassos', IstMitt 28 (1977–8) 169–211

Jeppesen (1992)
K. Jeppesen, 'Tot operum opus: Ergebnisse der dänischen Forschungen zum Maussolleion von Halikarnass seit 1966', JDAI 107 (1992) 59–102

Jeppesen (1994)
K. Jeppesen, 'Mausoleo', s.v. 'Alicarnasso' (P. Pedersen), EAA, 2nd supplement, vol. I (Rome 1994) 165–9

Jeppesen and Luttrell
K. Jeppesen and A. Luttrell, The Mausoleum at Halikarnassos II: The Written Sources (Jutland 1986)

Jeppesen and Zahle
K. Jeppesen and J. Zahle, 'Investigations on the Site of the Mausoleum 1970/73', AJA 79 (1975) 67–79

Johannowsky
W. Johannowsky, 'Osservazioni sul teatro di Iasos e su altri teatri in Caria', ASAtene 47–8 (1969–70) 451–9

Kabus-Preisshofen (1975)
R. Kabus-Preisshofen, 'Statuettengruppe aus dem Demeter-Heiligtum bei Kyparissi auf Kos', AntPl 15 (1975) 31–64

Kabus-Preisshofen (1989)
R. Kabus-Preisshofen, Die hellenistische Plastik der Insel Kos (Berlin 1989)

Kaiser Marc Aurel
K. Stemmer (ed.), Kaiser Marc Aurel und seine Zeit: Das römische Reich im Umbruch (exh. cat., Berlin 1988)

Kantzia
C. Kantzia, 'The Sanctuary of Apollo at Alasama on Cos', ArchDelt 39 (1990) 140ff.

Klee
T. Klee, Zur Geschichte der gymnischen Agone an griechischen Festen (Leipzig and Berlin 1918)

Koch-Harnack
G. Koch-Harnack, Knabenliebe und Tiergeschenke: Ihre Bedeutung im päderastischen Erziehungssystem Athens (Berlin 1983)

Kontoleon
N. M. Kontoleon, 'An Archaic Frieze from Paros,' in *Charisterion A. Orlandos* (Athens 1965)

Korres
M. Korres, 'Vorfertigung und Fernstransport eines athenischen Grossbaus und zur Proportionierung von Säulen in der hellenistischen Architektur', in *Bauplanung und Bautheorie der Antike*, Diskussionen zur archäologischen Bauforschung 4 (Berlin 1983)

Kreikenbom
D. Kreikenbom, *Bildwerke nach Polyklet: Kopienkritische Untersuchungen zu den männlichen statuarischen Typen nach polykletischen Nachbildern* (Frankfurt 1990)

Kruse
H. J. Kruse, *Römische weibliche Gewandstatuen des zweiten Jahrhunderts n. Chr.* (Göttingen 1975)

Kyrieleis
H. Kyrieleis, *Die Bildnisse der Ptolemäer* (Berlin 1975)

Lane-Poole
S. Lane-Poole, 'Sir Charles Newton, K.C.B., D.C.L., LL.D.', *The National Review* 24 (Sept. 1894–Feb. 1895) 616–27

La Rocca
E. La Rocca, *Amazzonomachia: Le sculture rontonali del tempio di Apollo Sosiano* (Rome 1985)

Laumonier
A. Laumonier, *Les Cultes indigènes en Carie* (Paris 1958)

Laurenzi (1931)
L. Laurenzi, 'Nuovi contributi alla topographia storico-archeologica di Coo', *Historia* 5 (1931) 603–26

Laurenzi (1932a)
L. Laurenzi, 'Statue-ritratto femminili dell'Odeion di Coo', in *Monumenti di scultura del Museo Archeologico di Rodi e dell'Antiquarium di Coo (Sculture di Coo)*, ClRh v.2 (1932) 113–39

Laurenzi (1932b)
L. Laurenzi, 'Statue del Demetrio di Chiparissi', in *Monumenti di scultura del Museo Archeologico di Rodi e dell'Antiquarium di Coo (Sculture di Coo)*, ClRh v.2 (1932) 155–89

Laurenzi (1935–6)
L. Laurenzi, 'Attivita del servizio archeologico nelle isole italiane dell'Egeo nel biennio 1934–1935', *BdA* 3 (1935–6) 129–48

Laurenzi (1938)
L. Laurenzi, 'Rilievo arcaico di Coo', *ClRh* IX (1938) 73–80

Laurenzi (1955–6)
L. Laurenzi, 'Sculture inedite del Museo di Coo', *ASAtene* n.s. 17–18 (1955–6) 59–156

Levi (1967–8)
D. Levi, 'Gli scavi di Iasos', *ASAtene* 45–6 (1967–8) 537–90

Levi (1972–3)
D. Levi, 'Atti della Scuola', *ASAtene* 50–51 (1972–3) 527–30

LIMC
Lexicon Iconographicum Mythologicae Classicae (Munich and Zurich 1981–)

Linders and Hellström (1989)
T. Linders and P. Hellström (eds), *Architecture and Society in Hecatomnid Caria. Proceedings of the Uppsala Symposium 1987* (Uppsala 1989)

Linfert
A. Linfert, *Kunstzentren hellenistischer Zeit: Studien an weiblichen Gewandfiguren* (Wiesbaden 1976)

Lippold
G. Lippold, *Die Skulpturen des Vatikanischen Museums* III.2 (Berlin 1956)

Love
I. C. Love, in *The Proceedings of the xth International Congress of Archaeology: Ankara-Izmir 1973* (1978)

Maiuri
A. Maiuri, *Nuova silloge epigrafica di Rodi e Cos* (Florence 1925)

Manderscheid
H. Manderscheid, *Die Skulpturenausstattung der kaiserzeitlichen Thermenanlagen*, Monumenta Artis Romanae XV (Berlin 1981)

Mayo
M. Mayo, *Honors to Archilochos: The Parian Archilocheion* (New Brunswick and New Jersey 1973)

Mendel
G. Mendel, *Catalogue des sculptures grecques, romaines et byzantines* (Musées Impériaux Ottomans) I (1912), II (1914)

Métraux
G. P. R. Métraux, 'A New Head of Zeus from Sardis', *AJA* 75 (1971) 155–9

Migeotte
L. Migeotte, *Les Souscriptions publiques dans les cités grecques*, Hautes Etudes du Monde Gréco-Romain 17 (Quebec 1992)

Mitsos
M. Mitsos, 'Epigraphika ex Asklepieiou Epidaurou', *ArchEph* (1967) 1–28

Mitropoulou
E. Mitropoulou, *Horses' Heads and Snakes in Banquet Reliefs and their Meaning* (Athens 1976)

Morricone
L. Morricone, 'Scavi e ricerche a Coo 1935–1943', *BdA* (1950) I, 54ff.; II, 219ff.; III, 316ff.

Musée de Kos
D. Davaris, *Musée de Kos: Catalogue des objets exposés* (n.d.)

Neppi-Modona
A. Neppi-Modona, *L'isola di Coo nell'antichità classica*, Memorie dell' Istituto Storico-Archaeologico di Rodi I (1933)

Niemeier
J. P. Niemeier, *Kopien und Nachahmungen im Hellenismus* (Bonn 1985)

Nilsson
M. P. Nilsson, *The Dionysiac Mysteries of the Hellenistic and Roman Age* (Lund 1957)

Özgan
R. Özgan, 'Zwei Grabreliefs im Museum von Çanakkale', in *AKGrP* II (1986) 27–33, pls 89–90

Paribeni
E. Paribeni, *Catalogo delle sculture di Cirene: Statue e rilievi di carattere religioso* (Rome 1959)

Paton and Hicks
W. R. Paton and E. L. Hicks, *The Inscriptions of Cos* (Oxford 1891)

Pedersen (1991)
P. Pedersen, *The Maussolleion at Halikarnassos 3.1: The Maussolleion Terrace and Accessory Structures* (Aarhus 1991)

Pfuhl-Möbius
E. Pfuhl and H. Möbius, *Die ostgriechischen Grabreliefs* I (Mainz 1977), II (1979)

Pugliese Carratelli
G. Pugliese Carratelli, 'Il damos Coo di Isthmos', *ASAtene* 25–6 (1963–4) 147–202

Répertoire II
S. Reinach, *Répertoire de la statuaire grecque e romaine* II.1 (Paris 1897)

Report(s)
C. T. Newton's Reports to the Trustees of the British Museum, British Museum Archives

Richter (1966)
G. M. A. Richter, *The Furniture of the Greeks, Etruscans and Romans* (London 1966)

Richter (1968)
G. M. A. Richter, *Korai: Archaic Greek Maidens* (London 1968)

Richter (1970)
G. M. A. Richter, *Kouroi: Archaic Greek Youths* (3rd edn, London 1970)

Robert
L. Robert, 'Hellenica. XI. Inscriptions relatives à des médecins', *RPhil* 13 (1939) 163–5

Samos XI
B. Freyer-Schauenburg, *Bildwerke der archaischen Zeit und des strengen Stils, Samos* XI (Bonn 1974)

Sculpture in Stone
M. B. Comstock and C. C. Vermeule, *Sculpture in Stone: The Greek, Roman and Etruscan Collections of the Museum of Fine Arts, Boston* (Boston 1976)

Segre (1933)
M. Segre, 'The Cretan War', *RivFil* n.s. 11 (1933) 365–92

Segre (1937)
M. Segre, 'Due leggi sacre dell'Asclepieio di Coo', *RivIstArch* 6 (1937) 191ff.

Segre (1944–5)
M. Segre, 'Tituli Calymnii', *ASAtene* n.s. 6–7 (1944–5)

Segre (1993)
M. Segre, *Iscrizione di Cos*, Monografie della Scuola Archeologica di Atene e delle Missione Italiane in Oriente VI. 1–2 (Rome 1993)

Sellers
E. Sellers, 'Sir Charles Newton', *RA* 3rd series, 25 (1894) 273–81

Sherwin-White
S. M. Sherwin-White, *Ancient Cos: An Historical Study from the Dorian Settlement to the Imperial Period* (Göttingen 1978)

Siebert
G. Siebert, *LIMC* v.1 (1990) 285–387, s.v. 'Hermes'

Stampolidis (1982)
N. Stampolidis, 'Kallimachos Alexandreus Agonothetisas', *AAA* 15 (1982) 297–310

Stampolidis (1987)
N. Stampolidis, 'The Altar of Dionysos on Cos: A Contribution to the Study of Hellenistic Sculpture and Architecture', *ArchDelt* 34 (1987) 2nd edn

Stuart Jones
H. Stuart Jones, *A Catalogue of the Ancient Sculpture Preserved in the Municipal Collections of Rome: The Sculptures of the Palazzo dei Conservatori* (Oxford 1912)

TD
C. T. Newton, *Travels and Discoveries in the Levant*, 2 vols (London 1865)

Thönges-Stringaris
R. N. Thönges-Stringaris, 'Das griechischer Totenmahl', *AM* 80 (1965) 1–99

Todisco (1993)
L. Todisco, *Scultura greca del IV secolo* (Milan 1993)

TrGF
B. Shell (ed.), *Tragicorum Graecorum Fragmenta* I (2nd edn, Göttingen 1986)

Waywell (1978)
G. B. Waywell, *The Free-standing Sculptures of the Mausoleum at Halicarnassus in the British Museum* (London 1978)

Waywell (1988)
G. B. Waywell, 'The Mausoleum at Halicarnassus', in P. A. Clayton and M. J. Price, *The Seven Wonders of the Ancient World* (London and New York 1988) 100–123

Waywell (1990)
G. B. Waywell, 'The Scylla Monument from Bargylia: Its Sculptural Remains', *Akten des XIII Internationalen Kongress fur Klassische Archäologie, Berlin 1988* (Mainz 1990)

Waywell (1993)
G. B. Waywell, 'The Ada, Zeus and Idreus Relief from Tegea', in O. Palagia and W. Coulson (eds), *Sculpture from Arcadia and Laconia* (Oxford 1993)

Williams and Ogden
D. Williams and J. Ogden, *Greek Gold* (London 1994)

Wood, *Ephesus*
J. T. Wood, *Discoveries at Ephesus* (London 1877)

Yalouris (1992)
N. Yalouris, 'Die Skulpturen des Asklepiostempels in Epidauros', *AntPl* 21 (1992)

Zanker
P. Zanker, *Klassizistische Statuen: Studien zur Veränderung des Kunstgeschmacks in der römischen Kaiserzeit* (Mainz 1974)

Zapheiropoulou
Ph. Zapheiropoulou, *Delos – A Guide* (Athens 1983)

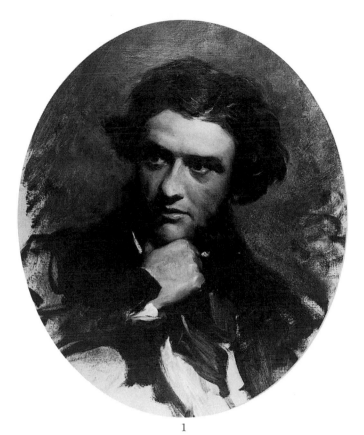

1

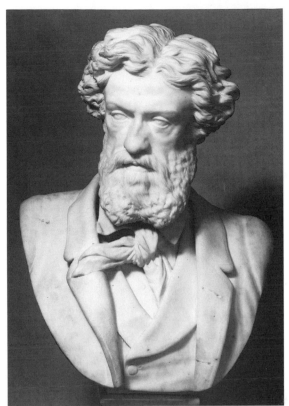

2

3

Ceremony of removing a piece of sculpture, in the British Museum

4

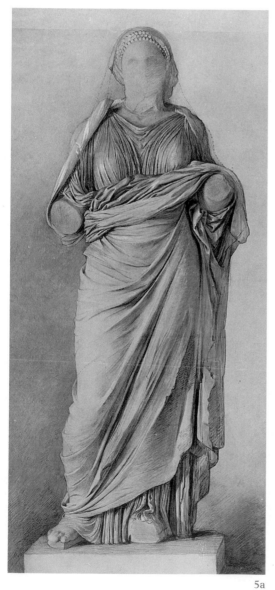

5a

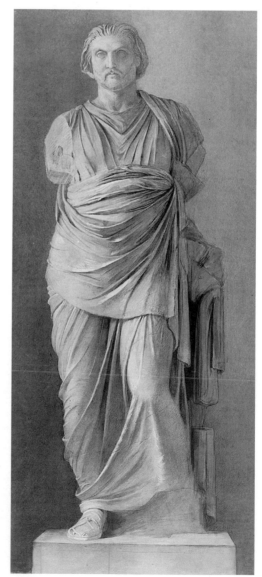

5b

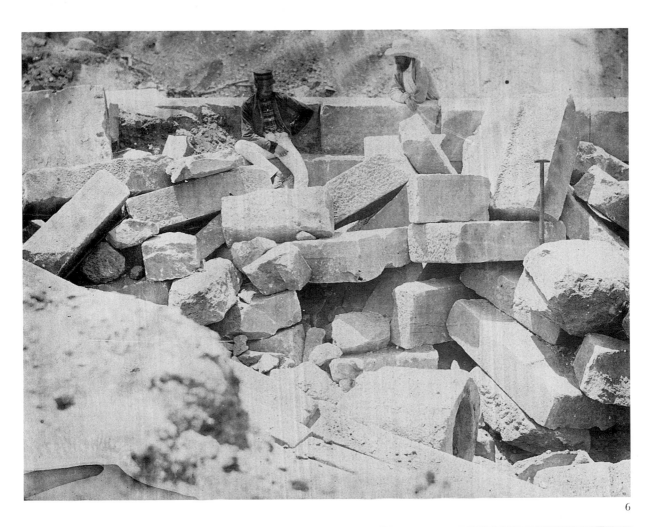

6

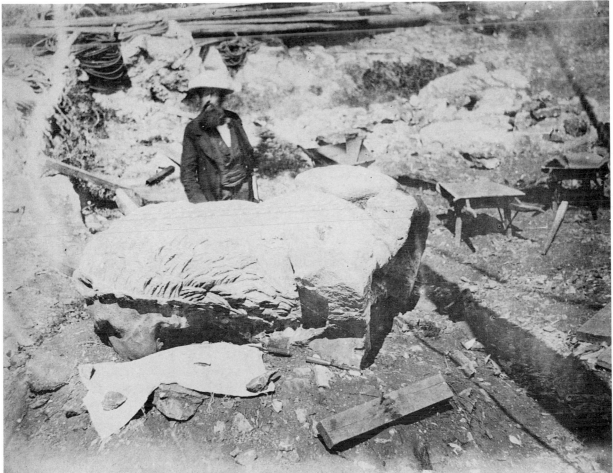

7

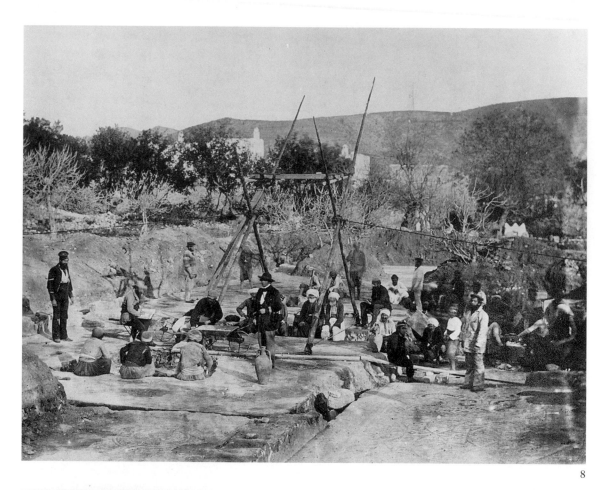

8

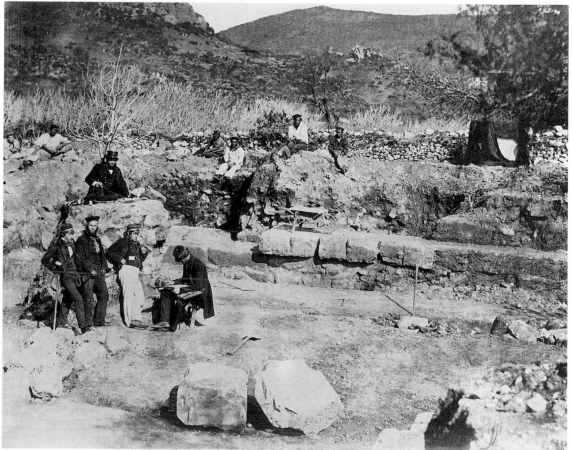

9

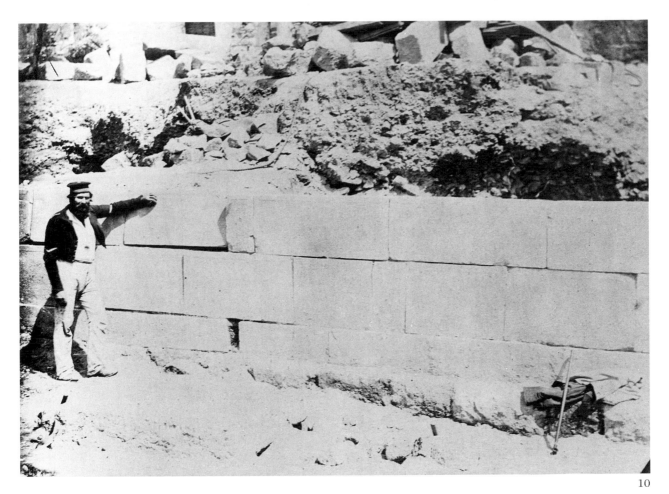

10

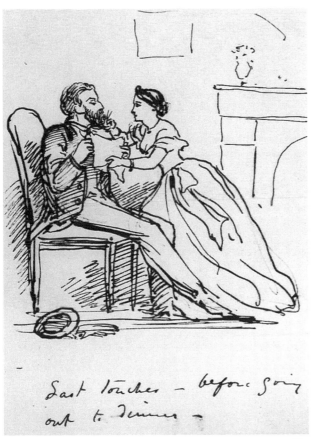

Last touches — before going
out to dinner —

11a

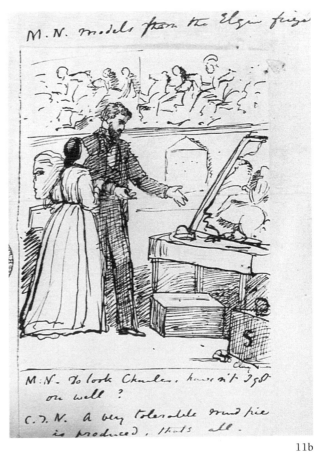

M.N. models from the Elgin frieze

M.N. To look Charles, haven't I got
on well?

C.I.N. A very tolerable mud pie
is produced, that's all.

11b

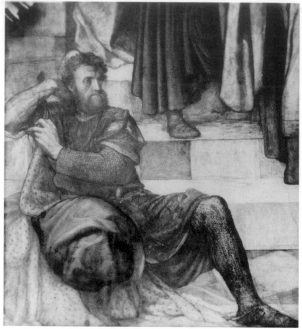

12

13

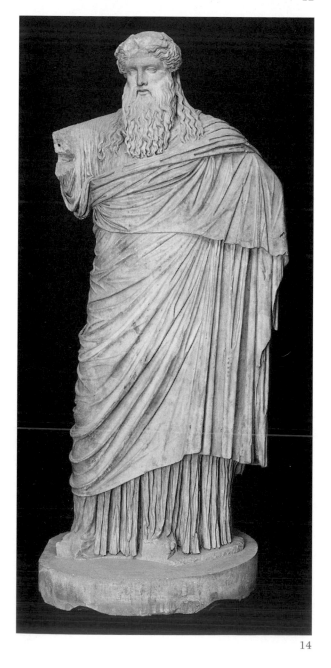

14

15

16

17

18

19

20

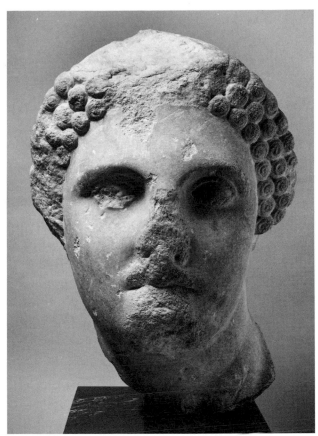

21

22

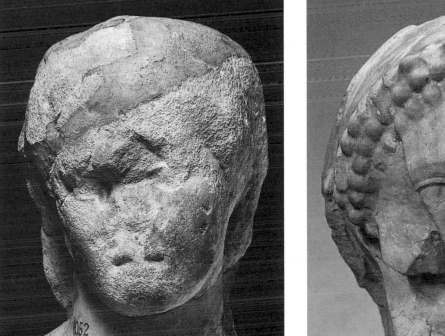

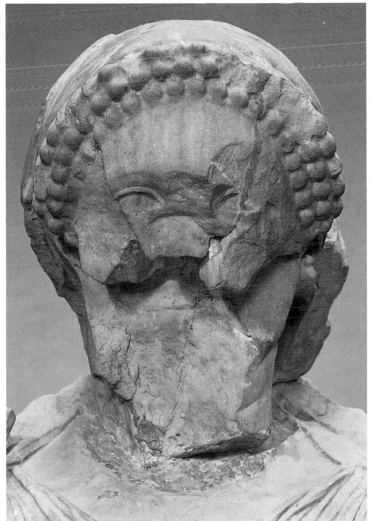

23

24

25

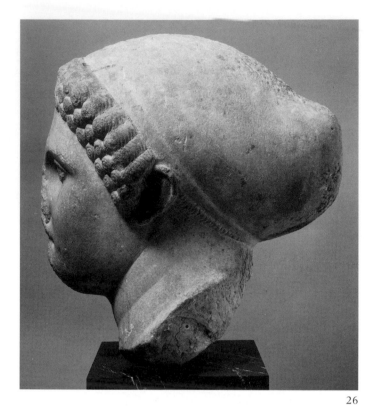

26

27

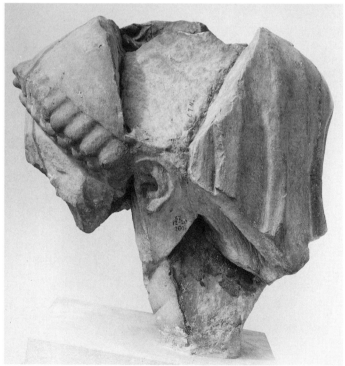

28

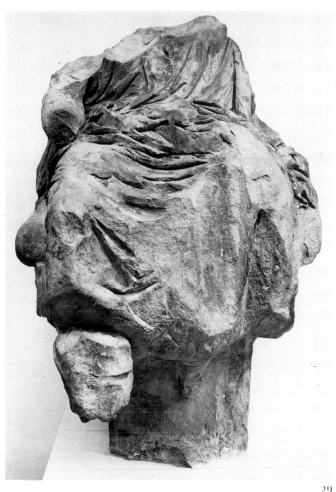

29

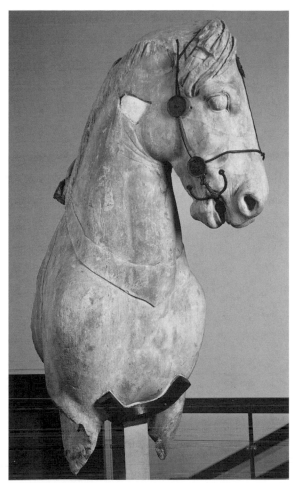

30

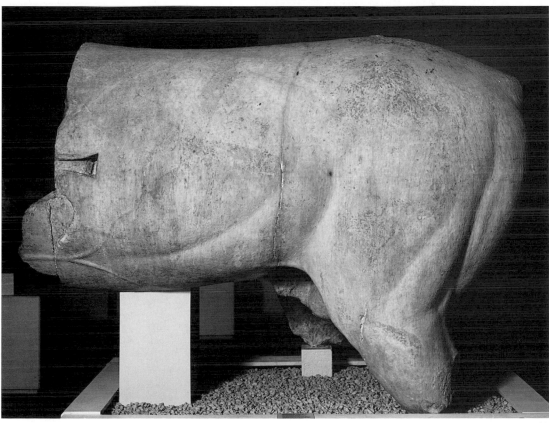

31

32

33

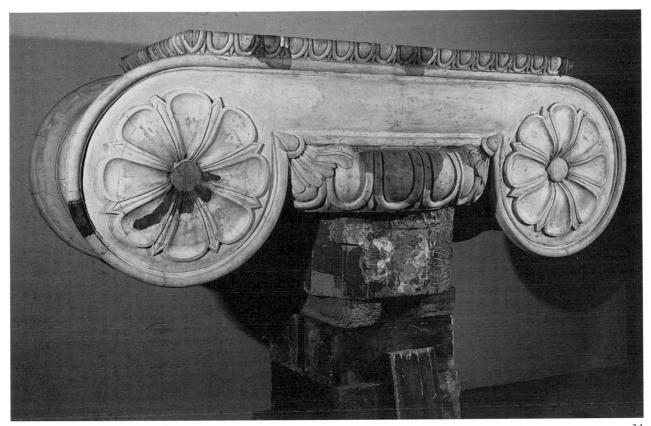

34

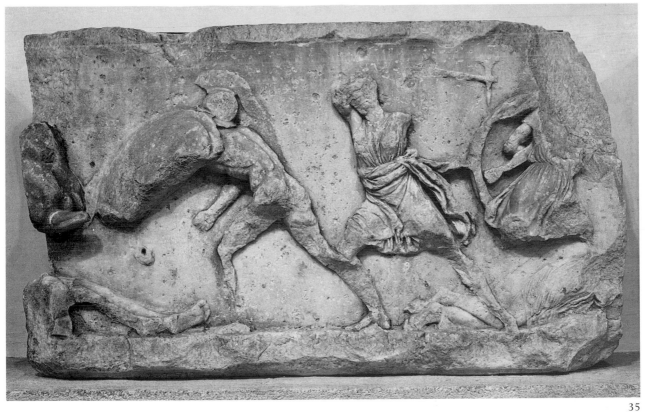

35

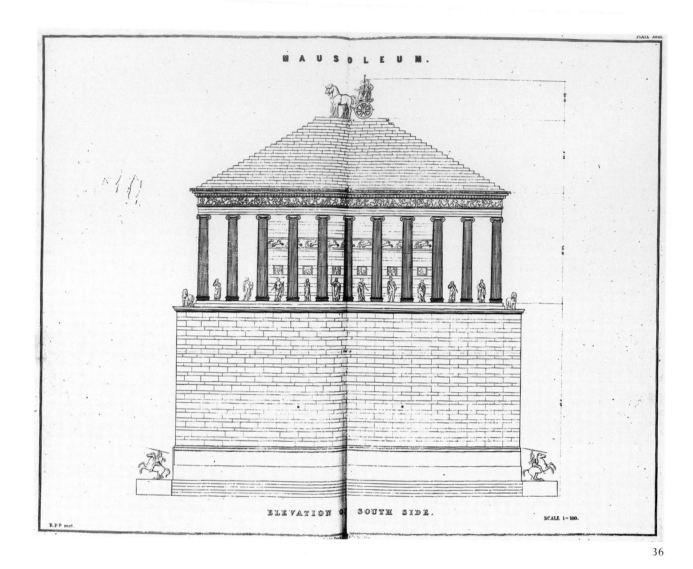

MAUSOLEUM.

ELEVATION OF SOUTH SIDE.

SCALE 1:100.

36

SLa 1-5

0 1 2м

38a

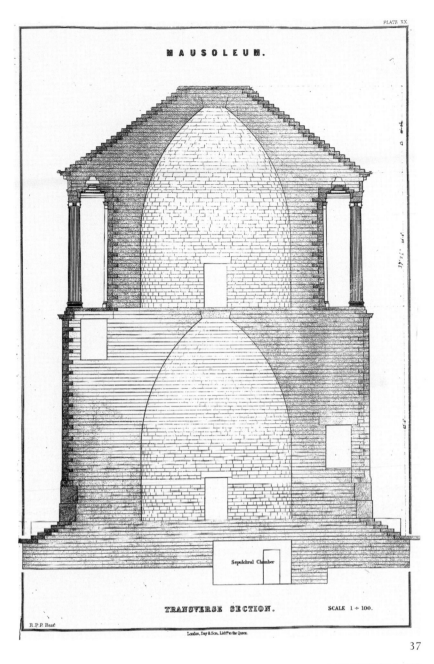

PLATE XX.

MAUSOLEUM.

Sepulchral Chamber

TRANSVERSE SECTION.

SCALE 1 + 100.

R.P.P. Reat.

London, Day & Son, Lith.rs to the Queen.

37

0 1 2 M SL a 6-12

6

9 10 11

7 8 12

7

38b

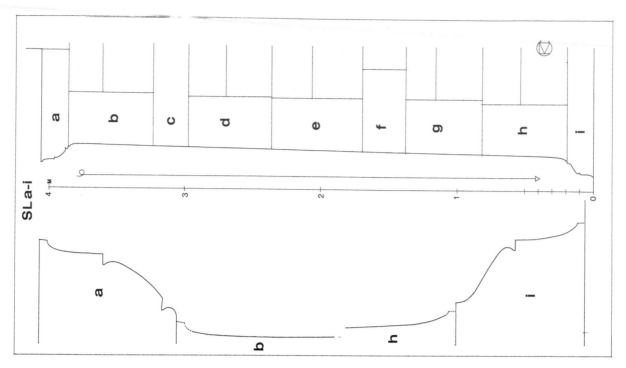

SLa-i

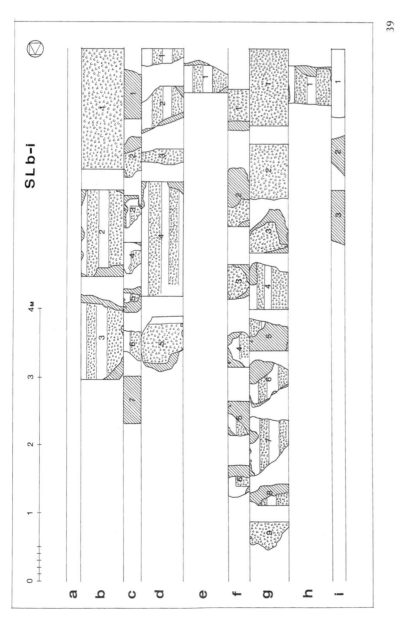

SLb-i

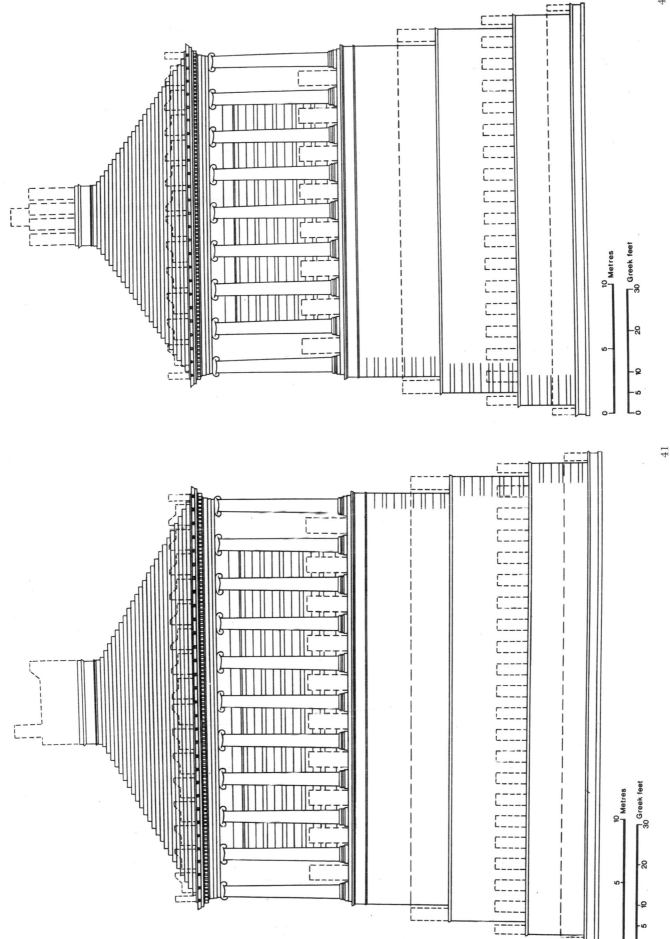

Metres

Greek feet

Metres

Greek feet

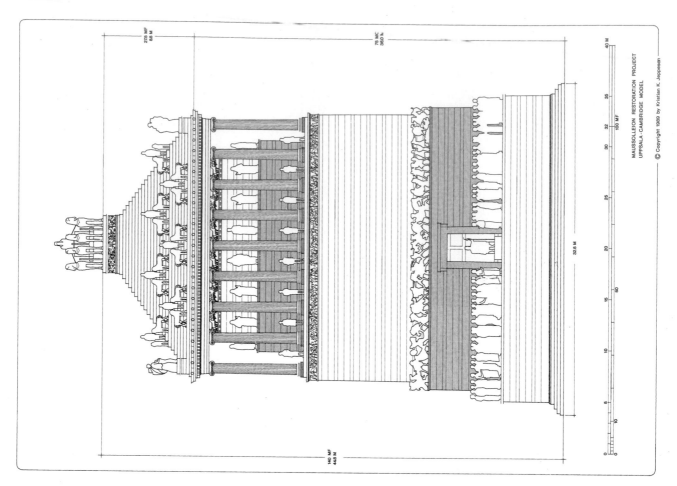

44

43

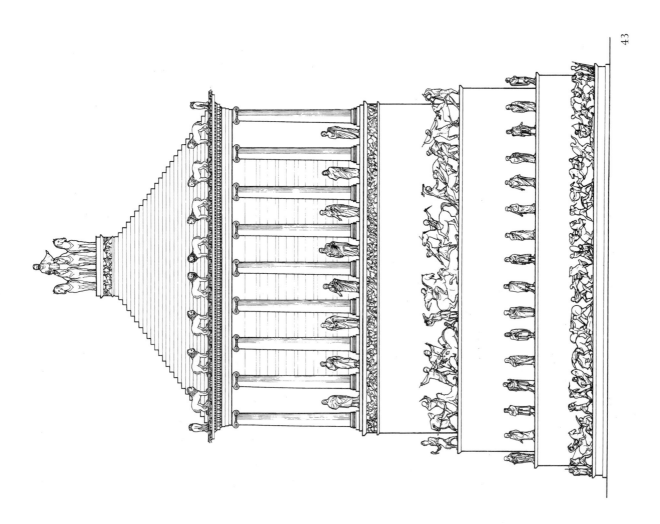

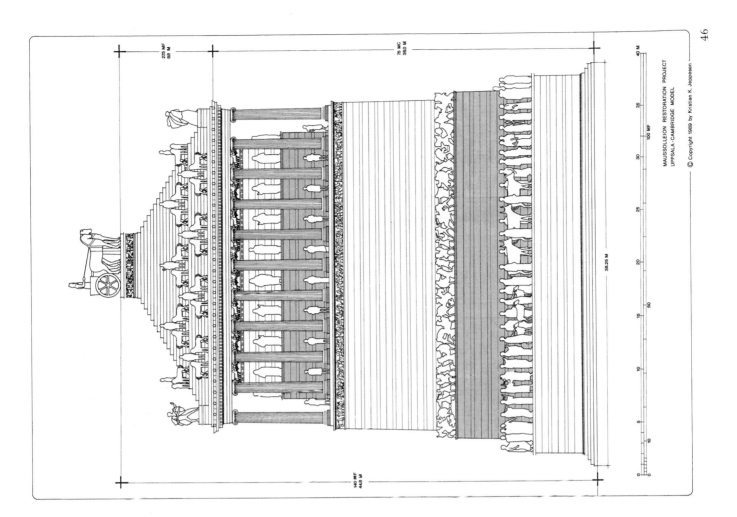

275 MF
88 M

75 MC
360 M

38.25 M

140 MF
448 M

MAUSSOLLEION RESTORATION PROJECT
UPPSALA-CAMBRIDGE MODEL

© Copyright 1989 by Kristian K. Jeppesen

40 M

100 MF

50

10

46

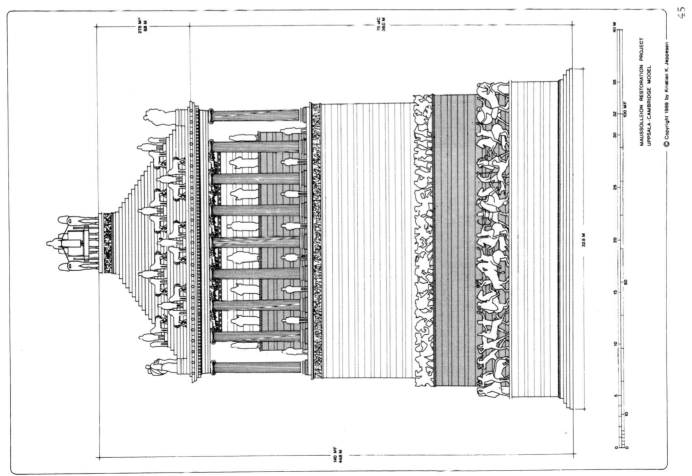

275 MF
88 M

75 MC
360 M

32.5 M

140 MF
448 M

MAUSSOLLEION RESTORATION PROJECT
UPPSALA-CAMBRIDGE MODEL

© Copyright 1989 by Kristian K. Jeppesen

40 M

100 MF

50

10

45

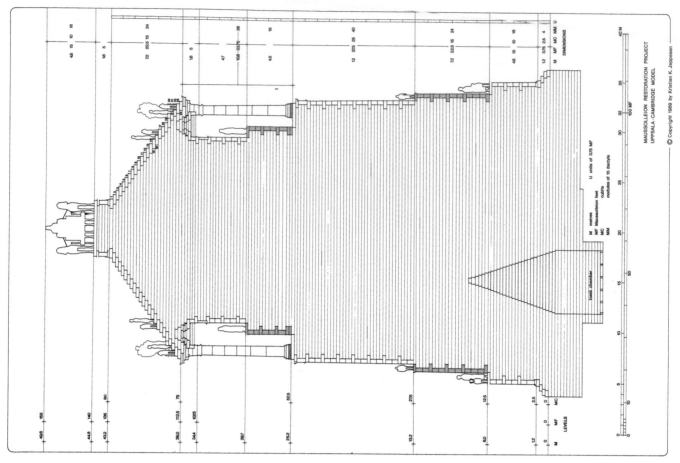

48

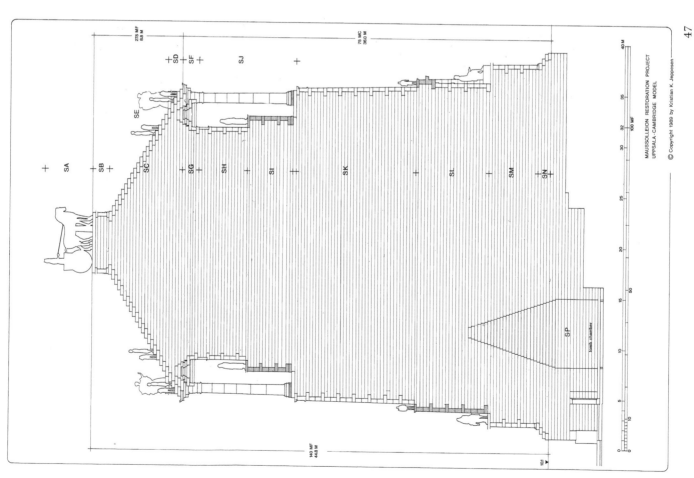

47

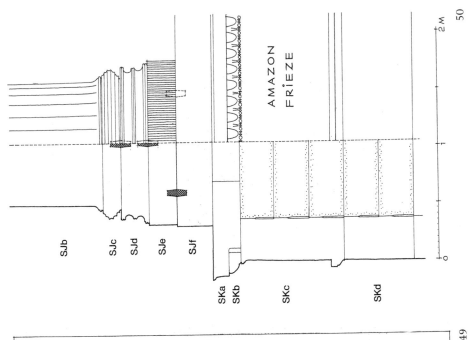

SJb

SJc

SJd

SJe

SJf

SKa
SKb

SKc

SKd

AMAZON
FRIEZE

2 M

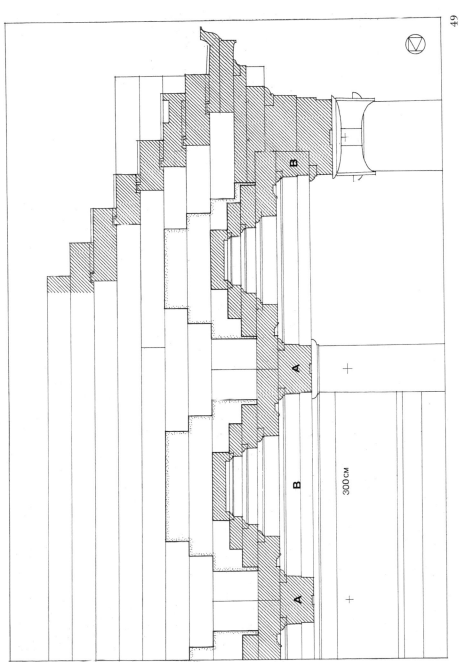

B

A

B

300 CM

A

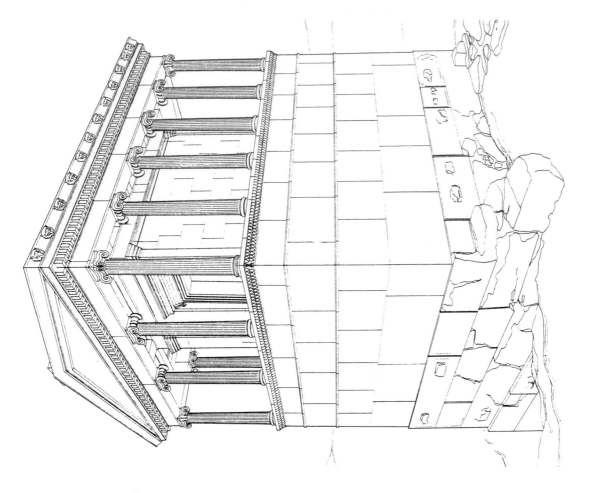

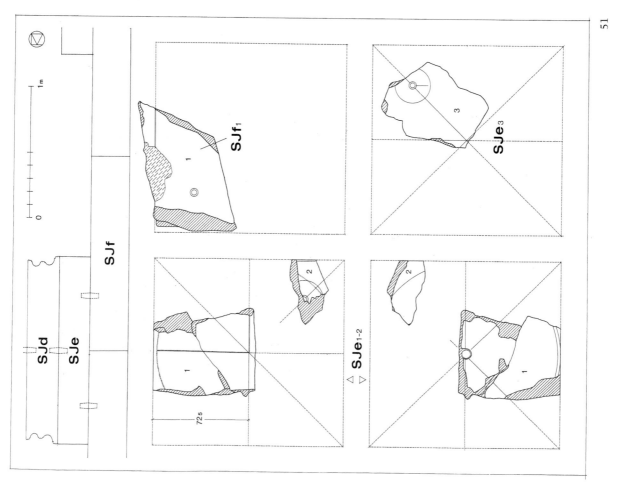

SJf₁

SJf

SJd SJe

SJe₃

3

SJe₁₋₂

72₅

1m

0

1

2

2

1

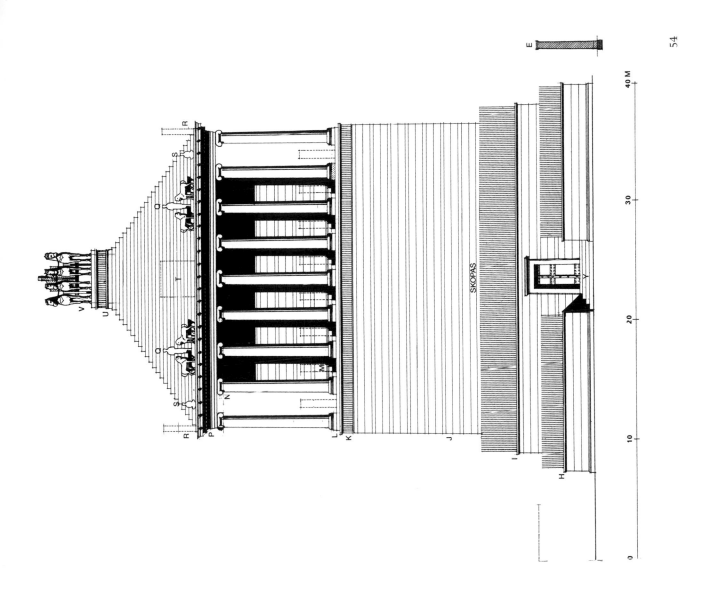

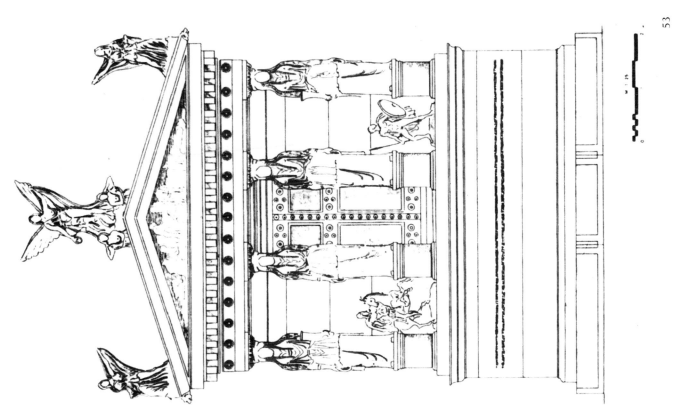

SKOPAS

54

53

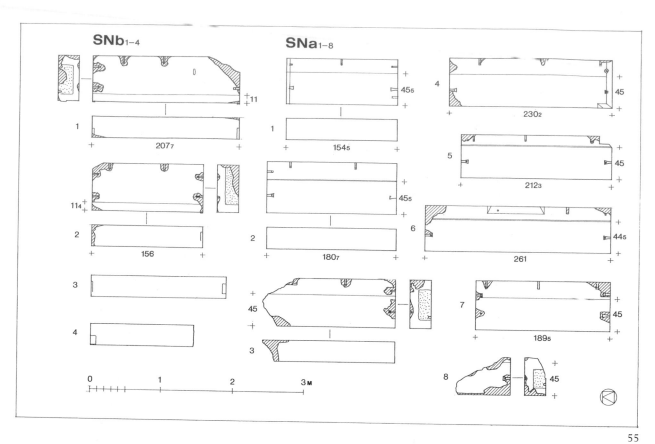

SNb₁₋₄ SNa₁₋₈

1 207₇
2 156
3
4

1 154₅
2 180₇
45
3

4 230₂
5 212₃
6 261
7 189₅
8 45

0 1 2 3 м

55

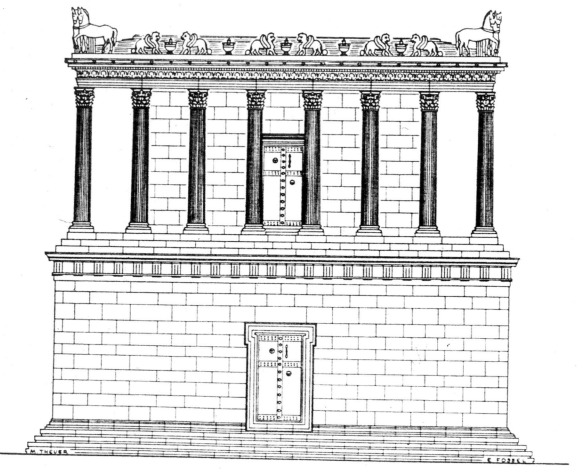

M THEUER E FOSSEL

0 10 20 30 FUSS

0 1 5 10 M

56

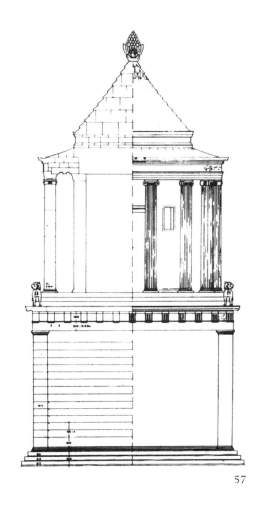

57

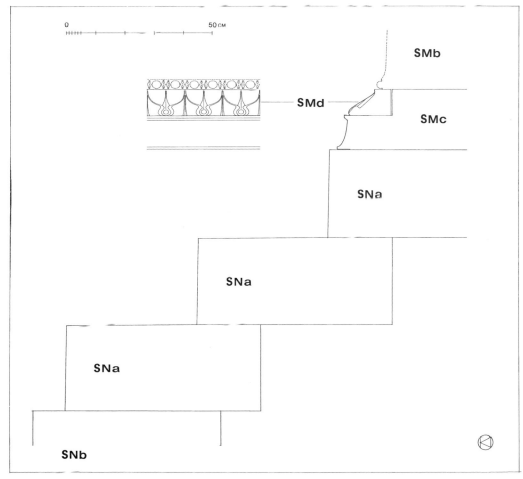

58

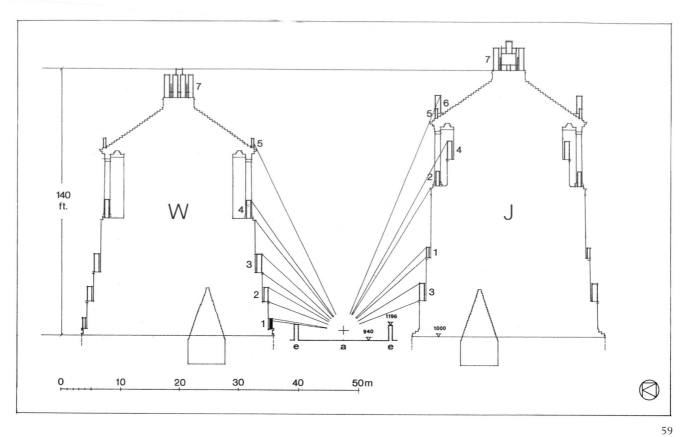

140
ft.

W

J

7

7

5

6

5

4

4

3

2

2

1

1

3

1196

940

1000

e

a

e

0 10 20 30 40 50m

59

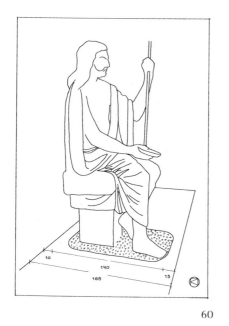

10 140 15

165

60

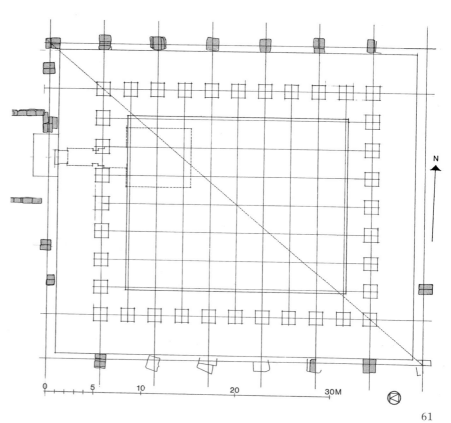

N

0 5 10 20 30M

61

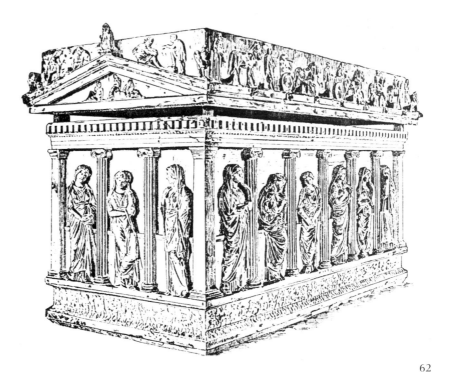

62

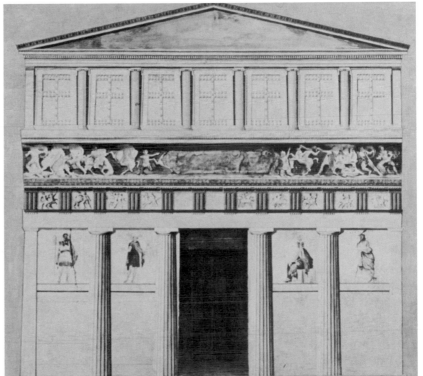

63

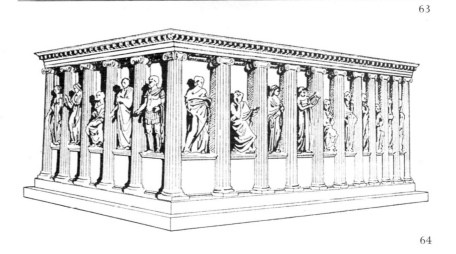

64

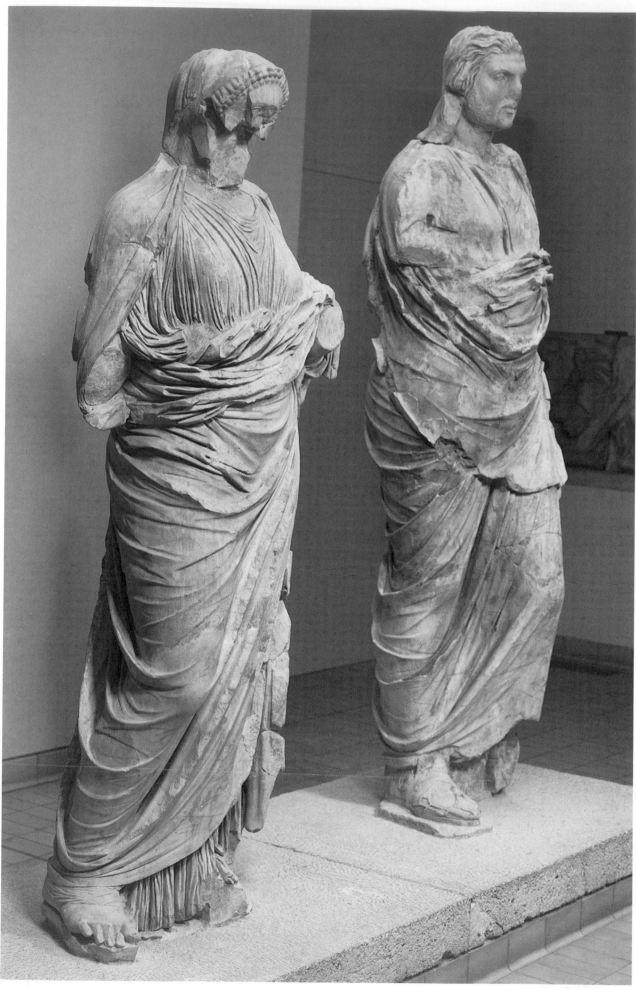

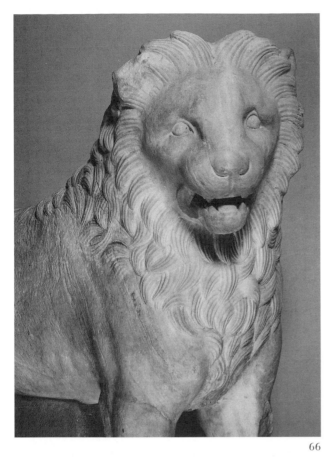

66

67

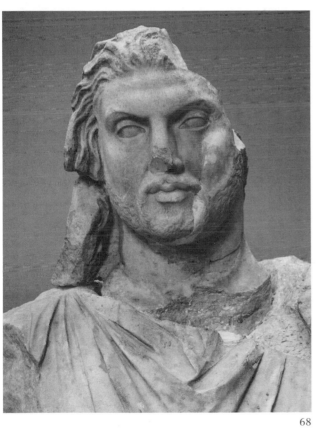

68

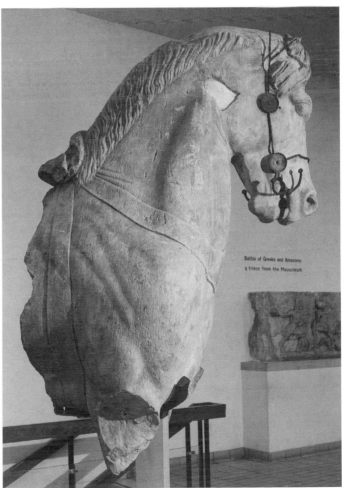

69

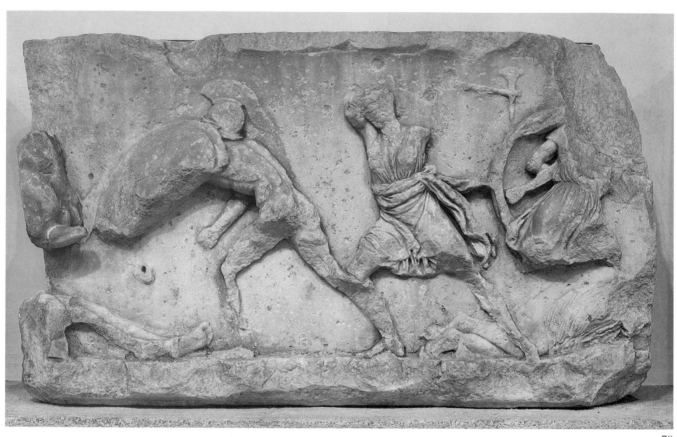

70

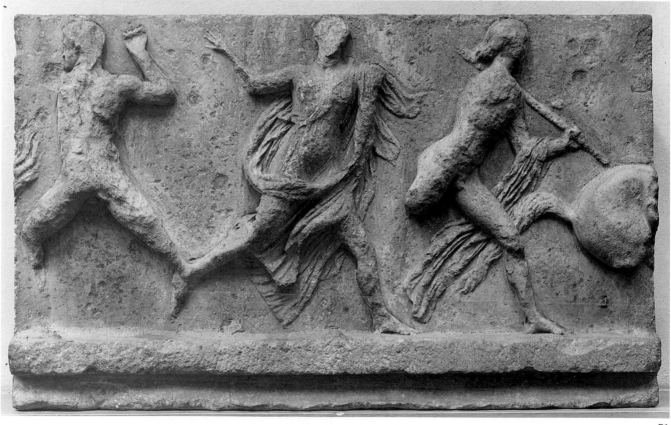

71

72

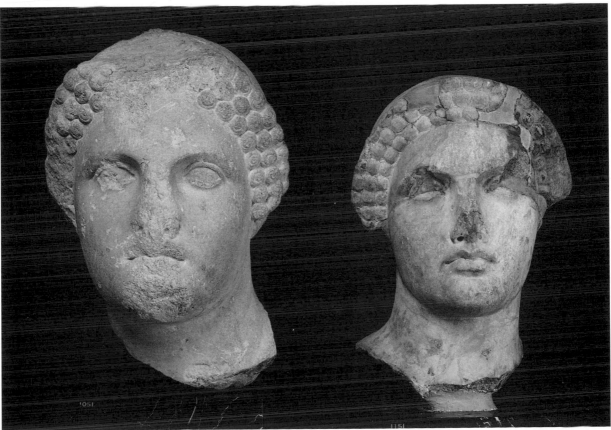

73

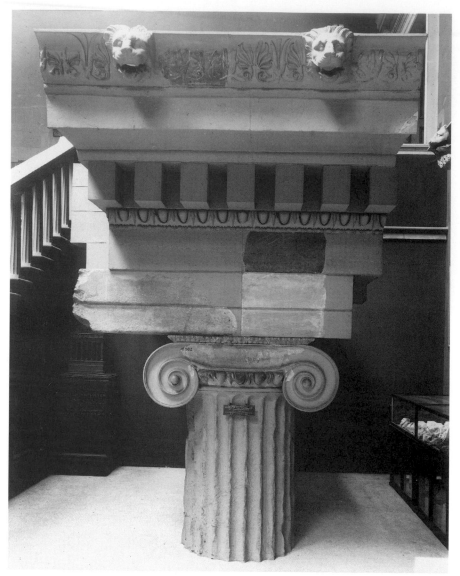

74

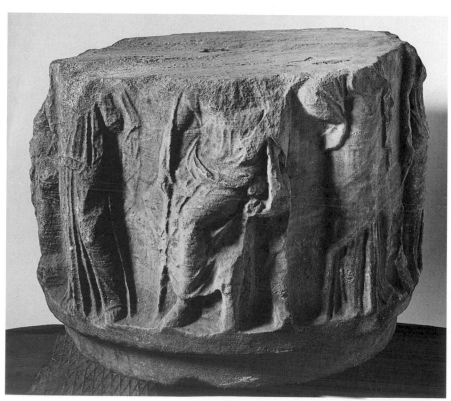

75

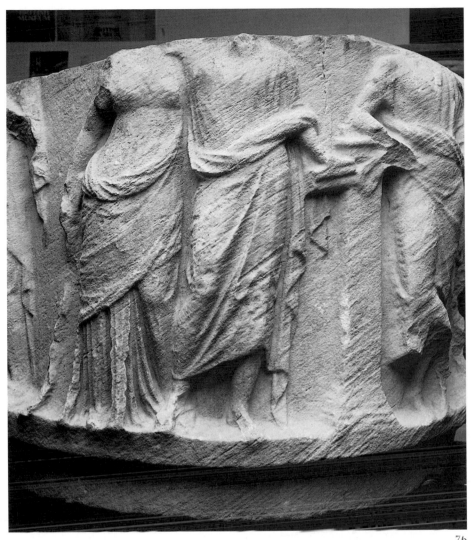

76

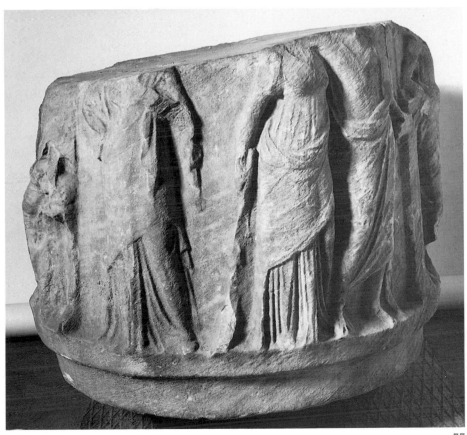

77

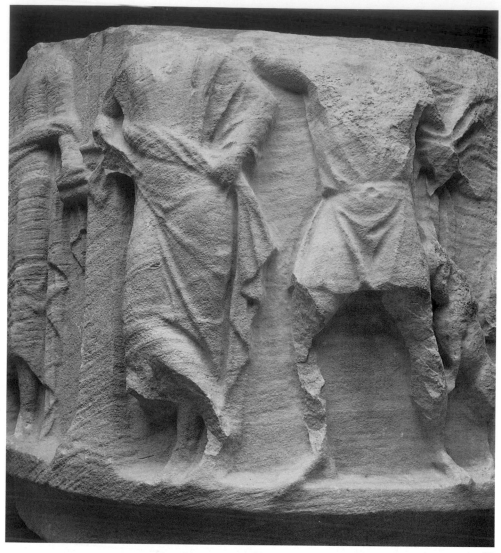

78

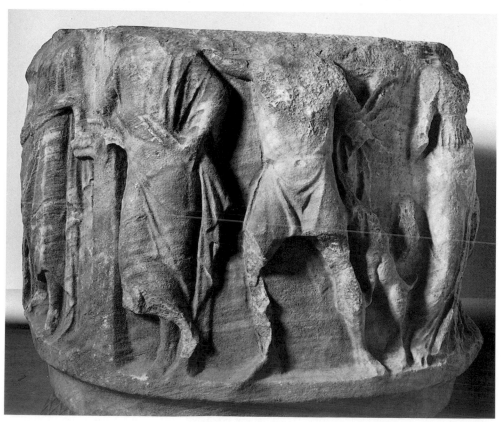

79

80

81

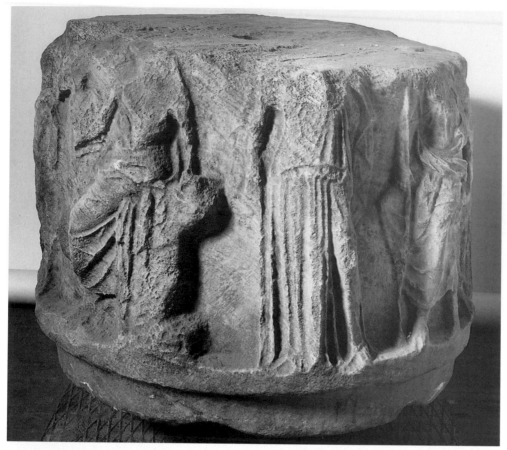

82

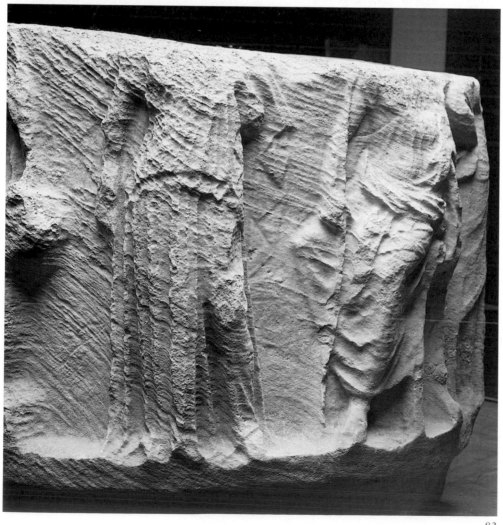

83

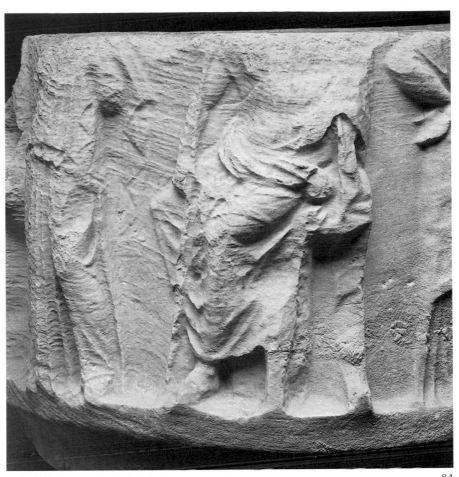

84

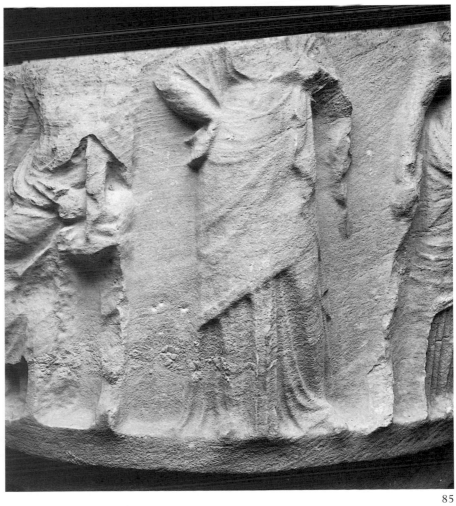

85

86

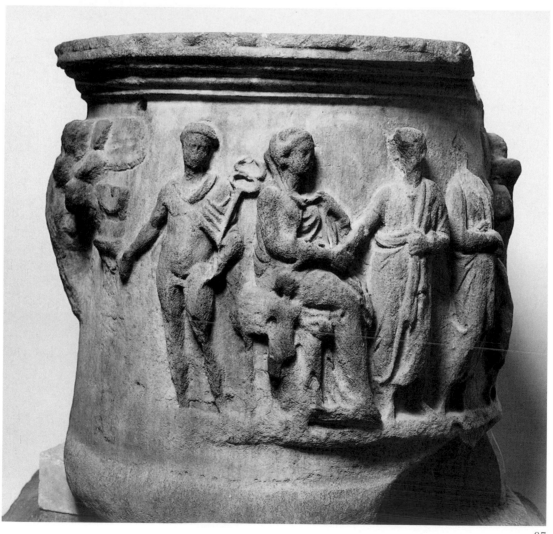

87

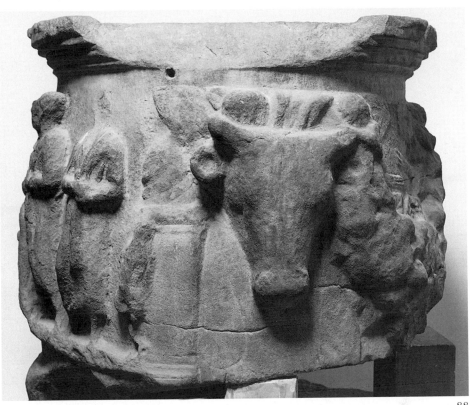

88

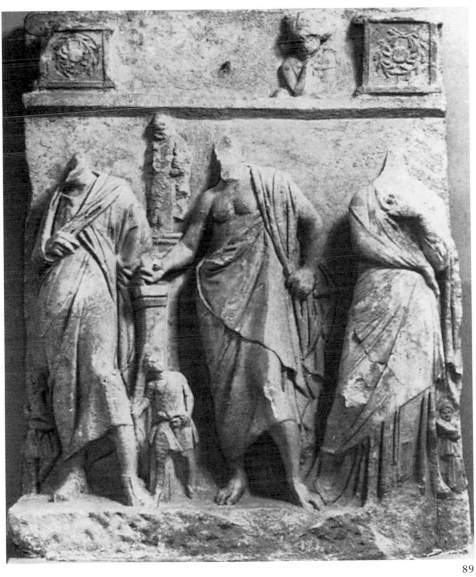

89

90

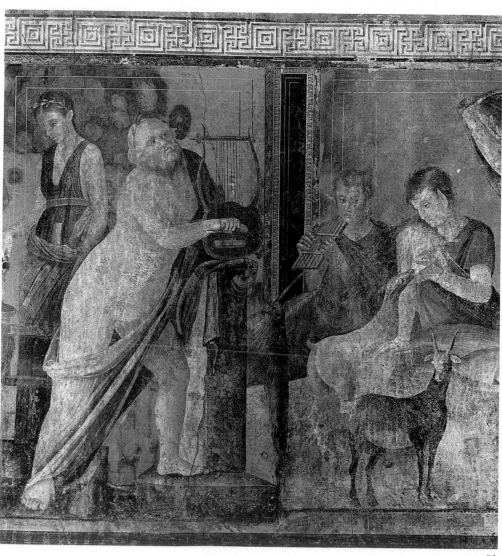

91

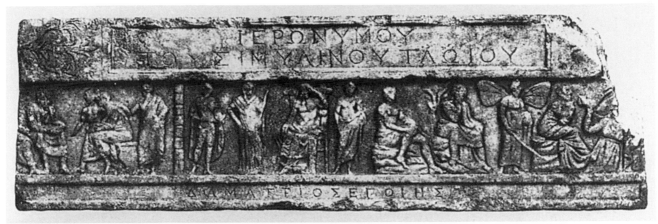

92

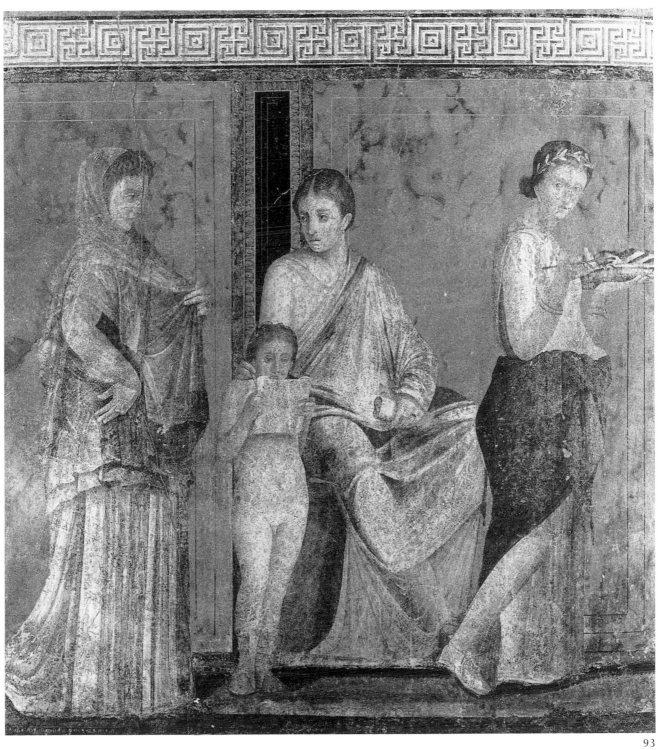

93

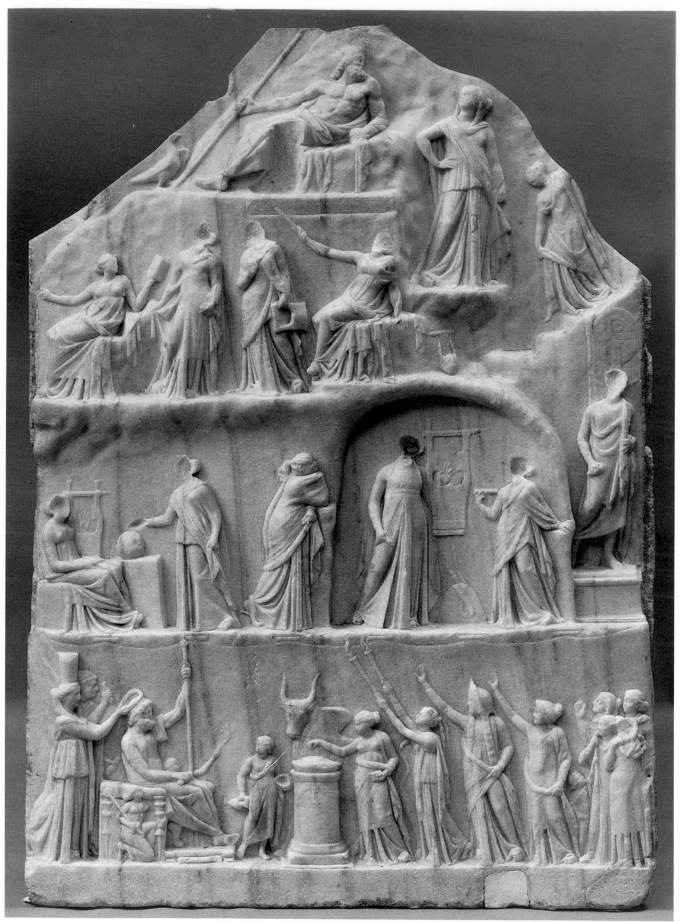

95

96

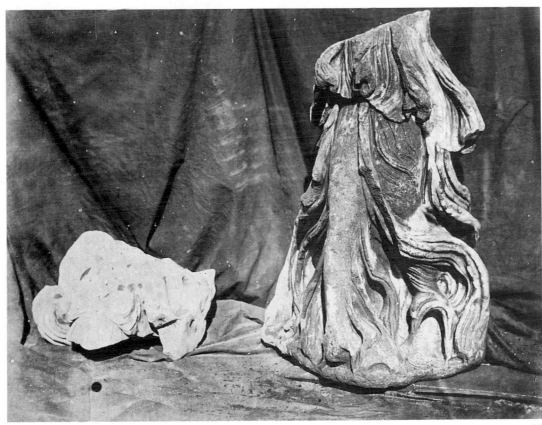

97

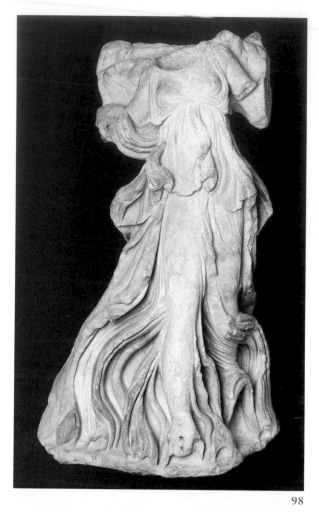

98

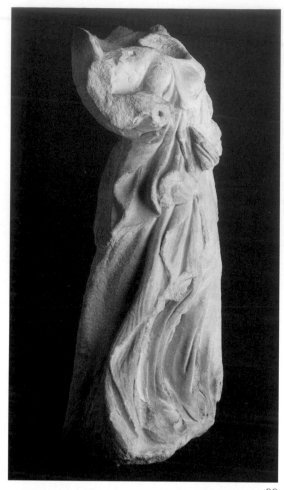

99

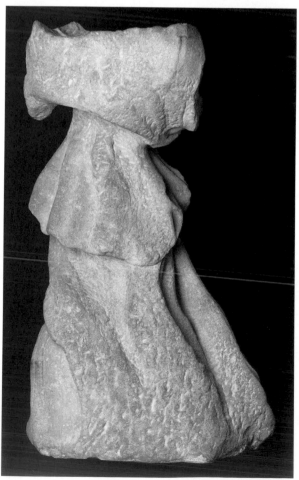

100

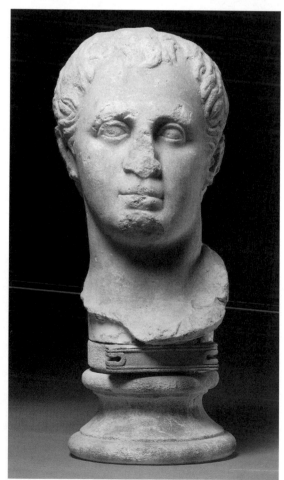

101

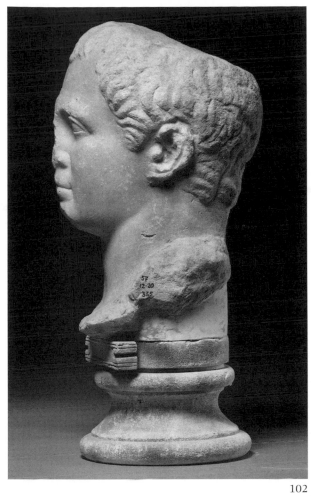

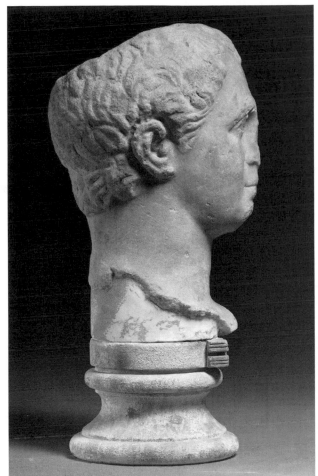

102

103

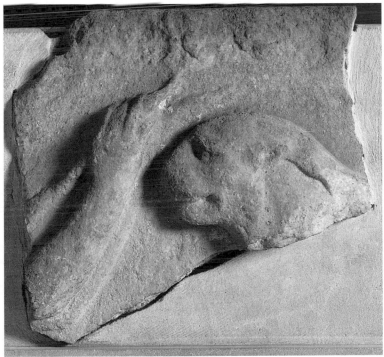

104

105

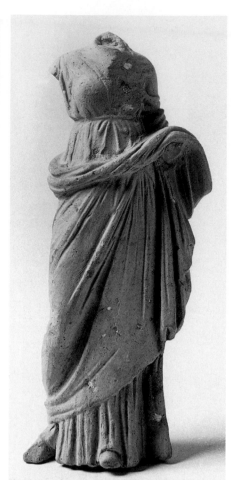

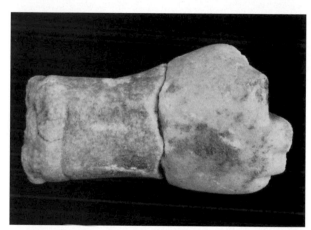

106

107

109

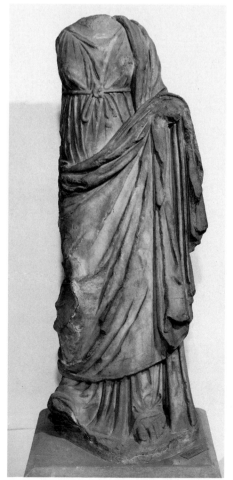

108

110

112

111

114

113

117

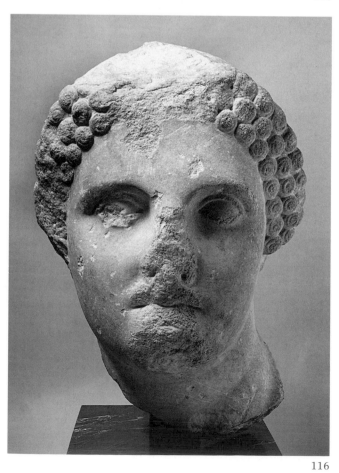

115

116

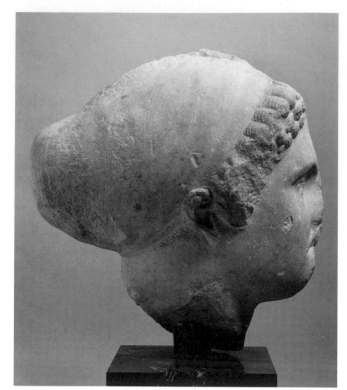

118

119

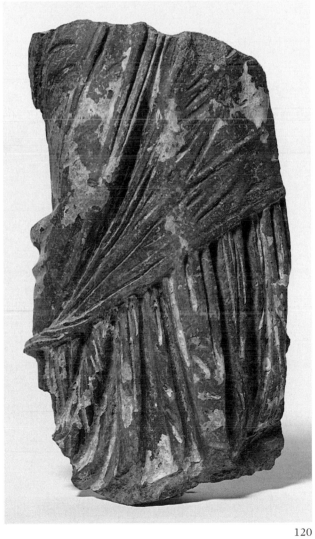

120

121

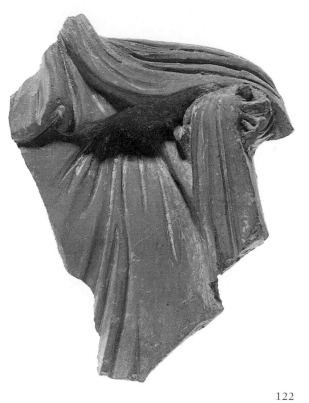

122

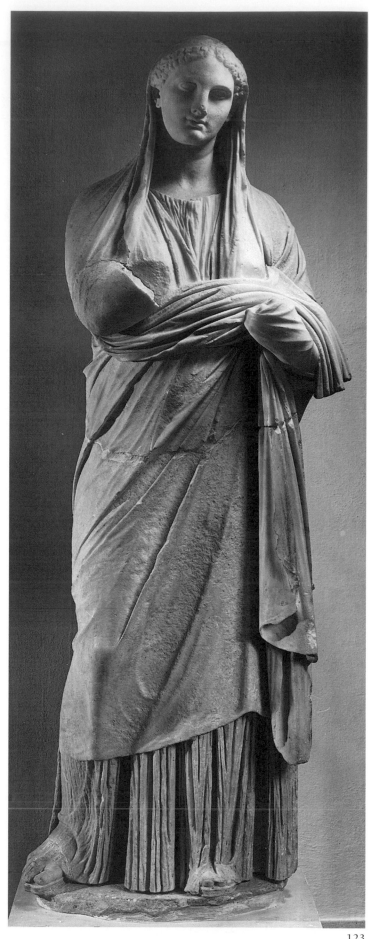

123

124

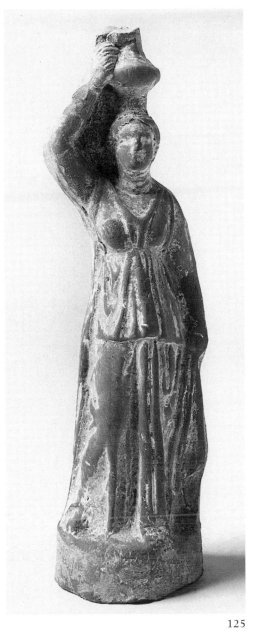

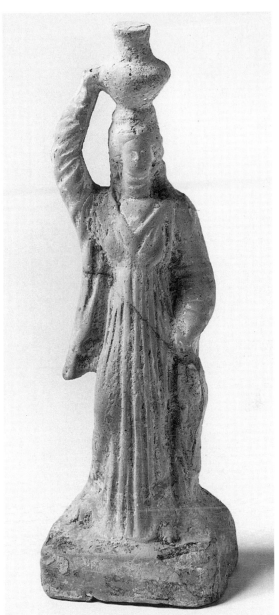

125

126

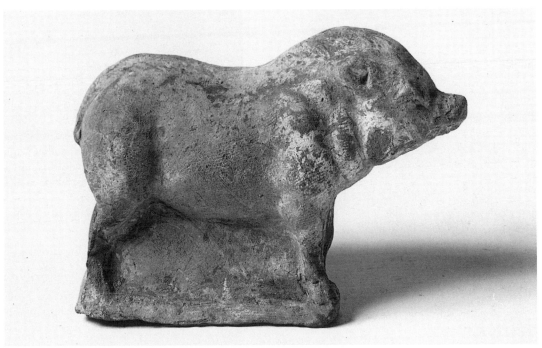

127

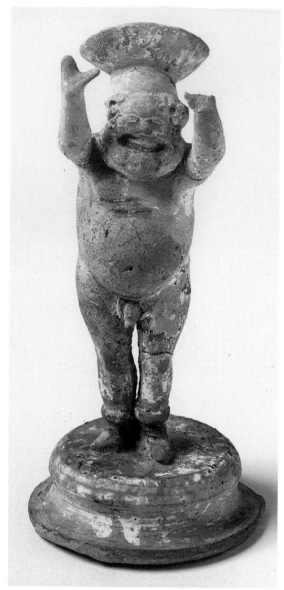

128

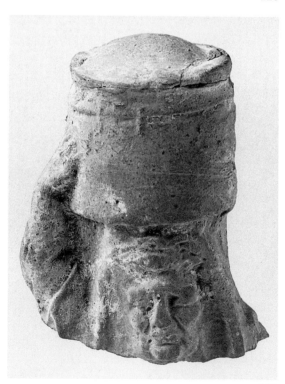

129

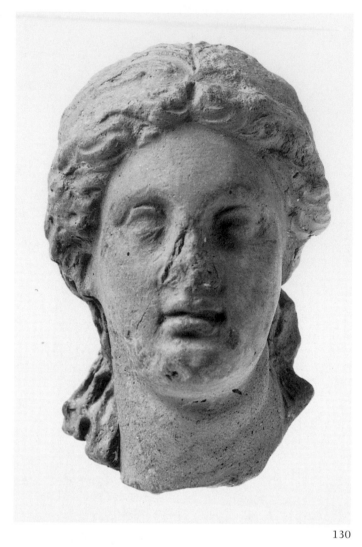

130

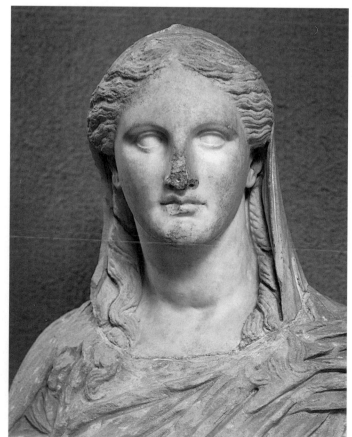

131

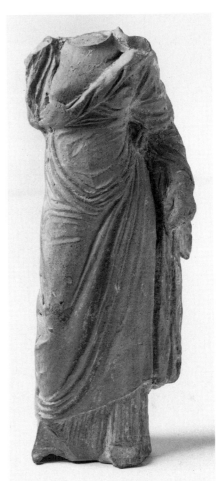

132

134

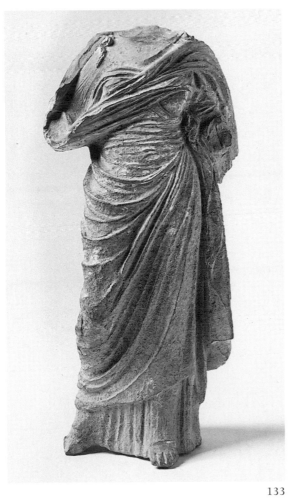

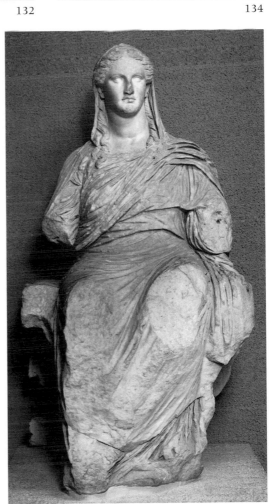

133

135

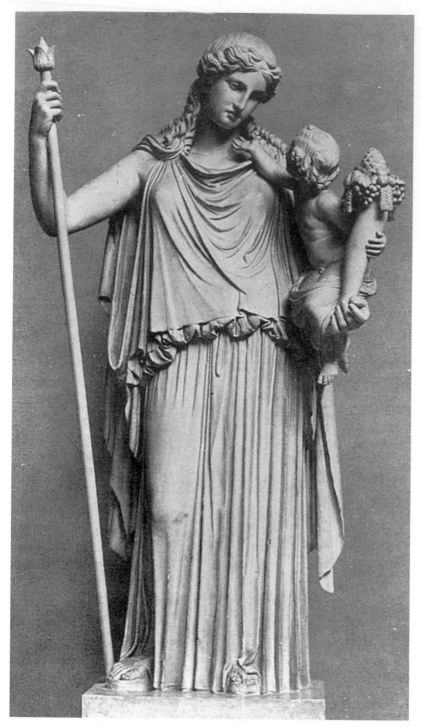

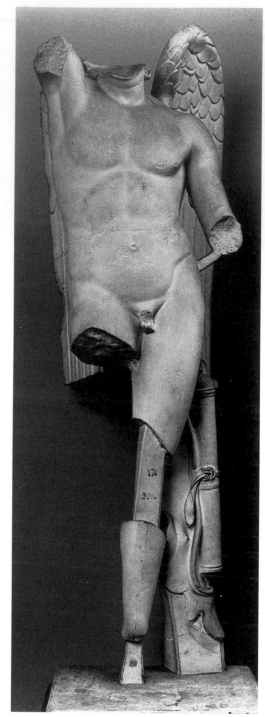

136

137

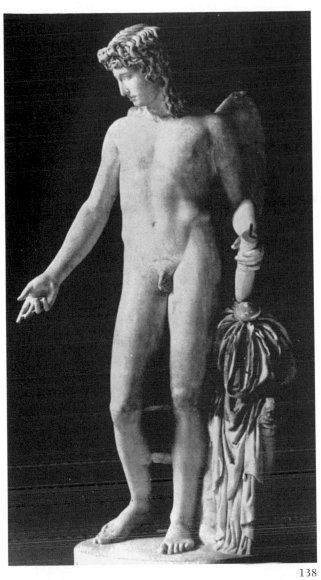

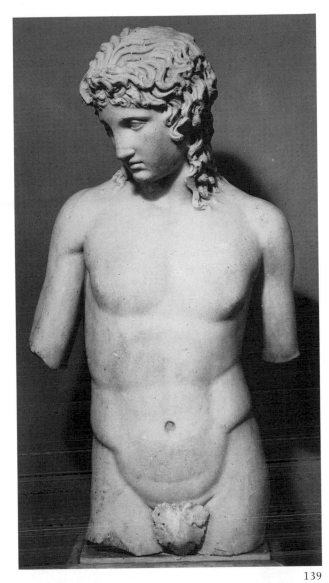

138

139

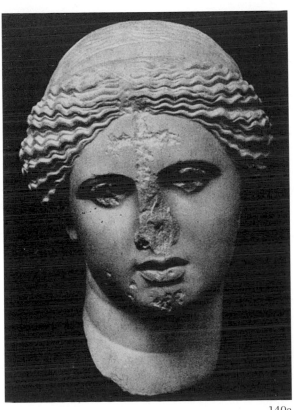

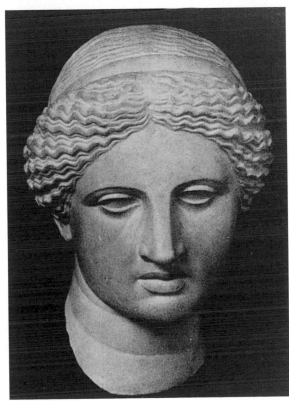

140a

140b

141

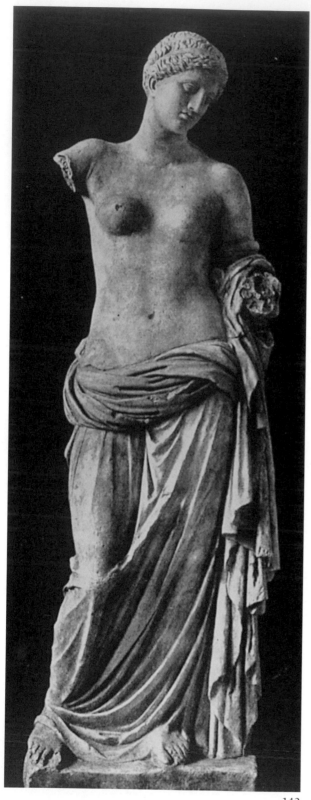

143

142

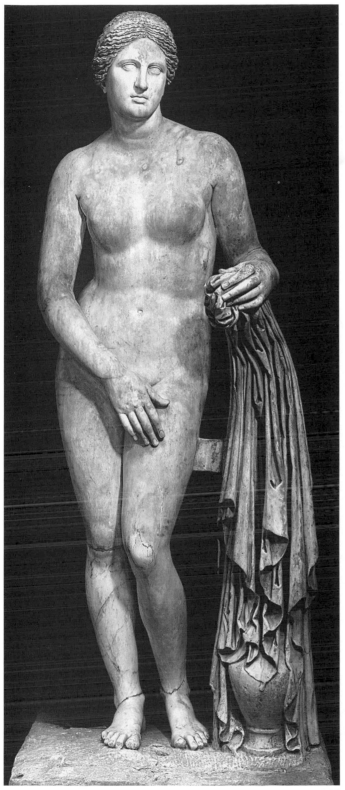

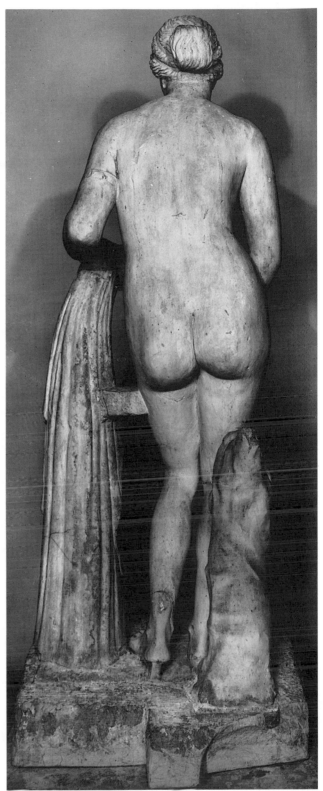

144

145

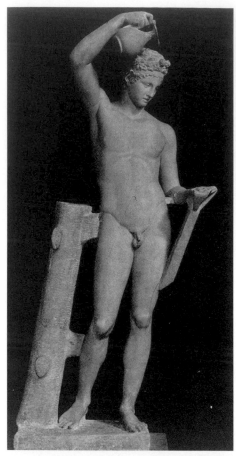

146

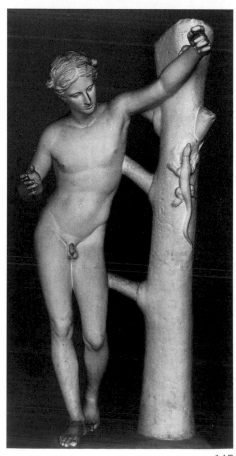

147

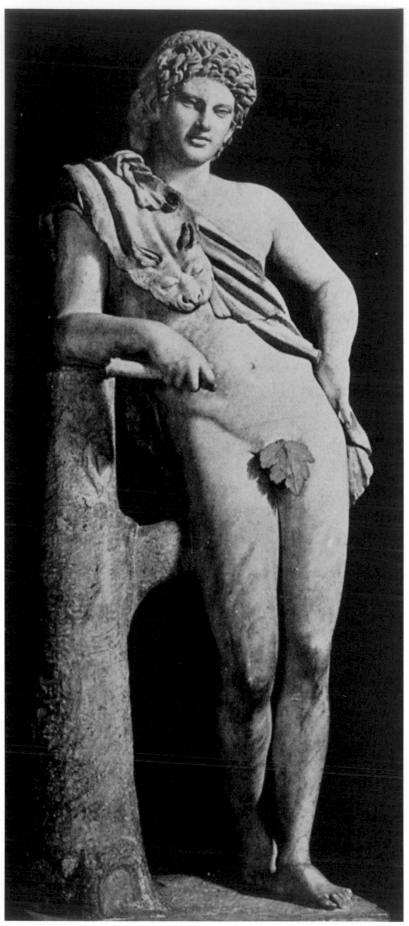

148

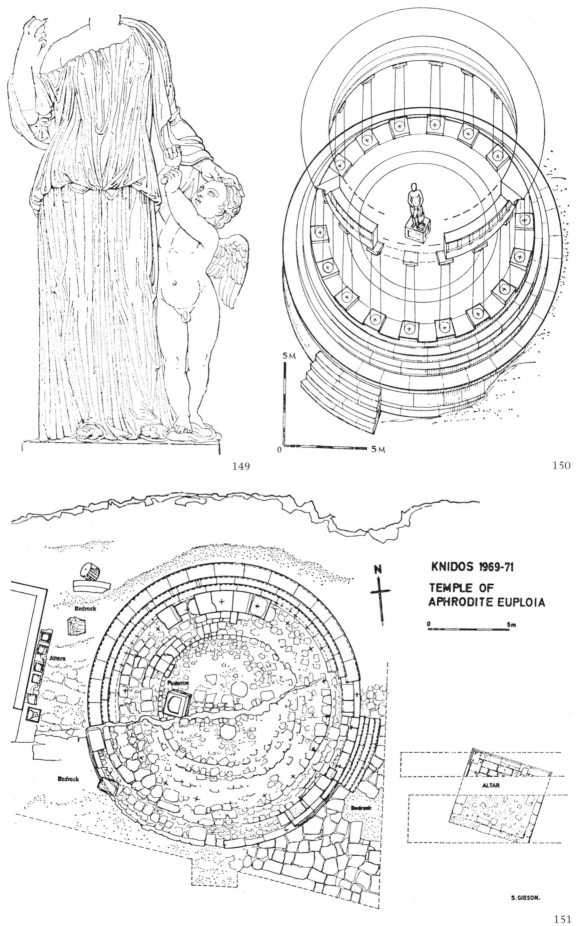

149

150

KNIDOS 1969-71

TEMPLE OF
APHRODITE EUPLOIA

0 5m

N

Bedrock

Alters

Pedestal

Bedrock

Bedrock

ALTAR

S.GIBSON.

5M

0 5M

151

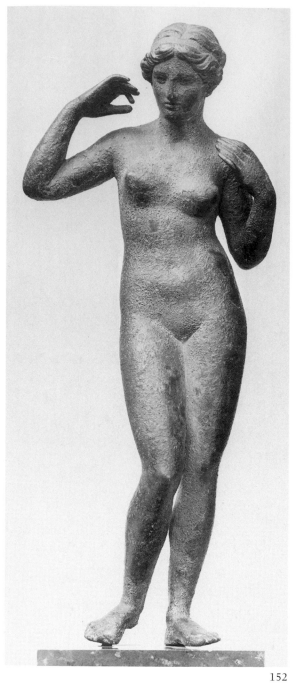

152

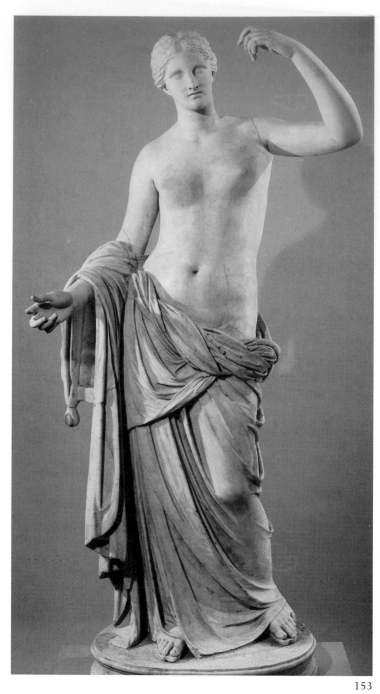

153

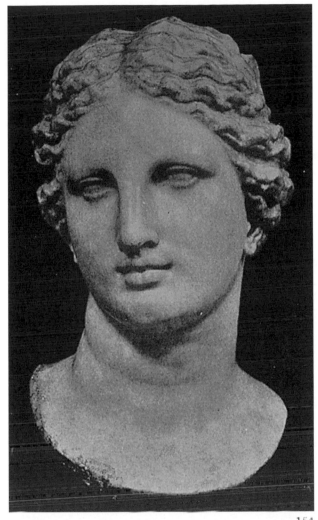

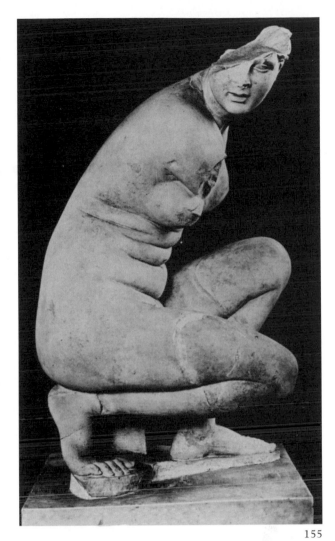

154

155

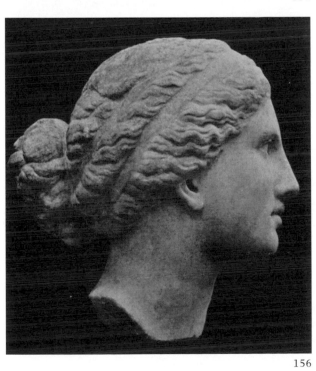

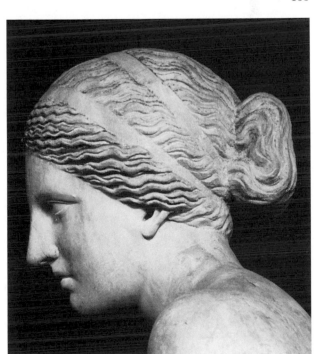

156

157

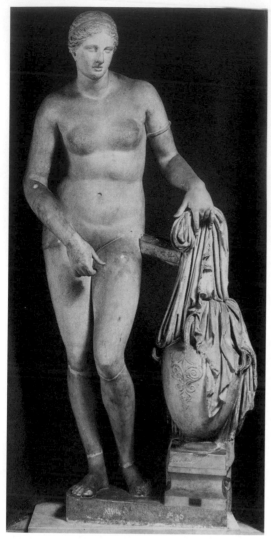

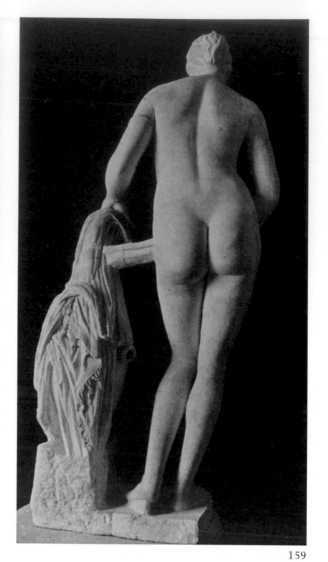

158

159

160

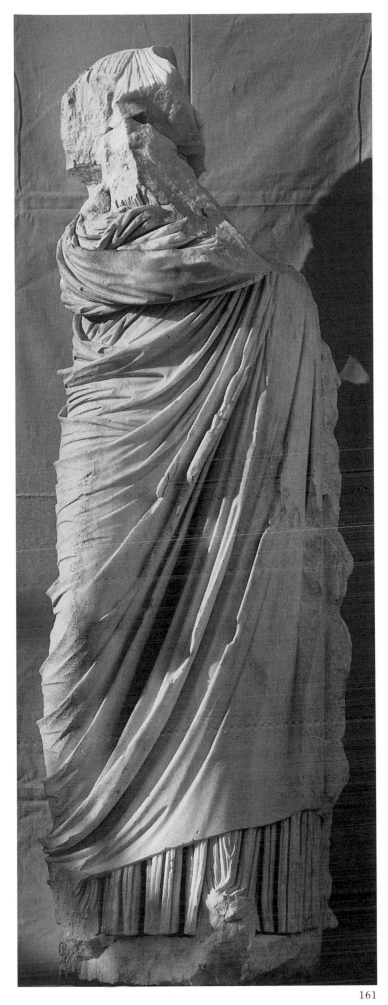

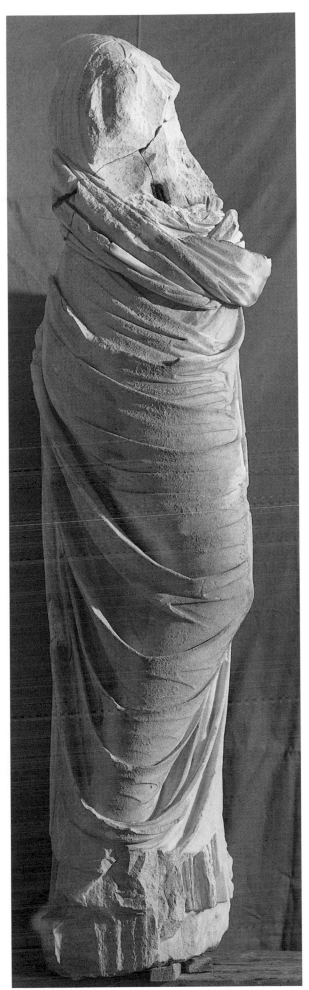

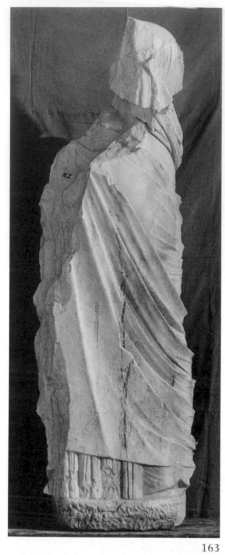

163

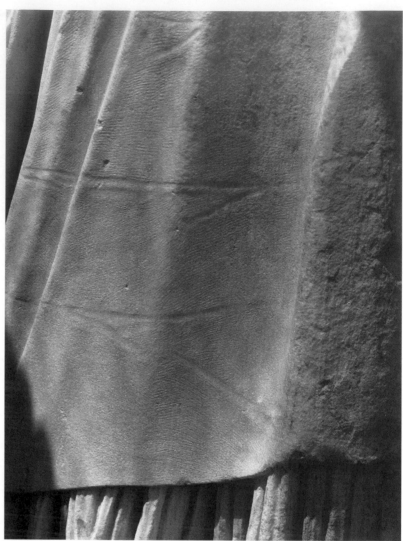

164

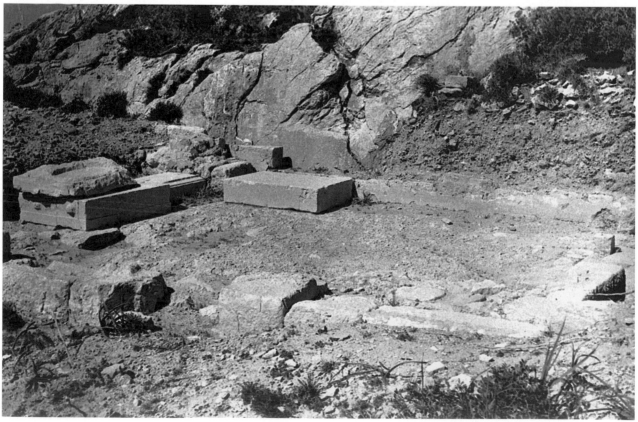

165

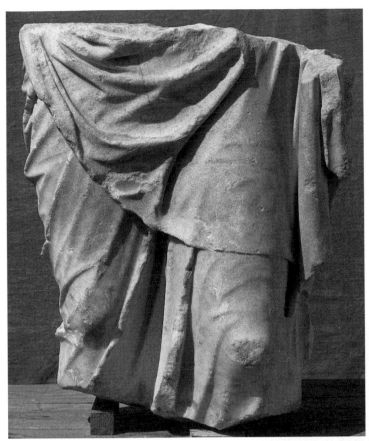

166

167

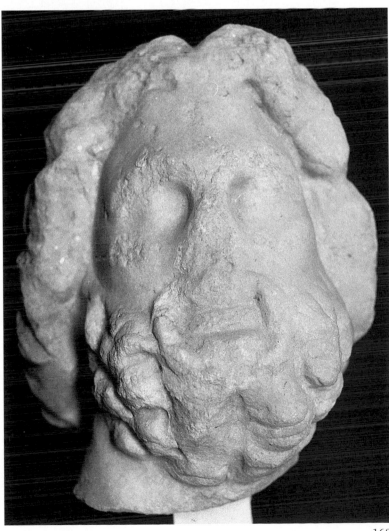

168

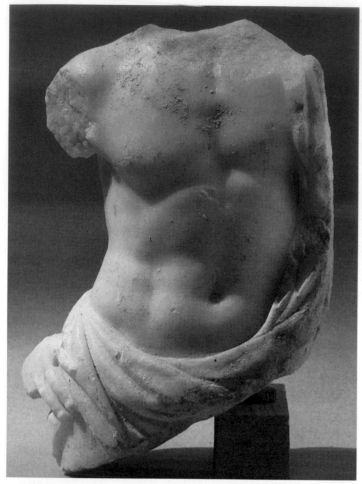

169

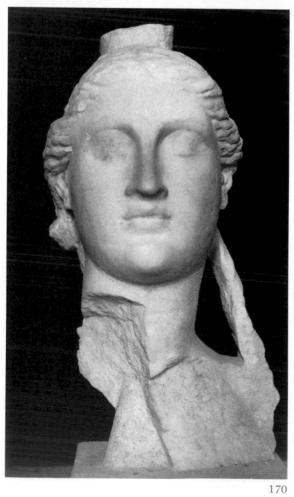

170

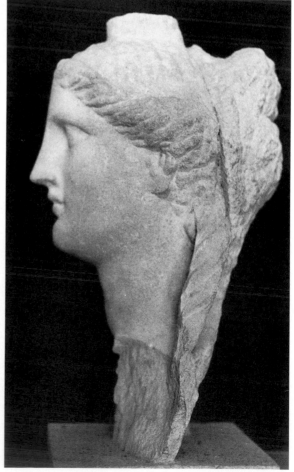

171

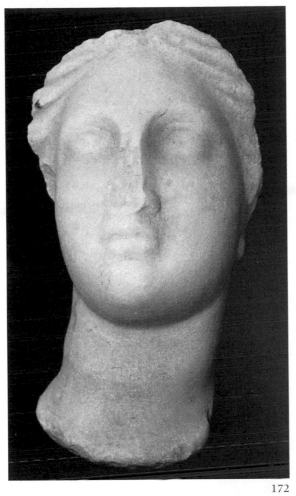 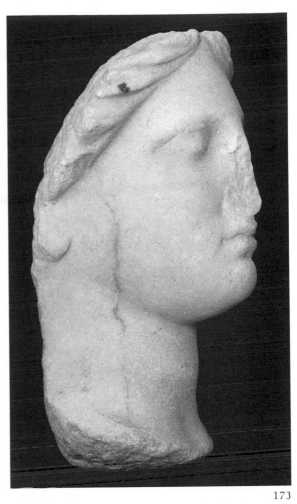

172 173

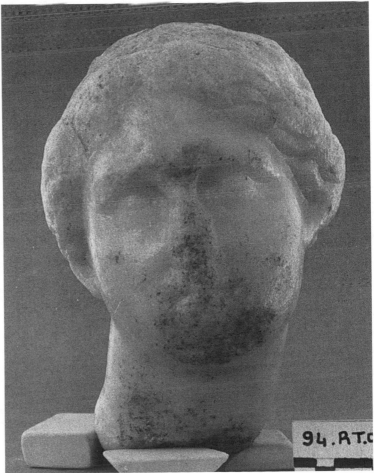

174

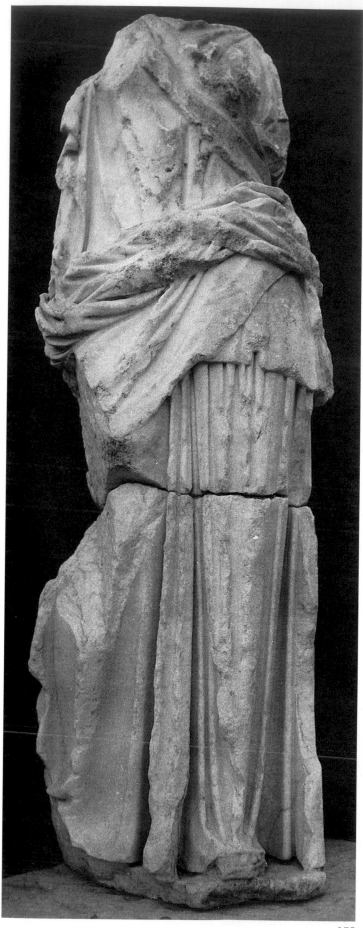

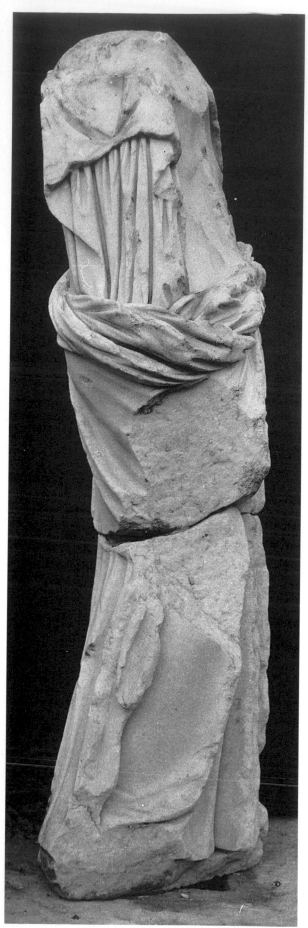

175

176

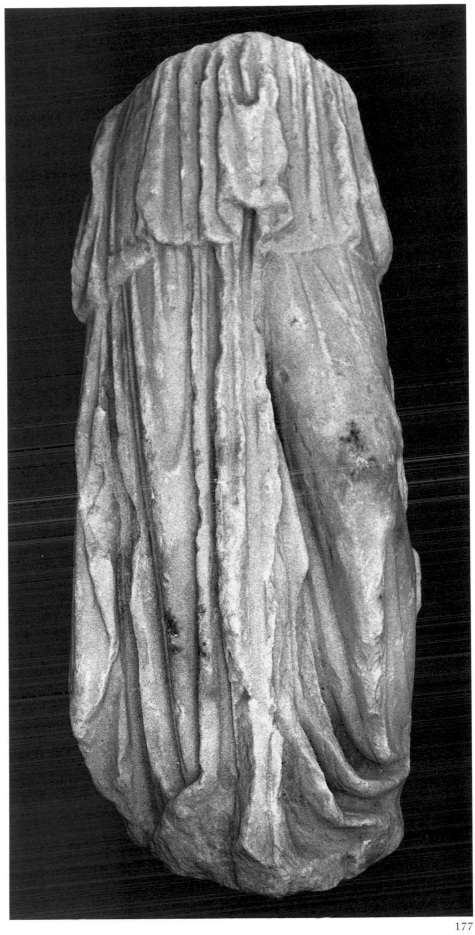

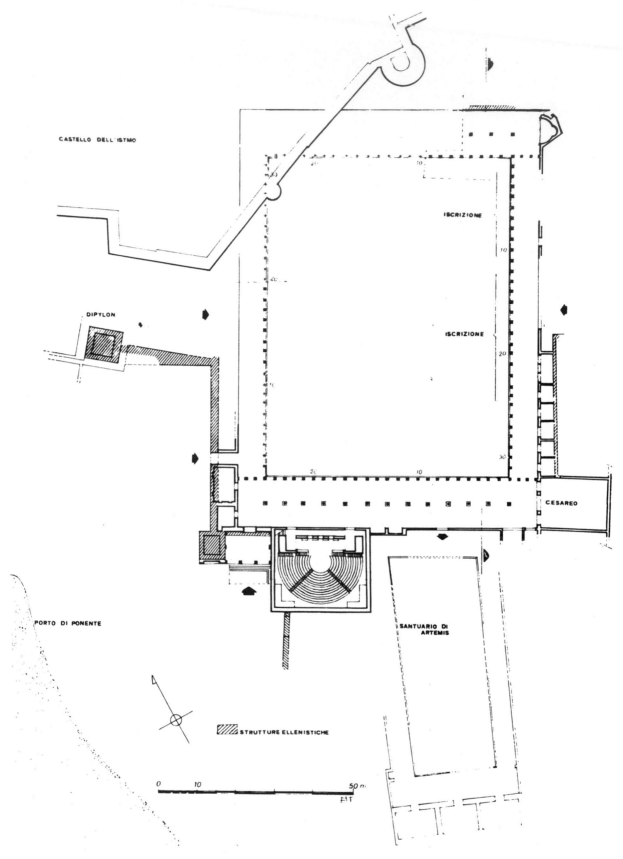

CASTELLO DELL' ISTMO

ISCRIZIONE

ISCRIZIONE

DIPYLON

CESAREO

PORTO DI PONENTE

SANTUARIO DI ARTEMIS

STRUTTURE ELLENISTICHE

0 10 50 m

178

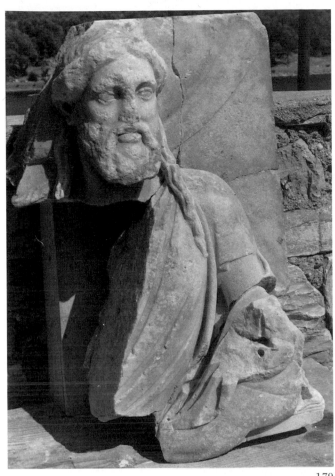

179

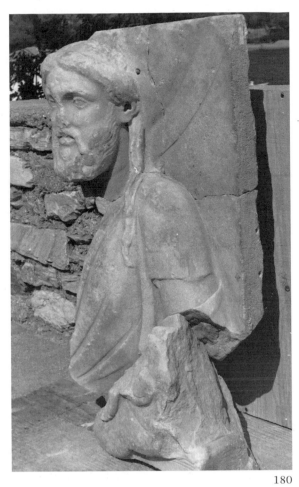

180

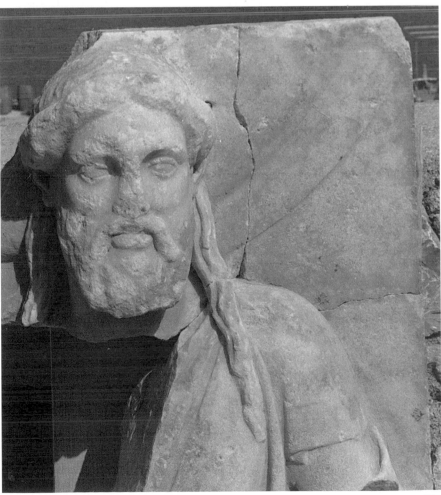

181

182

185

183

186

184

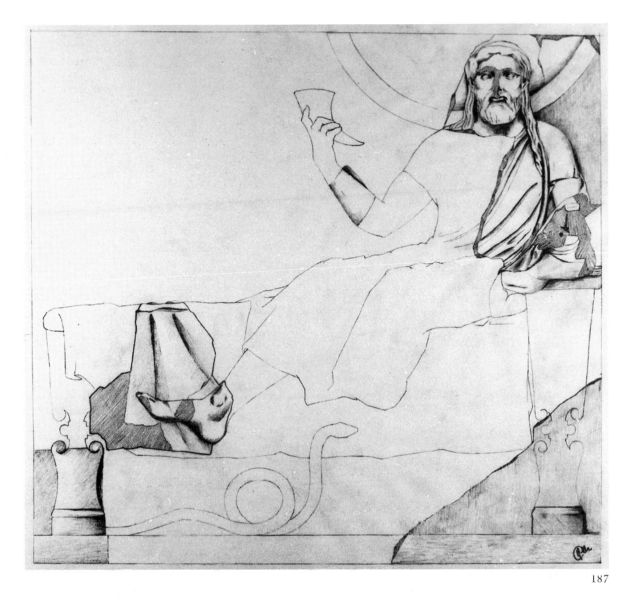

187

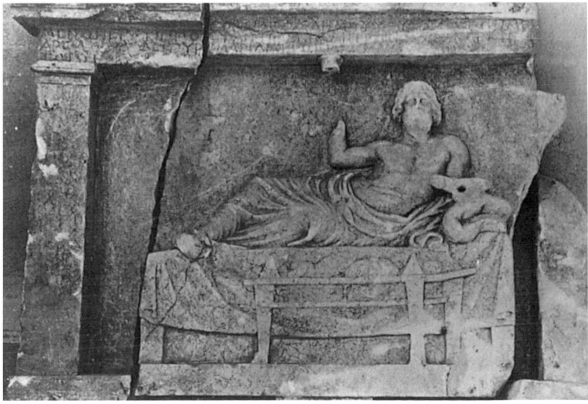

188

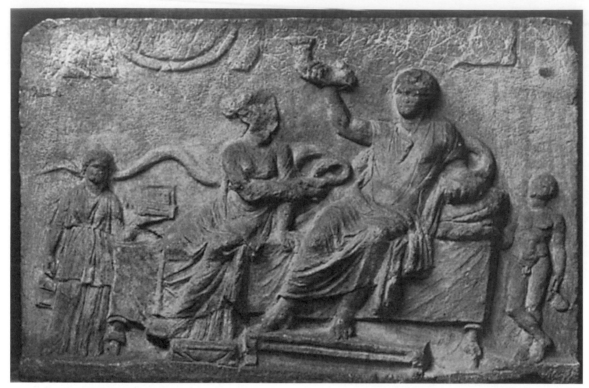

189

190

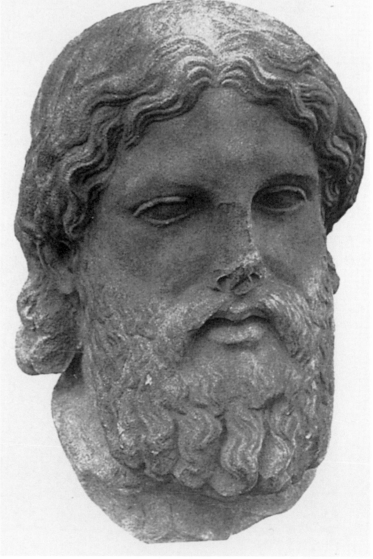

191

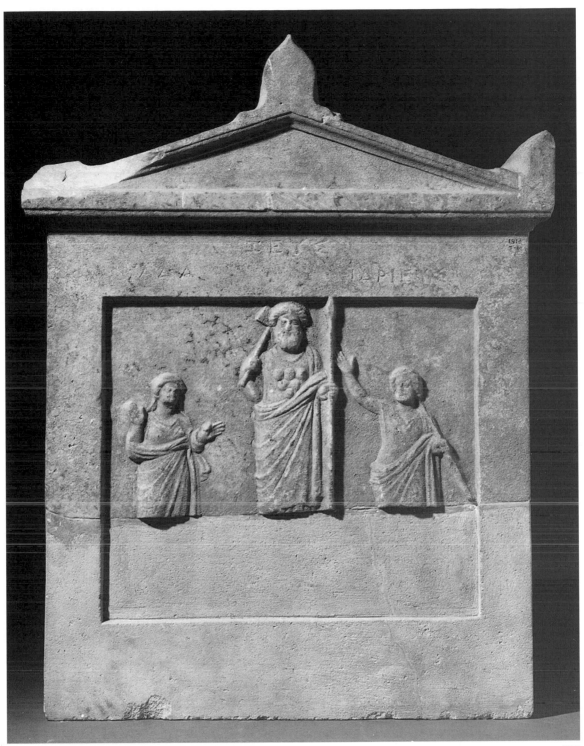

192

193

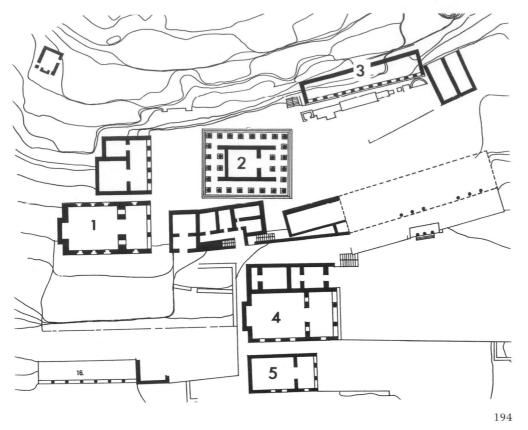

Plan of the central part of the shrine

1 Andron of Idrieus (Andron A)

2 Temple of Zeus

3 North Stoa (Roman Stoa of Poleites, possibly on same site as the Stoa of Mausolus)

4 Andron of Mausolus (Andron B)

5 Andron C

194

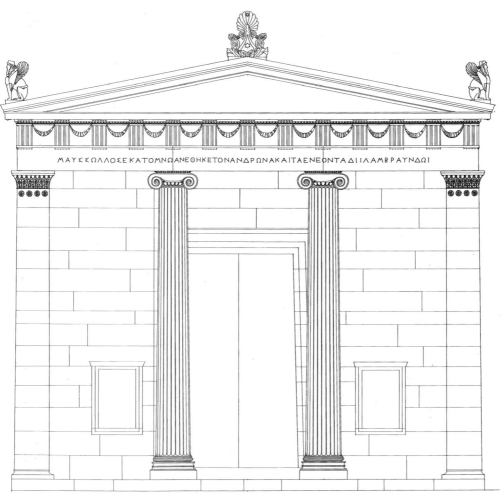

ΜΑΥΣΣΩΛΛΟΣΕΚΑΤΟΜΝΩΑΝΕΘΗΚΕΤΟΝΑΝΔΡΩΝΑΚΑΙΤΑΕΝΕΟΝΤΑΔΙΙΛΑΜΒΡΑΥΝΔΩΙ

195

196

197

198

199

200

201

202

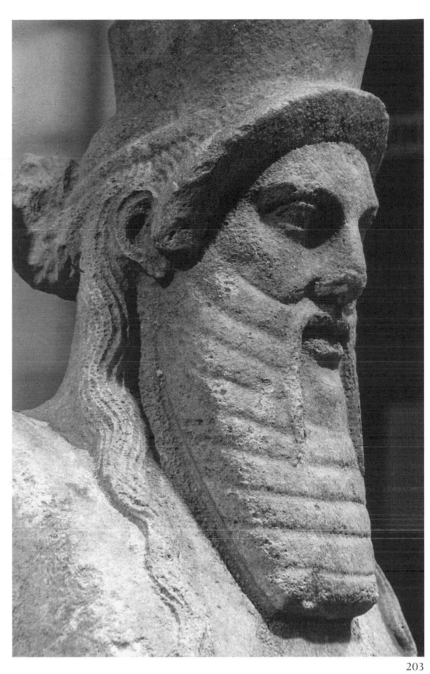

203

204

205

206

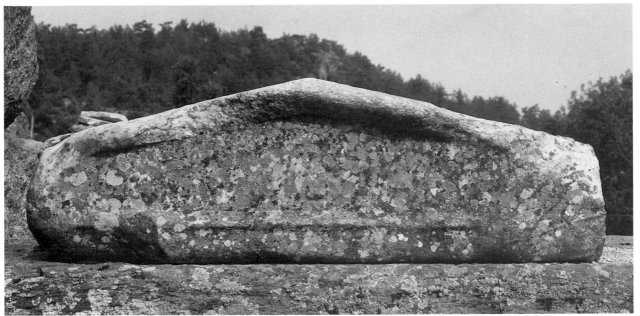

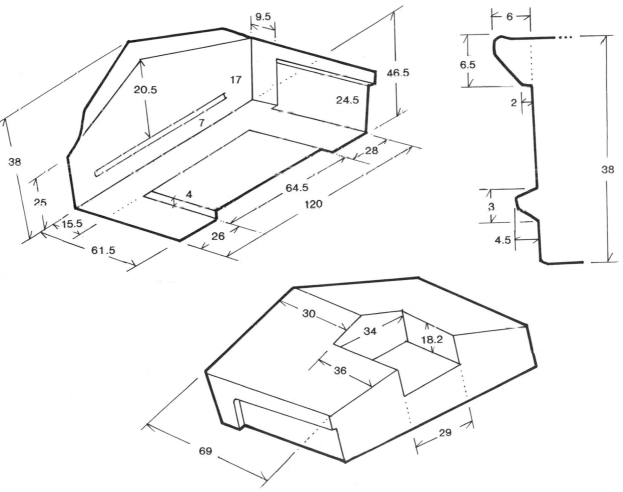

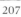

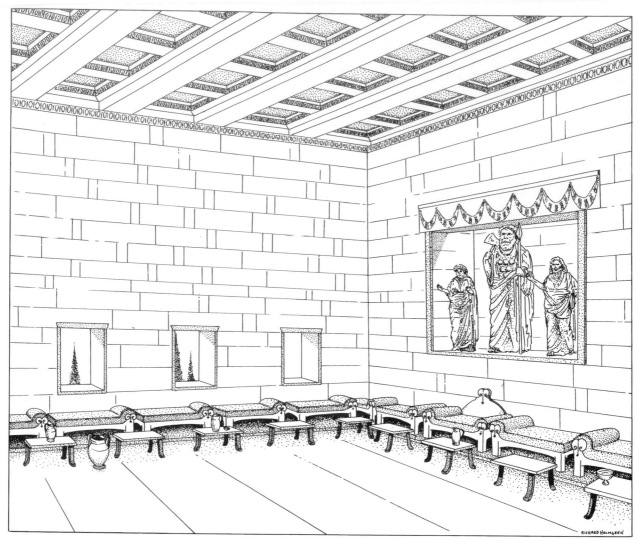

RICHARD HOLMGREN

209

210

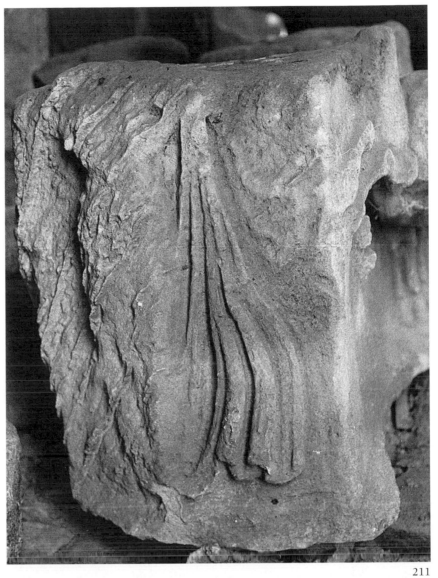

211

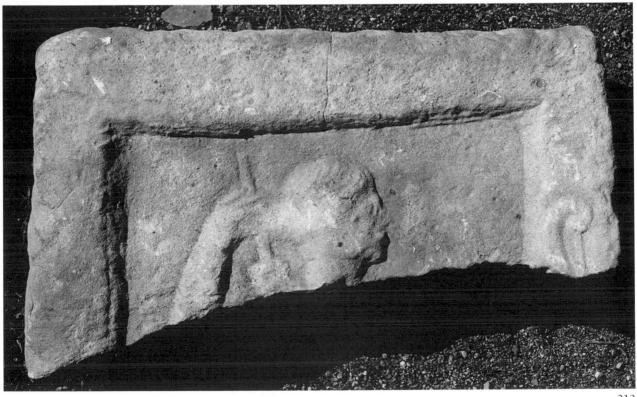

212

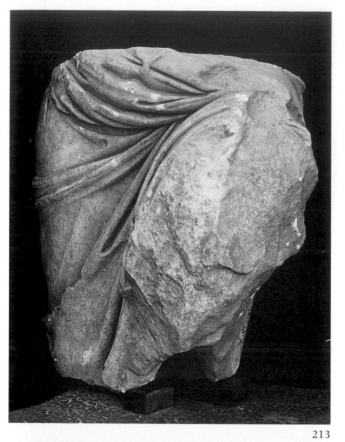

213

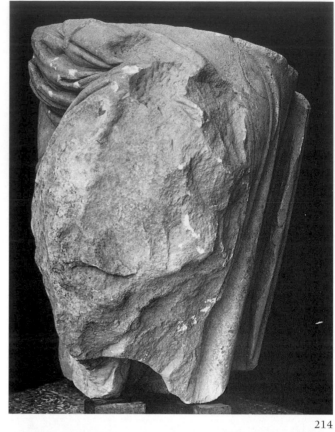

214

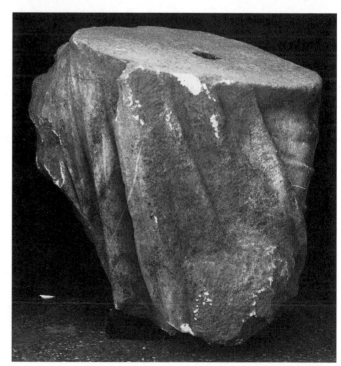

215

216

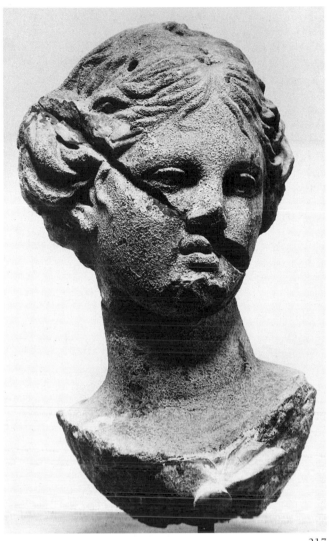

217

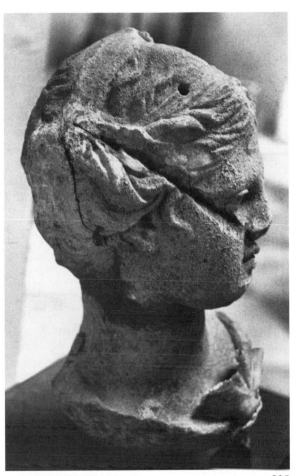
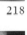

218

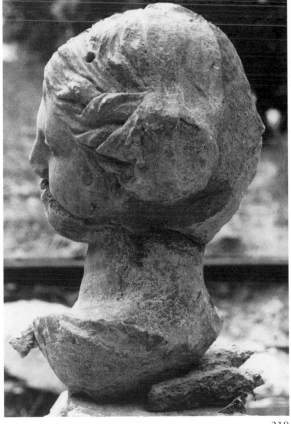

219

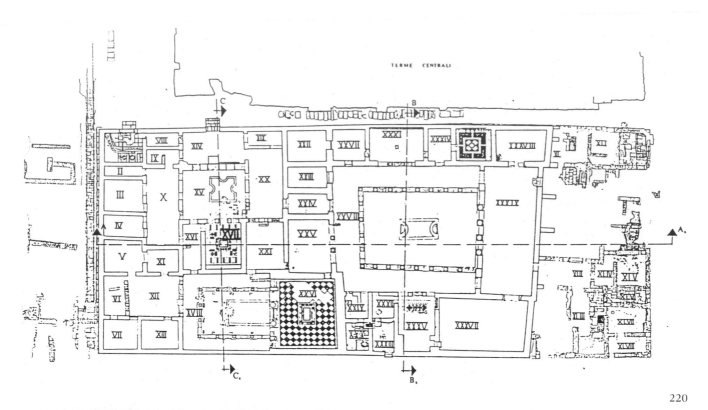

220

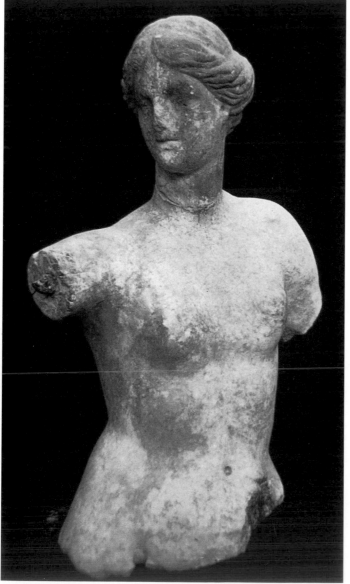

221

222

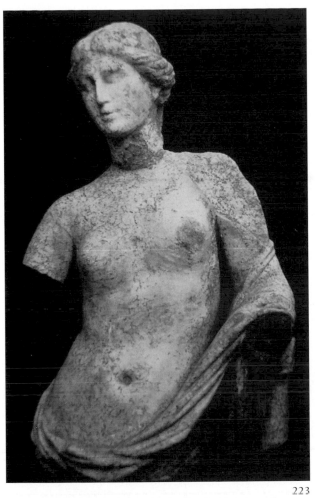

223

224

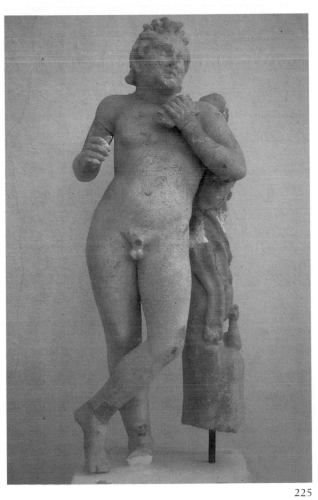

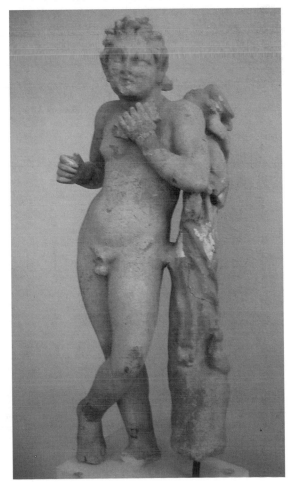

225

226

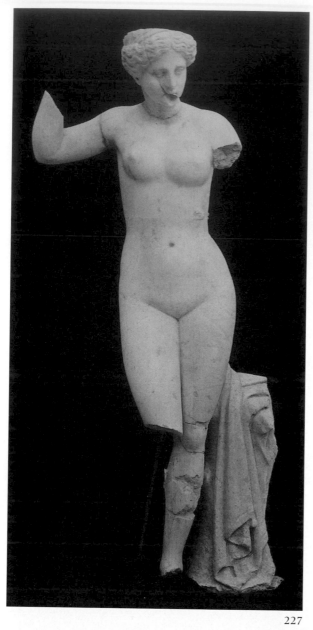

227

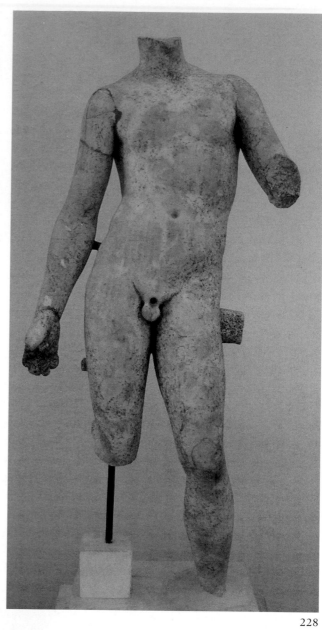

228

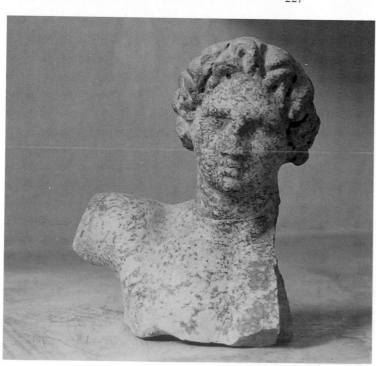

229

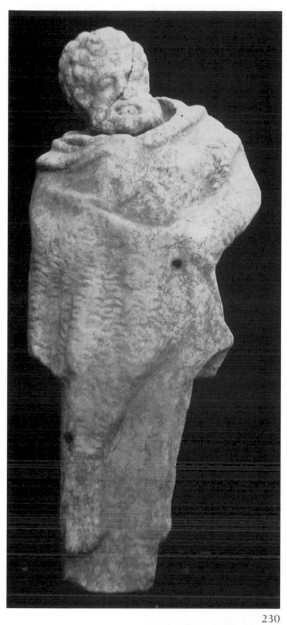

230

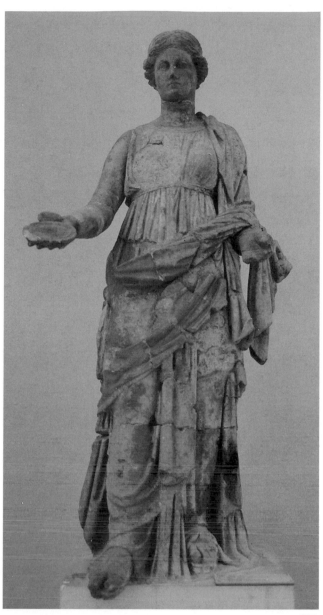

231

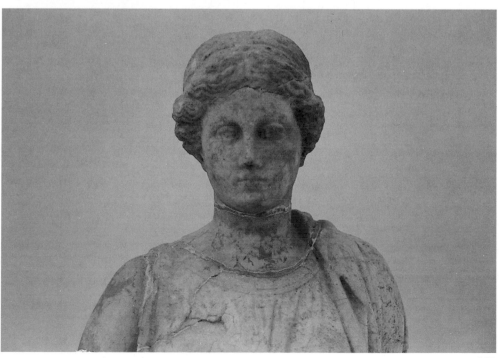

232

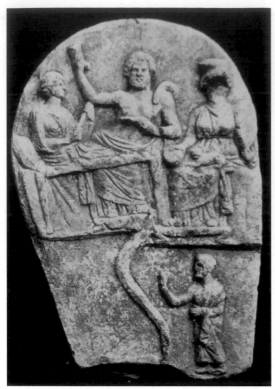

233

234

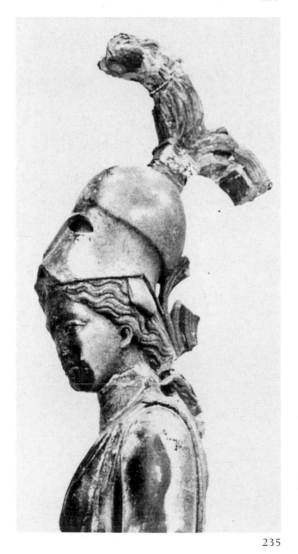

235

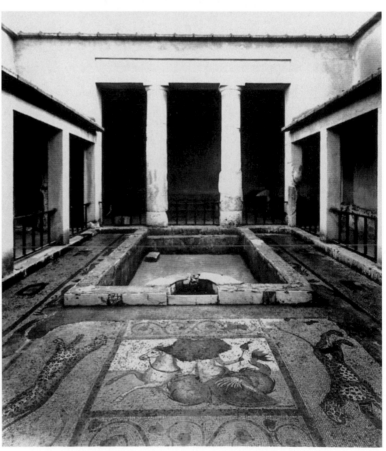

236

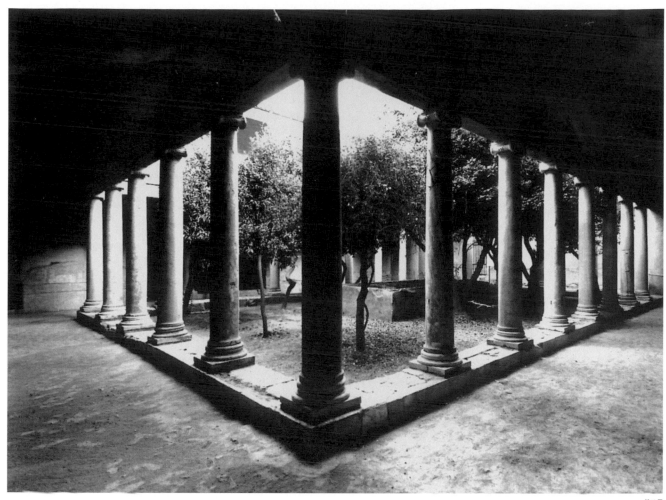

237

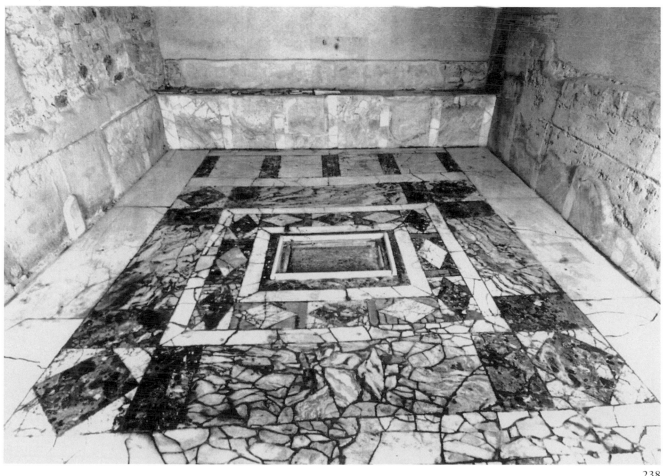

238

ΔΕΛΦΙΣΑΓΑΛΜΑΓΥΜΝΙΝΕΒΡΟΥΚΟΥΡΗΜΕΛΝΕΘΗΚΗΝ
ΔΟΡΚΑΔΟΣΕΓΜΗΤΡΟΣΜΝΗΣΙΑΝΔΑΞΕΔΕΓΠΑΤΗΡ

239

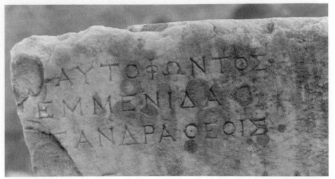

...ΑΥΤΟΦΩΝΤΟΣ
ΕΜΜΕΝΙΔΑ...
ΑΝΔΡΑΘΕΟΙΣ

241

ΑΙΣΧΡΟΝ Α

242

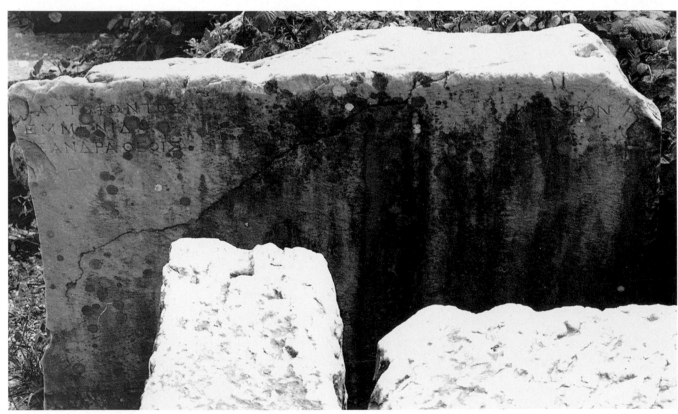

240

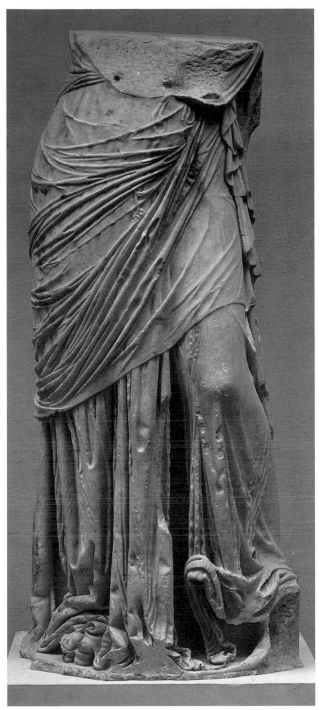

243

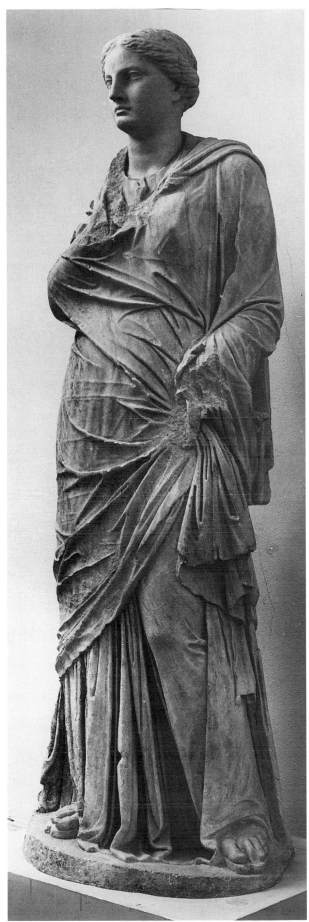

244

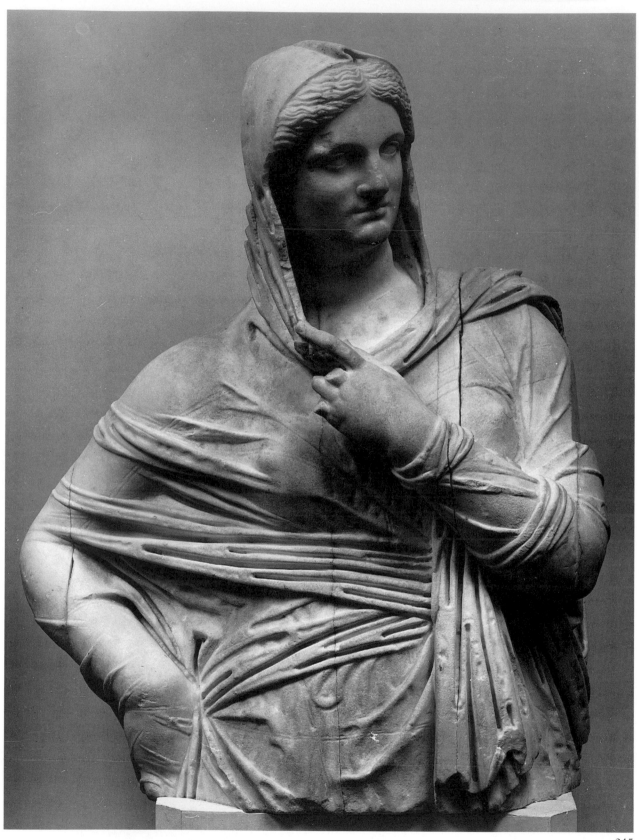

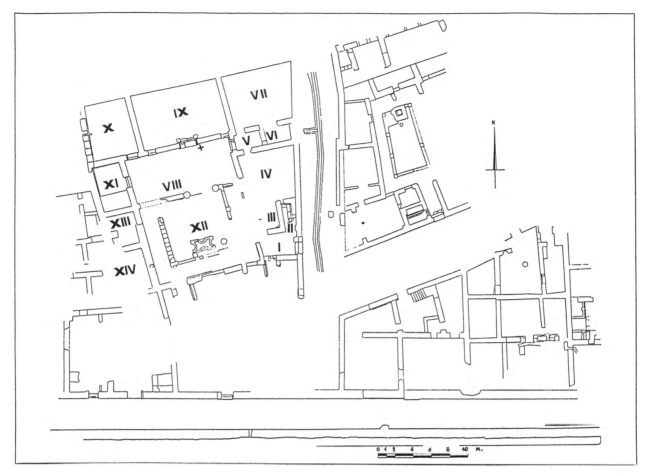

246

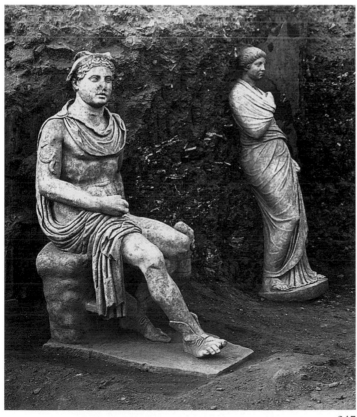

247

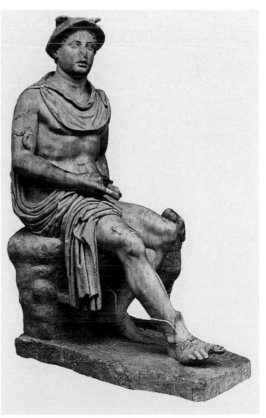

248

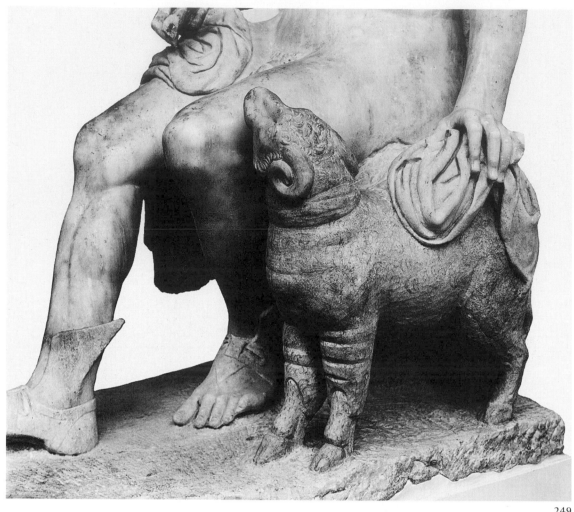

249

250

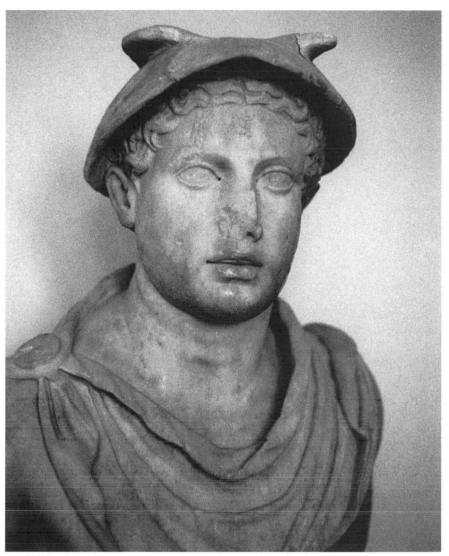

251

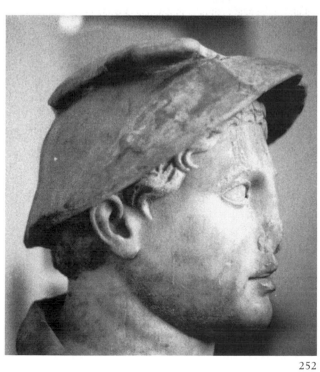

252

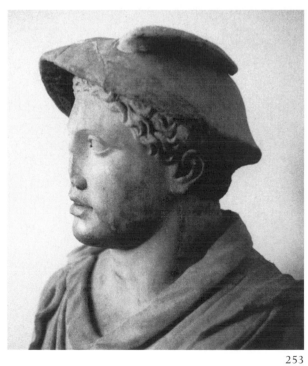

253

254

256

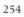

255

257

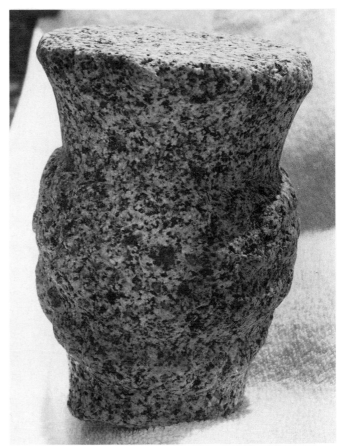

258

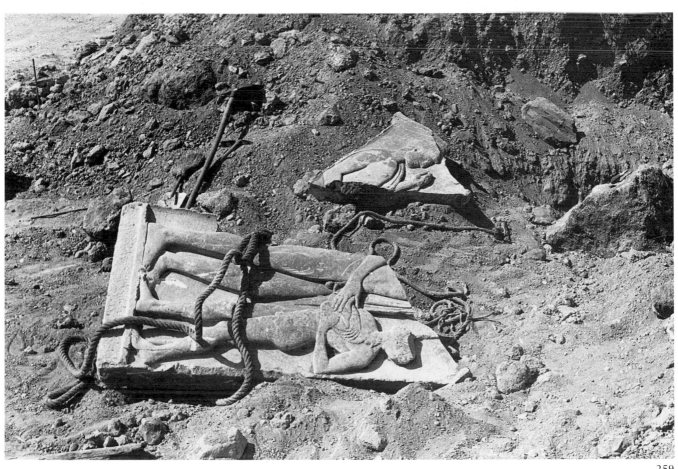

259

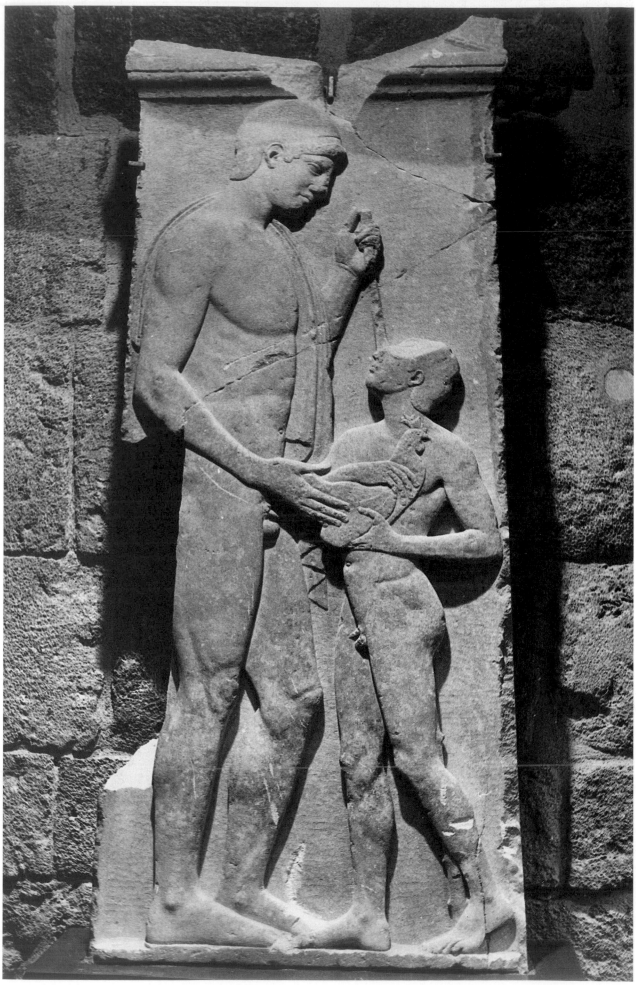

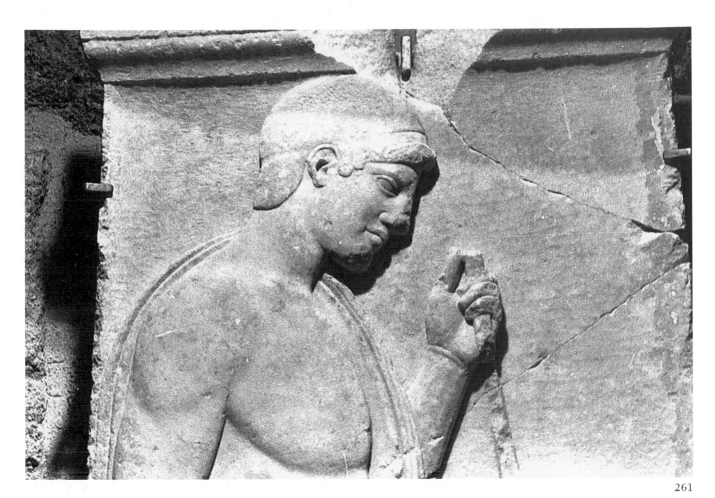

261

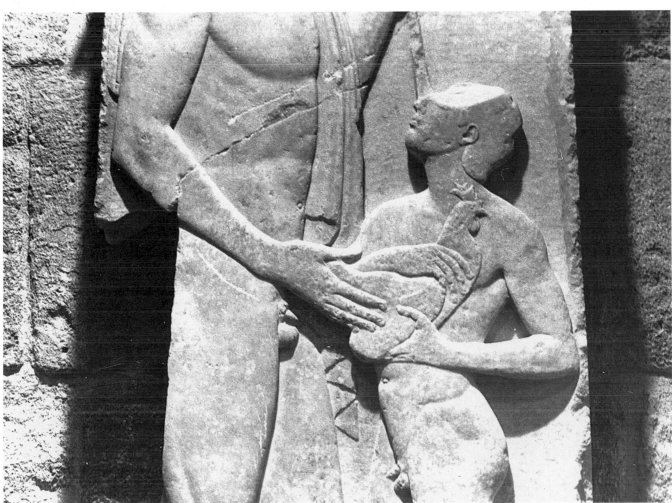

262

263

265

264

266

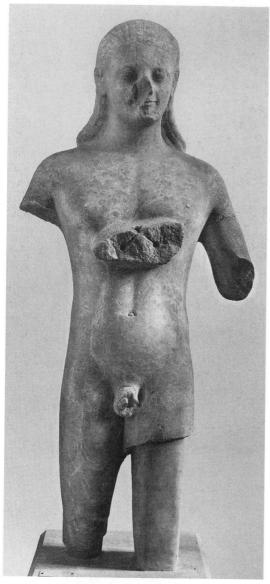

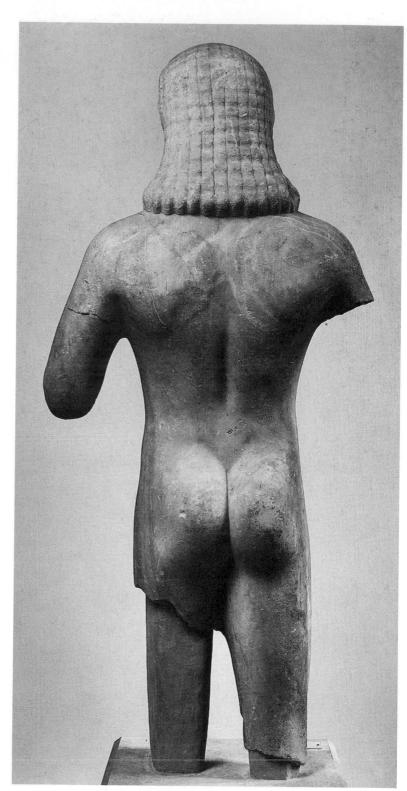

267

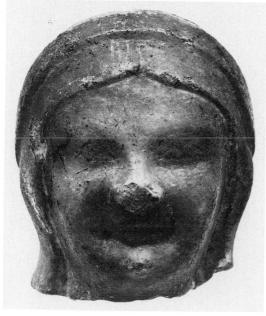

269

268

270

272

271

273

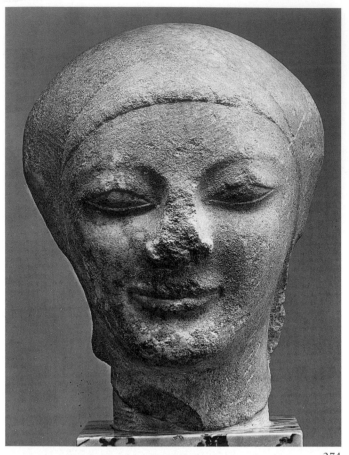

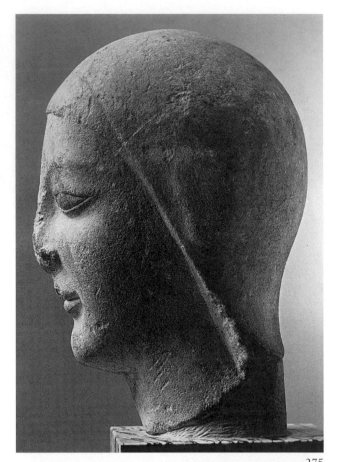

274

275

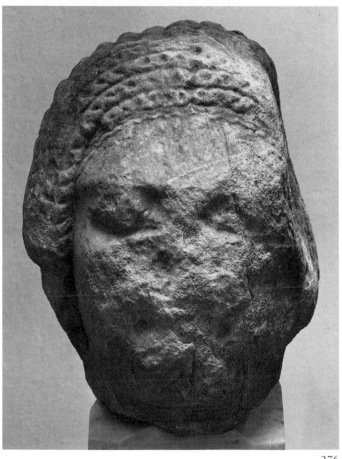

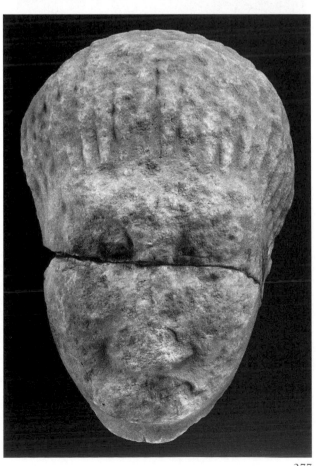

276

277

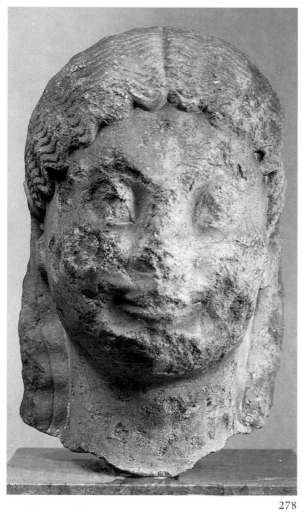

278

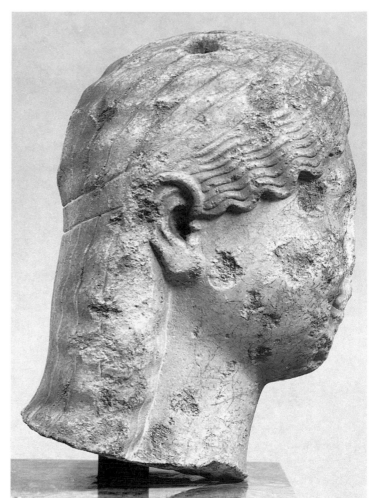

279

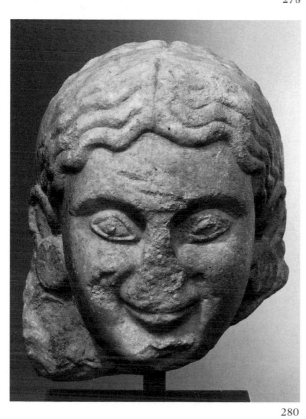

280

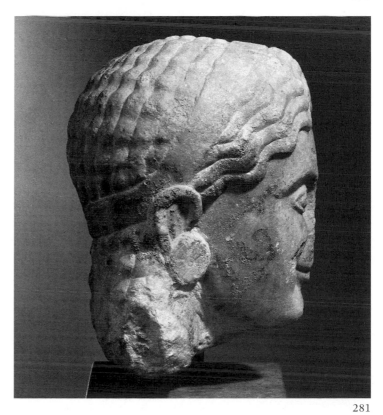

281

List of Illustrations

6 Susan Walker and K. J. Matthews: The marbles of the Mausoleum

8 Olga Palagia: Initiates in the underworld